THE MOST BEAUTIFUL LIBRARIES IN THE WORLD

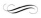

THE MOST BEAUTIFUL

LIBRARIES IN THE WORLD

Photographs by GUILLAUME DE LAUBIER

Text by JACQUES BOSSER

Foreword by JAMES H. BILLINGTON, THE LIBRARIAN OF CONGRESS

Translated from the French by LAUREL HIRSCH

HARRY N. ABRAMS, INC., *Publishers*

To Sophie, to patient love

CONTENTS

FOREWORD

A PAINTING IN MY OFFICE IN THE LIBRARY OF CONGRESS'S THOMAS JEFFERSON BUILDING bears the Latin inscription *Liber dilectatio anime*: Books, the delight of the soul. All libraries celebrate this delight, which is reinforced by the sheer beauty of the libraries featured in the pages of *The Most Beautiful Libraries in the World*. The libraries in this book are special because they ally architecture with literature.

The architects of the Library of Congress's Thomas Jefferson Building found inspiration in many of the libraries found in these pages. One of the architects, John L. Smithmeyer, was born in Austria and must have been familiar with the splendor of the Hofbibliothek, which is now the National Library of Austria, and melded some of its features into the Italian Renaissance design of the Library of Congress. Smithmeyer, along with the German-born Paul J. Pelz, his partner in the Library of Congress's architectural team, traveled to the great libraries of Europe, including the Renaissance-style Vatican Library, as they developed the architectural plan for the national library of a country just over one hundred years old.

Unlike many of the libraries of Europe, which were designed for an elite, Smithmeyer and Pelz were charged with rendering plans for a Library for the masses. Smithmeyer felt that it should provide the people with "insight into the colossal array of knowledge which the human mind has accumulated and still gathers together, and into the enormous machinery required for the access to and the utilization of every part of these intellectual riches."

Whether dazzlingly decorated or austere in design, all libraries provide an insight into the culture that brings them into being. *The Most Beautiful Libraries in the World* takes the reader into the grand spaces of libraries founded by monarchs, monks, and academics, as well as modern governments attempting to define as well as house a national culture. Among the libraries shown on these pages are some of my favorites and indeed some of the greatest. As a student at Oxford, I had the great pleasure of using the collections of the Bodleian Library within its historic halls. As a scholar of Russian history, I have enjoyed working in the National Library of Russia in Saint Petersburg. Its collections document the turbulent history of Russia and the many cosmopolitan collections of Russia's "window to the West." I wrote

my first major book in the beautiful National Library of Finland, which, like its Saint Petersburg counterpart, is part of a grand architectural ensemble. The experience of working with the Vatican Library inspired me to initiate an exhibition of treasures from the Vatican Library at the Library of Congress and display the great strengths of the Vatican Library collections in the history of the exact sciences, East Asian languages and literatures, and music history.

The Library of Congress is glad to be included among these great libraries, all of which embody a belief in the universality of knowledge with a casing of aesthetic grandeur. The Library's Thomas Jefferson Building, which is capped in the collar of its Main Reading Room dome with Edwin Blashfield's mural *The Evolution of Civilization*, now contains reading rooms representing the legacies of the whole world. The Library of Congress owes a cultural debt to the world's great libraries and the aesthetic and cultural tradition of these institutions.

Completed in 1897, the Library of Congress's Thomas Jefferson Building serves as the optimistic expression of the self-confidence of America at the turn of the last century. Its décor expresses the living connection between the classical past and the American future. This magnificent building was named for the Library's principal founder, Thomas Jefferson. It, along with the Library's other buildings, houses the collections of the Library of Congress that contain research materials in most of the world's languages, reflecting Jefferson's belief that there was "no subject to which a Member of Congress might not have occasion to refer."

As you move through the pages of *The Most Beautiful Libraries in the World*, I urge you to keep in mind not only the beauty of these libraries but also the civilizing and educational power of books and libraries. The countries and cultures that built these magnificent structures have evolved, but the body of knowledge resting on their shelves is a large part of the human memory that will have future uses that we cannot yet foresee. This reminds me of yet another inscription that greets me before entering my office at the Library of Congress: *Litera scripta manet.* The written word endures.

James H. Billington, THE LIBRARIAN OF CONGRESS

INTRODUCTION

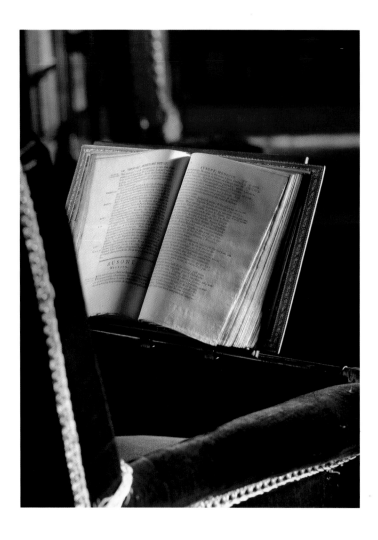

ONE MUST SPEND HOURS UPON HOURS, AND days upon days in the cocoon of a great library in order to understand and love the cozy isolation that it can provide. Some people will never break away from its spell and remain eternal readers, having lost the desire to discover the real world. Others will know how to find in libraries both knowledge and its instruments.

The history of libraries almost starts with the advent of writing, which not only enabled the conveying of orders and ideas, but also their preservation. In the third millennium BC in Sumer, people began to put slate tablets with cuneiform writing scratched into them in a special room, placing them in baskets or jars set on wooden shelves. A shelving system and vertical classification similar to what we use in our libraries today was even discoveredin Ras Shamra's "library" (c. 2000 BC). In Egypt, an inscription dating from approximately 2500 BC mentions the existence of a scribe at "the house of books" where rolls of papyrus were kept. In Ancient Greece, Pisistratus founded the first public library in 560 BC. Greek books were written on papyrus and during theclassical period there was a book trade, bookstores, copyists' workshops, and public and private libraries. But the great library of the Hellenic world, and antiquity in general, remains the one of ancient Alexandria. Its vast, almost mythic, prestige has endured long after the library was

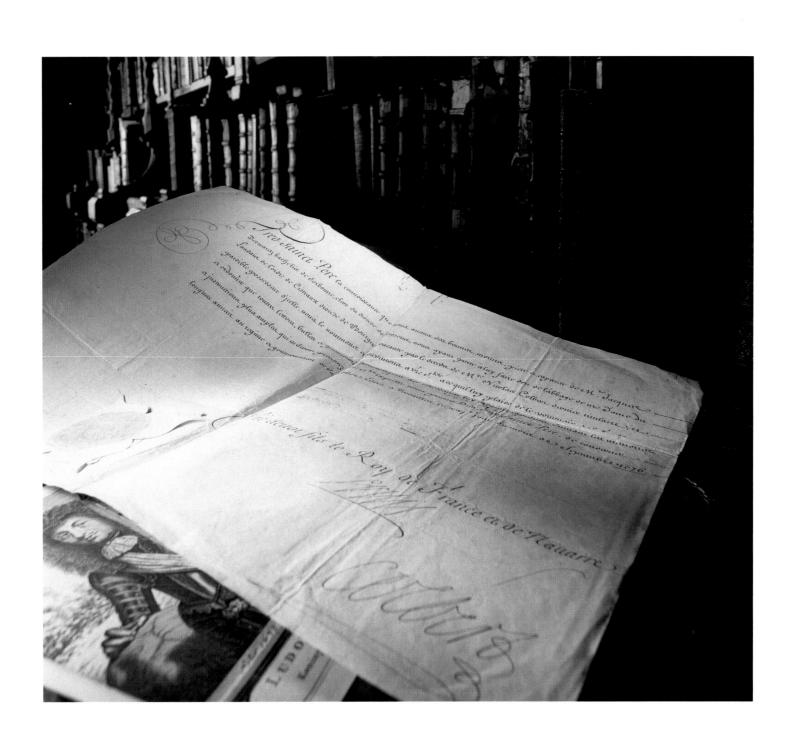

lost to flames. This prestige was not based upon the grandeur of the building, but rather, upon the library's essential role in the creation of a tool destined to preserve and disseminate knowledge throughout Greece's vast field of influence. Ptolemy Soter, who may have been Alexander the Great's half-brother, reigned over Egypt and several Mediterranean and Ionian islands. Wanting to transform his capital, Alexandria, into the center of the Greek world, he founded an establishment dedicated to the muses—a museum. There poets, philosophers, scholars, mathematicians, students, and priests could reflect upon and exchange ideas, write, and compose. A rapidly growing library was at their disposal. It soon possessed 200,000 papyri and, toward the end of the second century AD, perhaps as many as 700,000. There are several accounts of the library's demise—perhaps, it burned down in 47 BC, or was destroyed by Emperor Theodose in AD 391, or burnt by the Ottomans in AD 640. In April 2002, under the auspices of UNESCO, the new Library of Alexandria was inaugurated—and this glorious heritage may well be on the road to restoration.

The Alexandria Library reminds us that all human endeavors are organic—they are born, they live, and then die. As long as a library is both useful and is used, it will grow. When it no longer answers to its calling, in time it will lose its importance and, at best, its rich collections will be consulted only by historians, if by anyone at all. Such was the case with the great monastery libraries that proliferated throughout Europe from the beginning of the eleventh century. They were, for a long time, the seat of knowledge where one could study not only the works of the Church fathers (in Greek and Latin), but also those of Greek and Latin philosophers as well as Arab scholars. These libraries were instrumental in the establishment of the power of the Catholic Church. They lasted through the Religious Wars, and were triumphant in the Counter-

Reformation, but almost disappeared at the beginning of the nineteenth century. Whereas the center of learning had once been the monastery, it now became the university. The Roman Catholic Church's opposition to the powerful humanist and scientific movement that began sweeping across Europe at the end of the Middle Ages and its rejection of the Enlightenment, gradually caused philosophers, scholars, and students to turn away from the Church. Beginning in the seventeenth century, kings and princes, such as Mazarin and the Austrian emperor Charles VI, opened their libraries to the public. Universities, whose ties with religious hierarchies (whether Catholic, Protestant, or Anglican) had disintegrated, built (at considerable cost) great libraries such as those in Cambridge, Dublin, Coimbra, and Bologna. And finally, in the nineteenth century, states and cities began to create large libraries, which, for the most part, were open to the public and covered all fields of knowledge. Today, the intellectual prestige of a country is still based upon its network of libraries, how much it is used, how well it is organized, and if it is computerized. Culture, most broadly defined, is at last there for everyone.

The great libraries presented here were all establishments reserved for the elite, which, in part, explains the grandeur of their architecture and interior design. These libraries were constructed in a Europe where learning blossomed amid a minuscule population, and where the vast majority remained illiterate. While Charles VI, to the astonishment of his contemporaries, opened his libraries to (almost) everyone, he nonetheless forbade entry to "ignoramuses, servants, idlers, talkers, and gawkers." The library built by Sir Christopher Wren at Trinity College, Oxford, was an outstanding tool for research, but it must be said, the college (and library) was then only available to sons of the British nobility. A library is thus both a repository for, and a mirror of a culture.

What will our libraries be like in fifty years? Will we continue to build ever-bigger buildings to house the endless tide of books, periodicals, recordings, photographs, and films produced throughout the world? It is quite possible that computers will completely replace libraries—at least as we now think of them. First a national server, then a European one, and finally a worldwide center, accessible from anyone's home, might replace these marvelous reading rooms where so many students, researchers, writers, and scholars have come together during the past centuries. The future, radiant as it may be, sometimes also elicits nostalgia for the past.

This book presents twenty-three of the most beautiful libraries in the world. Those that were desired, constructed, and decorated by people convinced of the need to preserve and convey knowledge. Monks, abbots, kings, princes, academics, and patrons all partook in the great intellectual pursuits of the West, and all contributed to who we are today. If only for these reasons, we should thank and honor them.

This anecdote from Nicholas Basbanes, the author of two brilliant works on the passion for books (*A Gentle Madness* and *Patience and Fortitude*), sums up the fascination—highlighted in the following pages—that libraries have had for us for so many centuries. In 1995, Basbanes was consulting a three-volume work on the catalogue that appeared in 1914 of Samuel Pepys's library. He happened to be in the Athenæum in Boston and found some books that had been forgotten on a shelf in the basement. These volumes had never been opened; their pages never cut. The withdrawal slip indicated that they had never been borrowed. In a loud voice, the author asked, "It has been eighty-five years. For whom did you buy these books?" To which the librarian responded, "We bought them for you, Mr. Basbanes." ❧

Page 8: The Duc d'Aumale's armchair at Chantilly, in the reading room of one of the nineteenth century's greatest bibliophiles.
Page 9: A document signed by the young Louis XIV, in the Russian National Library in Saint Petersburg.
Below: In New York, seat 685 in the magnificent Rose Reading Room of the New York Public Library.

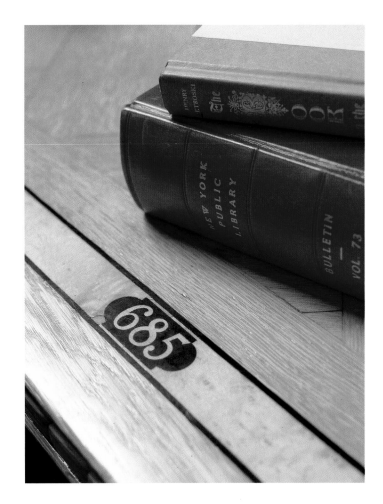

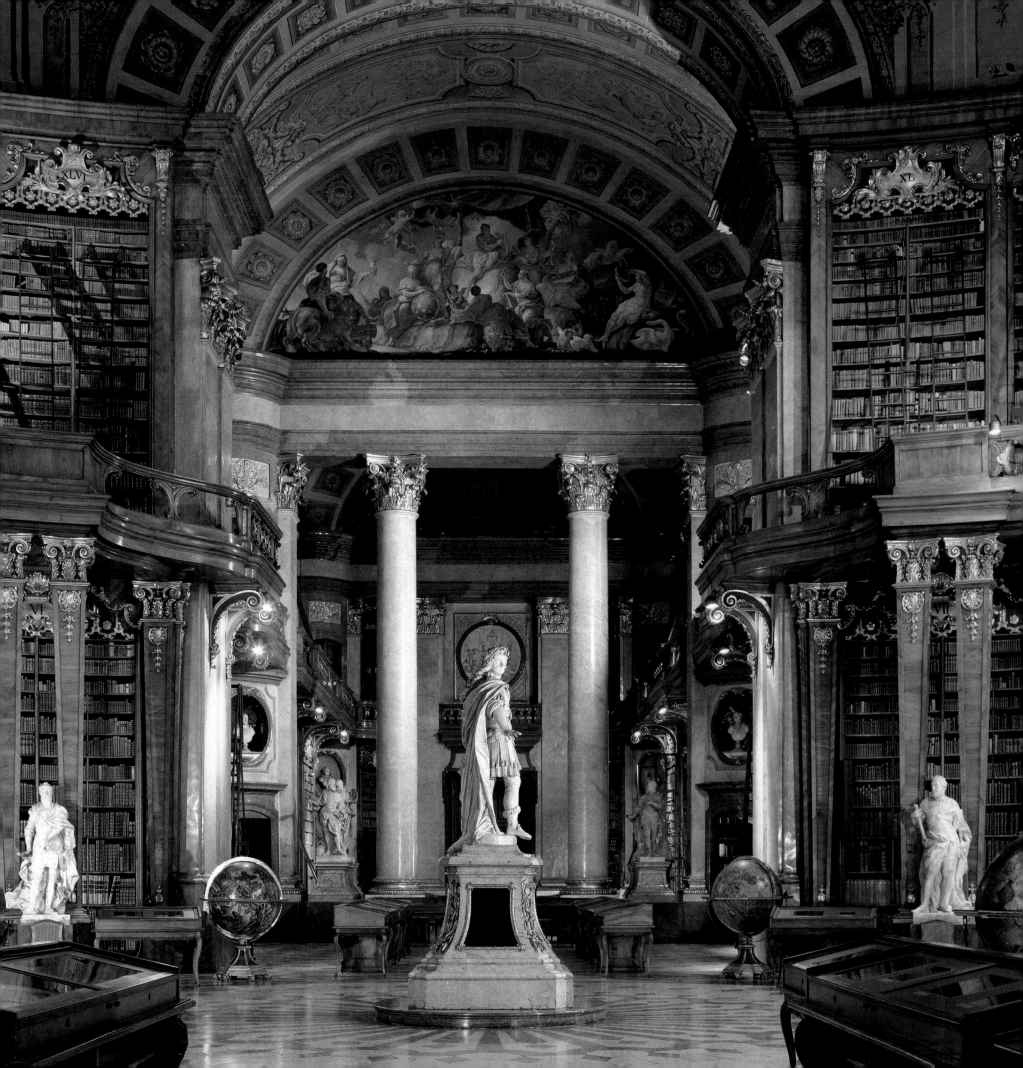

NATIONAL LIBRARY OF AUSTRIA

EVERY LIBRARY HAS ITS OWN HISTORY, EACH BRINGS to the aficionado its share of new emotions. The incomparable splendor of the library in Vienna, the former Hofbibliothek, is astonishing. An austere, paved square, the Josefplatz, is bordered on three sides by tall buildings that are a part of the vast Hofburg palace complex—the Augustinian convent whose church opens onto the square by way of a tiny entry and the imposing, massive, and not very attractive national library. The facade presents a classic, unembellished outline of cornices softened by the even coating of whitewash. The central avant-corps of the building is surmounted by an enormous, almost menacing quadriga sculpted by Lorenzo Mattielli that depicts the triumph of Minerva (Wisdom) over Ignorance and Jealousy. The visitor enters through a foyer that leads to a vast hall, originally reserved for the school of equitation. From there, a large staircase decorated with ancient inscriptions brought back from the southern provinces of the Empire leads to the Prunksaal, the ceremonial hall. Perhaps the Labrouste hall in the national library in Paris on rue de Richelieu is larger, and the perfectly circular hall in the British Museum more astonishing, but the Prunksaal, with its splendors of a Baroque cathedral, remains the most impressive of all the library halls in Europe.

For a long time, the Hapsburgs collected quality manuscripts and books. Albert III (1348–1396), a bibliophile, owned a collection of superb illuminated works. Frederick III (r. 1440–1493) marked all his books with the mysterious AEIOU, which has been interpreted to stand for *Austriæ est imperare orbi universo* ("It is Austria's destiny to rule the world"), evidence of family ambition and precocious prediction. His son, Maximilian I, inherited this love for books, as well as some of the treasures of his godfather Cardinal Bessarion, who was one of the most famous bibliophiles of his time. Moreover, his wife, Marie of Burgundy, daughter of Charles the Bold,

brought with her beautiful works from Burgundy and Flanders. But it was not until 1575 and the appointment of Blotius, the first imperial librarian, that the library became somewhat organized. Blotius spoke of how he came to realize the enormity of his task. "My God, what a state this library was in. Everything was so untidy, so dirty, and had been severely damaged by insects and worms, and all the rooms were covered with spider webs!" In a few years, he restored order to the lavish collection that was continually enriched by acquisitions and inheritances, while bitterly complaining about the inconsiderate readers who would borrow works and never return them. But how to place demands on Emperor Rudolph II who finally returned a book lent to him five years earlier? How to explain to him that the treasures of the imperial library were not intended to be offered as gifts? A century later, two enlightened emperors, Leopold I (r. 1658–1705), an aficionado of the arts and sciences and, even more so, Charles VI who reigned from 1711 to 1740, would finally take seriously the fate of the library belonging to a state that was to become one of the greatest world powers.

Leopold's project, including the plans that placed the library over the equitation hall, was put off for better days during the second great Turkish offensive that reached to the gates of Vienna. It would befall Charles VI to entrust Johann Bernhard Fischer von Erlach (1656–1723), the great court architect, with the plans for a library worthy of the new European status of an Austria now finally rid of the Ottoman threat. The architect died as work began and his son, Johann Emmanuel, took over the project.

The first great public library built in this part of the world, the Hofbibliothek is an absolute masterpiece of Baroque Austrian architecture. The size of a cathedral, its grand hall measures approximately 255 ft. long, 47 ft. wide, and 64 ft. high (77.7 m long, 14.2 m wide, and 19.6 m high). In the center, its "nave" expands to

form an oval 95 ft. in height (29 m) that is topped by a cupola measuring 96 by 59 ft. (29.2 by 18 m). At both entrances, a pair of heavy marble columns appears to support the cupola and visually divide it into two "wings," which are referred to as the Peace Wing and the War Wing. This magnificent building, which won the admiration of Europe, very soon experienced severe problems regarding its stability and Nicolo Pacassi, the architect of Belvedere, was called in to address them. Almost 200,000 books filled the two floors of stacks (sometimes shelved two deep), and over the second floor was a broad gallery accessible by four separate staircases, each replete with shelved books. The main hall had ladders on rollers to reach the books on the upper shelves, while on the gallery, some forty straight ladders served the same purpose, though their utilitarian appearance was somewhat incongruous with the quasi-religious atmosphere.

The decorations and the architecture melded to form a great and noble harmony even though, according to the custom of the period, the architecture, frescoes, sculptures, and fittings were assigned to different artists. The frescoes were done in 1730 by the painter Daniel Gran, who was already renowned for the grand decorations of abbeys. He based his designs on a set of iconographic images defined with the greatest precision by the imperial advisor Conrad Adolph von Albrecht. The central composition beneath the cupola depicts a sky populated—indeed, thronged—by a multitude of allegories or representations that pleased the emperor, who was concerned with perpetuating his image as protector of the arts. Among them are the Art of Governance and the Art of Warfare, surrounded by books and trophies; Austrian Magnanimity accompanied by Munificence and the Taste for Splendor; the Fortitude of the Emperor, surrounded by Mars and Vulcan; Gratitude, accompanied by the Genie of Studies; the Execution Order for the library, and a model of it carried by Ingenious Invention, a genie who expels

the enemies of erudition—Idleness, Ignorance, and Unjustified Blame—and hurls them into the abyss.

The emperor himself is particularly well treated, depicted in a Hercules Musarum at the center of the Prunksaal, just beneath the cupola. His statue is surrounded by those of generals, members of the Hapsburg family, and Austrian politicians. Under the cupola, in front of the staircases leading to the gallery, are white marble statues of sixteen ancestors of Charles VI. The sovereign had a keen vision of what a library should be and described what he expected of his: "The user should not pay anything, should leave enriched and should return often." He did not trust readers who wrote on the works and although he opened his doors to all, he did exclude "ignoramuses, servants, idlers, talkers, and gawkers." The Vienna Library was one of the first great public libraries in Europe.

Today, one no longer reads in the Prunksaal, and visits are no longer free. The great hall of Charles VI is a sort of museum for rare books of interest only to researchers. It still holds the collection of Prince Eugene of Savoy among its 200,000 valuable works. This celebrated great-nephew of Mazarin, who dreamed only of battles and was thus sent into the service of the Hapsburgs by order of Louis XIV, was a great bibliophile. Thanks to the help of a network of European agents led by the famous librarian Pierre Jean Mariette, his personal library consisted of 18,000 volumes. The emperor acquired this collection in the eighteenth century and it was given the place of honor beneath the cupola. The covers and spines of volumes damaged by the prince's weapons were rebound in morocco leather, the color indicating the contents. A deep red was used for history and literature, dark blue was used for theology and the law, and yellow for the sciences and nature. Among the rarest works is the eleven-volume atlas by the cartographer Joan Blaeu (1596–1673), *The Peutinger Table*, a kind of road map of the Roman Empire during the fourth century and *Le Livre du Cœur*

d'Amour Épris ("Book of the Love-Smitten Heart"), the magnificent illuminated work by the Duke of Anjou.

Renamed the National Library of Austria in 1918, the Hofbibliothek has become an enormous institution. With its 6.5 million books, including 7,866 incunabula and 65,821 manuscripts, it is slowly encroaching upon the Hofburg Palace. Occupying the largest part of the Neue Palast, the Augustine convent, it extends as far as the Albertina and incorporates the buildings set in an arc around the Michaeler Platz. In 1992, new underground installations designed to hold an additional four million volumes were inaugurated. Charles VI, Marie-Thérèse, and François-Joseph could never possibly have imagined that their proud mark, AEIOU, would come to signify (for the practical jokers) the triumph of the alphabet and that, using the same line of thought, their palace would be transformed into a library. ∽

Poetic and swirling, the extraordinary ceiling by Daniel Gran (1694–1757) recounts through allegories the history of the construction of the library. In the center is Glory, holding a pyramid, the symbol of her immortality and, just below, a medallion depicting Charles VI attended by Hercules and Apollo.

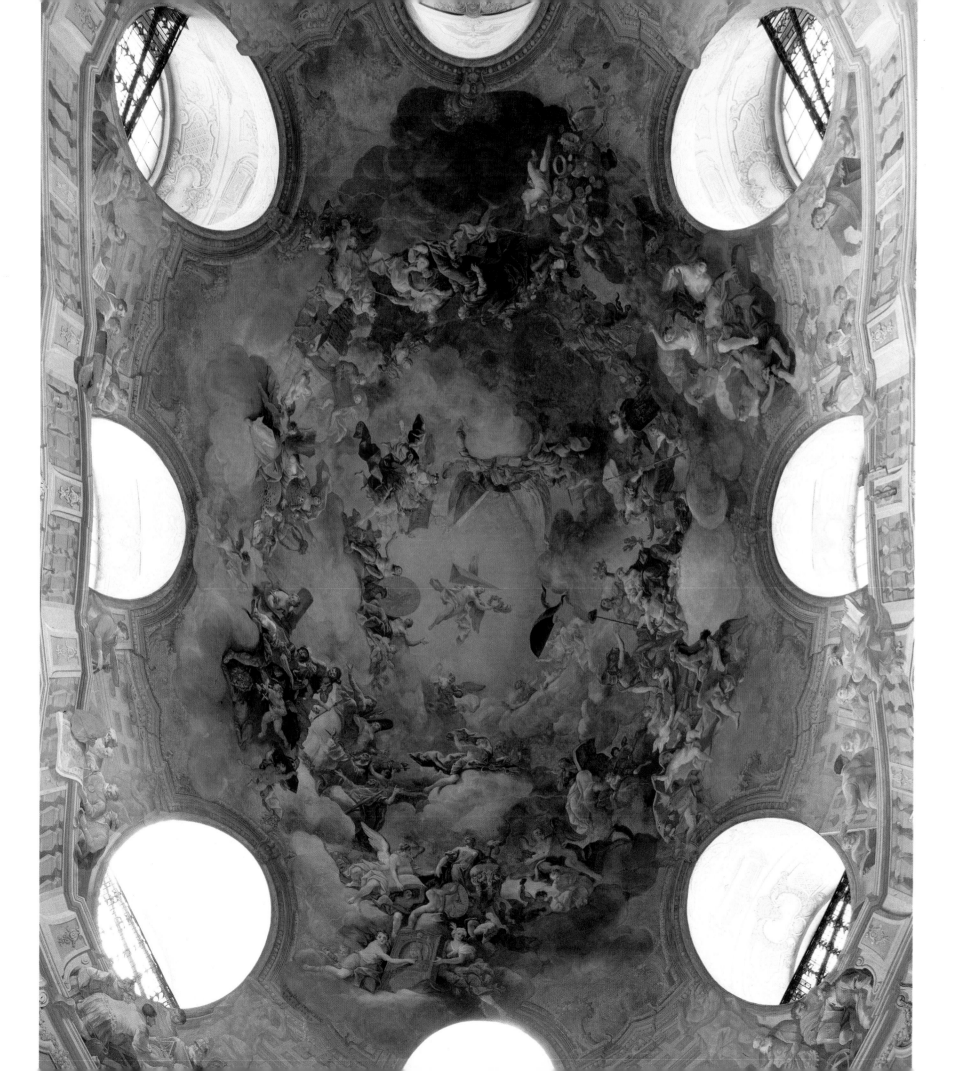

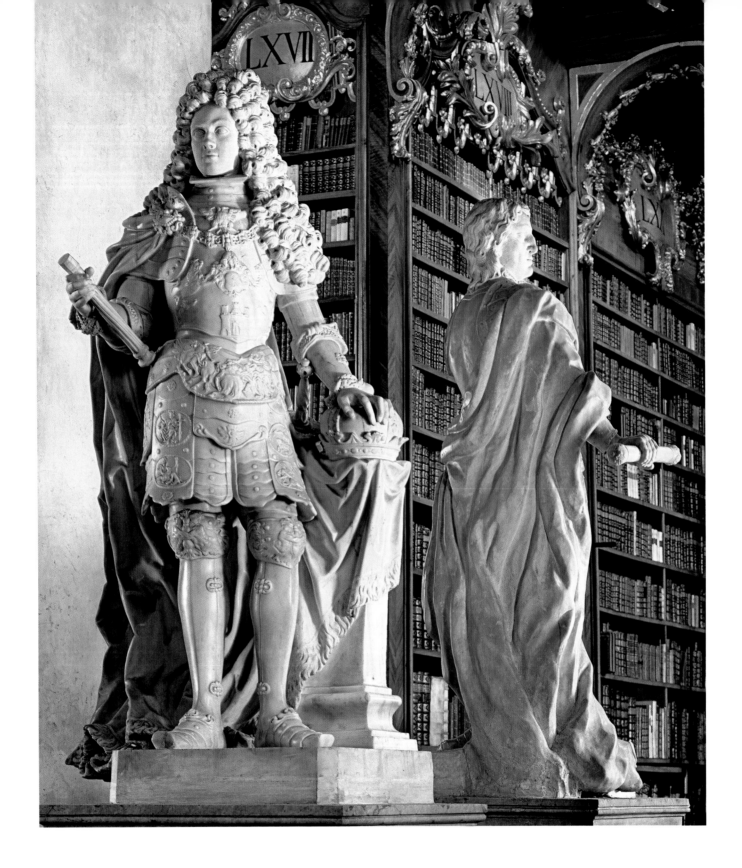

Above: Sixteen statues in white marble honoring the Hapsburg family surround the hall.
Here, an unidentified sovereign and the back of the Archduke Leopold Wilhelm (died 1662).

Right: The Prunksaal is no longer a reading room and is visited like a museum. The space formerly reserved for readers
is now dedicated to the display of seventeenth- and eighteenth-century masterpieces of map-making.

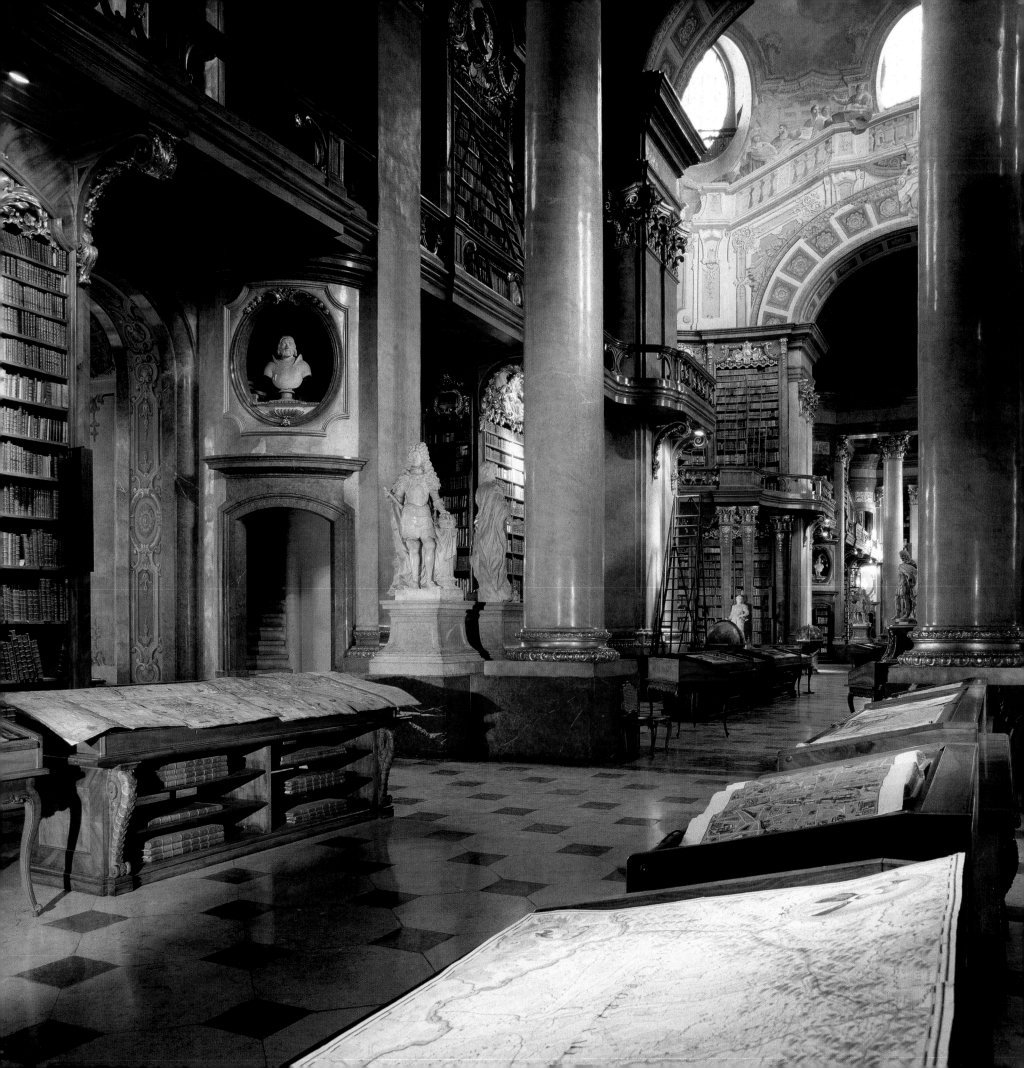

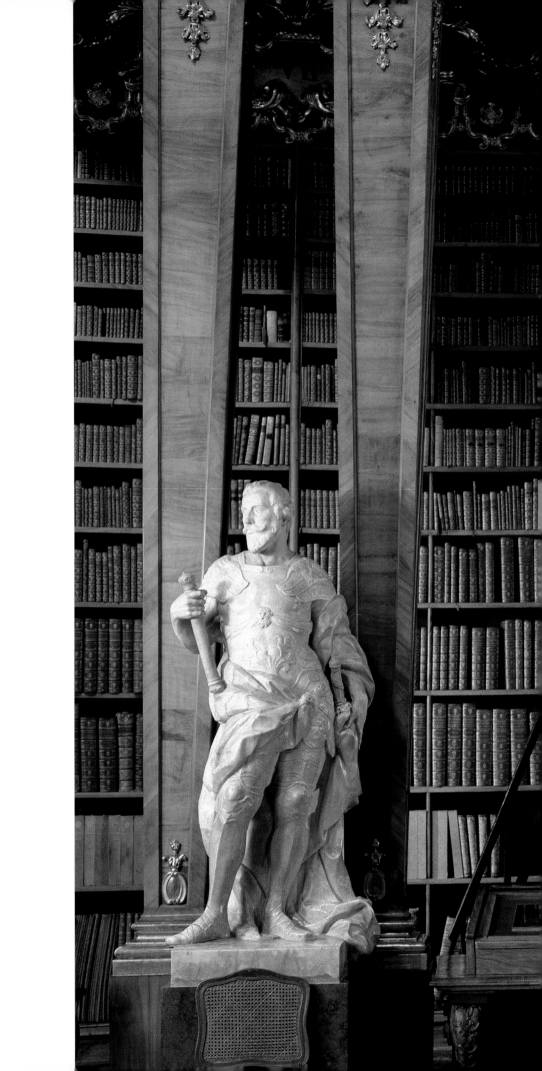

The books are shelved on two floors. The top shelves are accessed by a fleet of rickety stepladders and slender leaning ladders. Hidden doors conceal a staircase that leads to the upper floor.

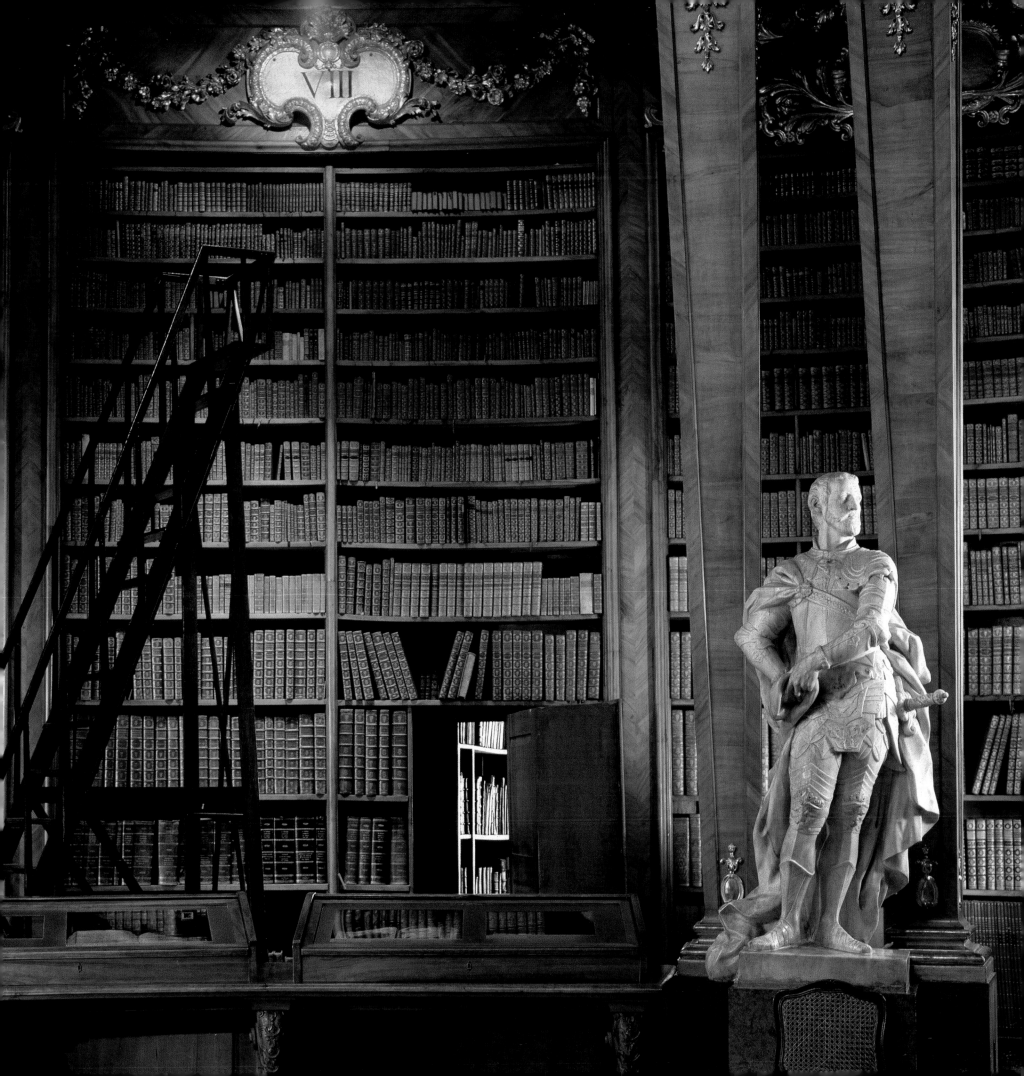

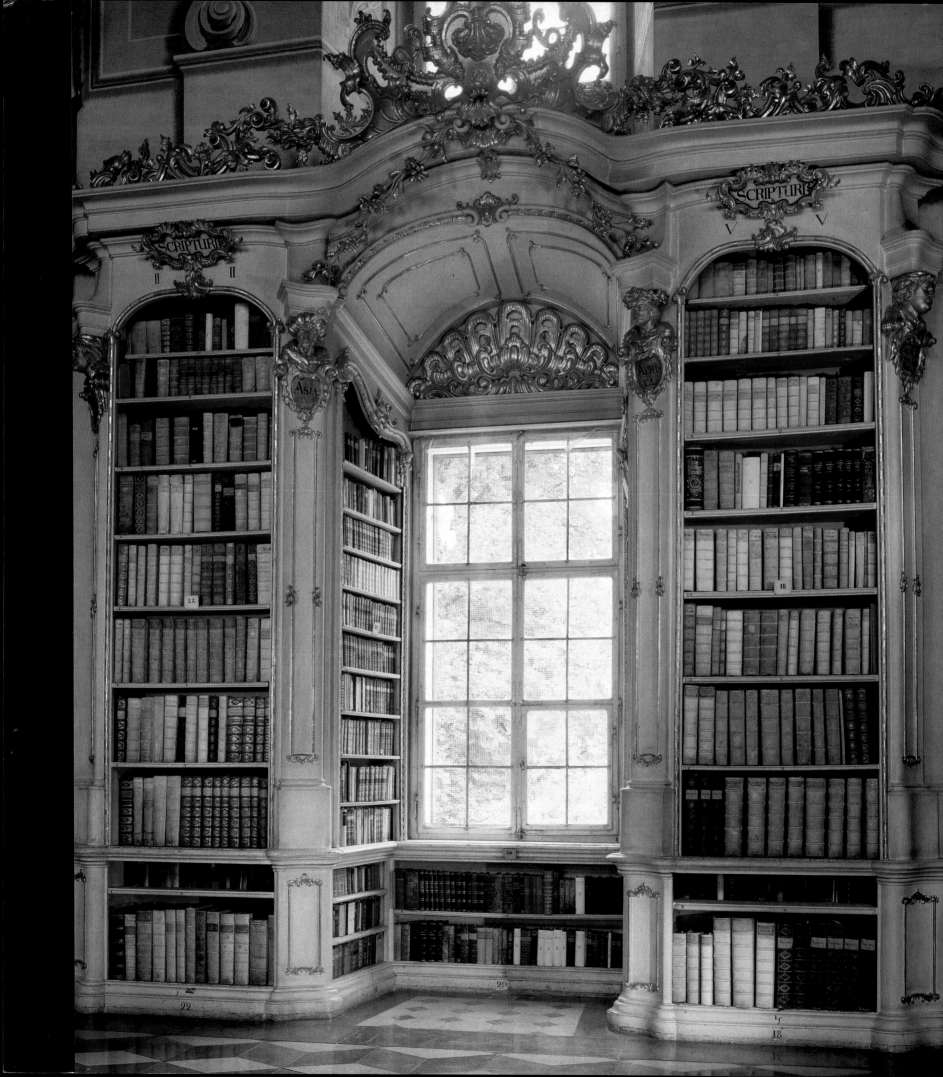

THE BENEDICTINE ABBEY LIBRARY OF ADMONT

NOT FAR FROM SALZBURG, ADMONT IS A TYPICAL small town of the Steiermark region of Austria located at the foot of some oddly shaped mountains. Attracted by the reputation of the Benedictine monastery established in 1074, Constantin Hauer made a visit to the library in 1779. Taken by the "art, taste, and splendor" of the vast hall, and fascinated by Abbot Matthaüs Offner (1716–1779), the creator of the library, he wrote, "Once the initial astonishment has passed, the outsider cannot keep from thinking how much this man must have read to have loved books so much."

"To love books" was not merely a quirk of Abbot Offner's personality. Reading, in fact, was prescribed in the Rules of Saint Benedict of Nursie, and for their enlightenment and health, the monks were required to read the sacred texts and interpolate their comments. For the Benedictines, "a monastery without a library was like a fortress without an arsenal." Thus, from its founding in 1074, Admont had a few books at its disposal that had been brought from Salzburg, and created a scriptorium where the works were copied, illuminated, and commented upon. The exegeses and commentaries of several learned abbots soon carried the library's reputation throughout Austria. One such abbot was Engelbert who, in an undertaking rather advanced for the thirteenth century, developed the library's collection in a spirit of universalism. The small, eleventh-century collection of a few dozen volumes grew richer. The first detailed catalogue, drawn up in 1370 and with a foreword providing advice to librarians, is one of the first theoretical works on library science. A huge hall, measuring 114 ft. 9 in. long (35 m), was constructed in the seventeenth century. Books were shelved in closed bookcases that are still in use today to store the most valuable manuscripts. The abbey underwent an enormous expansion thanks to numerous gifts and bequests, but above

all, due to the logging operations carried out in the vast forests it had owned since its founding.. By the eighteenth century, it had become one of the most powerful religious institutions in Austria, enabling Abbot Offner to embark upon a major modernization project, the central focus of which was the construction of a library that would be, upon its inauguration, "the eighth wonder of the world."

Josef Hueber (1715–1787), a marble polisher from Graz who became an architect-builder, drew up the plans for a late-Baroque hall that, on a smaller scale, is somewhat reminiscent of the court library in Vienna. In fact, he had worked with its architect, Fischer von Erlach. Its 230 ft.-(70-m) length extends down a central area under a cupola 41 ft. 8 in. (12.7 m) high, off which open two lateral, rectangular halls, each surmounted by three domes 37 ft. (11.3 m) in height. A gallery with a wrought-iron balustrade and gold ornaments runs the length of the space, doubling the area for bookshelves, and thus fulfilling the project's ambitious requirement to house a collection of 95,000 volumes. Abundant natural light streams through the thirty large bay windows, illuminating equally the ground floor and the upper level. Tall white bookcases with gold sculptures were installed between the windows. All remaining surfaces, particularly the ceilings and embrasures, are painted with frescoes. The floor, a mosaic of 7,500 brown, mauve, and beige marble diamond-shaped tiles, creates a fascinating and complex optical effect.

This technical description, however, conveys nothing of the spirit in which this masterpiece glorifying the Creator was conceived—a lavish *Gesamtkunstwerk*, or global work of art, where each element plays a role. The Austrian art historian Wilhem Mrazek wrote about the Baroque decoration, "Nothing appears in isolation within the allegorical principle; relationships emerge throughout, all forms of representation take on symbolic significance,

nature and creation are only one image of the divine." And thus Admont connects the architecture, sculpture, painting, carpentry, books, and even the floor.

At first glance, one is drawn by the chromatic eruption of the frescoes of Bartholomeo Altomonte (1701–1783), one of the last great painters of Baroque frescoes. All their iconography is aimed at the glorification of knowledge. Depicted in the first hall are Aurora's awakening of the spirit, philosophy, history, and jurisprudence, while illustrated in the second hall are theology, medicine, the fine arts, the practical arts, and the regency government. The two halls converge under a central space dedicated to divine revelation and wisdom.

The sculptures are distributed over three levels. On the uppermost level, twelve larger-than-life statues are installed in the four corners of each room. Represented in the first room are Moses with the Ten Commandments, the prophet Eli, Saint Peter holding the keys, and Saint Paul armed with a sword. In the central room, the four virtues—Divine Wisdom, Eternal Truth, Science, and Prudence—are depicted, and sculptures of the four evangelists are in the third room.

Under the central cupola, four bronze and wood groupings sculpted by Josef Stammel in 1760 spectacularly stage the *Vier Letzten Dinge* ("Four Last Things"), the final phases of a person's destiny: Death, Last Judgment, Hell, and Heaven. Baroque works worthy of a sculptor who had spent time in Rome, they call out to the visitor with their bitter power. Death is presented as an old pilgrim grabbing a winged skeleton that is about to thrust a dagger through his heart. The man's face reflects a deep questioning of the existence

that he has led and which, in moments, will be taken from him. We are far removed from the charming, joyful, illuminated allegories seen in other Baroque monasteries, such as the one in Metten. The visitor, who was usually a Benedictine monk, found himself confronted, in a rather theatrical way, by the destiny of man. Only religion—that of Revelation (Moses, Eli, Peter, and Paul), and the teachings of the four evangelists put into practice by the four virtues—will yield a happy outcome, in Paradise. The books, which for the most part are bound in white leather to blend with the bookcases and frescoes, are shelved thematically: medicine, philosophy, secular history, miscellany, humanist writings, civil law, politics, the fathers of the Church, exegeses, religious canon, ascetic writings, sermons, Church history, and theology.

This careful categorization remains in use today, for the most part, even though acquisitions made by the abbey during the nineteenth and twentieth centuries brought the collection to more than 145,000 volumes, including 1,400 manuscripts and 900 incunabula. Unfortunately, several of the most famous manuscripts were sold during the 1930s when there was a collapse in the lumber market, thus putting the abbey in difficult financial straits. When the Nazis annexed Austria in 1938, the monks were expelled and a large portion of the library's holdings was dispersed among different institutions, including the concentration camp at Dachau. Today, Admont has recovered its books, its splendor, and the rhythm of its monastic life under the Benedictine rule in which the historian Lewis Mumford saw nothing short of the foreshadowing of the organization of the welfare state.

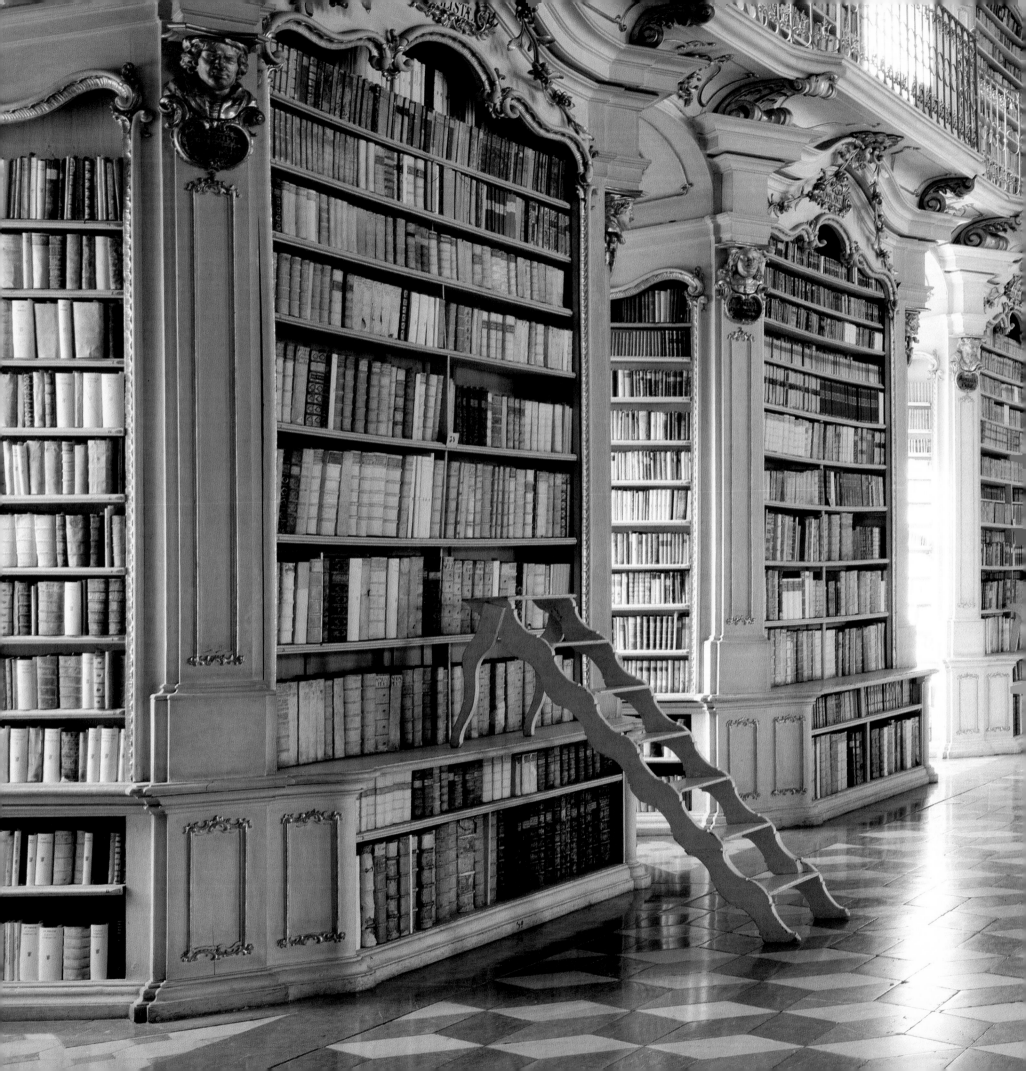

THE BENEDICTINE ABBEY LIBRARY OF ADMONT

The floor design, composed of 7,500 diamond-shaped marble tiles, creates a fascinating optical effect. It could have been inspired by a treatise on geometry by Kepler.
Sixty-eight gilded wooden busts complete the iconographic sequence of the library. The philosopher, the painter, the poet, eight sibyls, and the four continents are represented.
Admont was fortunate to have escaped the tribulations and fires that befell so many abbeys. Almost thoroughly pillaged following the Nazi annexation of Austria,
the abbey has succeeded in recovering and rebuilding the greater part of its collection.

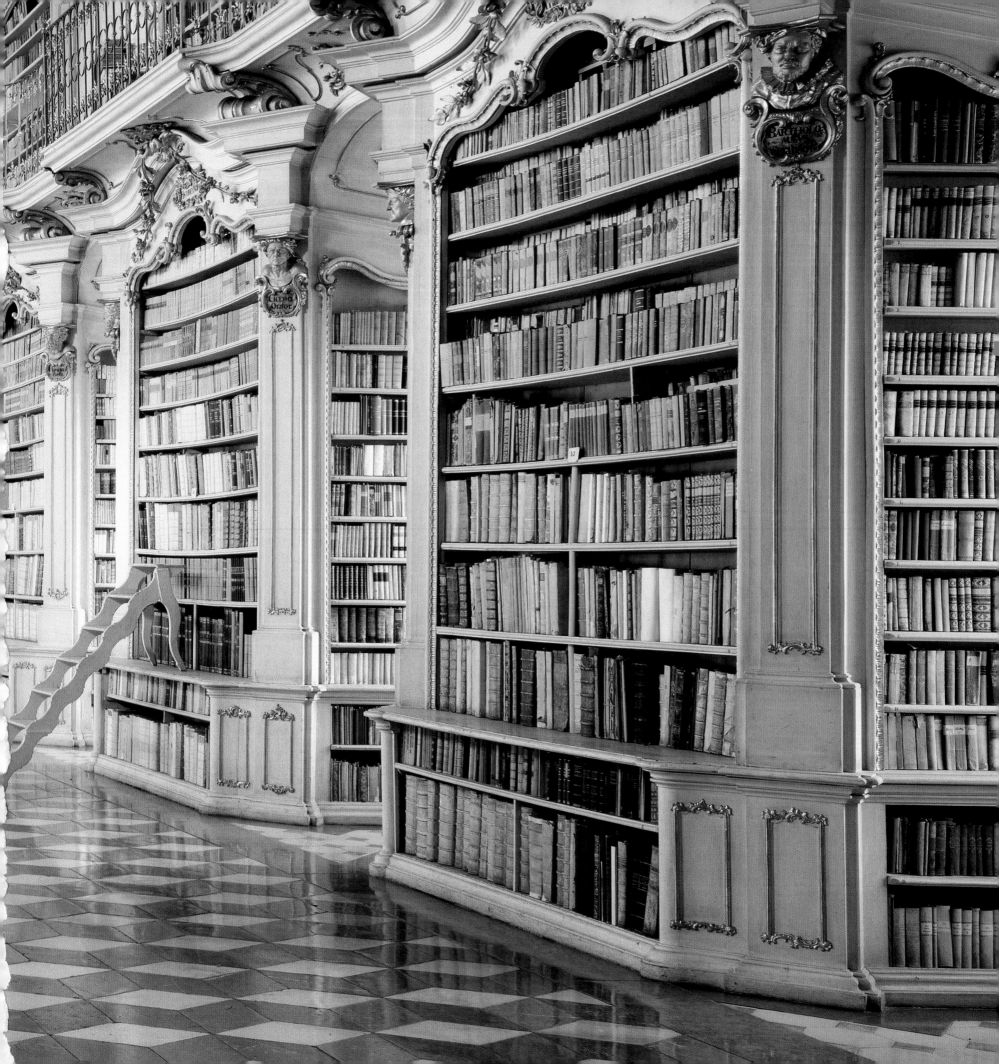

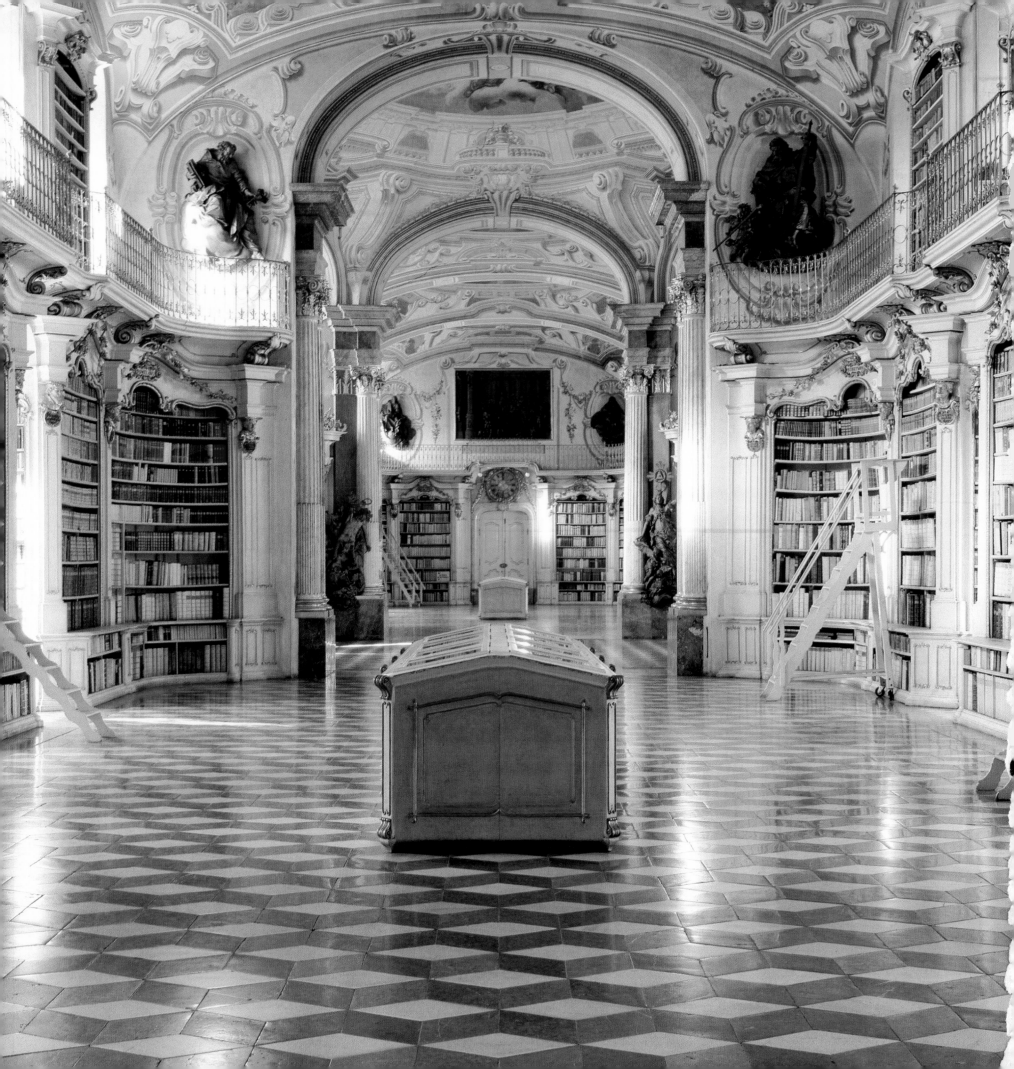

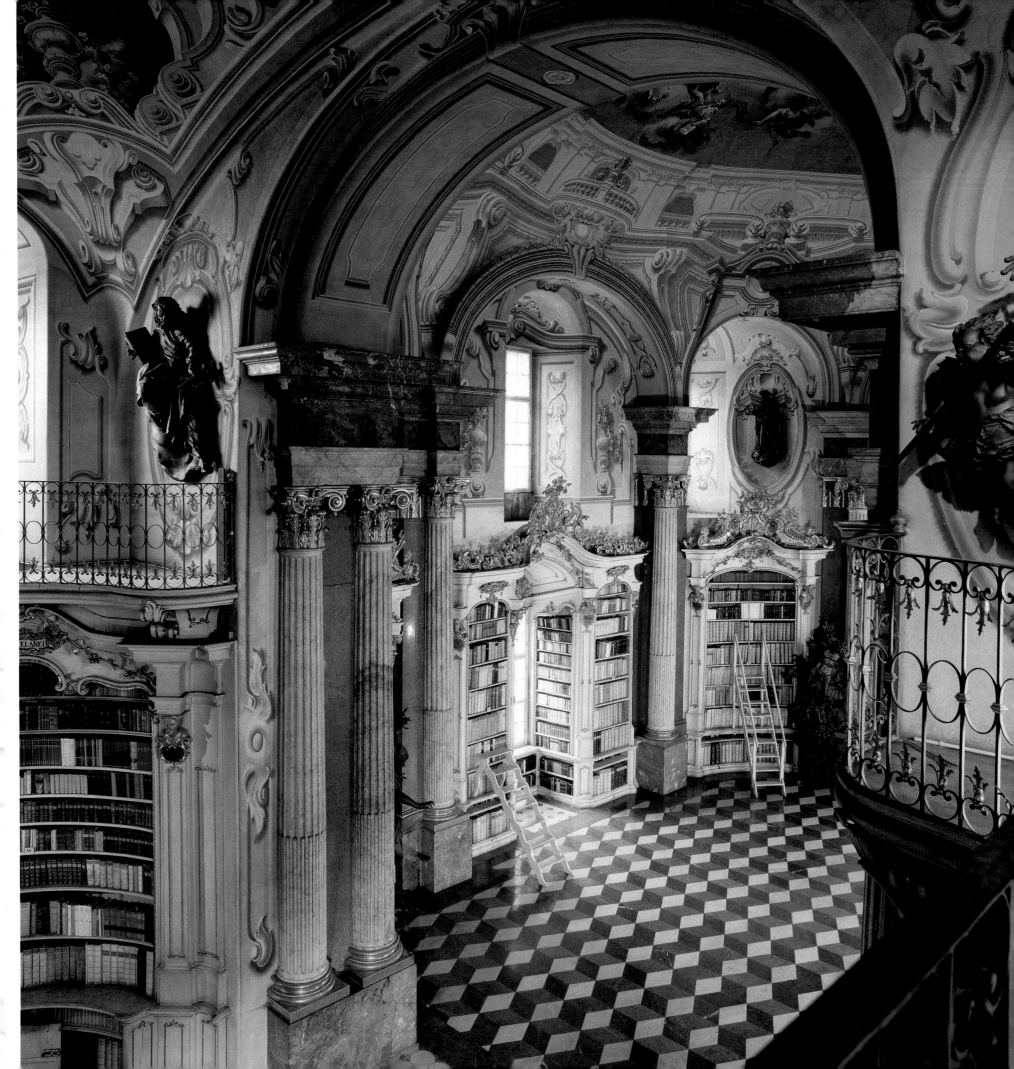

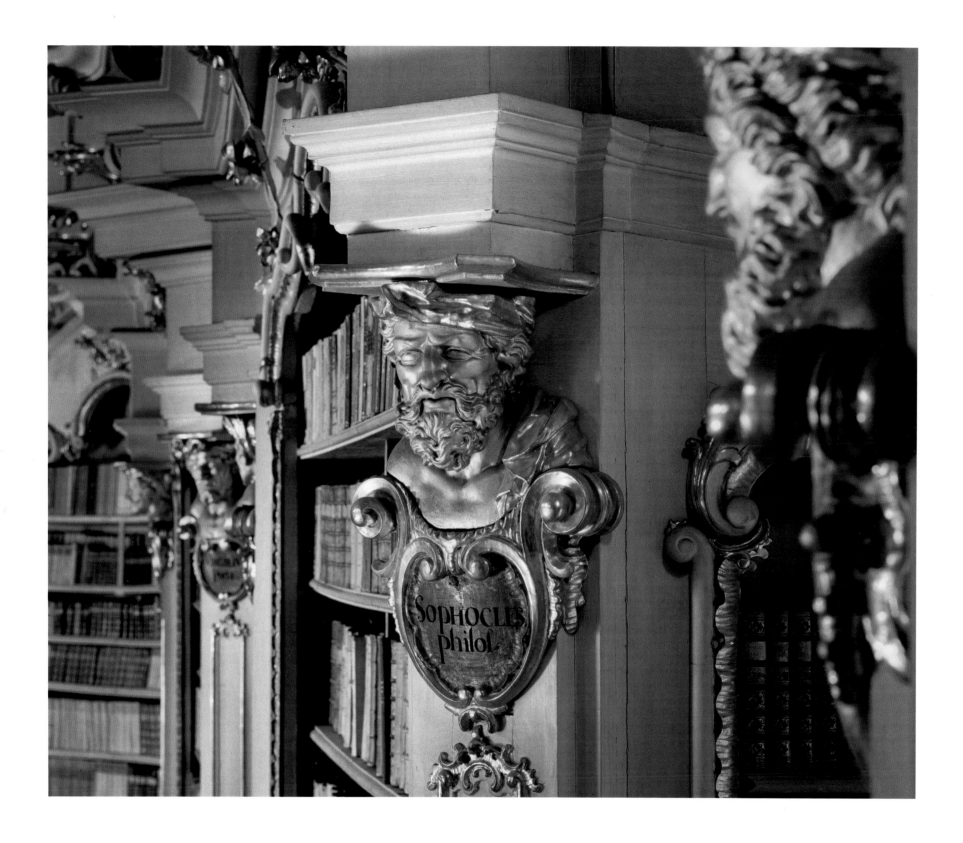

Admont is the world's largest monastery library, and one of the richest and most opulent of the Baroque period in Austria and Germany.

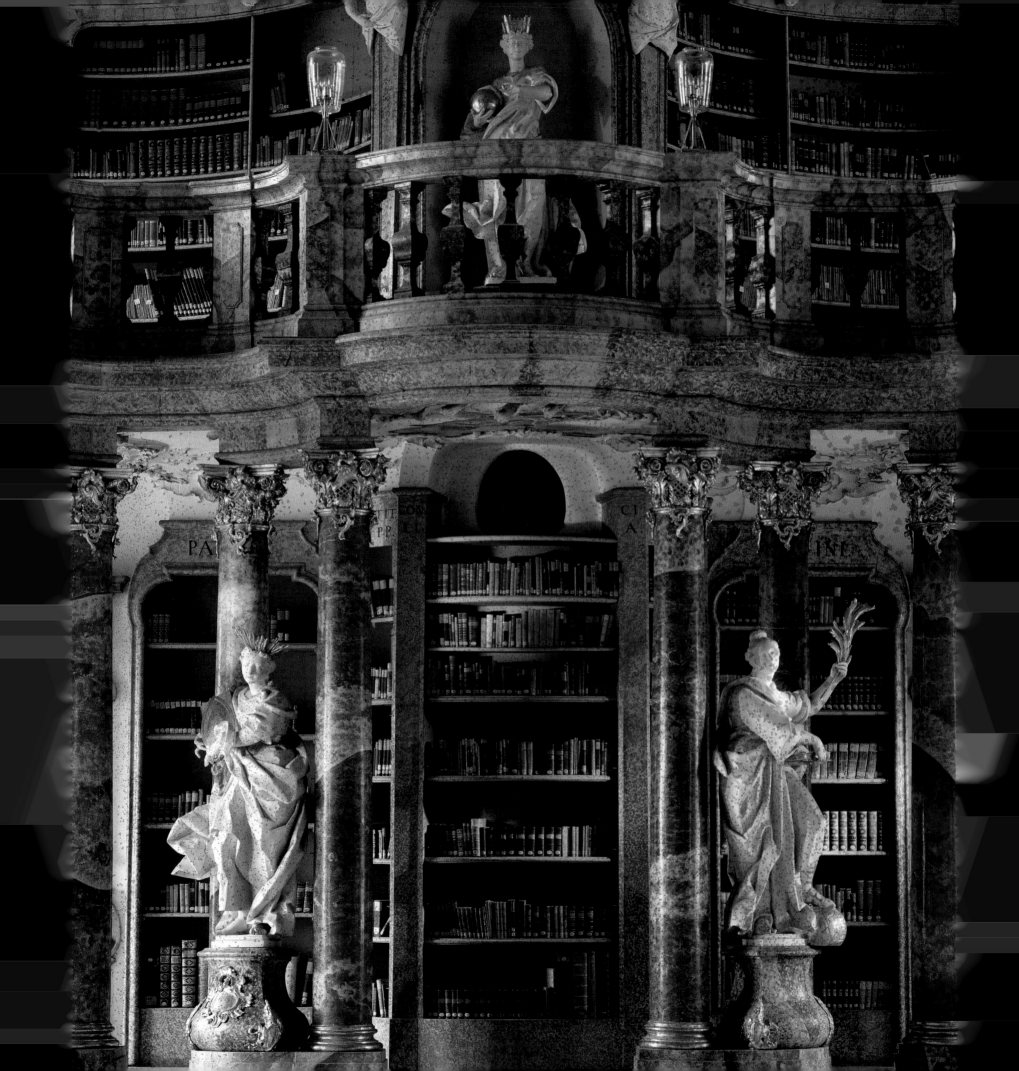

THE MONASTIC LIBRARY AT WIBLINGEN

THE IMPRESSIVE PINK BUILDINGS OF WIBLINGEN Abbey proudly stand in what today is the suburbs of Ulm but was once a pleasant countryside at the confluence of the Iller and Danube Rivers. Their size reflects the influence that was exercised, during certain periods, by one of the most powerful Benedictine cloisters in Swabia. Founded in 1093 by the counts of Kirchberg, the abbey experienced its first peak during the thirteenth century when its scriptorium was famous throughout the Germanic world. This was followed by a prolonged crisis. In the sixteenth century, Emperor Maximilian I handed it over to the Fugger banking family so they could create a permanent fiefdom, and it then saw renewed prosperity. Bought back by the Benedictine Order in 1701, a major reconstruction project was launched in 1714 that would continue for seventy years. This was a glorious period that was soon followed by its fall and dissolution during the great secularization movement of the clergy's holdings at the beginning of the nineteenth century. Today, Wiblingen is a part of the University of Ulm. A rather enviable end for this place of high learning that has inscribed over the entry to its library a quotation from Saint Paul to the Colossians (2,3): *In quo omnes thesauri sapientiæ & scientiæ* ("In whom are hid all the treasures of wisdom and knowledge").

In 1740, the rather cultivated Abbot Meinrad Hamberger set in motion the construction of new buildings and, in particular, a two-story library. His purpose was that of a pastor undoubtedly a little disappointed with the souls in his charge, as he planned, "to awaken a new desire and a new love for spiritual and learned exercises among the monks." To this end, he used all the means at his disposal to create a ponderous allegorical and representative schema that was applied to both the architecture and decorations. He was the originator of this "global art work" done in a playful, incredibly luxurious Rococo style, suitable for a reception hall—which was,

in fact, one of its functions. This space, depicting the power of the mind, welcomes its guests, the readers, and invites them to a celebration of knowledge that falls between human learning and heavenly revelation.

Both the twenty-first-century visitor and the practicing Catholic cannot help but be stunned by the profusion of gold and marble, by the statues and frescoes surrounding the imposing statues that represent the four monastic virtues, one of which is the renunciation of worldly goods. How to comprehend this unbridled example of decorative luxury that the triumph of the Counter-Reformation does not fully explain? And how not to compare this space that could serve as staging for the *Knight of the Rose* with the austere splendor of the Roman or French Baroque of the same period? A large part of the answer lies in history and economics. Wiblingen represented—we are in 1750—the apogee of the material power of the princes of the Church in Germany during the Germanic Holy Roman Empire, and that period, with its attachment to symbolism, wanted to flaunt its power. German abbeys competed with the kings, princes, and dukes of this extremely subdivided country that was finally experiencing a period of peace and prosperity. But soon, with the Ratisbonne Ordinance of 1803, most of the clergy's holdings were secularized and archbishops, bishops, and abbots lost their imperial titles. At the same time, Germany not only endured the comings and goings of French troops who pillaged and burned some abbeys, but also opened itself to some of the ideas of the French Revolution. The religious communities received little support as the papacy had been weakened. As in Austria and Switzerland during the same period, and a little later in Spain and Portugal, monasteries, with their unabashed power—and insufficient recruitment—were dissolved, and their holdings seized and redispersed. The riches of a library such as the one in Wiblingen no doubt, in its way, helped draw attention to the accumulation of

wealth of these religious institutions that had enjoyed autonomy and nearly absolute power in a given locale.

However, when Abbot Hamberger summoned the architect Christian Wiedemann, such threats did not exist and were not even imaginable. The plan for the library was one of great simplicity—a mere rectangle measuring 74$\frac{1}{2}$ by 36 ft. (23 by 11 m). The space is divided into two levels, the second being a wide gallery supported by thirty-two colored stucco columns, which is accessed by two staircases concealed behind bookcases. The grandness of the gallery draws the eye upward toward the ceiling's flat and elongated cupola. In the fresco that decorates the ceiling, numerous architectural elements are presented in a perspective that creates a distinct sense of ascension toward the sky, or heaven. Knowledge leads to heaven and thus, to the Divine. Such is the message of this philosophical-theological iconographic display in which each element plays a role.

The ceiling, the work of the painter Martin Kuen (1719–1771), is signed and dated 1744. The young artist studied in Venice with Piazzetta and Tiepolo, whose chromatic palette probably influenced him. The large fresco occupies the central area of the vault and, in a trompe l'oeil, a balustrade seems to lead to a second level of the gallery, creating the impression of a much greater height. In the center, a symbol of divine wisdom and knowledge, a female personage accompanied by the Lamb of God is enthroned in the center of the sky. As an antithesis, depicted around the perimeter of the vault is a series of scenes distinctly separated by architectural elements, each one corresponding to the category of the books shelved beneath it. Thus, one can see Alexander conversing with Diogenes, Apollo and the nine Muses, Ovid being banished by

Augustus, Pope Gregory I sending missionaries to Great Britain in 596, and the king of Spain commanding the Benedictines to go to America in 1493. Monks of the order are pictured a bit farther off, beneath some palm trees, preaching the Gospels to the pagans.

Eight wooden statues placed on marble pedestals of contrasting color—the works of Dominikus Hermenegild Herberger—are displayed on the ground floor among the groups of columns. To have them stand out from the rest of the "décor" of exaggerated chromatic gloss, the artist had the idea to give them a "porcelain" sheen, a rather pleasant effect that creates the impression of a fine and luminous white marble, which has been embellished with details and wreaths decorated with fine gold. Four of the statues personify worldly knowledge of Jurisprudence, Natural Science, Mathematics, and History. Four others symbolize the monastic virtues of Obedience, Renunciation of the World, Faith, and Prayer. Ever so elegant, these statues adhere to the great tradition of mannerist sculpture that held reign in southern Germany over a long period.

At its dedication in 1757, the library had almost 15,000 works, more than some university institutions during the same period. When secularization occurred in 1803, most of the collection was transferred to Stuttgart and today the few hundred ancient works, occupying the somewhat bare shelves, do not give a true impression of what was once—over a period of almost eight centuries—one of the most prestigious Benedictine libraries in Swabia. All the same, in its incomparable, exuberant, and excessive theatricality, the site remains one of the pinnacles of the late Baroque. Wiblingen is today, as it was in the eighteenth century, a sumptuous challenge for the eye and the spirit. ⌒

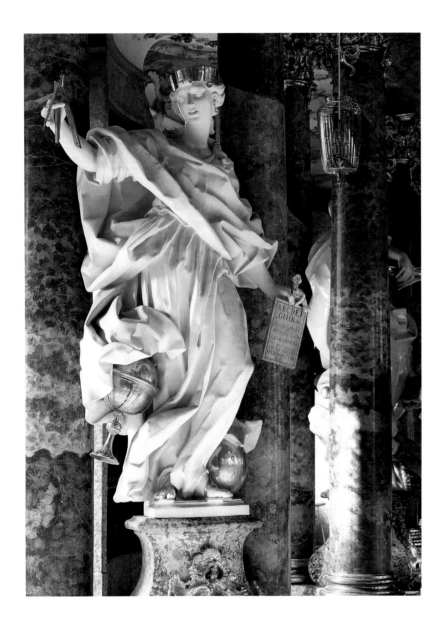

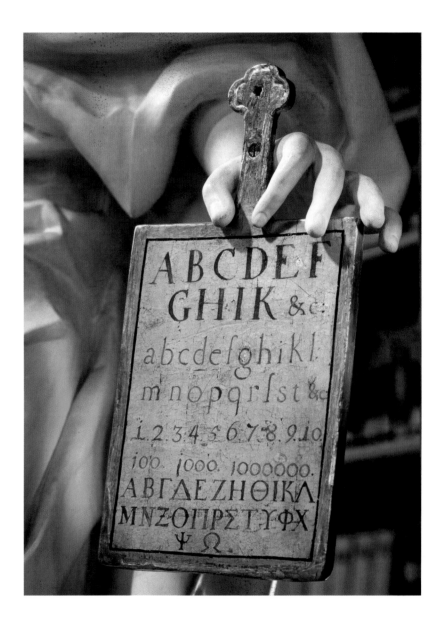

Sculpted by Dominikus Hermenegild Herberger, ten larger-than-life wooden statues are part of the decorations. Shown here is Mathematics.

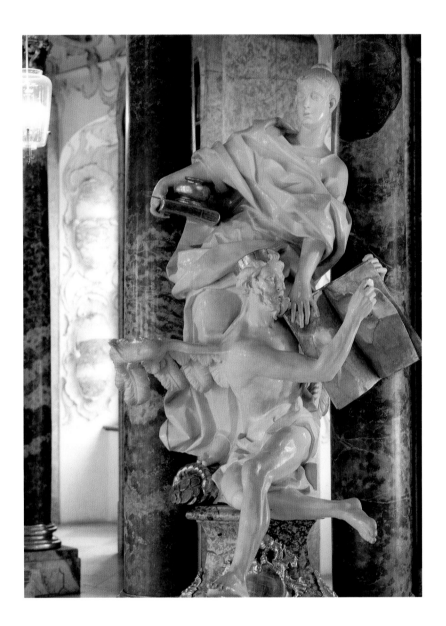

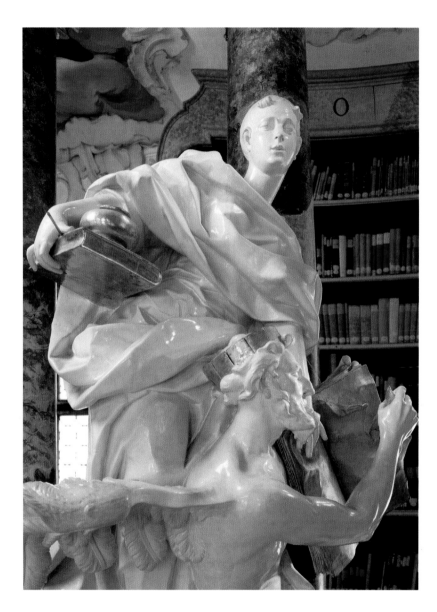

History. Its foot rests upon a cornucopia from which gold coins pour. Chronos, or Time, is at its feet.

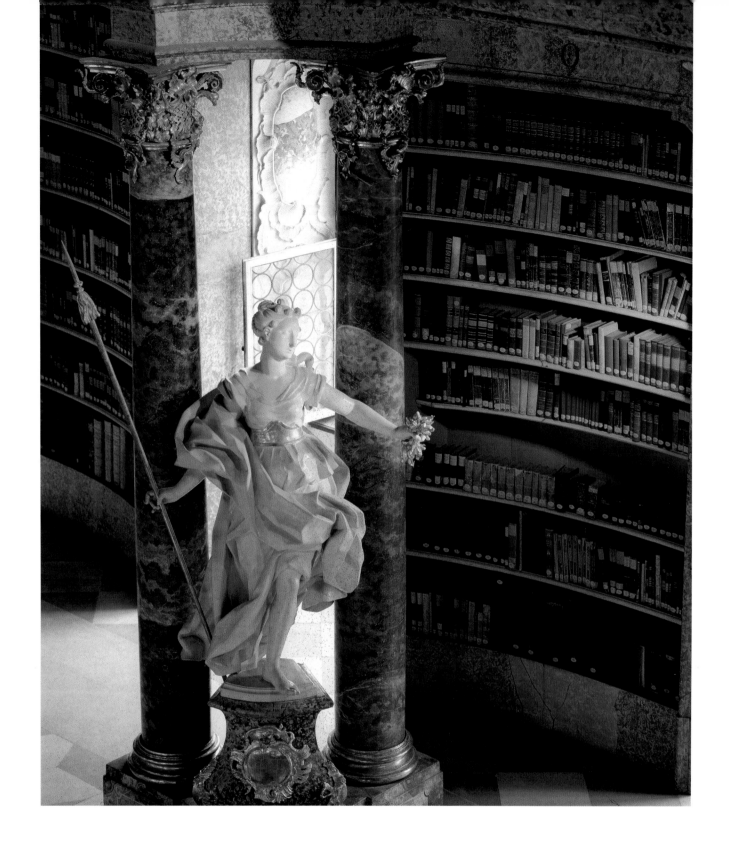

Above: An allegory of the Natural Sciences.

Right: Beneath the overhang of the gallery: Pope Gregory I. On the ceiling: Adam and Eve in paradise.

All the frescoes are the work of the twenty-five-year-old Franz Martin Kuenz during his stay in Wiblingen.

Following pages: The library at Wiblingen; an illustration of the Baroque concept of a "hall of sacred feasts."

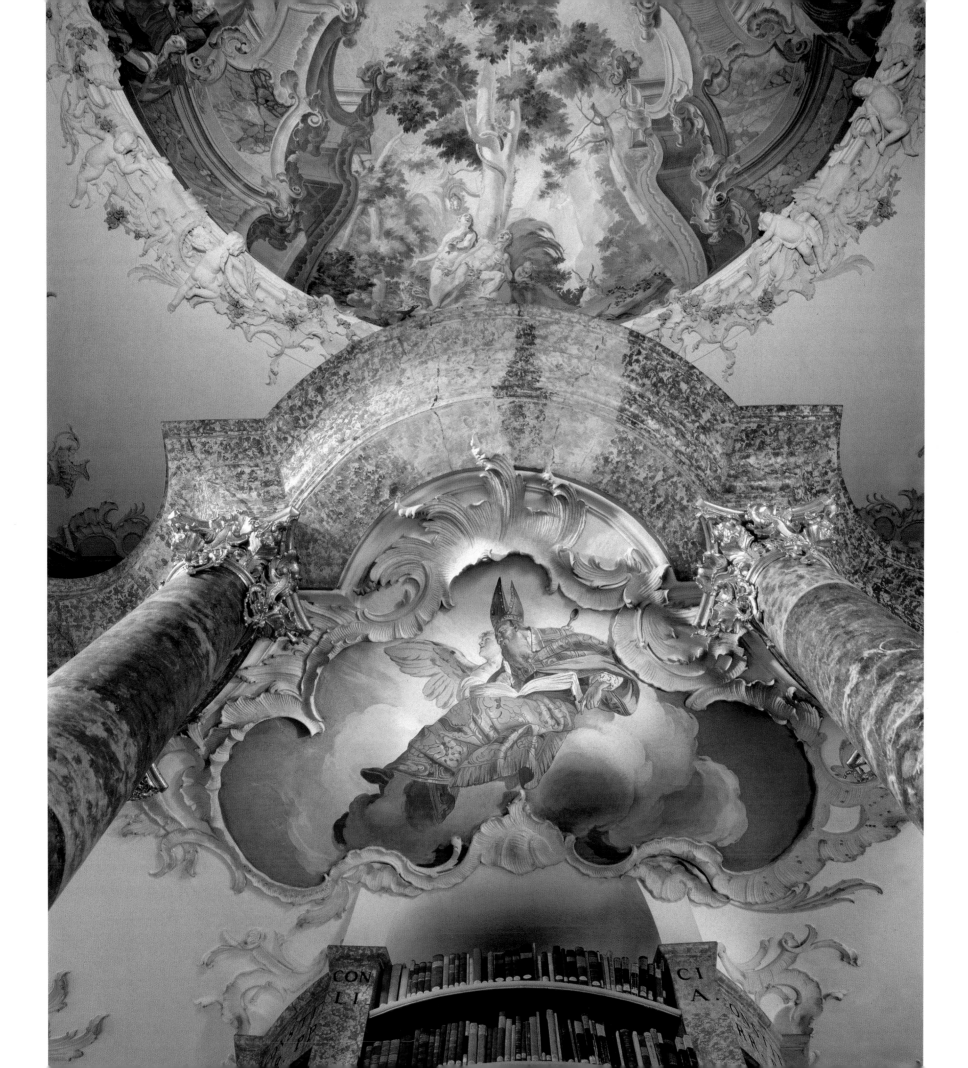

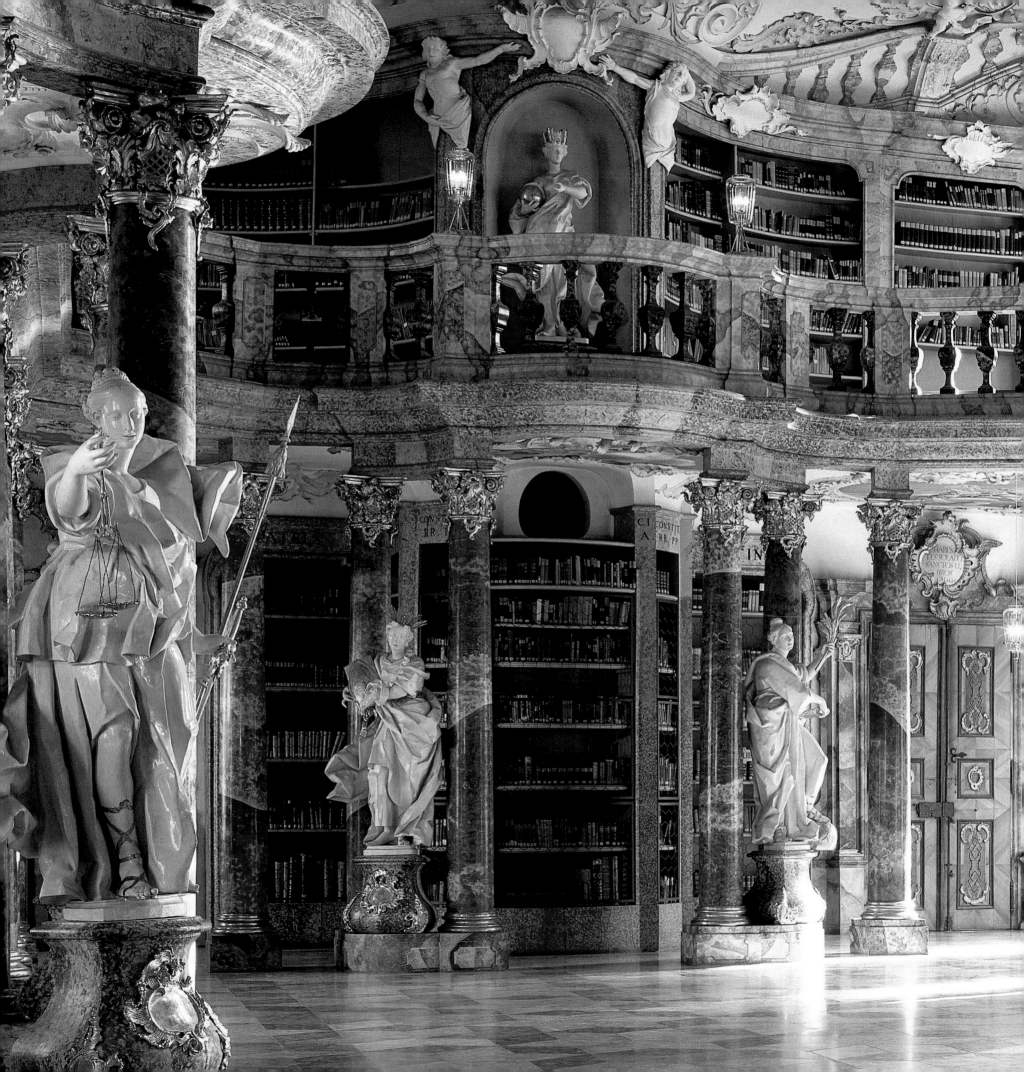

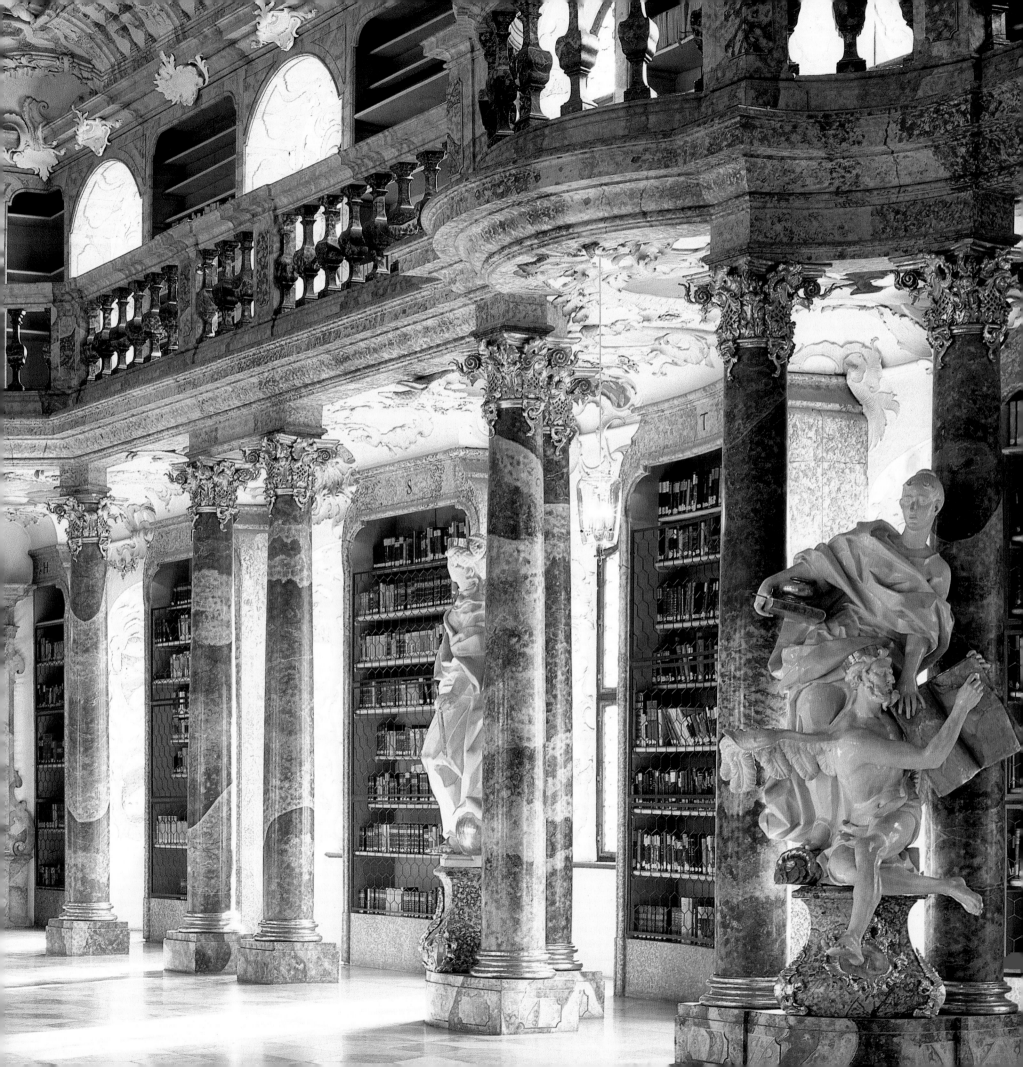

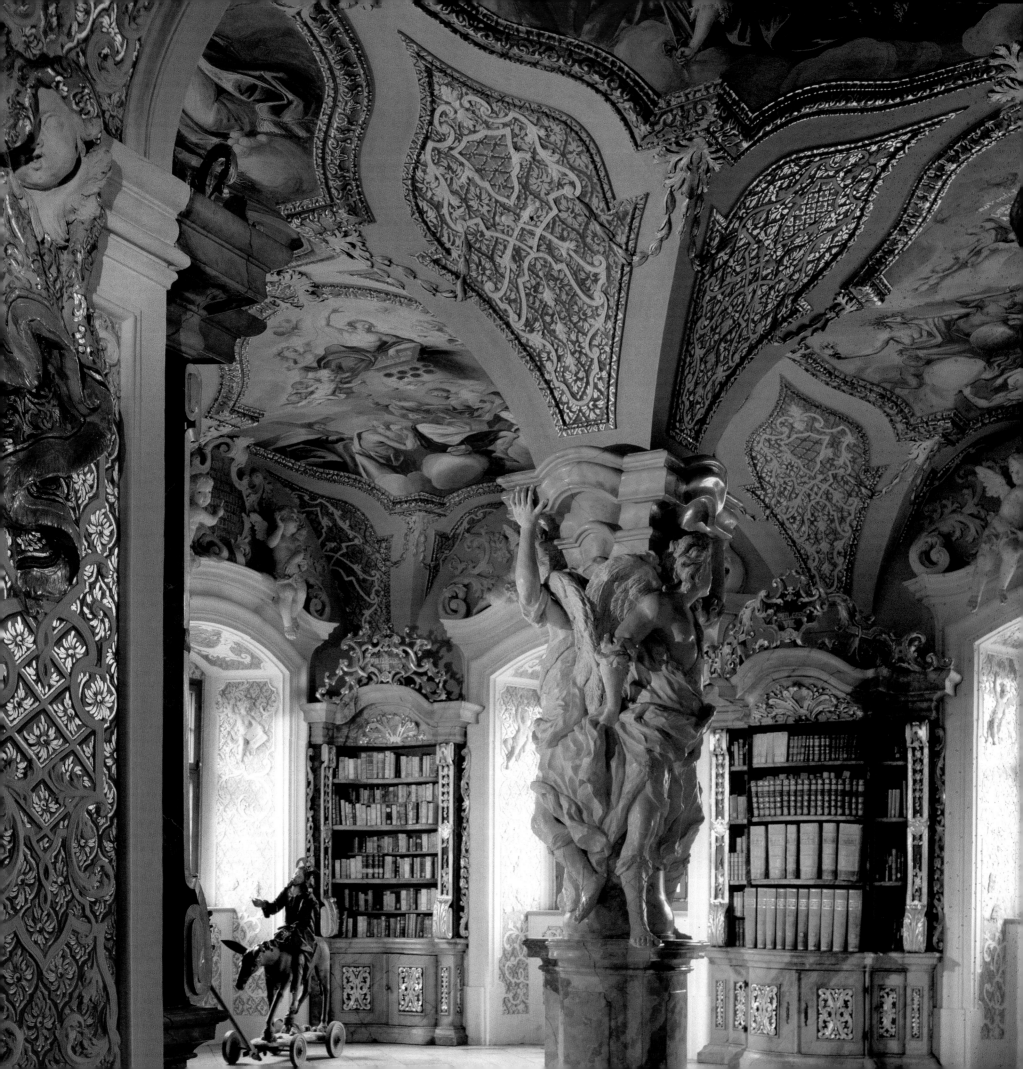

GERMANY

METTEN

THE BENEDICTINE ABBEY LIBRARY OF METTEN

IN THE GREEN VALLEY OF THE UPPER DANUBE, AT the edge of the Bavarian forest, towers the Benedictine abbey Sankt Michael in Metten. Its huge, white buildings stand out in the rustic and peaceful landscape, but it was not always that way. Founded in 766 by the blessed Gamelbert von Michaelsbuch, the abbey came under the protection of Charlemagne in 792 and thus was afforded the privileges and immunity necessary for a totally secular activity—the clearing and settling of the Bavarian forest and the border regions to the east. The abbey experienced an often-tumultuous history typical of great religious entities that were the beneficiaries of princes who saw a way to extend their power to the far reaches of the feudal structure. The abbey quickly grew, was ravaged by a fire in 1236, came under the control of Wittelsbach in 1246, then fell into deep decline for the duration of the Reformation before being restored at the beginning of the seventeenth century. It was finally rebuilt at the end of the Thirty Years' War. During this period, Abbot Roman Märkl created the Baroque decoration of the church, the large receiving hall, and the library. At the beginning of the nineteenth century, affected by a decrease in the number of vocations and poorly adapted to the new political climate, many abbeys—including Metten—became secularized.

A few years later, however, King Louis I of Bavaria decided to restore Sankt Michael and make it the most important Benedictine abbey in his kingdom. In return, he asked the new community to take responsibility for education. In 1837, the abbey opened both a seminary and a school, and played an active role in the rebirth of the Benedictines. Bonifaz Wimmer, a monk from the abbey, was even sent to the United States to found the first American Benedictine abbey, which he did in Latrobe, Pennsylvania. This abbey still exists today.

Pushing open the door of the Metten abbey library is almost like initializing a computerized visit using synthesized images of one of its architectural promenades. One gets the distinct impression that it is real, however something in the proportions, the hyperabundance of effects, and the hypersignificance of the smallest detail makes it seem virtual, false. Roman Märkl, an abbot from 1707 to 1729 in charge of the decoration of the library, whose hall was rebuilt in 1624, would no doubt be disturbed by the skeptical amazement of the twenty-first century. But it would be difficult not to acknowledge that the Baroque, which loved to graze the heights of excess, had gone too far this time. The Benedictines never attached great importance to the vow of poverty and throughout Europe their institutions were known for their comfort, even their luxury. But rarely did their decorative endeavors go to such an extreme.

Here, there is stucco, gilding, frescoes, wainscoting, cherubs, atlantes, garlands, bouquets, allegories, and inscriptions that share such an exuberance that they almost obviate the books. Moreover, readers were a worry in eighteenth-century Catholic Bavaria at a time when the Reformation and the Counter-Reformation still waged, and keep in mind that all the evils deemed reprehensible by these reformers were blamed on reading the sacred texts too closely. More than being a research tool, this library served a quasi-incantatory function through an iconographic precept approved by the order's theologians. It was necessary to distinguish between good understanding and bad understanding— the good being that of the Catholics, the bad being that of the Protestants. But the subliminal message was that divine grace, revelation, and faith were above knowledge, and that one should be suspicious of books and pointless discussions. This is the reason for some of the depictions on the ceiling, such as Thomas Aquinas and Anselm of Canterbury arguing about the Immaculate Conception, the Catholic Church confronting the Protestant the-

ologians Luther, Calvin, Melanchthon, and Zwingli, Saint Jerome being flagellated by angels who reproach him for liking to read Cicero, Otto of Cluny pushed aside from the true path by contact with the works of Virgil, and, of course, Saint Benedict, drafter of the Rules of the Order, inspired by God. These frescoes are the work of a startling hand, Innocenz Anthoni Waräthi, who at the beginning of the eighteenth century had developed a personal style strongly influenced by mannerism and with no small dose of the "*saint-sulpicien*" spirit (before the term was ever coined). He depicts the four evangelists as busy characters writing in unlikely positions, their eyes rolled upward. Saint Mark's lion leans affectionately on the left arm of his "master," Saint Luke's ox tenderly looks out at the viewer, Saint Matthew is writing on the back of Saint Mark, while rather effeminately, Saint John idly crosses his legs. Farther away, Saint Benedict appears, literally, to be illuminated in an inverted perspective that is quasi-expressionistic. The cherubs are innumerable, the medallions distend into weird shapes, and the colors are mellow. Franz Josef Ignace Holzinger's stuccoes owe something to childlike mannerism. In the center of the room, two support columns are concealed under the wings of the cardinal and theological virtues, in a movement so well executed that it is truly a decorative masterpiece.

With such warnings gliding over their heads, librarians and readers at Sankt Michael could not be too bold. Although during the Middle Ages, the abbey had become known for the quality of its scriptorium and its illuminators, practically nothing of that period remains; a fire in the thirteenth century most likely ravaged the library.

Worse still, at the time of secularization in 1803, books were dispersed and hundreds of volumes were sent to the court library in Munich and the university library in Landshut. Upon its reestablishment in 1830, several hundred works were recovered, coming in part from other secularized abbey libraries, but, in truth, the bulk of the collection was not restored until later. In 1839, a *Lesebibliothek* (reading library) was created for the students of the seminary and school, and the bookshelves of the historic library were once again bare. The library sought acquisitions and today has some 175,000 volumes, primarily on religion, the history of the Benedictine order, and the history of Bavaria.

As can be seen today, the Metten library represents the most tumultuous moment in Bavarian Baroque. Emerging from the terrible Thirty Years' War, the kingdom regained confidence in itself, commerce was reorganized, and religious establishments, long threatened, regained some of their power and privileges. Without false shame, modesty, or nuance, the extreme luxury of this décor was an affirmation of faith and power, a proclamation of victory for the greatest glory of God. ❧

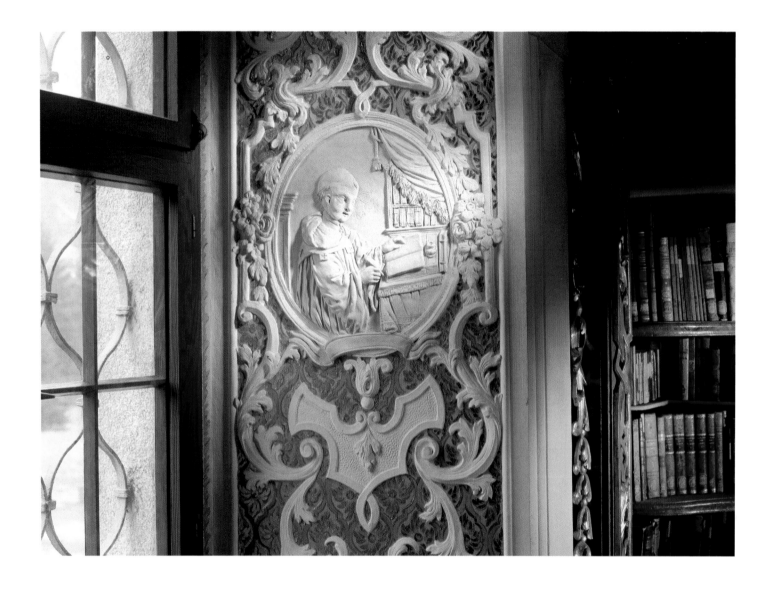

Above: In each window embrasure, stucco medallions by Josef Holzinger honor great Benedictines in a style that is oddly childlike, at least to the modern eye.
Right: Detail of a bookcase with sculpted and gilded wood ornaments.

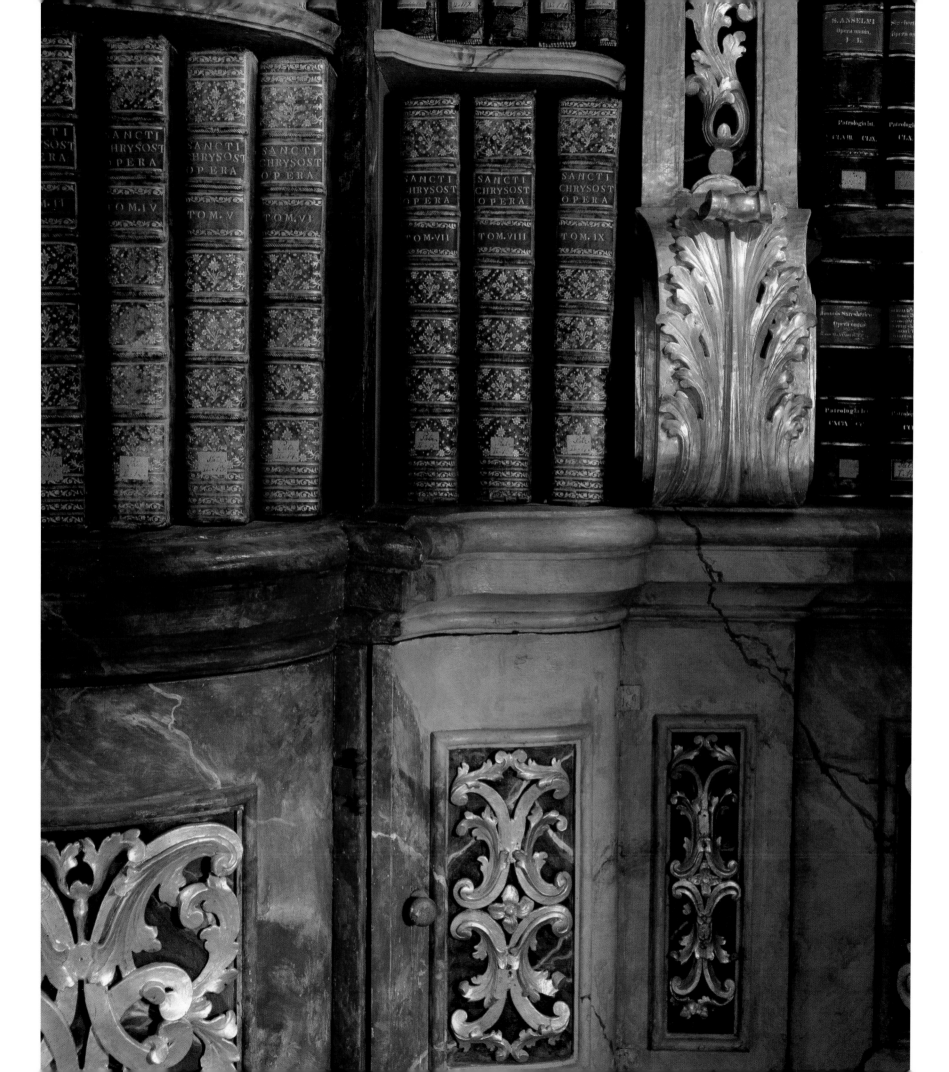

Above: Detail of a pillar. The springing of the ceiling is adorned with four putti medallions.

Left: The central pillars are "upheld" by stucco atlantes that envelop the structure in a flight of legs, arms, and bodies.

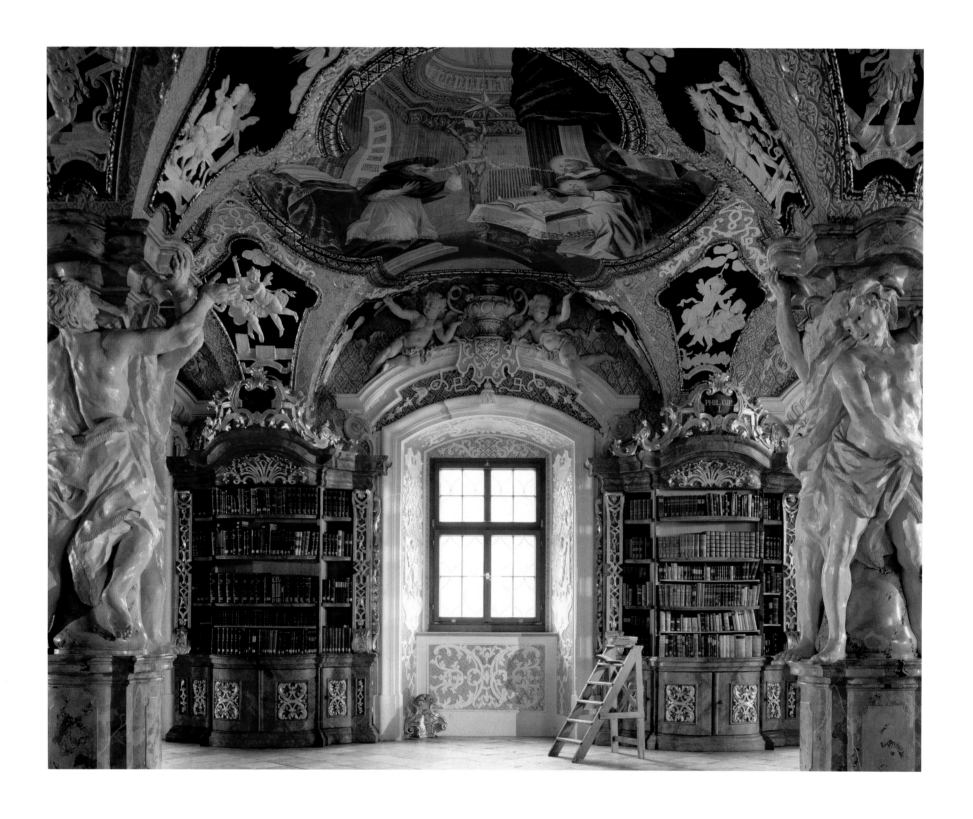

Above: The richly decorated furniture by Jakob Schöpf naturally fits in with the exuberance of the stucco and fresco decorations.

Right: The fresco painter Innocenz Anthoni Waräthi's style was inspired by late mannerism, to which he added a surprising inventiveness, as can be seen in this depiction of the seven deadly sins.

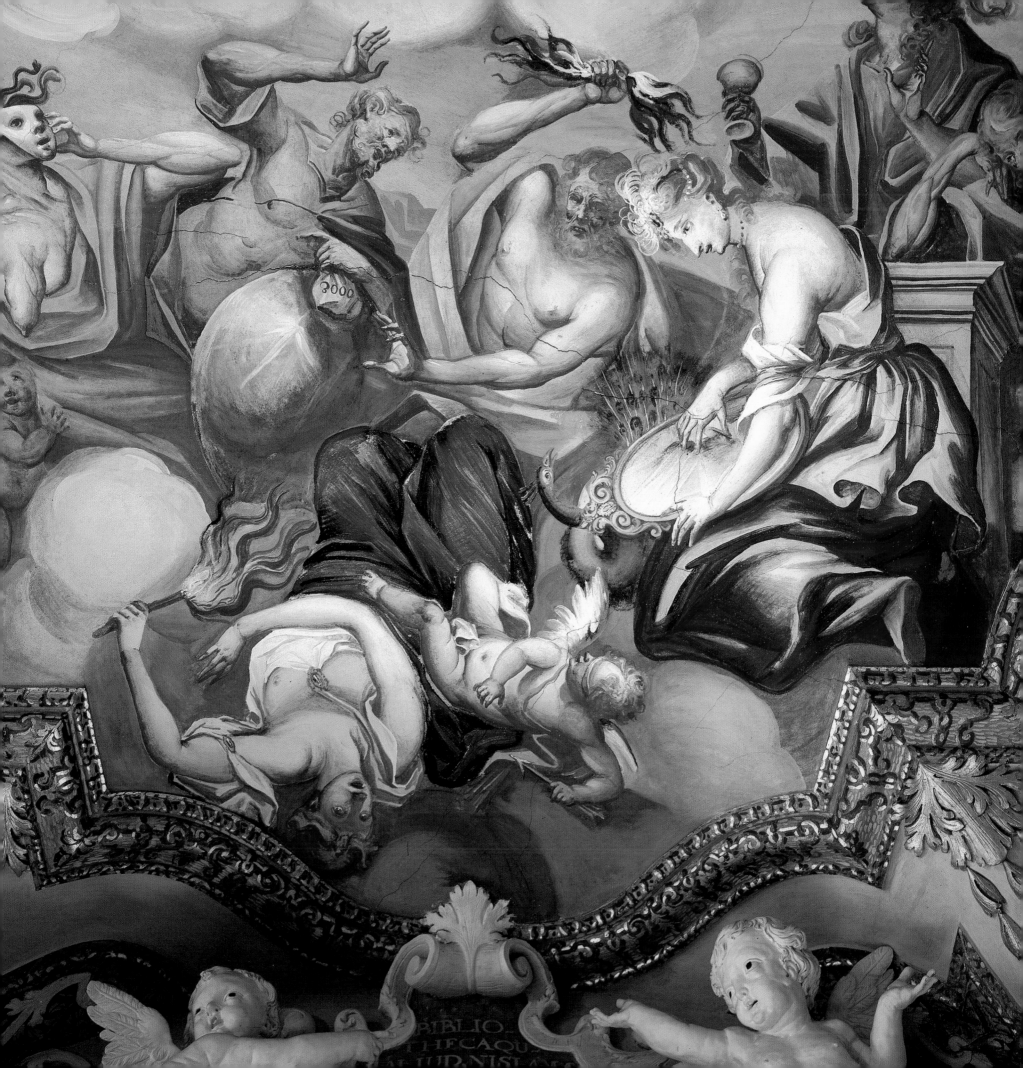

BIBLIO
THECAQU
AELIVD NISLA

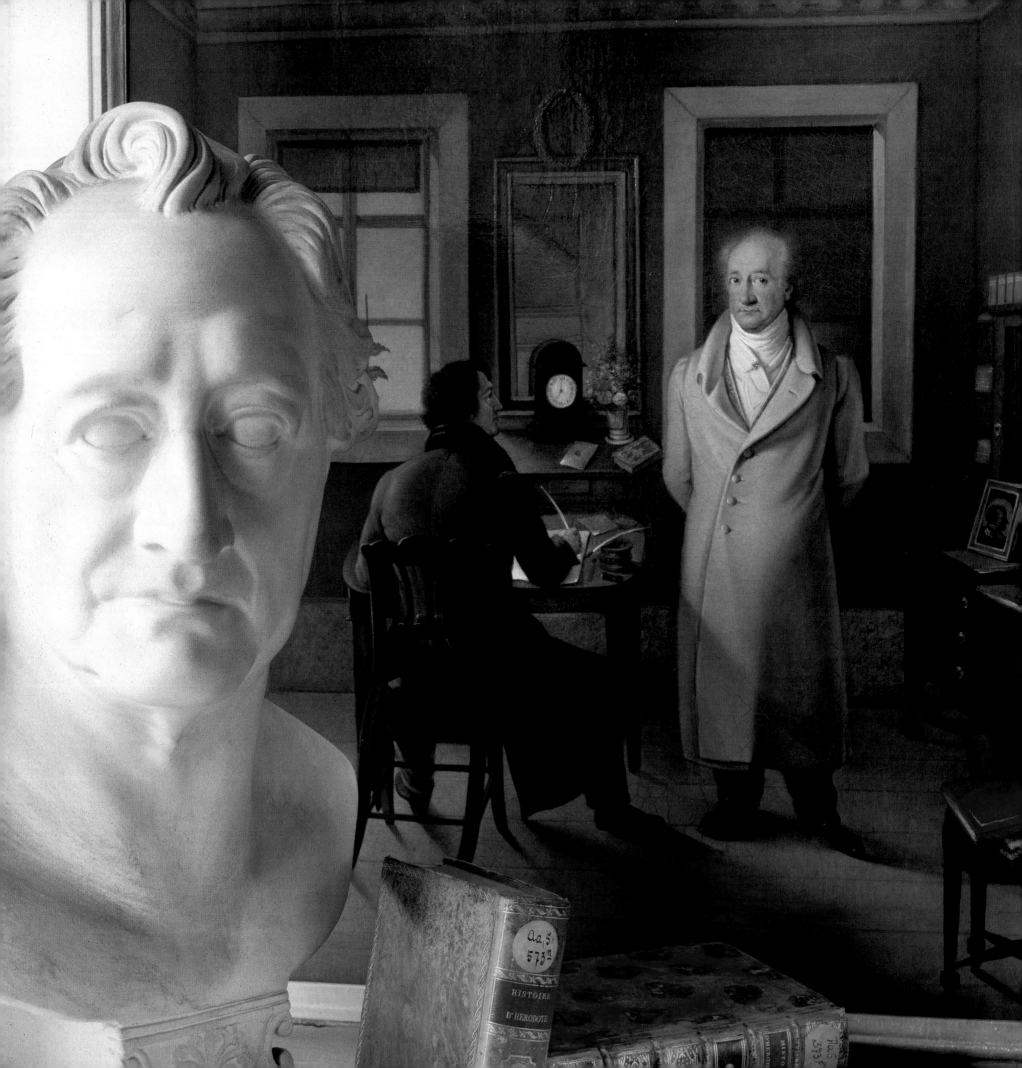

THE HERZOGIN ANNA AMALIA LIBRARY

BORN A PRINCESS OF BRAUNSCHWEIG-WOLFEN-büttel, the niece of Frederick II of Prussia, Anna Amalia, was married in 1756, at the age of seventeen, to the very young and sickly Duke of Sachsen-Weimar-Eisenach, Ernst August II. The purpose of their union was to quickly preserve the line of this impoverished duchy, whose greatest source of wealth was the sale of soldiers to the King of Prussia. Two years later, while the Seven Years' War raged, the duke died. In the words of Anna Amalia, "My eighteenth year was the beginning of the greatest period of my life. I was a mother for the second time, and became a widow, a guardian, and a regent." Fortunately quite intelligent and energetic, she appointed a competent prime minister and within a few years had succeeded in restoring the public finances. Nostalgic for the prestigious courts of her parents and uncle, Anna Amalia's great project was to make Weimar an intellectual center in this somewhat outlying region of Germany. She set about this task and, after yielding power to her son Carl August in 1775, became even more involved. She loved the theater, music, literature, and with great generosity invited painters, musicians, and poets who enjoyed a spirit of great freedom gathered around her *Tafelrunde* or "round table." She modernized Weimar, closed down the remaining cowsheds, installed public lighting and, in 1761, decided to transform the sixteenth-century *Grüne Schlößchen* ("Little Green Castle") into a library to house the works of the Residence that were transferred there in 1766.

A ducal library had existed, of course, in the Weimar since the sixteenth century, but it was not officially inaugurated until 1691. The collection had a well-founded base but the duchess, with her distinct taste for literature, was familiar with its weaknesses. Work was conducted quickly, using an original plan. The heart of the building was open, thus creating a vast central room for reading and preservation. It was surmounted by a sizable gallery replete with bookshelves. Encircling the hall, between it and the castle, is a wide corridor with bookshelves on both sides. Its late-Rococo décor is sober, simple, charming, and functional. The floor is a parquet decorated in dark slats shaped like a carpet. Everywhere are paintings, framed drawings, and white marble busts of the celebrated visitors to this site, which had long been renowned throughout Europe. So far from the excesses of the Baroque monasteries, here was a place created for those who loved books.

One, the most famous among them, took great pleasure in Weimar and the company of the young duke and his mother the duchess. Arriving in 1775, the renowned Goethe lived there until his death in 1832. It was Carl August who, in 1775, at the age of eighteen, invited him to visit Weimar. The young writer had achieved astonishing fame thanks to his epistolary novel *The Sorrows of Young Werther*. The two young men led a merry life, even when it might have meant disrupting the strict rules of decorum that governed the lower German courts. They were inseparable and worked to modernize the state while enjoying themselves at the same time. The duke appointed the writer his personal advisor and in 1782 got Emperor Josef II to bestow a title upon him. This enabled Goethe, whose company the duchess also enjoyed, to sit at the prince's table, which would otherwise have been prohibited by the court etiquette of the day. At that time, Weimar became the intellectual capital of Germany, particularly in the domain of theater, and the city was pleased to have as a guest the most brilliant representative of romanticism. As the years passed and its protagonists aged, the *Sturm und Drang* was transformed into German romanticism. Goethe was seen everywhere. He reopened a silver mine, concerned himself with the economy, public finance, forestry, and mining, and had a passion for osteological anatomy (he discovered a jawbone) and optics. At the same time, in keeping with his gradual

rhythm of maturation, he composed thousands of lines of *Iphigenia* and *Egmont*, wrote his great novel about the apprenticeship of Wilhelm Meister, and ceaselessly worked on his *Faust*. He was also named director of the Großherzogliche Bibliothek of Grüne Schlößchen in Weimar, a post he retained from 1797 to his death. He reorganized the library in a scientific manner and increased its collection from 50,000 volumes to some 132,000 volumes, making it one of the largest libraries in Germany. At this time when religious congregations were secularizing, entire collections of manuscripts and incunabula arriving from regional monasteries were routinely sent to Weimar. Goethe was a very active director, at least from time to time. He imposed a hard-and-fast schedule of fines for borrowers who returned books late, and some of his hand-written notices still exist.

With such godparents—the duchess died in 1807 and Goethe remained very active until his death in 1832—the library enjoyed quite a reputation. The prince's family carried on with an ambitious policy of acquisition throughout the nineteenth century, and thus acquired collections of scores from Mozart, Haydn, and Gluck, and part of the libraries of Schiller, Achim and Bettina von Arnim, Liszt, and Nietzsche. A collection of Faust and Shakespeare was established, as was one on Germany, and a third on Italy, a land that served as a source of great inspiration. Germany dreamed of Italy, that country "where the lemon trees blossom" and where

Goethe lived what he described as the happiest period of his life. Upon his death, he left the Weimar library the 5,424 volumes of his private collection, which are still kept in his last home. The library has become the primary institution for the study of German classicism to such an extent that, in 1969, it even bore the name of the *Zentralbibliothek der deutschen Klassik* (Central Library of German Classicism).

Today, the Herzogin Anna Amalia Bibliothek is a center of literary and cultural historical research. Its collection contains 900,000 items, which include 500 incunabula, 2,000 medieval manuscripts, 10,000 maps and globes, 4,000 musical scores, a 13,000-volume collection on the subject of Faust, and 10,000 on Shakespeare. The library suffered severely due to lack of maintenance during World War II and, with the building in a dangerous state, visits became practically impossible. Books disappeared during the 1960s and 1970s, sold by the Communist state for hard currency. For a long time the "little castle" has been very cramped and hundreds of thousands of volumes have been dispersed throughout the city, making research somewhat complicated. What does remain is the extraordinary testimony of Duchess Anna Amalia's library to the union of a great family and a genius, and the intellectual life in Germany's princely courts during an era when, once the Napoleonic wars were forgotten, the country experienced considerable economic and cultural development. ⌁

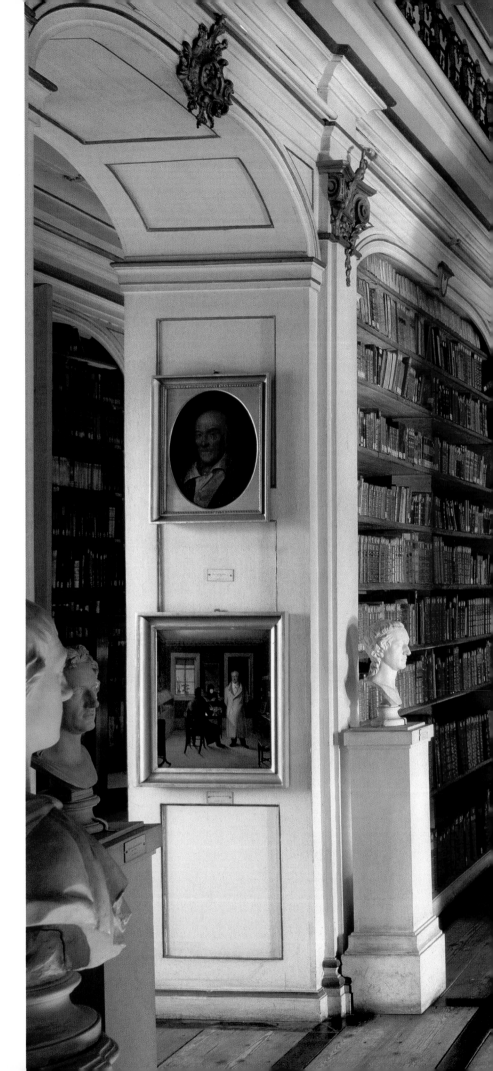

Above: Written in French, one of the first scientific library catalogues,
set up a few years after its transfer to the "little green castle" in Weimar.
Right: Since 1766 the ducal library has been located in the former residence of the prince,
remodeled at great cost to accommodate its reading room and two levels of bookshelves.

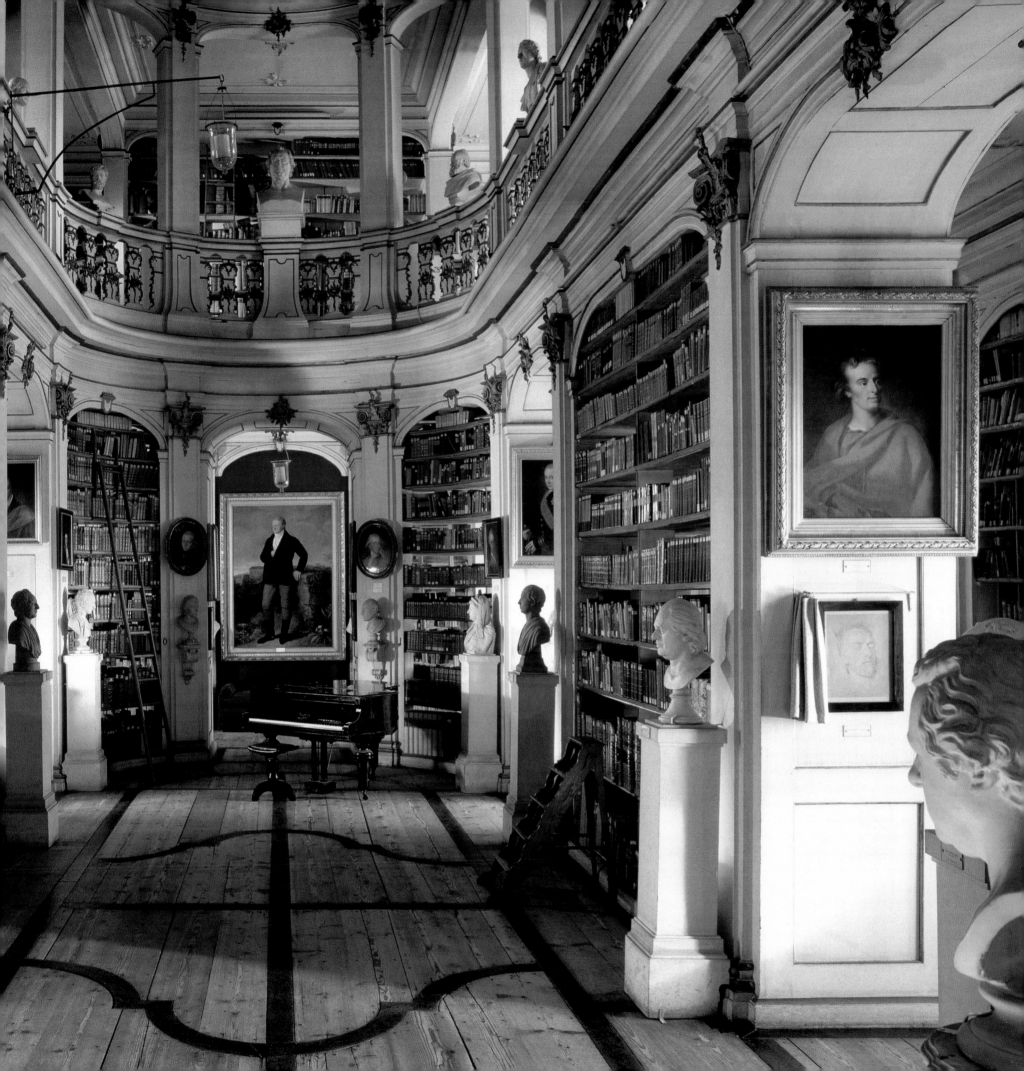

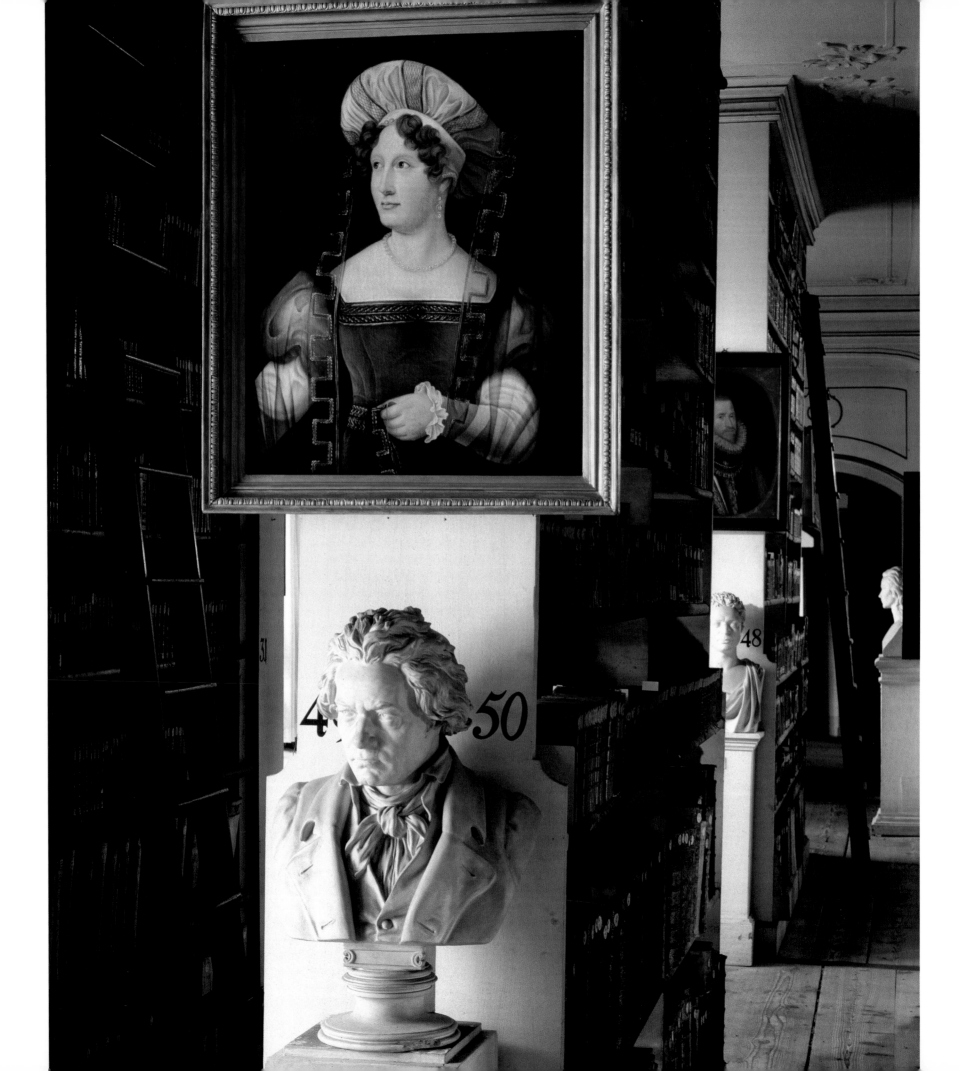

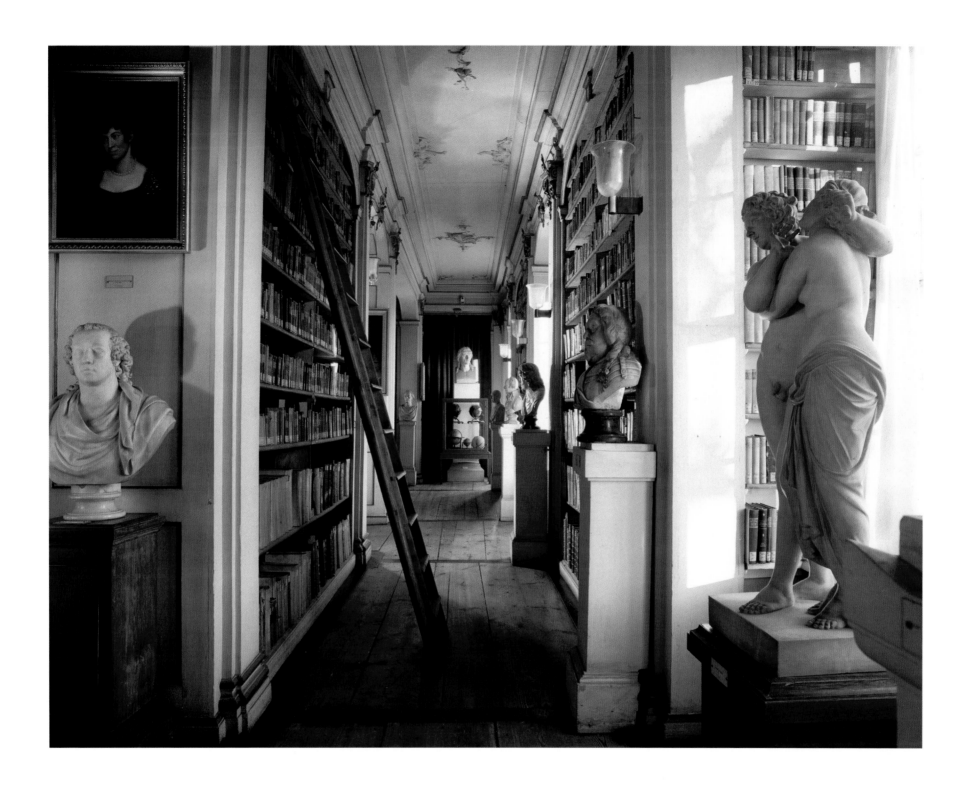

Above: The layout is simple and functional. In the spirit of its founder, it is a working library whose prestige comes more from the wealth of its collection than from its décor.

Left: The few spaces not occupied by books are used to display a collection of fine paintings and busts of famous men such as Beethoven. These objects have come primarily from entire libraries that were bought in the eighteenth and nineteenth centuries, or from bequests to the institution.

lucem a tenebru. Appellauit q̄
et tenebras noctem. Factum q̄ est uespe
et mane dies unus. Dixit quoq̄ deus. F
mamentum in medio aquarum: et di
aquas ab aquis. Et fecit firmamentum
diuisit q̄ aquas que erant sub firmam
ab his que erant supra firmamentum
tum est ita. Vocauit q̄ deus firmame
cælum. et factum est uespere et man
secundus. Dixit uero deus. Congr
aque que sub cælo sunt: in locum u
appareat arida. Factum q̄ est ita. E
uit deus aridam terram. congregat
aquarum appellauit maria. Et ui
quod esset bonum et ait. Germin
herbam uirentem: et facientem se
gnum pomiferum faciens fructu
nus suum: cuius semen in semetips
terram: et factum est ita. Et pro
herbam uirentem: et afferentem
ta genus suum: lignum q̄ facien
et habens unumquodq̄ sement
speciem suam. Et uidit deus q
factum q̄ est uespere et mane
Dixit autem deus. Fiant lumin
mento cæli et diuidant diem
et sint insigna et tempora et
et luceant in firmamento cæ
minent terram. Et factum est
us duo magna luminaria. lum
ut preesset diei: et luminar
esset nocti. Et stellas. Et po
mamento cæli: ut lucerent
preessent diei ac nocti

ITALY

ROME

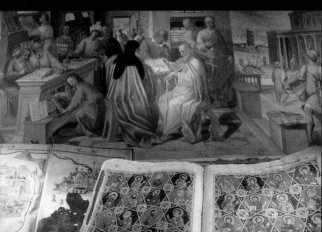

THIS FAMOUS FRESCO BY MELOZZO DA FORLI (1438–1494) appears in all works on Italian Renaissance painting. Although it now hangs in the Vatican's Pinacoteca Apostolica, it was created for the inauguration of Pope Sixtus IV's library. The pope is pictured surrounded by his nephews, a monk, and a kneeling, dignified character with gray hair who points at a cartouche with an explanation of the scene. It is none other than Platina—humanist, biographer, bibliophile, and the most mythical librarian of all the great Western libraries. This work, with its fascinating perspective, architectural precision, and treatment of faces, finds its place in history as an important symbol of the interest that the popes had in writing and, to a certain degree, also brought about the birth of the sublime Biblioteca Apostolica Vaticana.

Nevertheless, for a long time the papacy attached only small importance to books. The oldest accounts speak of the presence of a library in the old seventh-century Saint Peter's Church, but it was so poorly maintained as to be unusable. The separation between the works belonging to the reigning pope and the Church's hypothetical "central" library was never made. The Avignon Pope Clement VI was truly a well-read man who owned more than 2,400 volumes; however, when the pope returned to Rome in 1367, no one made a great effort to send his library there. One of the first personal projects of Nicholas V, an erudite and passionate bibliophile who, to his great surprise, was elected pope in March 1447, was to reorganize the preservation of the books in the Vatican's possession. At the time, it consisted of merely 340 ancient manuscripts, no doubt, possessions of the earlier library, and included only two in Greek. His goal was to make Italy once again one of the great intellectual centers of Europe and he hoped with this proposed library to draw humanists and scholars to Rome. This was still an era before the advent of printing, and when the manuscript remained the most valuable means to transmit knowledge. There was a return to the study of ancient works, in particular the Greeks, the only way by which one could come closer to the knowledge of antiquity. No one thought twice about crossing Europe in order to copy (provided permission were granted) the texts of those philosophers, as well as the works of the Fathers of the Church. Nicholas V sent envoys to Germany, Denmark, and most certainly to Greece to buy all the manuscripts they could find. Hundreds of codices arrived in Rome, one of which, incidentally, was *De re culinaria* by Apicius, a book on cuisine. Knowing he could not buy everything, Nicholas V hired translators and copyists who went straight to the churches and monasteries to work. By the time of his death, the Vatican's collection had reached more than 1,200 volumes. It has been reported that upon visiting the library his successor, Callistus III, exclaimed, "This is how the riches of the Church of God have been squandered." Three years later, he was succeeded by Pius II, a Piccolomini from Sienna who owned a vast library that can still be visited at the cathedral in that city. Finally, Sixtus IV decided to designate a place near the Sistine Chapel for the library. Divided into four halls, it was furnished with small desks to which the works were chained, but was rather freely open to scholars, the religious, and travelers. Its first librarian, Bartolomeo Sacchi, a great organizer known by the name of Platina, went forth and increased the library's holdings to 3,500 volumes. The fame of the Vatican would reach its peak under Leo X—Giovanni de' Medici—who was elected in 1513. A humanist and lover of Greek literature, the new pope further expanded the library and founded a Greek college where one could study, in the original language, that vast majority of Christian sacred texts written in Greek, along with the great commentaries. In 1527, however, Rome was devastated by the imperial army of Charles V and many of the manuscripts disappeared,

either having been stolen, torn apart, destroyed, or burned. This tragic episode marked the end of the Vatican of the Renaissance and the humanist library available for research, study, and the furthering of knowledge.

What followed was the Vatican of the Counter-Reformation. The Roman Church had very nearly succumbed to the theological arguments of a German monk who had hoped to use the invention of printing to promote the reading of the Bible. In essence, every believer would have access to the founding text. One of Rome's responses was to try to control the distribution of books. The *Index Librorum Prohibitorum (Index of Banned Books)*, instituted by Paul V in 1559, remained in force until 1966. This censure grew malignant and access to the knowledge contained in ancient manuscripts, possible sources for new exegeses, became more difficult. The account that brought Montaigne to visit Rome in 1580 illustrates this effort, which developed in stages throughout the sixteenth century. Detained at the border, most of the writer's books were confiscated, among them his *Essays*, which would appear in the *Index* a century later. Several of his books were seized merely because the translator was a heretic. The Vatican, however, did extend Montaigne a rather warm welcome and he was able to consult freely the handwritten works of Seneca, Plutarch's *Moralia*, a work by Virgil, and the Acts of the Apostles "written in very beautiful gold Greek letters, as vivid and fresh as if it had been done today." But soon thereafter the Vatican again shut itself off from the outside world, and it became progressively more difficult to get access to its collections. This did not impede the Supreme Pontiffs from continuing to amass treasures. In 1623, for example, the elector Maximilian of Bavaria presented the Palatine Library (which he had seized in Heidelberg) to Rome. In 1657, the renowned library of the dukes of Urbino arrived at the Vatican and in 1690 the vast collection of Queen Christine of Sweden, who had lived in

Rome for a long time, was acquired. The eighteenth century saw further acquisitions, such as the prestigious collection of the Barberini family, bought by Pope Leo XIII. Access to these books was reserved to princes of the Church and duly accredited readers and researchers, who were closely watched. Great complaints about the absence of a reliable catalogue were common, and consultation of the inventories was often prohibited, thus requiring advance knowledge of the reference number of the desired manuscript. Visiting hours became progressively shorter, so that by the middle of the nineteenth century they were 9 AM to noon. In 1852, Paul Heyse, a young German poet researching the songs of the troubadours, was thrown out for having dared to copy some verses. One could read, but not copy. This was a belief that came directly from the Middle Ages when copying manuscripts was a right rarely granted and a dangerous transgression when it was not. The dramatic fate of Saint Colomba is a case in point. He was expelled from Ireland in the sixth century for having copied a book he admired without authorization.

For European intellectuals, the Vatican Library slowly became a legendary place where works were hidden away because they might be dangerous to religion. Suspicion was fostered by the utterly defiant attitude of the papacy toward the thinking of the eighteenth and nineteenth centuries, along with its repeated condemnations and refusal of any theological evolution that could be interpreted as the abandonment or questioning of its beliefs. Following a visit to the Vatican, Chateaubriand, for a time France's ambassador to Rome and a fervent Catholic, wrote in his *Voyages en Italie*, "[. . .] the spiked Iron Gate, there, is the gate to science. Magnificent repository: invisible books. If one could study them, one could entirely recast modern history." In his *Promenades dans Rome*, Stendhal was even more explicit. "It is remarkable to see the head of a religion who wants to annihilate all books with a library. Also,

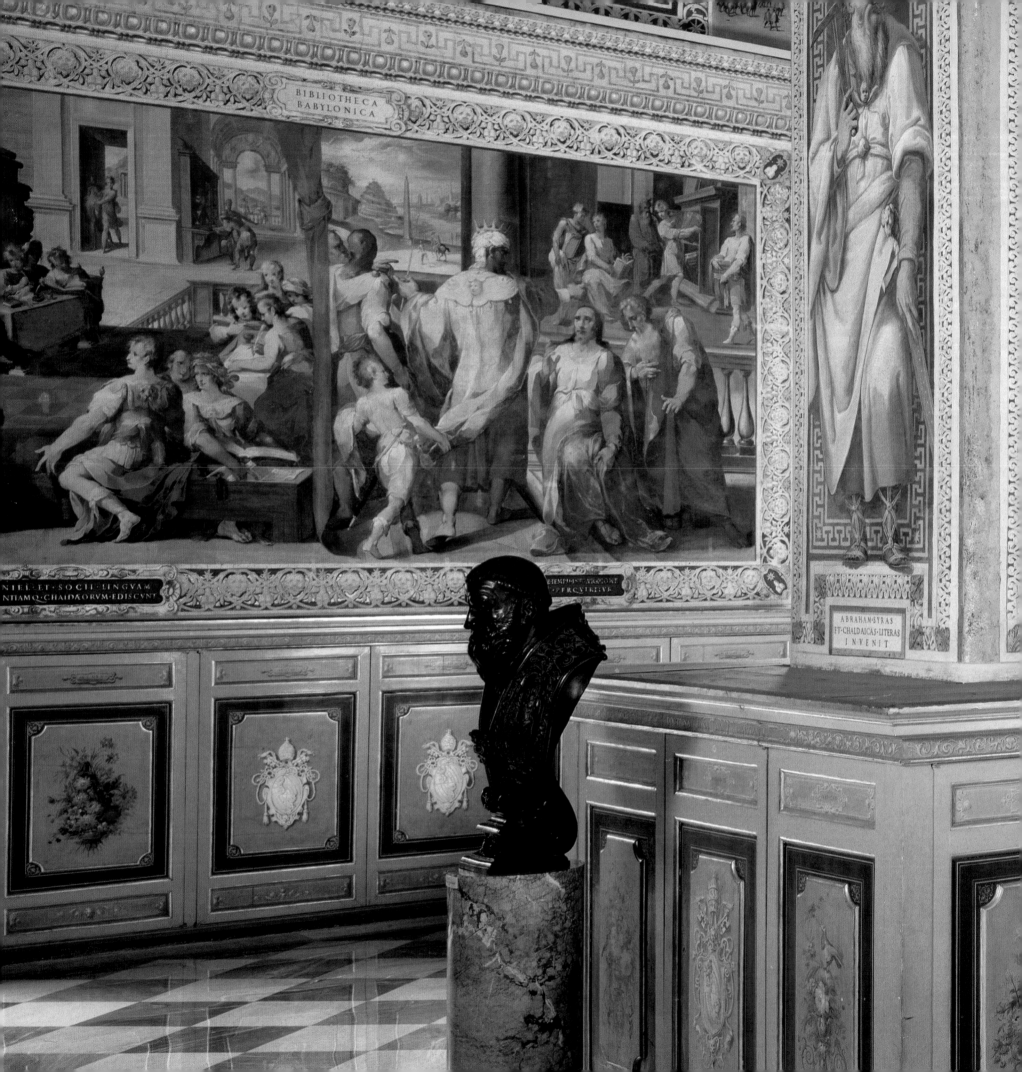

BIBLIOTHECA
BABYLONICA

ABRAHAM·SYRAS
ET·CHALDAICAS·LITERAS
INVENIT

Right: The Vatican Library is one of the rare important institutions that "hides" its books. The ancient collection is still stored in locked bookcases and, until 1613, consulted works were chained to desks.
Panorama: The large reading room that Pope Sixtus V (r. 1585–1590) had built by the architect Domenico Fontana (1543–1607). The luxury of its décor is interrupted by
the austerity of the more functional halls that date from the time of Pope Sixtus IV.

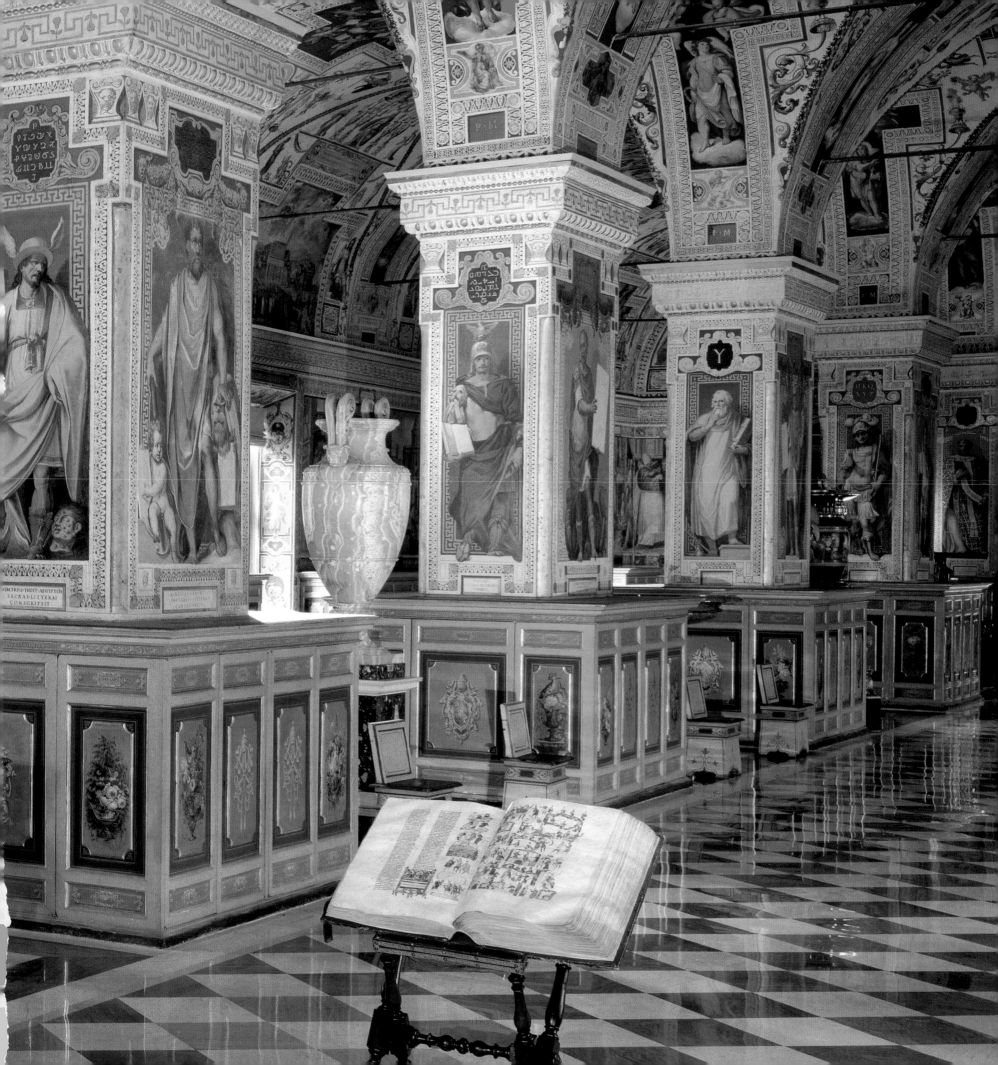

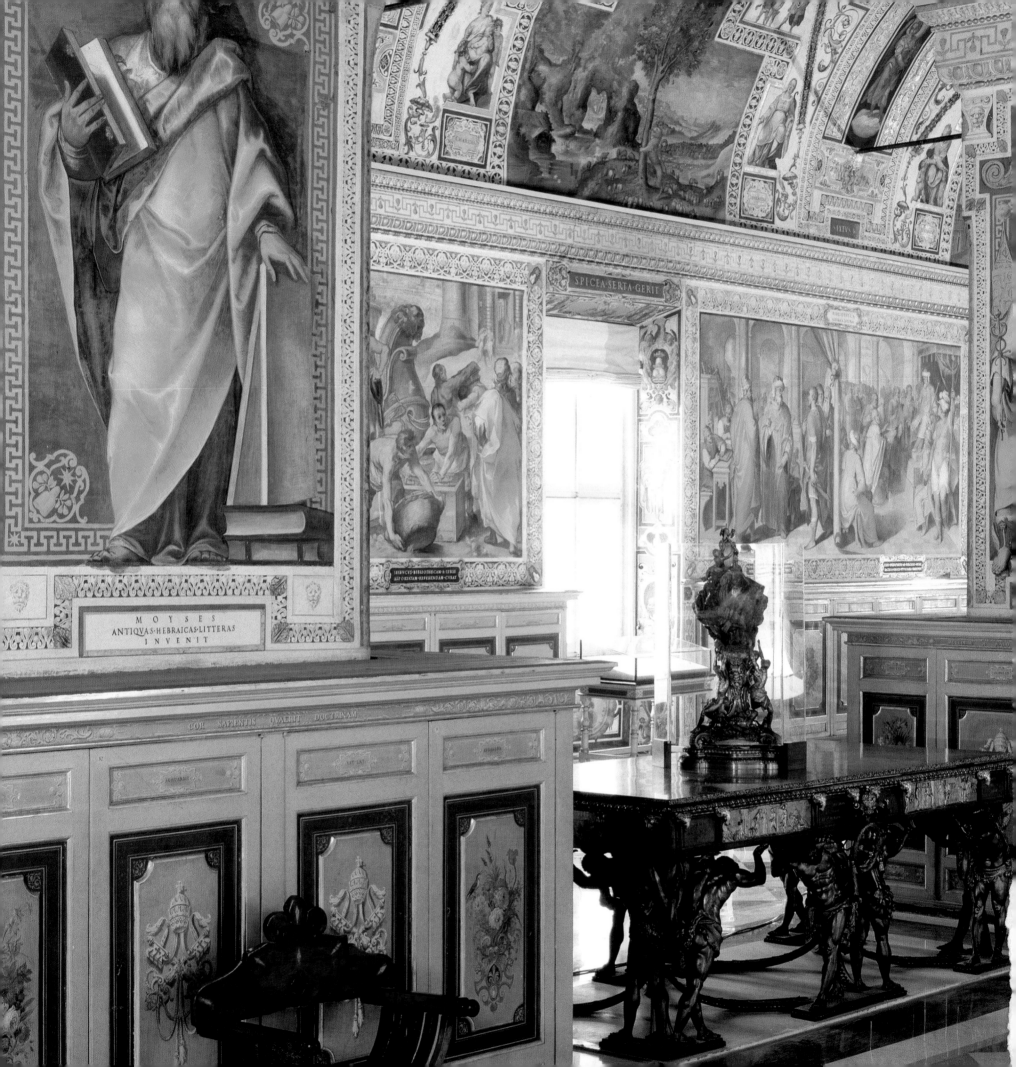

SPICEA·SERTA·GERIT

MOYSES
ANTIQVAS·HEBRAICAS·LITTERAS
INVENIT

COR SAPIENTIS QVAERIT DOCTRINAM

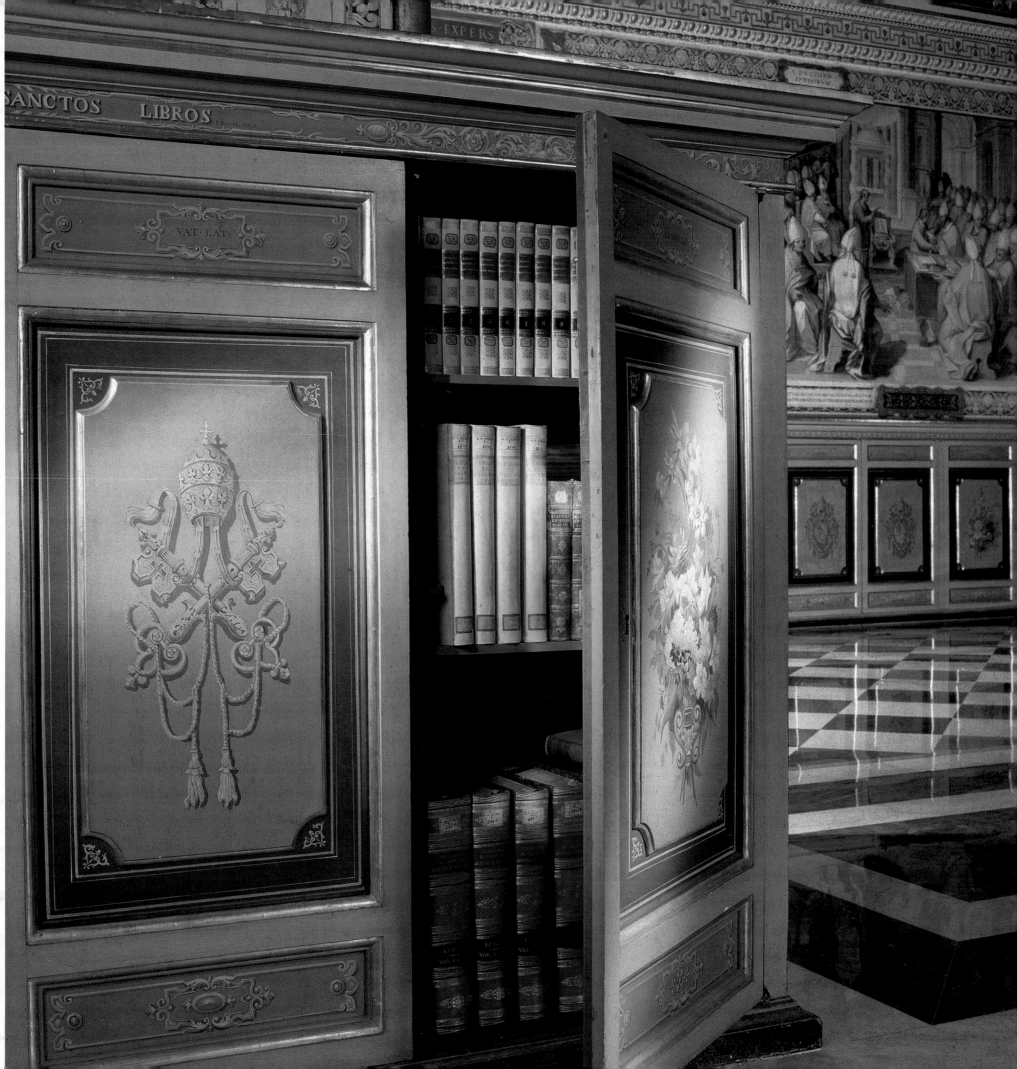

what must be seen is how they receive interested foreigners, particularly the French." Further on, he continued, "There are offices, filled with manuscripts, that cannot be entered without being excommunicated *ipso facto*." The fact that one of the four halls of the library, where papal archives and certain manuscripts were kept, had been called the Secret Archives since the time of Sixtus IV was considered proof that knowledge was being withheld. Another complaint is that the Vatican was—and remains—one of the rare, important institutions in which books cannot be seen because they are all locked in cabinets. In the twenty-first century, the Biblioteca Apostolica is most definitely open, but not everyone can enter.

As revealed in the fresco of Melozzo da Forli, the Vatican library was not housed in a worthy setting until the reign of Sixtus IV. It was then comprised four halls decorated with frescoes by three grand masters: Melozzo, Romano, and Ghirlandaio. All these frescoes have disappeared save for one depicting Platina. One century later, Sixtus V (r. 1585–1590) had a vast, splendid hall constructed by the architect Domenico Fontana, which is the one known today. It was decorated with frescoes by Cesare Nebbia and Giovanni Guerra, which have recently been restored. Fortunately, one of the authors of the iconographic and apologetic sequence, Angelo Rocca, published a descriptive abstract in 1591. The great councils on the defense of faith (Constantinople, Ephesus, Nicaea, etc.) are depicted on one side of the hall, while on the other are depictions of the great libraries of antiquity (Babylon, Athens, Alexandria, Ceasarea, and others). The eight central pillars were dedicated to the great philosophers of antiquity such as Pythagorus and Palamedes, to certain Church fathers such as Saint Jerome and Saint Cyril, to some of the gods of Olympus, and the third even to Isis. The first pillar, however, is dedicated to Adam, the second to Moses and Abraham, and the eighth to Christ. The style is monumental, the ornaments abundant, and the scenes both detailed and emphatic. It is the Roman faith, in full glory, proud of its power, its history, and its triumphs.

Today, the Vatican Library is a modernized institution that efficiently manages an incomparable collection of 1,600,00 printed works, including 8,300 incunabula, 150,000 manuscripts and archives, more than 100,000 engravings and intaglios, and, finally, 300,000 coins and works of art. Open to registered researchers and teachers, it has a computerized catalogue, although it is quite possible that all its riches, in particular its collection of manuscripts, have not been completely investigated, at least not recently. It certainly is no longer the "cemetery of books" as Adler, a translator of the Old Testament called it in 1783, but perhaps still a repository whose treasures are saved for eternity. ∽

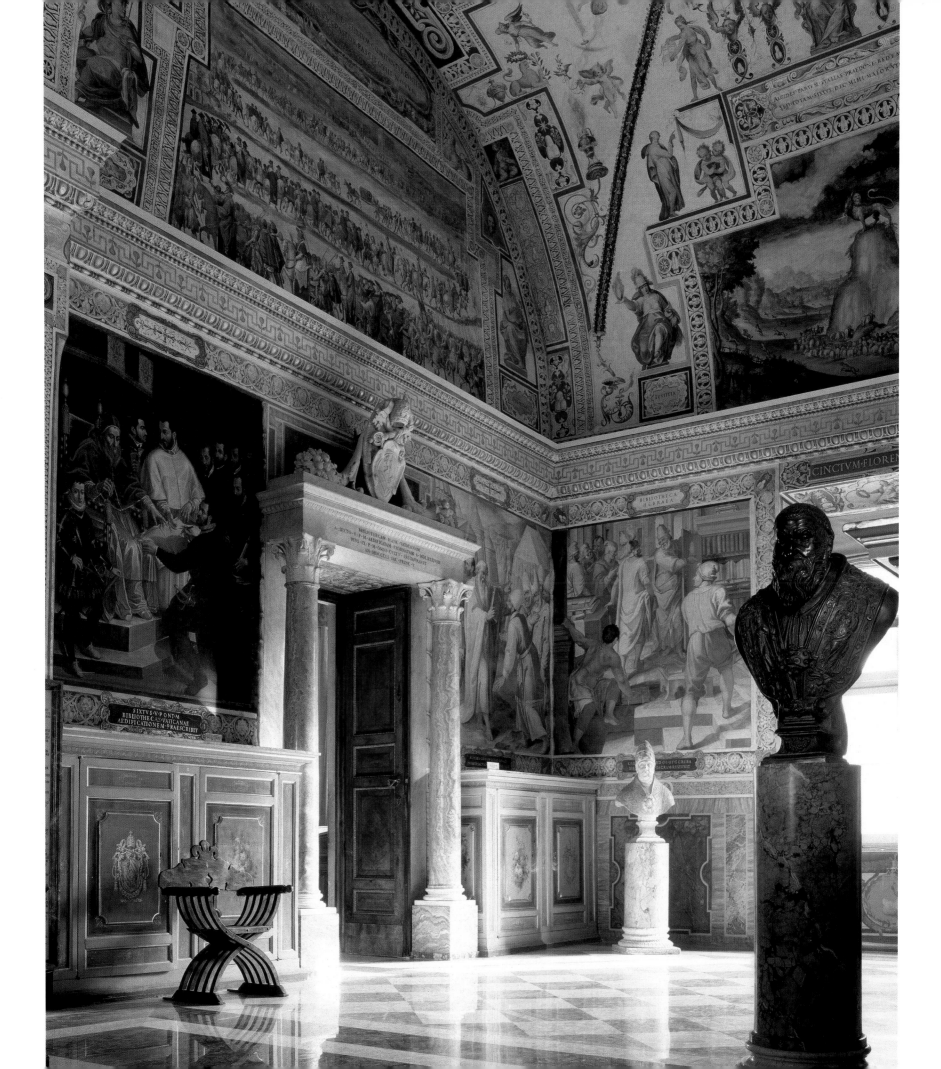

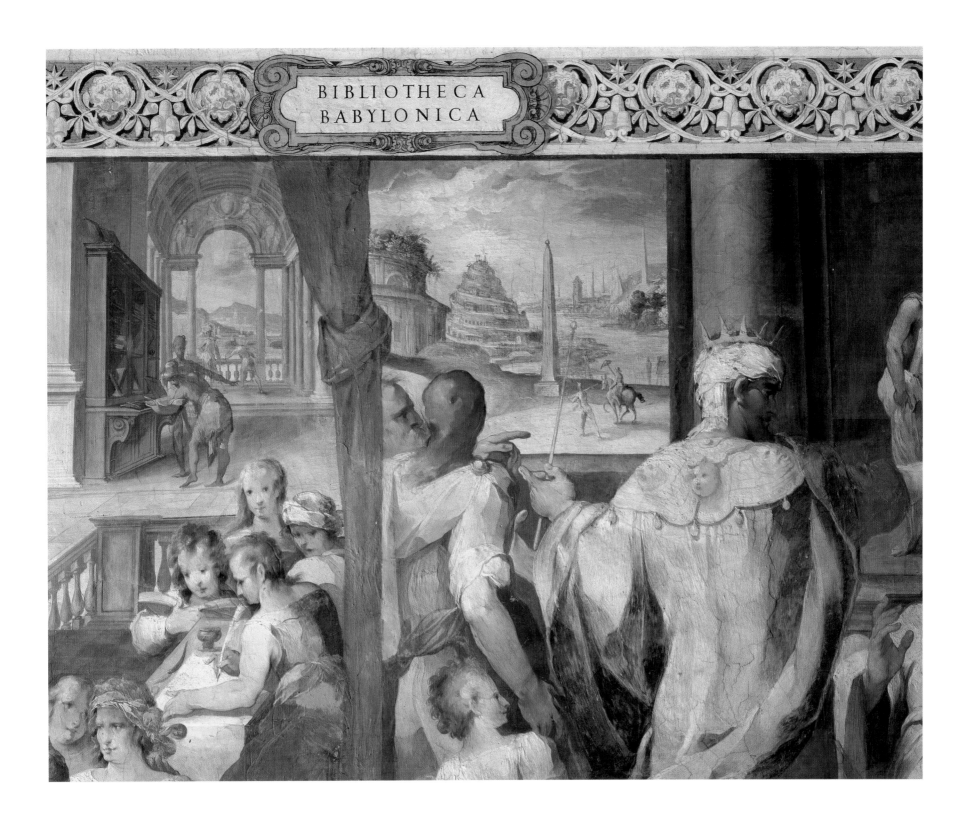

The reading room is decorated with frescoes by Casare Nebbia (1536–1614) and Giovanni Guerra (1544–1618), which depict the principal Roman monuments, several councils and, as seen here, the celebrated libraries of antiquity, which the Vatican Library could justly rival.

The riches of the Vatican are incalculable. Among its treasures are the Codex Vaticanus *of Virgil, the* Vatican Code B *(a fourth-century Greek Bible), the* Chronicles of Constantin Mannes *(fourteenth century), the* Book of Job *(a twelfth-century edition from a Constantinople scriptorium), and a translation of Aesop's* Fables *handwritten by Martin Luther.*

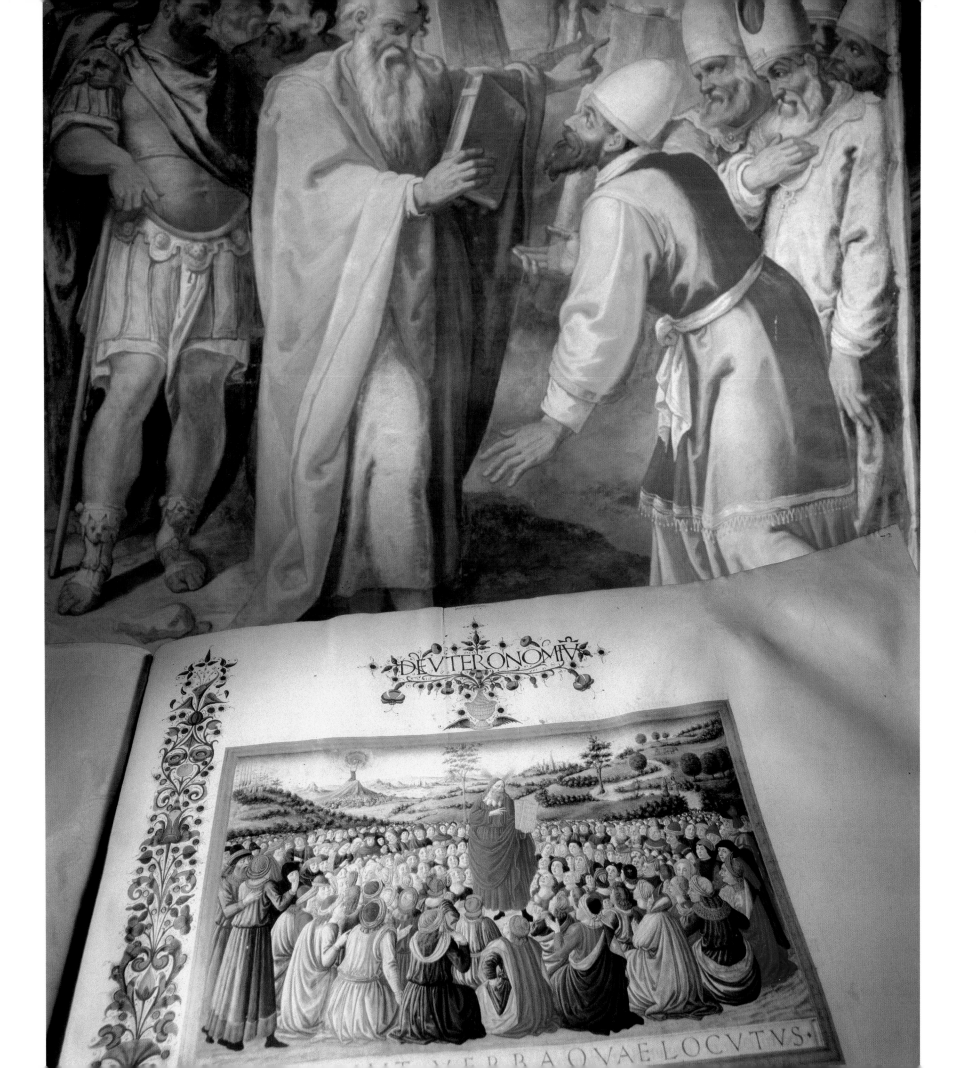

DEVTERONOMIA

···IT VERBA OVAE LOCVTVS·

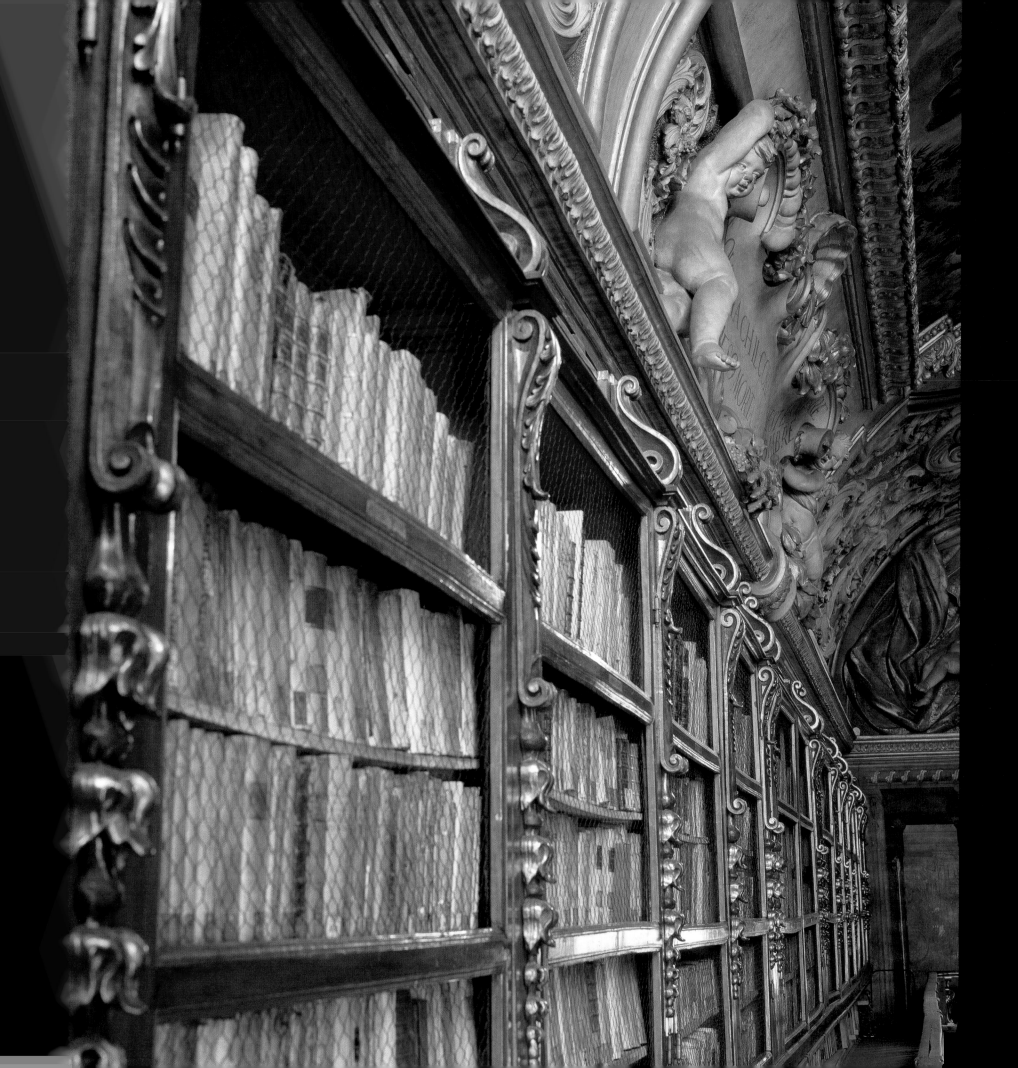

RICCARDIANA LIBRARY

THE HISTORY OF THE BIBLIOTECA RICCARDIANA IS a fine illustration of the fate of those great Florentine families whose power marked European history, yet whose fall left it unaffected.

The Riccardi family descended from, or pretended to descend from, a German *condottiere* (leader of mercenary soldiers), or perhaps simply from a tailor who obtained Florentine citizenship in 1367. His son quickly amassed a fortune, and his grandson founded a bank in 1659. At the height of their glory, the family bought the Medici mansion. A masterpiece by Michelozzo, this palace was first the prototype, and then the archetype of the Florentine *palazzo*. Not far from the Duomo and the Piazza San Lorenzo, its austere facade is adjacent to the Via Larga, then one of the widest and most beautiful streets in Florence. Its broad eaves overhang ample cornices and protect the facade, which superimposes three types of stone bonding patterns: rusticated, table bossage, and smooth. These were not an architectural detail; they were symbolic. The defensive, rusticated pattern of the first story visually confirmed the power of the family; the elegant presentation of the *piano nobile* (second story) exemplified their wealth; and the third story lent a lightness and height to the construction and thus a greater sense of nobility. All the same, this immense and luxurious palace was too small for the Riccardi family. It took no less than ten years of work for the Marquises Gabriello and Francesco Riccardi to renovate this immense building, which, over a period of a century, accommodated the minor members of the reigning family after its leaders had moved to La Signoria and, later, to the Pitti Palace.

The Riccardis were true bibliophiles, and beginning in the 1550s Riccardo Riccardi started to collect works of literature, poetry, and religion, but Marquis Francesco truly founded the library. It was he who constructed and decorated it and expanded the library's collection of books. His marriage to Cassandra Capponi helped. She was the daughter of the famous and erudite Vincenzio, a friend of Galileo. Upon Francesco's death in 1688, he owned 5,000 printed works and 249 manuscripts, part of which had been bequeathed to his daughter. For the Riccardi family, the library was not merely a symbol of *la pompa* (prestige), as was the case with so many other collections of the era. The Riccardis took great care of the library, and in 1737 opened it to the public—i.e., to recommended researchers and scholars.

Proof of their concern abounds. The Riccardis bought several buildings neighboring their palace in order to raze them and construct a new wing for their collection. For the interiors, they employed Giovanni Battista Foggini, a noted decorator and sculptor, and also Luca Giordano, one of the most celebrated painters of the period who was known for his ability to work quickly. The library has not changed since the end of the seventeenth century. Its main room is relatively narrow, but with very high ceilings dominated by a fresco. The two long walls are furnished with a rather severe set of sculpted and gilded shelves chosen by Francesco Riccardi himself. The upper level has a small adjoining gallery. The books, which have been rebound in a tawny or off-white leather, are all protected by a metal grill. The setting is somber and somewhat oppressive, and the eye tends to look upward toward the luminous, optimistic, and heartening sky executed by Giordano, based on an iconographic schema designed by the senator Alessandro Segni. The human spirit is represented by a young man in armor seated in a stormy landscape—an allusion to the difficulties encountered on the road to knowledge. Surrounded by Philosophy, Theology, and Mathematics, he raises his eyes toward Wisdom, a young woman armed with a globe and a scepter. Two *putti* hold up an inscription of Petrarch that reads, "They raise our intellect from

earth to heaven." The fresco covers the entire ceiling, while its springing is laden with inscriptions and stucco ornamentation. At one of the far ends, there is a representation of part of the Riccardi-Caponi coat of arms, while at the other end is a bust of Vincenzio Capponi by Foggini.

The heirs of Francesco Riccardi continued to expand the library, which reached the zenith of its reputation in Europe at the end of the eighteenth century. But at that point, their power was nothing more than a memory. Their banking pursuits had long since been abandoned, and the family fortune invested in less-than-profitable lands. Undoubtedly, the princely existence, numerous villas, art collections, and the unstable state of Tuscan politics contributed to this rapid decline. In 1813, the commune of Florence bought the library, thus preventing its sale at auction, and made it into an institution open to the public. Two years later, it was given it to the Italian government. The Medici-Riccardi Palace is now the seat of the prefecture of Florence, the provincial counsel, and the president of the province. Today, one can only visit the grand Michelozzo courtyard with its Baccio Bandinelli masterpiece, *Orpheus*, a marble statue that rises up from its plinth, which in and of itself is a course on the history of ornamentation. On some days, the medieval-style interior garden designed by Michelozzo can be seen from the entryway.

The contents of the Riccardiana catalogue is testament to the high culture of the fifteenth, sixteenth, seventeenth, and eighteenth centuries and contemporary acquisitions focus on enriching this collection. There are many treasures that include an elegant compendium from the fifteenth century of Virgil's *Bucolics*, *Georgics*, and *Aeneid* with illuminated panoramic illustrations; an illuminated *Trattato di Matematica* that belonged to one of the first Medicis; a *Historia Naturalis* by Pliny (tenth to eleventh centuries); *Tristano* in an ancient Tuscan translation of the myth from Brittany; a stunningly illuminated psalter dating from the thirteenth century; and the large-format *Biblia Atlantica* from the twelfth century. The library also owns numerous handwritten manuscripts of the great thinkers of the Renaissance such as Pico della Mirandola, Marsilio Ficino, Petrarch, Boccaccio, and the architect Leon Battista Alberti.

One could not truly study the Renaissance, Florence, or the birth of the Italian language without visiting the Riccardiana Library, where researchers and art-history students of all generations can be found. A library conceived for the pleasure of a family, it has become the precious repository of an essential part of European culture. ✐

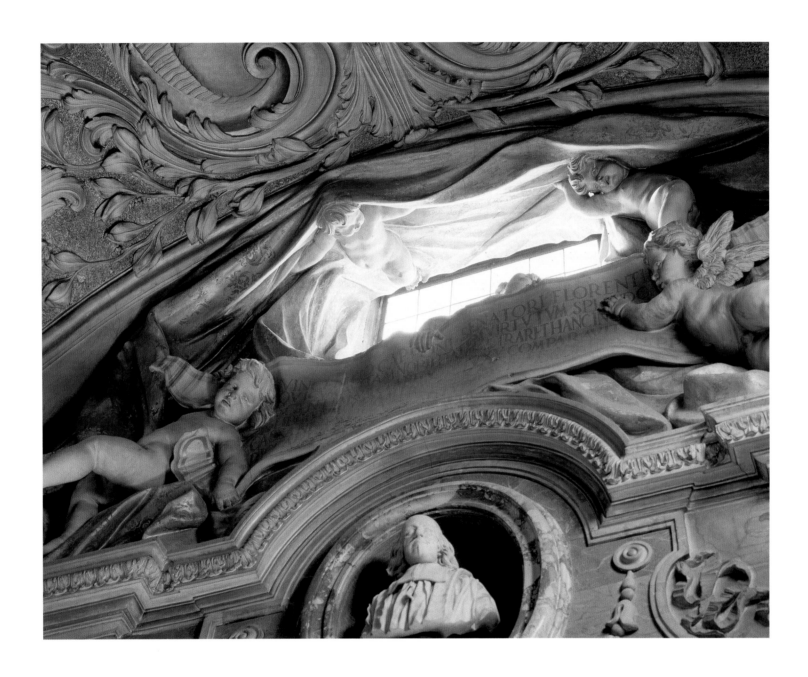

Above: A bust of Vicenzio Capponi by Giovanni Battista Foggini. Capponi, a celebrated intellectual and traveler, who collected more than 5,000 works that he bequeathed to his daughter Cassandra, wife of Francesco Riccardi. This legacy made the Riccardi library one of the most important in Tuscany.

Right: The Giordano ceiling of the reading room. Of Neapolitan origins, Luca Giordano (1632-1705) was one of the painters most respected by the Italian and Spanish aristocracy and clergy at the end of the seventeenth century.

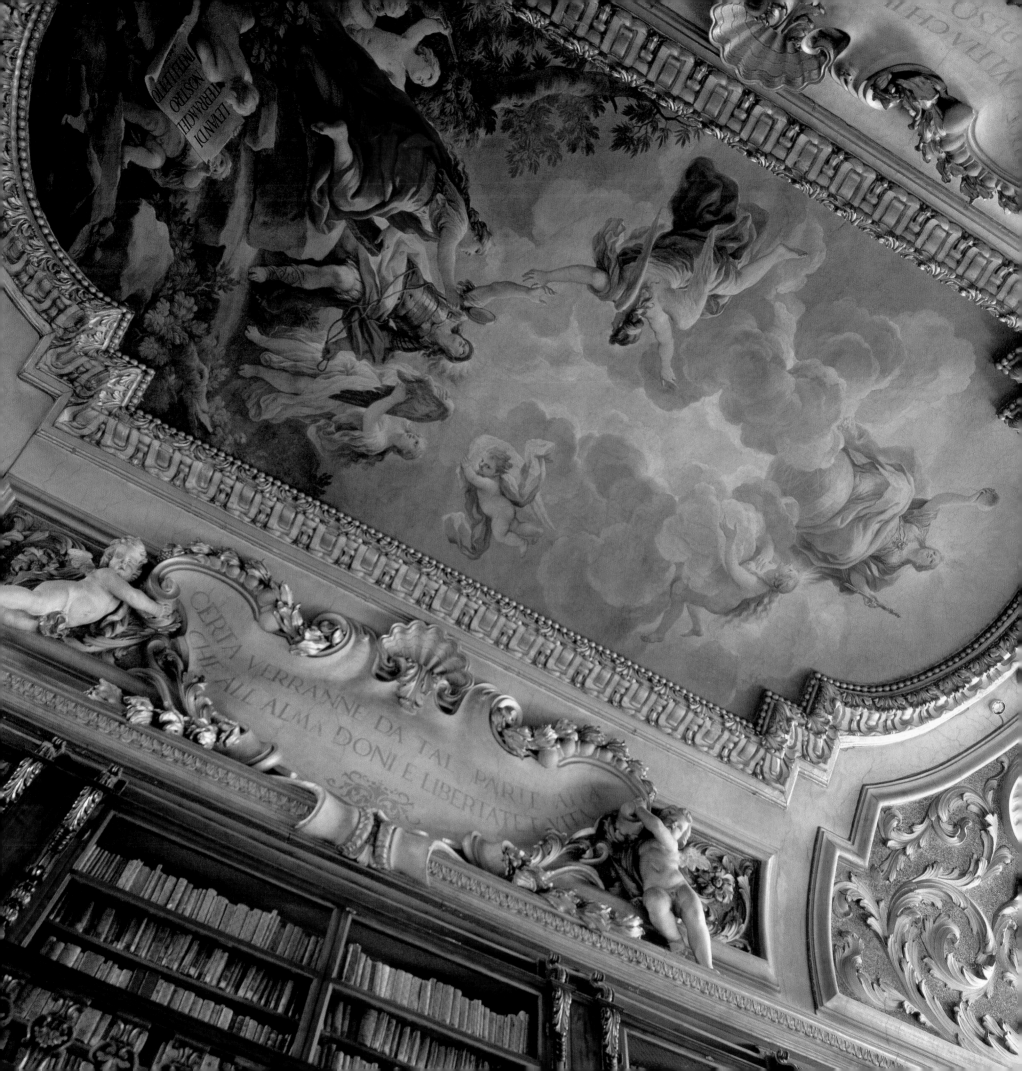

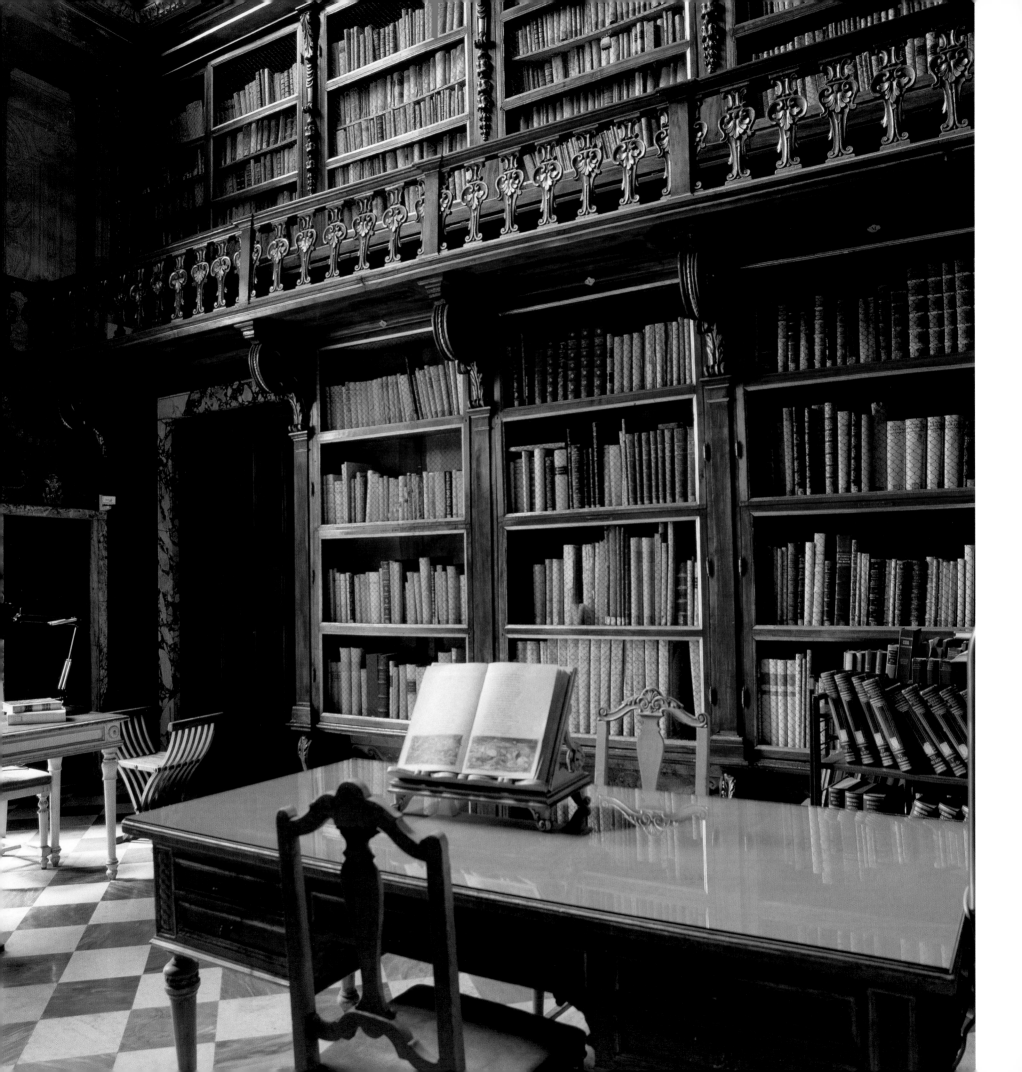

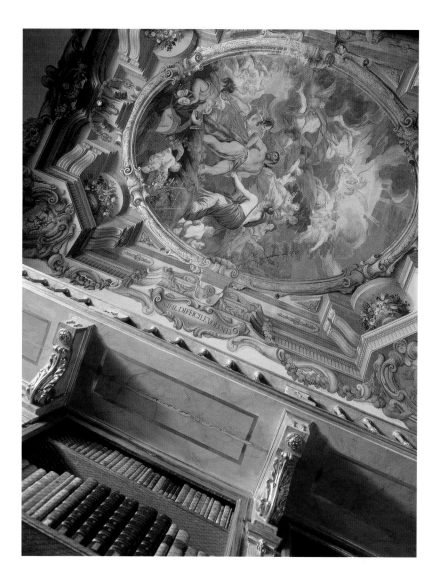

Above: The exhibition hall, an annex to the library, was redecorated in 1786. The ceiling, a work by the Nasini brothers—Giuseppe and Tommaso—
depicts Hercules at the crossroads, confronted by the choice between pleasure and virtue.
Left: The bookshelves at the Riccardiana Library were made from wood chosen by Francesco Riccardi, who kept a close watch on the construction
and decoration of this new wing of the Medici palace specifically built to house his library.

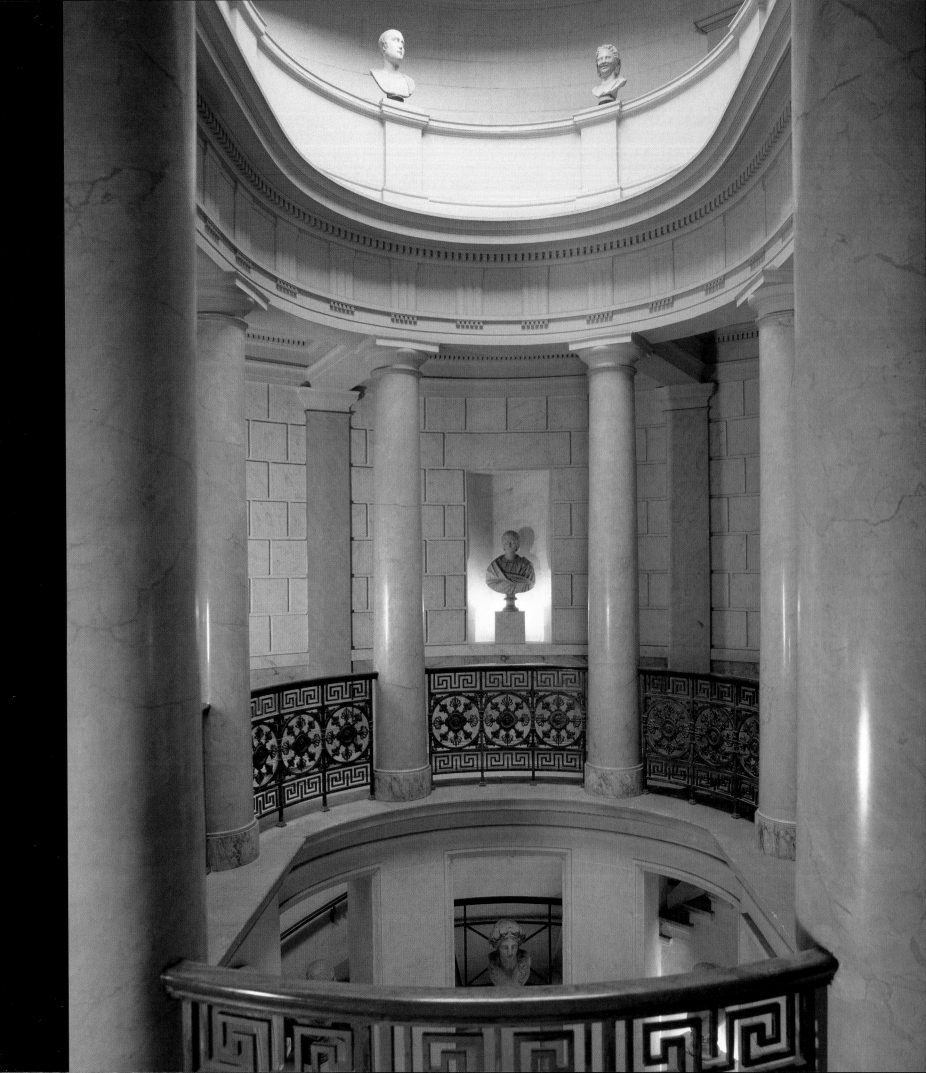

THE MAZARINE LIBRARY

THERE EXISTS NO GREAT LIBRARY WITHOUT A GREAT librarian. Blotius in Vienna, Santa Anna in Mafra, Ambrose Ussher in Dublin, Bodley in Oxford, along with many others gave the institutions in their charge the impetus that enabled them to traverse the centuries in search of universal knowledge. It could be said that Gabriel Naudé (1600–1653), more than his employer Cardinal Mazarin, was the founder of the Mazarine Library. His writings, particularly his *Advice for Forming a Library* (1627), which had great influence in Europe through the eighteenth century, are the roots of modern library science.

Born into a modest Parisian family that nonetheless valued education, Naudé was a brilliant student. With an impressive and precocious erudition, he put his intelligence at the service of reason. He was a libertine in the true philosophical sense of the term. Rather than study theology and pursue an ecclesiastical career, he chose medicine. To finance his studies, at the age of twenty, he became the director of the library of the president of the French parliament, Henri de Mesmes, one of the wealthiest men in Paris. During this period, Naudé also published several short political works, as well as writings on superstitions, which still had a strong influence at the beginning of the seventeenth century. In 1626, he left to pursue his studies at the School of Medicine in Padua. Returning to Paris, he was introduced into the Dupuy brothers' *salons*, where the greatest minds of the time met. He became secretary to Cardinal da Bagno, the nuncio to Paris, then left again for Italy and returned to Paris in 1642 when Mazarin entrusted him with his library. From that point on, he was the "great collector" who crossed France and the rest of Europe in search of books to acquire for the cardinal. He bought, essentially in bulk, private collections and entire libraries. Books piled up in the Hôtel de Clèves and, at great expense, Mazarin readied the Hôtel Rubœuf (found today on rue de Richelieu in Paris) and foresaw a huge gallery to

shelve his acquisitions. Naudé designed the plans for the library, with shelves covering the walls and a circular gallery that could, at some future date store more books. The cardinal, a cultured man, understood that owning a great library could help to secure his power, or as one might say today, his "image." He freely financed Naudé's travels and between 1642 and 1651, Naudé accumulated more than 40,000 volumes, making the Mazarine Library the largest in Europe. At this time, the renowned Bodleian Library in Oxford possessed only 12,000 volumes. It was a novel idea that even though the library was private it was open to the public and Naudé even made a door leading from the street to assure direct access. But then, La Fronde (the 1648–1653 uprising by the aristocracy and the parliament against Mazarin) erupted. Mazarin was exiled, a price was put on his head, and his possessions seized and sold. Naudé actually succeeded in saving several thousand works by having them rebought at public sales using fronts. He also noted down the names of other buyers (one of whom was Christine of Sweden) so he would know where to find his books. Soon thereafter, he left for Sweden to reorganize their royal library, but poorly provided for, decided to return to France. On his return trip, he died in Abbéville in 1653.

When Mazarin returned to power, he went about recovering his library based upon the advice left him by his librarian. He bought back his books and, amusingly, even had courtiers—old and new—come offer him works from his own collection that they had bought at auctions at very low prices.

Gabriel Naudé was one of the first great organizers of a library of modern European cultural history. Very early, and with great precision, he set down his objectives in his *Advice*. He disposed of large funds and, above all, was provided with sustained backing. A lover of fine books, he amassed more than 8,000 volumes for his own library, which Mazarin bought from Naudé's heirs, after having seized the books for security reasons.

The Mazarine Library thus existed before finding its present home on the quai Conti in Paris. On March 6, 1661, three days before his death, the cardinal added a codicil to his will in which he put aside two million francs from his fortune and a capital sum for the construction of a college designated for the youth of poor nobles from the provinces acquired by France during his tenure. This was to become the Collège des Quatre-Nations, within which a library was planned. In 1660, the cardinal had examined plans for a sumptuous temple with a palace and a library that would assure the perpetuity of his book collection, bought and maintained at such great expense. Finally, Colbert, the executor of Mazarin's will, engaged La Vau to build the college that the architect wanted to put up on the ruins of the Nesles gate and the ancient fortifications. At his death in 1670, only the shell of the building had been completed, and the initial two million francs were already spent. It was not until eighteen years later that the institution received its first students. Mazarin's tomb, constructed by Jules Hardouin-Mansart, would not be erected until 1693, thirty-two years after the cardinal's death. In response to the physical constraints of the plot of land, Le Vau conceived the original plan for the Mazarine Library in the form of an "L," and over the centuries the library—except for its ceiling—is practically the only part of the college that has not required modifications. Initially the architect constructed an elegant vault that was replaced in 1739 by a flat, raised ceiling to gain space for books. The oak woodwork on the Corinthian columns, the hammered iron guardrail on the gallery, and even the pedestal shelves are those taken from the Mazarin palace in 1668. Between 1968 and 1974, major renovations were undertaken, including the replacement of the creaky floorboards, which for generations had distracted readers. At regular intervals around the room, fifty busts—in an alternating pattern of marble and bronze—are displayed on pedestals, creating a sort of pantheon.

The collection of the Mazarine Library, some 500,000 volumes, developed over time. Just following the Revolution, the cardinal-minister's 40,000 volumes were doubled. Oddly, the upheaval surrounding the Revolution served to benefit the "Library of the Four Nations" entrusted to Gaspard Michel (known as Leblond), a former abbot who profited from the "revolutionary requisitions." Didn't the State have some 1,600,000 volumes that it did not know what to do with, after confiscating them from monasteries and libraries? In a few years, it managed to recover more than 50,000 additional works. The Mazarine, renowned for its 2,000 manuscripts—which, upon the cardinal's death, Louis XIV confiscated for his own library—reestablished its own collection of ancient books. Today it consists of more than 3,500 volumes and includes a manuscript of the *Roman de la Rose* dating back to the first half of the fourteenth century, a fourteen-volume annotated edition of the Bible, the *Heures* by Charles de France, and many priceless musical scores. A library of high culture, the Mazarine could not retain the universalist calling that the cardinal and Naudé had had in mind. Since 1926, it has developed an area of specialty—regional and local French history—that is very rich, but little known.

Ultimately, the only thing that remains of the fame of this most eminent and reviled cardinal-minister is one of his rare acts of generosity—the creation of his library. ◠

Above: A seventeenth-century globe of the zodiac.

Right: The Mazarine Library is very near the cupola of the Institut de France. Just a few days before his death in 1661,
Cardinal Mazarin amended his will to include the Collège des Quatre-Nations.

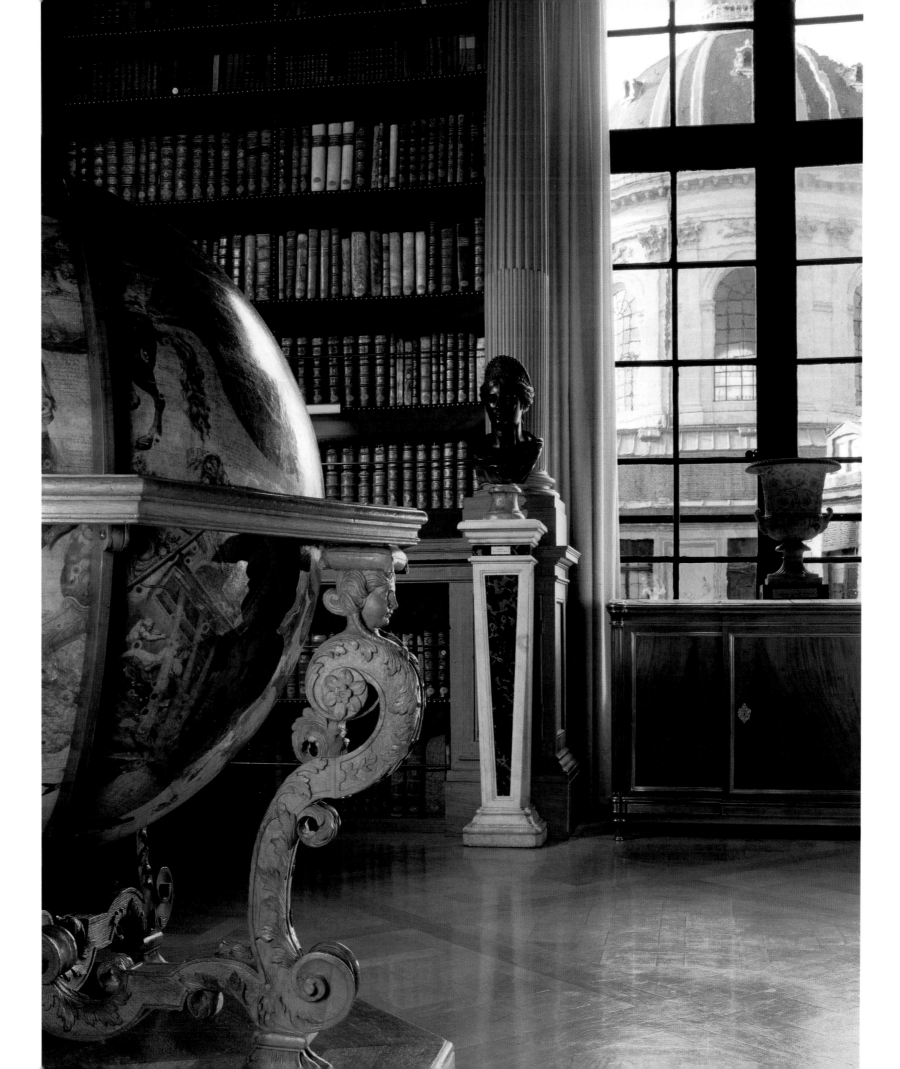

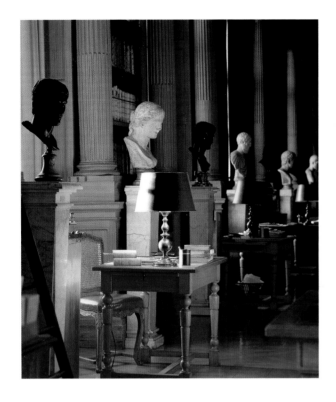

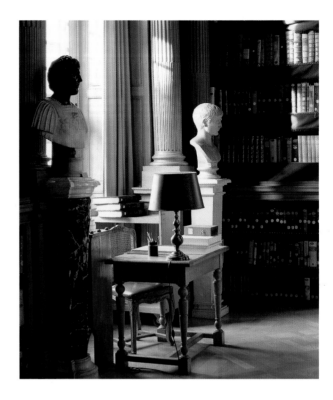

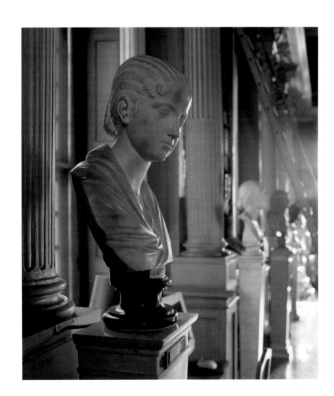

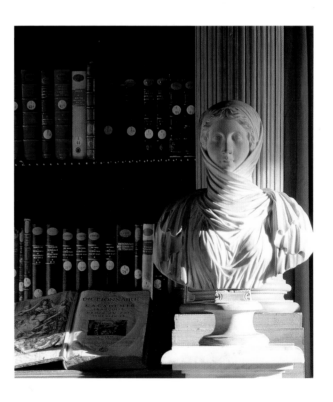

Above: In a charming disorder, fifty busts of poets, philosophers, emperors, scholars, athletes, and conquerors are displayed around the hall.

Right: The extensive modernization undertaken during the 1970s preserved both the scholarly and luxurious atmosphere of the hall.

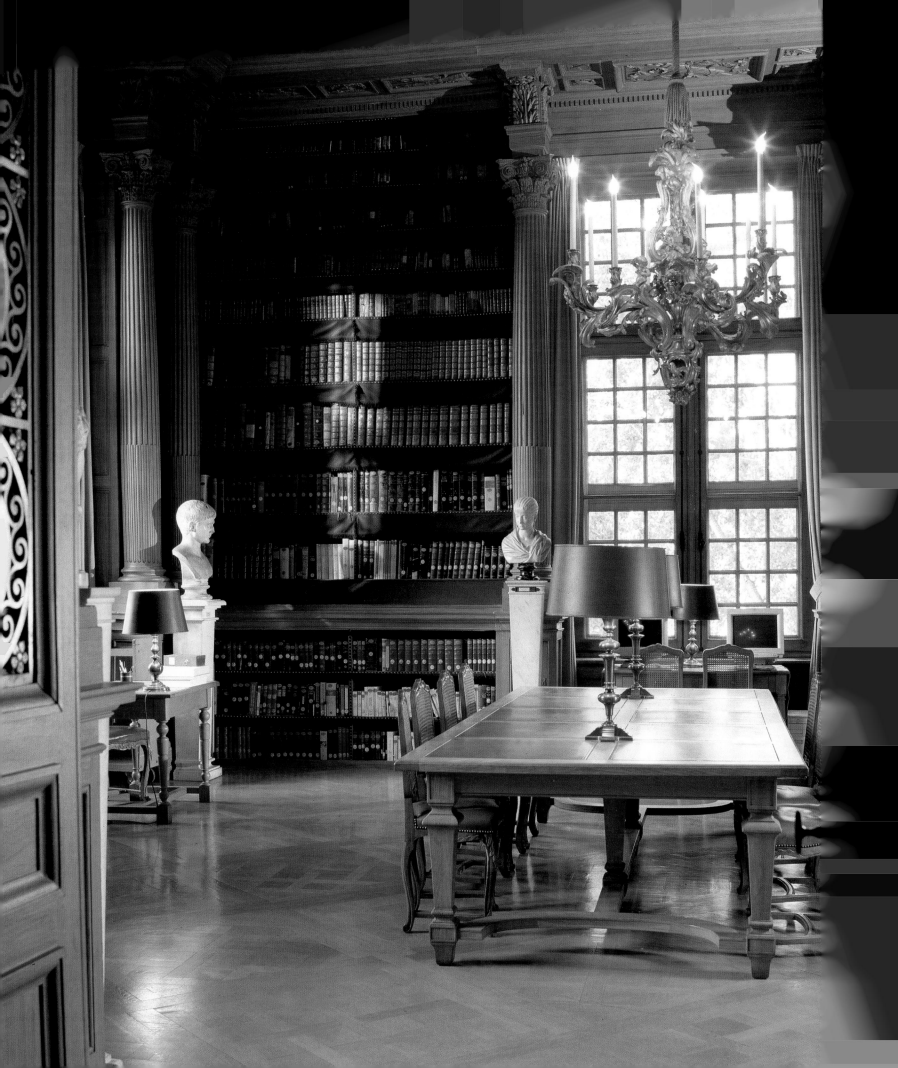

THE INSTITUTE LIBRARY

ONLY A TALL AND BEAUTIFUL DOOR WITH THE cardinal's coat of arms separates the Mazarine Library from the Institute Library, but their entire histories set them apart. The first was the creation of a powerful and cultured man of the seventeenth century who, at the end of his life, wished to make available all the works he had gathered. The second was brought about during the Revolution to serve as a working tool of an encyclopedic and ambitious undertaking—the National Institute.

After abolishing the royal academies ("gangrenes of an incurable aristocracy"), the fathers of the Constitution of Year III did not give them even a posthumous homage when founding the National Institute, which assumed the functions of the academies. On the occasion of the establishment of the Institute Library in what had been Mazarin's Collège des Quatre-Nations, Abbot Grégoire (1750–1831) wrote these fine words: "The wish of the French Constitution, the only one to have formed an establishment for the perfecting of reason, was that genius, as irrepressible as water, uncontrollable as fire, rushed toward all discoveries. Law protects science; science will protect freedom. And by this fortunate concurrence, all useful inventions, all new truths, discerningly and evenly applied, will enlarge all sources of abundance, will enhance the sum of happiness." The National Institute divided the diverse activities of the spirit into "classes," returning to the names of the academies under the Restoration: the Académie Française, the Académie des inscriptions et belles lettres, the Académie des sciences, the Académie des beaux-arts, and the Académie des science morales et politiques.

In 1805 this "parliament of scholars" created the Palace of Fine Arts, which had been the former Collège des Quatre-Nations built in 1662–1667 by Le Vau and transformed into a prison during the Revolution. The coexistence of the Institute and the School of Fine Arts, for which Vaudoyer had made profound changes in the Collège, did not work out and in 1840 the decision was made to move the students to the Petits-Augustins convent a little farther away.

The Institute required a library that would suit its needs and serve as a tool for studies and research, a function that the Mazarine Library could not fulfill. In 1802, a wing formerly occupied by apartments was opened up to its full height and transformed into a gallery 118 ft. long (36 m) to accommodate the Mazarine collection. This peaceful and beautiful space was made into the Institute Library and its layout has changed little since 1805. The bookshelves that cover all the walls of the reading room are in part composed of woodwork taken by Abbot Leblond from the abbey at Saint-Denis, while in the center, placed one after another, are large reading tables dating from 1795. Their massive, griffin-shaped feet were made from papier-mâché to save money, but they have, nonetheless, made it to the twenty-first century in perfect condition. A huge table made from Cuban mahogany and designed by Limone, which was taken from the library at Versailles, stands at the far end of the hall and is used to display new acquisitions. An impressive timepiece crafted by the clockmaker Henri Lepaute towers between two windows. It was once used to toll the change of sessions at the academies. With two dials, it shows both solar and civil times, and the date and year according to both the Gregorian calendar, and the Republican calendar, which was created by Fabre d'Églantine and was used in France between 1793 and 1806. The central tables are primarily occupied by visiting readers (researchers and guests personally recommended by a member of the Institute), while the academy members generally prefer the comfortable small carrels that line one side of the hall and are furnished with armchairs and open shelves filled with books and periodicals.

Today, the Institute Library has 600,000 works consisting of 188 incunabula, 11,500 old and 859 current periodicals, almost 8,000 references for manuscripts, and 553 compendia of handwritten fragments, countless drawings, prints, maps, plans, old photographs, medals and objets d'art, as well as the Lovenjoul collection, which alone contains 1,370 literary manuscripts, 40,000 works, and other items. The building has several annexes, and recently a much vaster space was opened in Marne-la-Vallée (some twenty miles east of Paris) where rarely consulted periodicals have been moved. These figures are certainly impressive for an institution of such great prestige, but their importance is diminished as they are only available to a very small number of people—the members of the five academies. Initially, the National Institute housed the library of the Commune de Paris, which essentially was created from the bequest of Antoine Moriau, a proxy for the king. Later it was considerably expanded by its librarian, Bonamy, and the generous donations of the abbot of Livry. On the eve of the Revolution, it possessed 24,000 works and 2,000 manuscripts. The Institute, moreover, was authorized to stock up from the several stores of "revolutionary acquisitions." This is where it recovered a part of the holdings of the libraries of the royal academies, with the exception of those of the Académie Française, which had disappeared in the upheaval. The collection then quickly grew, due to an extensive purchasing policy, as well as numerous gifts and bequests. Under the Directoire, Napoleon Bonaparte, himself a member of the Institute, donated twelve extraordinary original manuscripts of Leonardo da Vinci (*The Notebooks*) brought back from the sublime library in Milan. The manuscripts concern a variety of subjects such as optics, perspective, geometry, architecture, and painting, and are illustrated with numerous drawings and sketches in the master's hand. Napoleon also presented the library with several charred rolls of valuable papyrus that had been discovered in the Herculaneum and were given to him by the King of Naples. Throughout the entire nineteenth century, and even to the present day, major gifts from academy members, such as the bequest from Duplessis of 5,000 works, or that of the Bolivar library dedicated to South America or Maxime Du Camp's gift of his library, manuscripts, and voluminous correspondence, have poured in. In 1907, the Belgian aristocrat Viscount Charles de Spoelberch de Lovenjoul bequeathed his enormous collection of documents on nineteenth-century literature and writers, notably Honoré de Balzac, George Sand, and Charles-Augustin Sainte-Beuve. In 2000, the daughter of Georges Lubin, who had published twenty-six volumes of George Sand's letters, made a gift to the library of her father's entire archives, which included the famous chronology that, day by day, hour by hour, describes the great author's life. The Institute has become an indispensable venue for those interested in George Sand—a just revenge for one who, being a woman, could not have been elected into the Académie Française. The library's current acquisition policy no longer allows it to be as encyclopedic as it was in 1805. It has focused on the members of the Academy and their works, with a strong leaning toward the humanities, history, the French language, archaeology, and the history of science. It tries to coordinate its activities with those of the Mazarine Library, with which it now maintains an excellent relationship. This has not always been the case, and at one time the door that separates them was walled up.

The Institute Library undoubtedly remains the richest of its kind in the world. It is a protected place where the immortals find themselves in an appropriate serenity with all the academies joined together. Time passes slowly, the noise of the city has been banished, and the discretion of the staff is only surpassed by their competence and availability. The great debates of that past era are somewhat distant from the academies, and the "parliament of scholars" has slowly become the most elegant of clubs. ✐

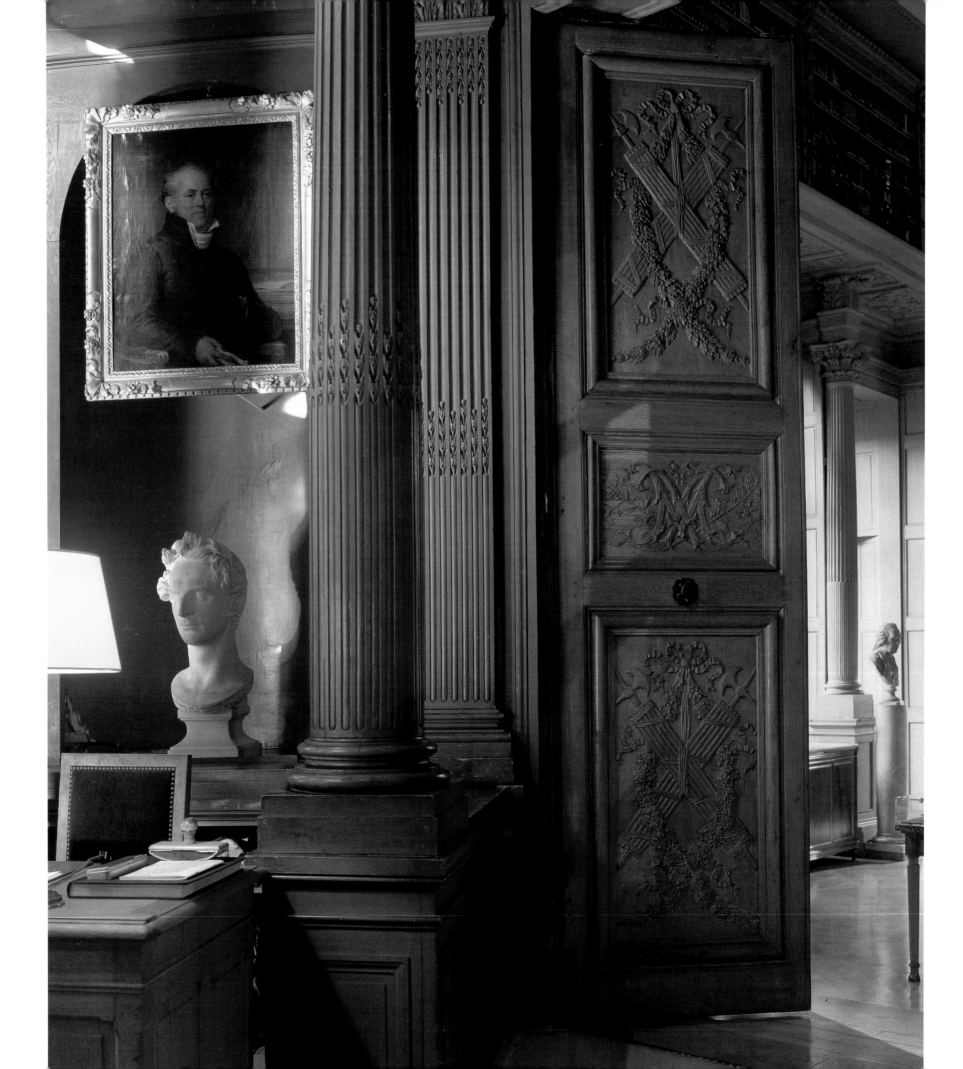

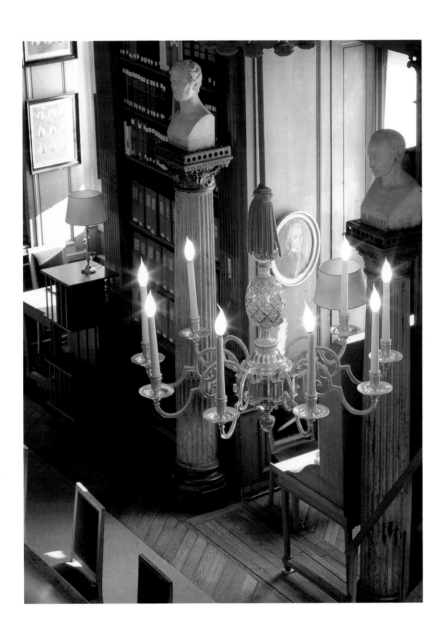

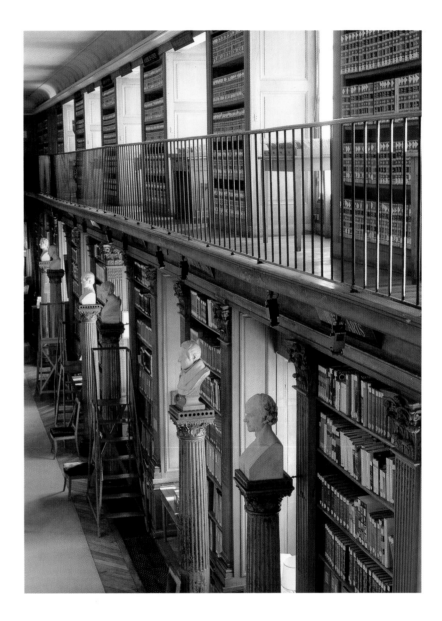

Above: Busts of famous members of the Académie displayed on plinths shaped like columns;
maintaining the ambiance of the great hall and creating the effect of tiers.
Left: The sculpted oak door with Cardinal Mazarin's coat of arms that separates the Library
from the Mazarine Institute. Once, during the nineteenth century, it was walled over.

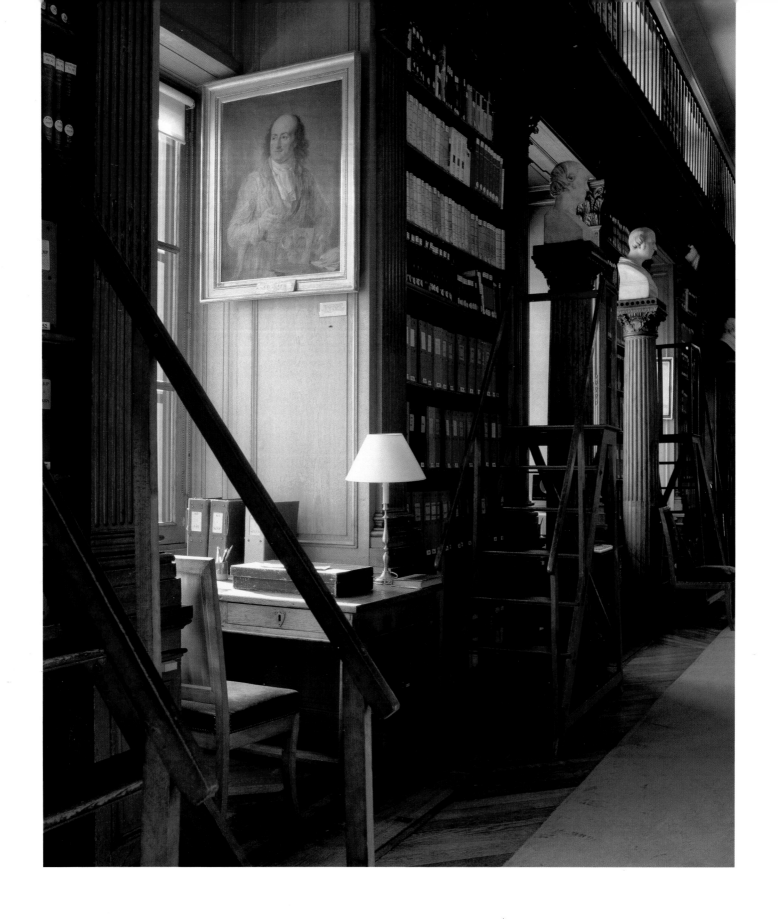

Above: Small carrels furnished with books and periodicals are located in the window embrasures.
Right: One of the large reading tables with griffin-shaped feet made of papier-mâché and finished to appear like bronze.

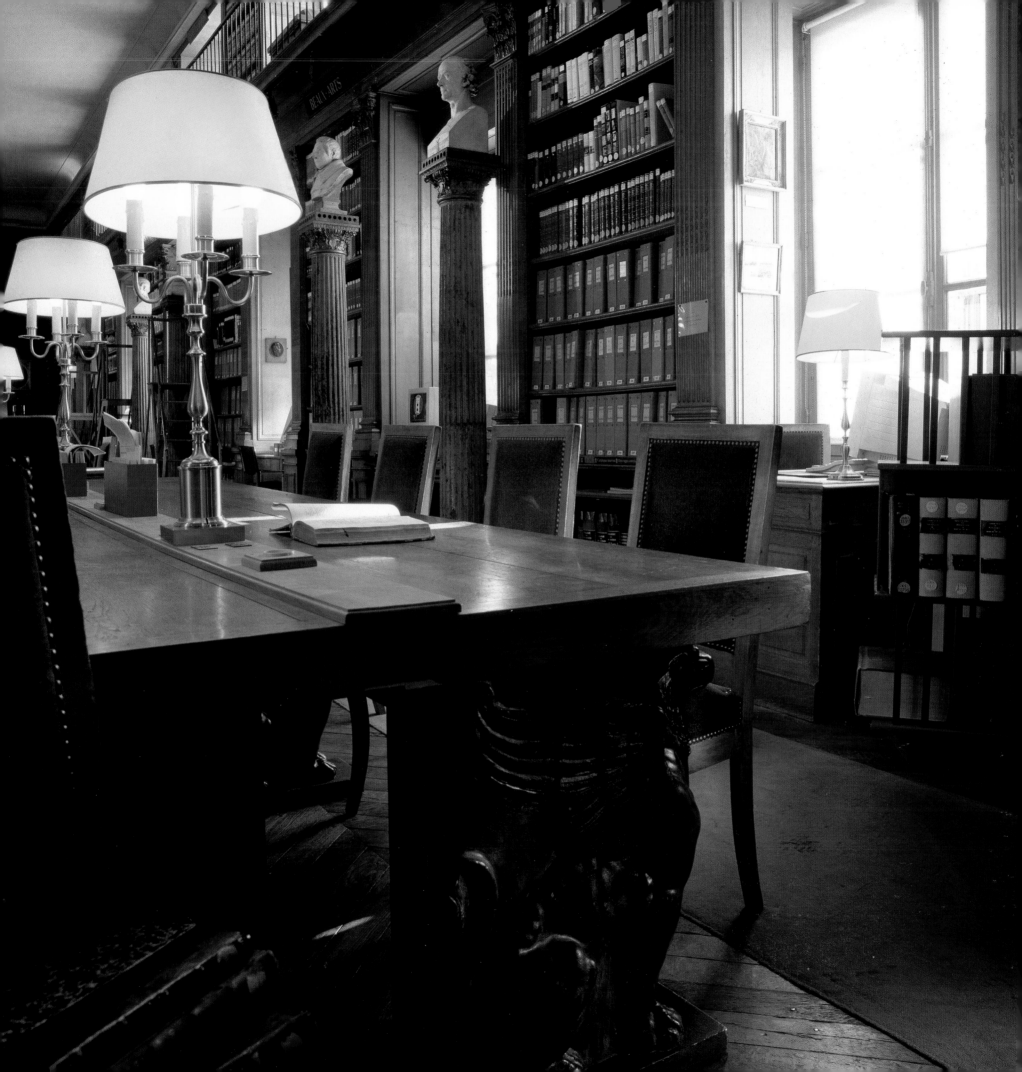

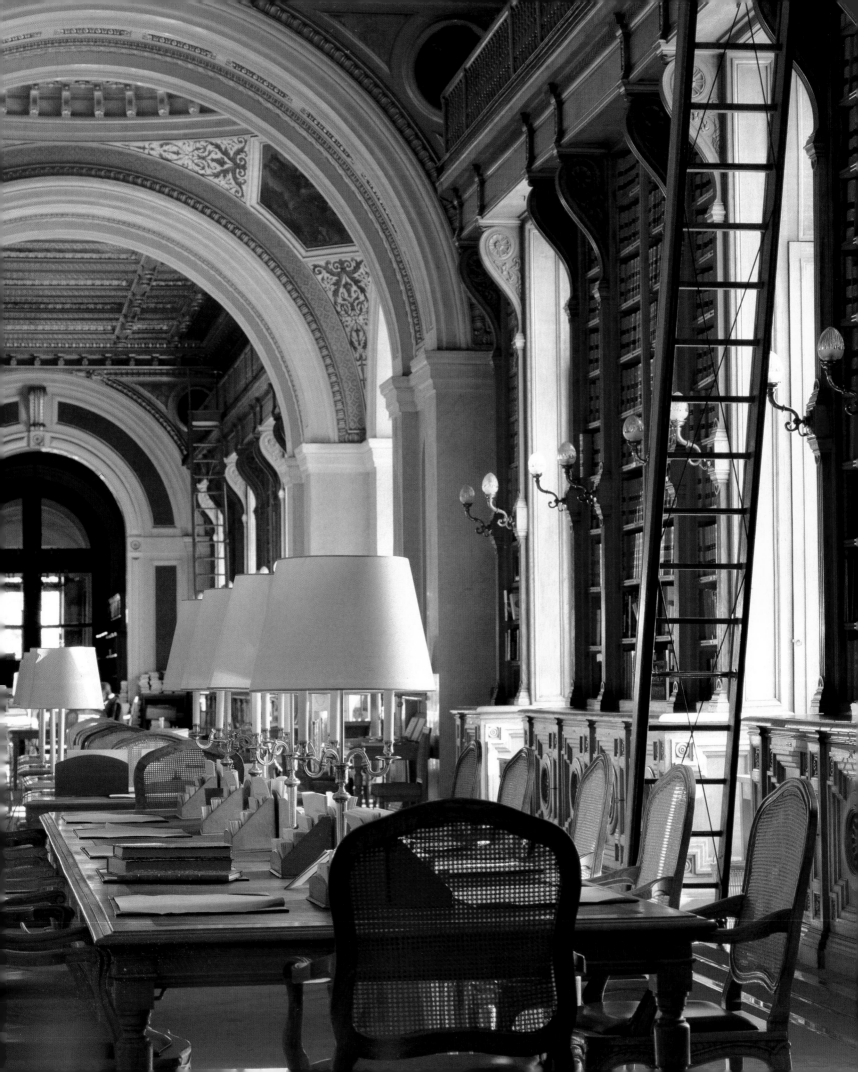

THE SENATE LIBRARY

TO ARRIVE IN THE COURTYARD OF THE ÉTAGE NOBLE (second floor) of the Palais du Luxembourg, one must mount the grand neoclassical central staircase. The library designed by the architect Alphonse de Gisors is located just behind the imposing semicircle girded by a long corridor that is punctuated by an interminable row of coat racks. Not well known—it is for the exclusive use of senators—it does have one of the most beautiful and most comfortable reading rooms in Paris. But if politics has always felt at home within the Luxembourg walls, books have had to fight for their place.

In 1615, Marie de Médicis, widow of Henry IV and regent of the kingdom, decided to build a palace that was more comfortable and better located than the Louvre, which held too many bad memories for her. The Italian queen missed the palaces and villas of her native Tuscany, in particular the Palazzo Pitti, where she grew up. The location that she chose at the edge of the city, on an incline and opening onto what was still almost countryside, resembled the site of the Pitti. The architect Salomon de Brosse (1571–1626) who, both historically and aesthetically, made the bridge between mannerism and classicism, immediately embarked upon the construction of this enormous residence. But the work dragged on longer than projected and in 1624, the queen sent a severe formal demand for work to be finished as quickly as possible. While the architecture is resolutely Tuscan, the design of the grand courtyard is Parisian. In 1625, Marie moved in with her court and collection of art works and paintings. The collection included the celebrated series of twenty-four huge canvases depicting her life, which the rather vain queen commissioned from Rubens in 1621. They now hang in one of the most impressive halls of the Louvre. Frustrated at having been pushed aside by Cardinal Richelieu, the young King Louis XIII's prime minister, the queen made a rather feeble

attempt to regain power. The famous *Journée des Dupes* would end with her permanent exile to Cologne.

The palace remained in the royal family and was periodically occupied by some of its most unruly members, such as the Duchess of Montpensier, the daughter of the regent also known as the *Grande Mademoiselle*; but less colorful members also made it their residence, one of whom was the Count of Provence, later to become King Louis XVIII. Appropriated by the Revolution for use as a prison, it quickly returned to functions more worthy of its magnificence and from that point on, accommodated the parliaments of the Directoire, the Consulate, the Restoration, the Second Empire, and, finally, the Republic.

It was not easy to transform this luxurious palace into the Chamber of Peers, which explains the rather ungainly appearance of the building when seen from the gardens. In fact, very little of the interior decorations from the royal residence remains, save for some exquisite woodwork. The architect Jean Chalgrin (1739–1811) had built a semicircle between the two wings that open onto the gardens. Between 1836 and 1841, Alphonse de Gisors added an avant-corps that links the two new pavilions of the wings and the long gallery intended for the exclusive use of the library. Today the library comprises two huge, separated rooms. The library-reading room faces the gardens, while the annex is in the wing of the palace that opens onto the courtyard. The gallery, which measures approximately 213 by 23 ft. (65 by 7 m), is lit on only one side by seven bay windows. The woodwork, capitaled columns, bookshelves covering the walls, and the twenty-rung movable ladders are all made of a light-color oak that has been polished by time. A few busts and paintings adorn the area between the windows, but the most striking element of the hall is its ceiling, the work of three already renowned artists—the central section is the work of Delacroix; the eastern, Riesner; and the western,

Roquefau. The works of the last two painters, depicting Knowledge, Philosophy, and Wisdom, among other suitable themes, presented a pleasant escape for the reader or senator who, from time to time, dreamily gazed toward the infinity of the laws. On the other hand, Delacroix executed two major pieces that took five years of his life to create. The first defines the central entrance of the library which is beneath a cupola 23 ft. in diameter and 11½ ft. high (7 m in diameter and 3.5 m high), decorated with this painting inspired by the fourth canto of Dante's *Inferno*. "It is a place in Elysium where great men are gathered who have not received the grace of baptism." One can only imagine how the painter succeeded in defending such a subject before an official commission, but the reference to Dante and Elysium undoubtedly led to the decision. In the archivolt above the central bay window, he depicted a theme more appropriate to a library. "Alexander placing the poems of Homer in a golden chest that belonged to Darius." A series of medallions symbolizes the desired presence in these premises of Philosophy, Eloquence, Poetry, and Science. The style is innovative, with neither depth nor relief. The colors are luminous, almost sharp. Here the painter started to put into practice what he had written about in his journal: "[. . .] to produce shaded tones by straightforward and transparent tones." He used a recipe for copal varnish learned from Bonington that allowed him to work with the speed of a fresco painter. These two brilliant works are almost shocking when compared with the neighboring works by his timid colleagues.

The second hall of the library truly does not deserve to be called an annex, since an annex is rarely so sumptuous. The residence of the *Grande Mademoiselle* until 1750, when it was transformed into a museum for some hundred paintings from the Offices of the King, it became the first public museum in Europe and was open to visitors two days a week. In 1780, the Count of Provence closed

it so he could keep the use of the gallery for himself. The museum was reopened, however, under the Empire. Its vaulted ceiling is decorated with vibrant allegorical panels of the twelve signs of the zodiac painted by Jordaens (1593–1678) and mounted within a grisaille discreetly altered many times to adapt to the monogram and the coat of arms currently in power. In 1886, the Senate took over the annex to use as an extension for its library, which today houses rare and historic works, one of which is a splendid *Description de l'Égypte* stamped by Morel and given to the Chamber of Peers by Louis-Philippe.

The history of the library is intertwined with that of the palace; particularly in its function as the meeting place of the Parliamentary Assembly. From the year VIII (1800), the Senate of the Consulate decided to provide itself with an indispensable research tool. The collection would be drawn from the one at the Arsenal, and to compensate, the senators promised free access to the public on certain days of the week. The project got mired down, the senators became impatient and settled for a temporary library of a small number of books taken from several reserves in Paris that were often the fruits of revolutionary "requisitions." The buying policy was rather muddled. Among the hundreds of volumes reflecting the senators' interests but bearing little relationship to their debates is a book on Neapolitan flora bought in 1820, and another on Gothic and Roman monuments in Vienna bought in 1829. In 1830, the collection consisted of 11,000 volumes and was catalogued according to the Brunet system, which separated works into five sections—A: Theology; B: Law; C: Science; D: Letters; and E: History (with additional subcategories). Essentially designed for a modest library, this system quickly became unsuitable for an institution that was continually growing richer. Under the Third Republic, it was converted to a numbering system that was not

particularly scientific, but quite practical and remains in use today. The library's collection was enriched by the bequests of senators among whom a friendly and generous competitive spirit developed. In 1821, the Count of Morel-Vindé donated a magnificent set of maps and plans that are kept in specially built cabinets. In addition, entire collections were acquired, such as the one from Pixérécourt in 1840 on the Revolution (poems, songs, plays, and engravings from the period) and the celebrated Duprat-Taxis Compendium, a compilation by a genealogist of a mass of information, as precise as it is disturbing, that concerns "the new French peerage after the Charter decreed by ordinance on August 25, 1817." These revelations on the nobility of the Empire and the political pliability of the aristocrats created such a scathing attack that the great referendum of the Chamber of Peers bought the document and buried it deep in its coffers. By chance, however, it was found in 1887.

Today the Senate Library, which also administers the institution's archives and conducts research and documentation for the senators, possesses more than 450,000 volumes and 1,300 manuscripts and receives more than 700 periodicals. Its collection is understandably centered on parliamentary activities. Works on jurisprudence and economy comprise a major portion of its acqui-

sitions, which, nevertheless, have quite closely followed the careers and writings of the members of the upper assembly since its inception. Chateaubriand, Monge, Chaptal, Hugo, Ingres, Sainte-Beuve, Mérimée, Littré, Poincaré, and Clemenceau are among the many famous names that, at one time or another, have sat in the halls of the Luxembourg Palace.

In a muffled silence, the Senate employees manage this vast, primarily private library. It is rather empty when the Senate is not in session, but more lively when senators come to consult their sources between meetings. There was a time when the job of librarian at the Senate was offered to men of letters at a modest stipend. Around 1880, the poets Leconte de Lisle and Lacaussade "the perfect notary of poetry," who hated one another and let it be known, worked there, as well as Ratisbonne, whose only function was to register new acquisitions. But above all, there was Anatole France, who was a simple clerk to whom the three others delegated their tasks. Following his first success as a writer, Anatole France quit his position, his "six steres of wood, six hundred kilos of coal, and eighteen kilos of oil" and fled to the Académie Française with its dream library. ᴄᴇ

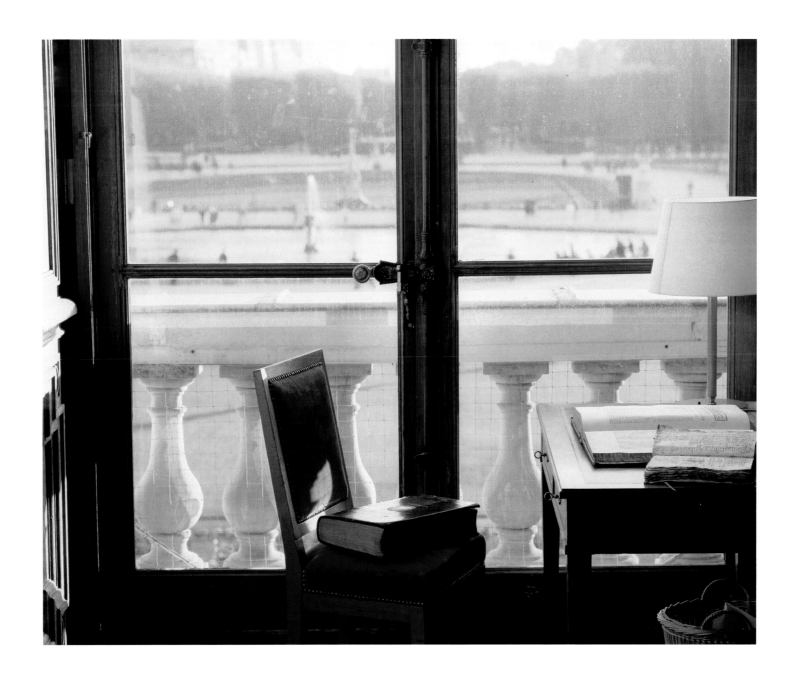

Located in an avant-corps built from 1836 to 1841, the library of what was then the Chamber of Peers overlooks the Luxembourg Gardens through seven huge bay windows.

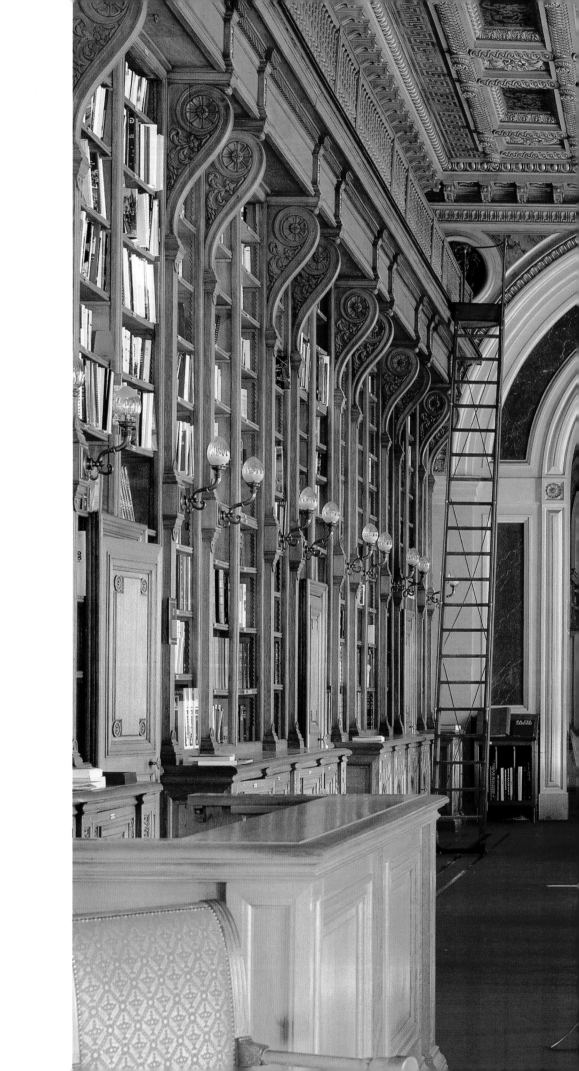

*Although the architectural style of the grand reading room is neoclassical in inspiration,
its coffered ceiling harkens back to the classical, Italianate palace of Marie de Médicis.*

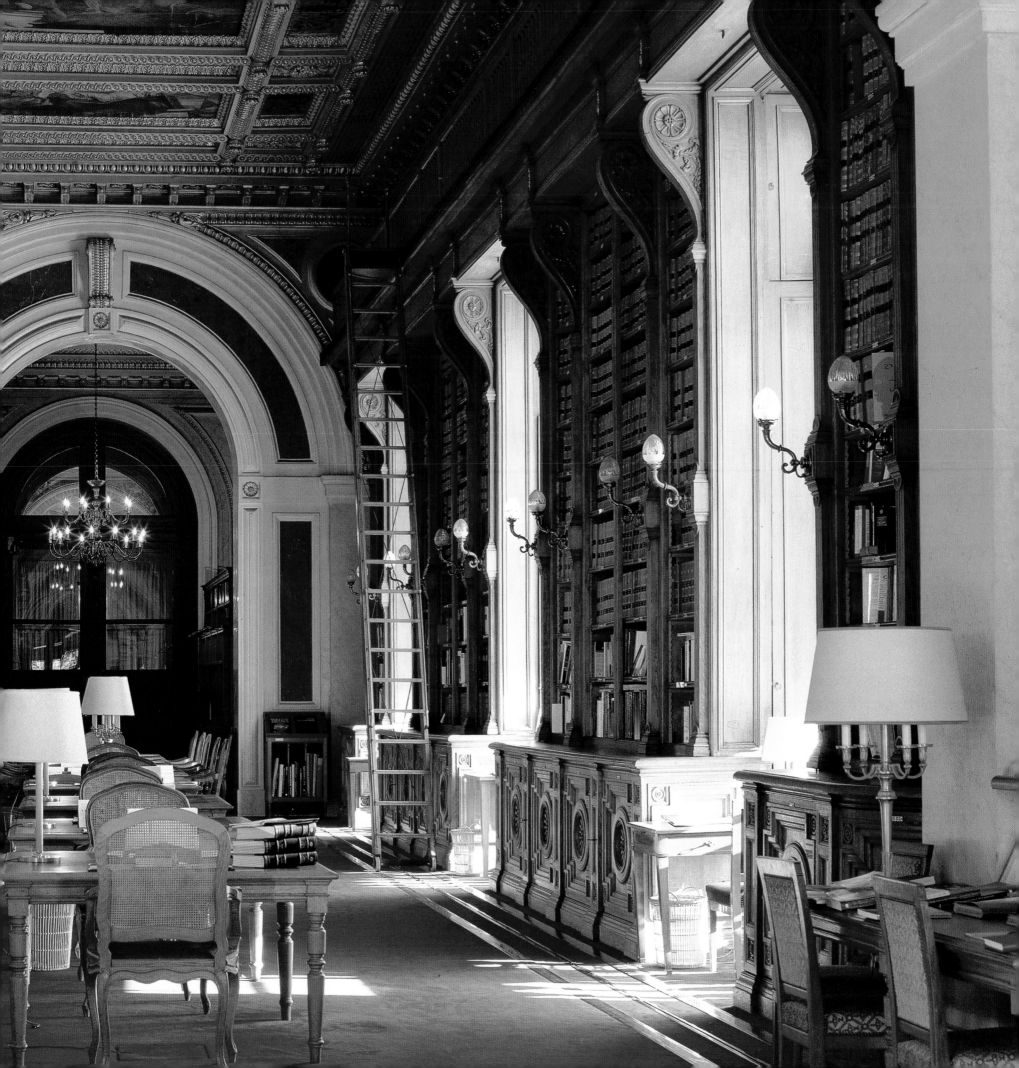

Above: A nineteenth-century card catalogue that has been replaced by computers.

Right: L'Histoire, *a neoclassical marble statue by Antoine Desbœuf (1793–1862), was commissioned by the Minister of the Interior
in 1840 and presented in 1842 after its exhibition at the Salon that same year (registered number 1922).*

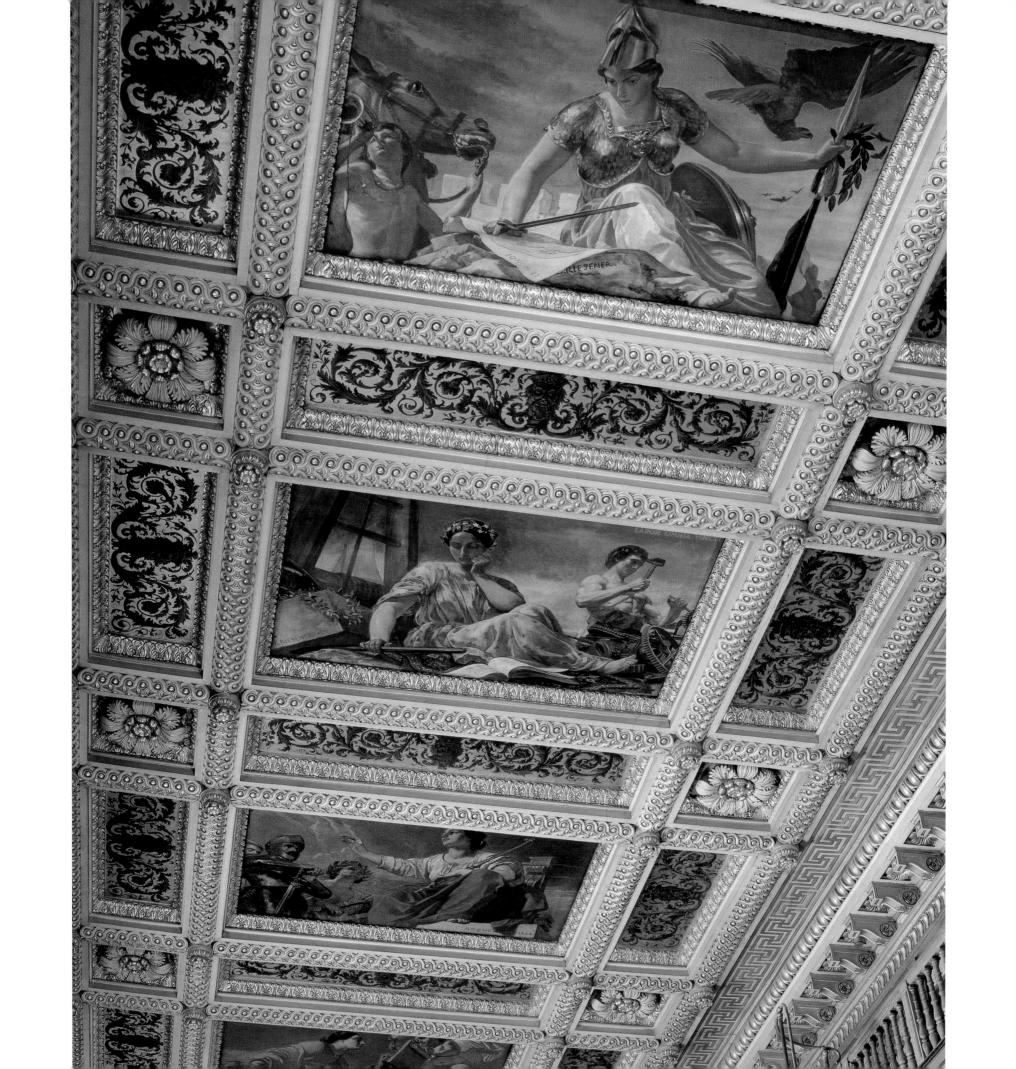

Above: The cupola at the entrance of the library was entrusted to Eugène Delacroix who painted there "a kind of Elysium where great men are gathered who have not received the grace of baptism."

Left: The allegorical ceiling painted by Léon Riesener (1808–1878), a close cousin of Delacroix.

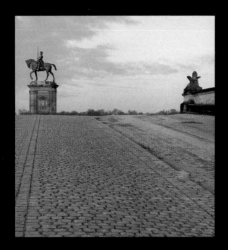

THE CABINET DES LIVRES OF THE DUC D'AUMALE

ONE CANNOT STUDY THE HISTORY AND DEVELOP-ment of manuscripts, illuminated works, incunabula, and prints without spending long hours in the National Library of France, the Vatican, Trinity College, and the great libraries of American universities. But the bibliophile pushes a love for books far beyond admiring and consulting them. Those who truly love them want to possess them—the drama of the aficionado of beautiful books forced to scour bookstores and auction houses trying to find what has evaded his rivals. Henri Eugène Philippe Louis d'Orléans (1822–1897), Duc d'Aumale, son of Louis-Philippe as well as conqueror and brief governor of Algeria, was one of the greatest bibliophiles of the nineteenth century. In the first plans for his dream château, which he intended to build in Chantilly, it was the library that occupied the central space.

This prince, whose motto was "I shall wait," lived an unusual life and spent twenty-six years in exile. Intelligent, cultivated, an excellent military man, at one time he could even have aspired to take the crown when French society, destabilized by the fall of the Second Empire, was unsure what authority it should support. The ideological divisions and the inflexibility of the monarchists prevented a second restoration, and the Duc d'Aumale, "an ambitious man without daring," (Jules Richard in *Le Gaulois*, October 7, 1873) returned to exile and from then on only awaited the end to an existence he could have better filled. Chantilly and bibliophilia were, without question, first the pastime and then the passion that enabled him to forget the vicissitudes of history. The Duc d'Aumale had lived through the same forced renunciation in 1848, when Louis-Philippe and his family had to flee France for England. Returning too soon from Algeria, at twenty-six years old he found himself idle. In 1830, at eighteen years of age, he inherited the entire estate of his godfather, Prince Louis de Bourbon-Condé, which had been confiscated during the Revolution but

then returned in 1814, making him a very wealthy man. In 1850, upon the death of Louis-Philippe, he added a part of the Orléans estate to his vast fortune, which his marriage to Marie-Caroline de Bourbon-Sicile only increased with properties in Sicily. Thus, while in England, he led the life of an aristocrat, entertained often, hunted, and discovered bibliophilia. In fact, he had inherited the celebrated library and archives of the Duc de Bourbon who, himself, had incorporated those of Montmorency and Condé. Despite the many "requisitions" of the Revolution, 800 manuscripts were saved. Passionate about history, the Duc d'Aumale had them all sent to England and offered to write the catalogue for the Condé library. Although he never completed this long project, it succeeded in creating in this cultivated man a deeper interest in books and a taste for bibliophilia.

The nineteenth century remains one of the greatest periods in the history of bibliophilia. The Revolution broke up many libraries, in the best cases "requisitioning" them, but far more often getting them at very low prices or indeed, through pillaging. The market, i.e., booksellers and auction houses, was flooded with rare works in the finest condition, which the astute aficionado could buy. The passion for books, which to this point had been a privilege of noble families, booksellers, and printers, spread. In 1810, Jacques-Charles Brunet issued the *Manual of Booksellers and Book Lovers*, which would be rewritten and expanded several times and serve as a guide for aficionados during the entire nineteenth century. Prices quickly increased and the rarest manuscripts became the objects of mad battles between the great collectors, the likes of Prince Anatole Demidoff, Lord Hertford (the future Wallace Collection), and the Duc d'Aumale. The century was punctuated by some great auctions and direct purchases from needy heirs. These sales included the 1849 Howe sale in London, as well as the Baudelocque, Clinchamp,

and Standish sale that the Duc d'Aumale bought en bloc (2,500 volumes), and the Cigongne sale (2,910 items), which the duke also bought for 375,000 francs. From England he sent brokers across all of Europe and in 1856 Panizzi, the librarian of the British Museum, informed him of the existence of a rare manuscript in Genoa. One month later, into his possession came the crowning jewel of his library—the *Très Riches Heures* of the Duc de Berry. In 1891 he learned that the Lignac family wanted to part with a prayer book that had belonged to Saint Louis. It was the Psalter of Ingeburg of Denmark, a thirteenth-century masterpiece. Not long before his death, the duke acquired the Breviary of Jeanne d'Évreux, a superb and perfectly preserved manuscript, and the plates by Jean Fouquet, which he had cut for the *Book of Hours* of Étienne Chevalier, a fifteenth-century treasurer of France. At his death, his collection comprised—and still comprises—1,600 manuscripts, 12,500 printed books dating from the fifteenth through nineteenth centuries, almost 30,000 other printed works of the nineteenth century, to which would be added thousands of diverse books, as well as two other collections bequeathed to Chantilly, and numerous periodicals.

The prince had a wide range of interests: literature, first and foremost, as well as history (often tied to the Condé's and his own family), poetry, philosophy, theology, geography, and science. He wrote a card about each of his purchases; however, the entry for the *Très Riches Heures* became a thirteen-page essay in which he not only recounted its acquisition, but also the history of the work itself. These notes constitute an invaluable mine of information for the contemporary bibliophile that to this day has not been fully exploited. The duke was also an aesthete, as is evidenced by his marvelous collection of paintings and sculptures, and his incessant search throughout Europe to gather the most beautiful pieces for the collection that is now in Chantilly. He was very sensitive to the quality of the bookbinding, and his library illustrates the evo-

lution of this art from the twelfth to the eighteenth centuries. He looked for fine examples, but did not hesitate to rebind a volume if he deemed it necessary. The duke employed the best bookbinders in Paris and London, such as Bauzonnet, Trautsz, Cappé, and Duru, who created original designs for him inspired by the bindings dating from the period of the work.

Bibliophilia is an expensive passion and a great devourer of space if one practices it on a princely scale. His residence, the Orléans House in Twickenham, was soon invaded by his massive purchases. When he made plans to return to Chantilly with its reconstruction in mind, he decided very early on to include a library in his future château to replace that of the Duc de Bourbon-Condé, which was small and uncomfortable. In the restoration project that he presented to Félix Duban (1797–1870), an architect of royal and aristocratic châteaux, the library occupied a central place, and in the final reconstruction plans by Honoré Daumet (1826–1911), a student of Duban and a renowned historicist, two libraries were proposed, and two created—the Cabinet des Livres du Prince and the Bibliothèque du Théâtre, or the modern library used primarily for conservation.

For the aficionado, the Cabinet des Livres du Prince is a magical place. Its architecture is of a great sobriety, in the spirit of Labrouste and the great public libraries then under construction in Paris, i.e., a "modern" style using new techniques. The construction of the shelving and doors of the glass cases is completely metal, whether of iron, cast iron, or metal plate covered in leather so as not to damage the precious bindings. The interior sides of the doors that lead into the room are covered in *faux* book spines, all with titles of lost Greek and Latin works. When the doors are closed, the room appears to be entirely covered in books. The access leading to the upper section is also constructed of metal and its railing is furnished with lecterns that instantly open up. Hidden in the floorboards of this

access ramp are rolls of geographical maps that have been affixed to canvas and can be unfurled to protect the bindings from the sun that pours in through four huge bay windows overlooking the gardens and fountains. There are two large desk-tables in the center for consulting the works, one of which is even equipped with a lectern that is activated by a hidden handle. The prince enjoyed receiving his collaborators and bibliophile friends at the far end of the library where comfortable armchairs, also furnished with lecterns, were arranged in front of a small fireplace over which a bust of the Grand Condé by Coysevox presided. The arrangement of the books according to their bindings (format, period, color) generates a feeling of riches and luxury. Who would not be transported by the love of books in such an atmosphere?

The Bibliothèque du Théâtre is located nearby. Its name is a reminder that the library was constructed in 1888 on the site of the old Bourbon-Condé Theater. It holds thousands of volumes, which are, for the most part, less rare and less valuable than those in the prince's Cabinet, but still a treat for any contemporary bibliophile. In the center there are shelves for the prince's collection of draw-

ings, conserved in large cardboard boxes with red spines. The duke was also interested in the art of drawing and owned, among other treasures, more than 300 works of Poussin. Researchers have easy access to the collection and a small, charming room overlooking the fountains has been reserved for their use. One scours through catalogues—partly computerized, partly still handwritten—beneath the prince's hunting trophies.

In the deeds that conferred guardianship of the estate of Chantilly to the Institut de France in 1884 and 1886, the duke, a member of the Académie Française, specified that nothing must ever leave the château. Thus his treasures are never lent, which explains why they are not well known. These wonderful collections of books, paintings, sculptures, glassworks, objects, and photographs, among the most prestigious from the nineteenth century, tranquilly rest in a state of perfect conservation. They wait, as the prince had during his lifetime, but, nevertheless, remain the most refined illustrations of a peaceable passion—the love of books, which is also a passion for the history of our culture. ✐

The base of a sculpted bronze oil lamp created for the reading room.

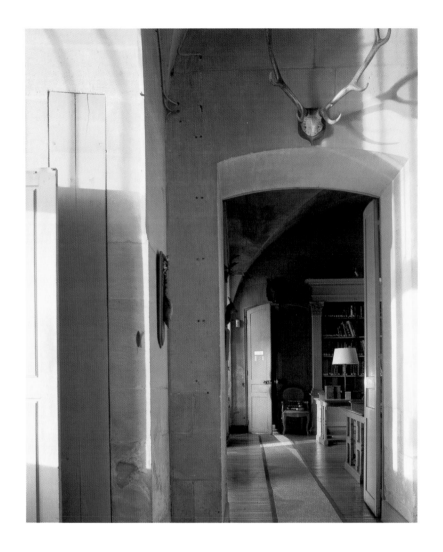

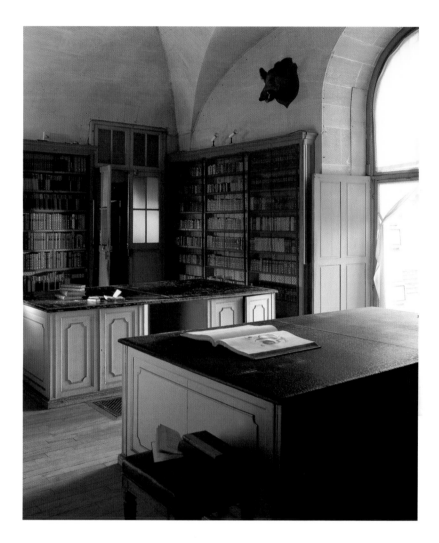

Above: The small room overlooking the park where researchers come today to consult the library's works.

Right: Valuable ancient maps and engravings are displayed in glass cases that are protected from sunlight by rolls of canvas.

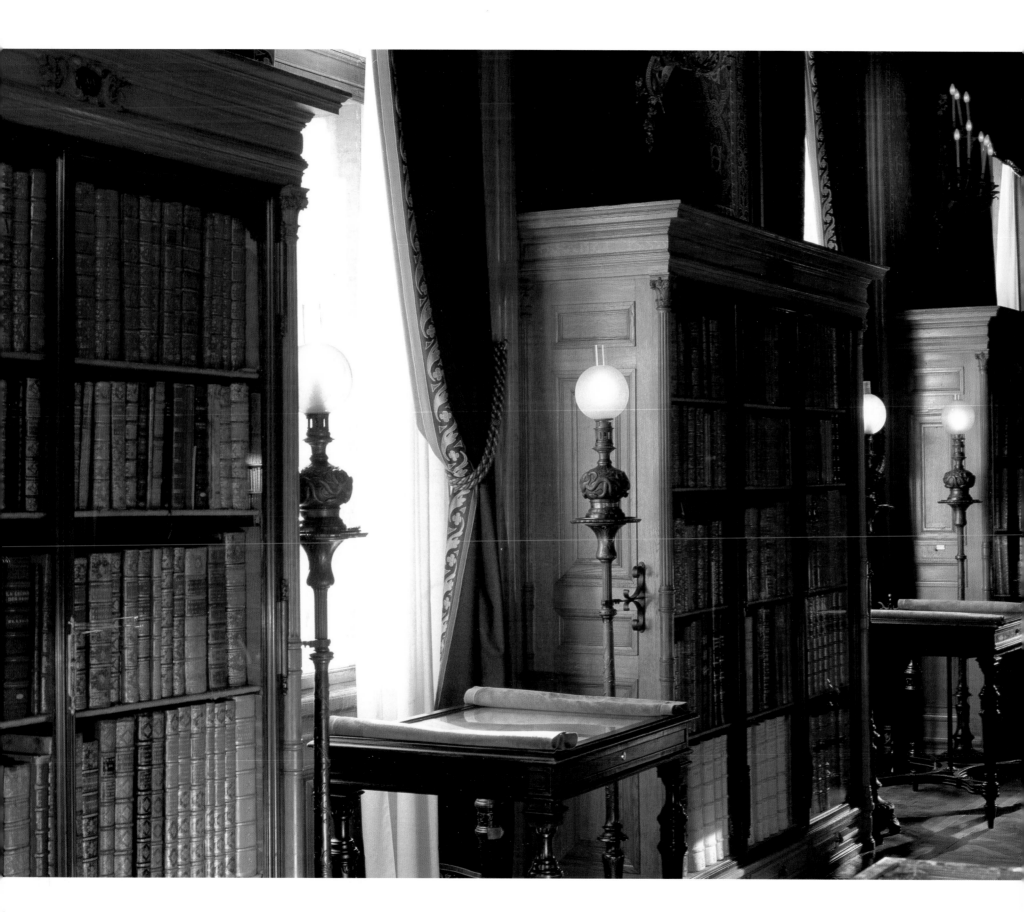

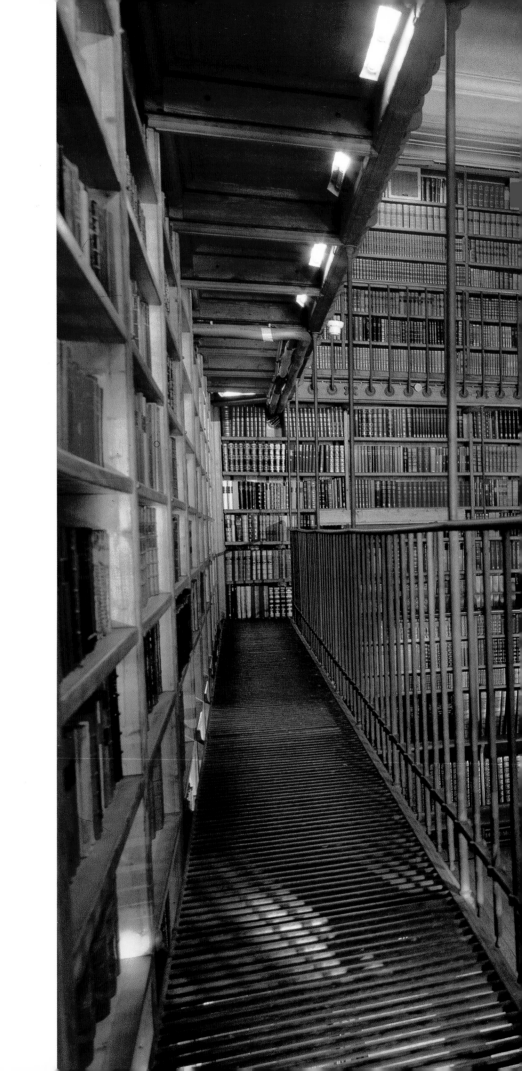

The modern library, installed by the duke in the former theater, where primarily drawings, maps, and "modern" books are kept. In the foreground, a cabinet that holds drawings by François Clouet, Nicolas Poussin, and many important artists of the Italian Renaissance.

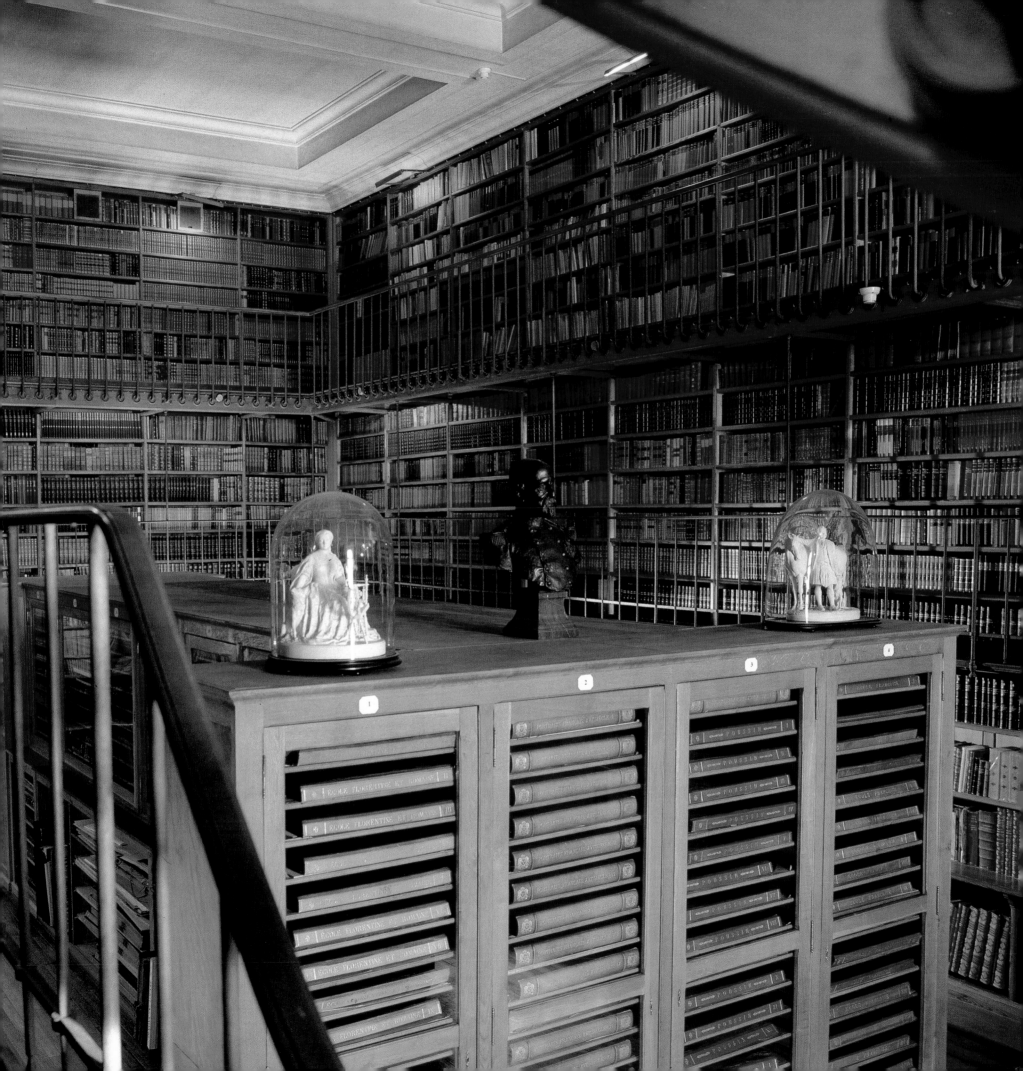

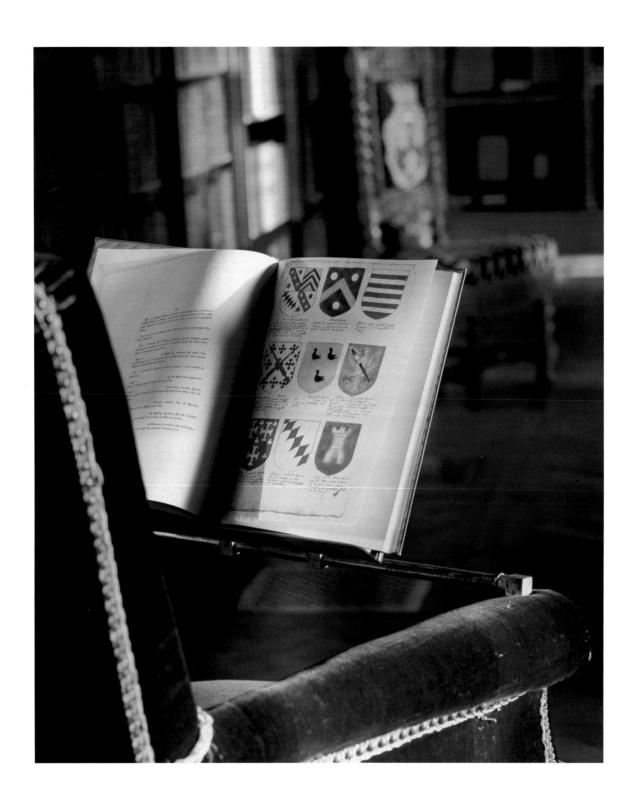

Above: One of the duke's armchairs equipped with a movable lectern.
Right: At the far end of the Cabinet near the fireplace where the duke enjoyed consulting the works of his collection
and receiving his bibliophile friends. Above the mantle, a bust by Coysevox of the Grand Condé.

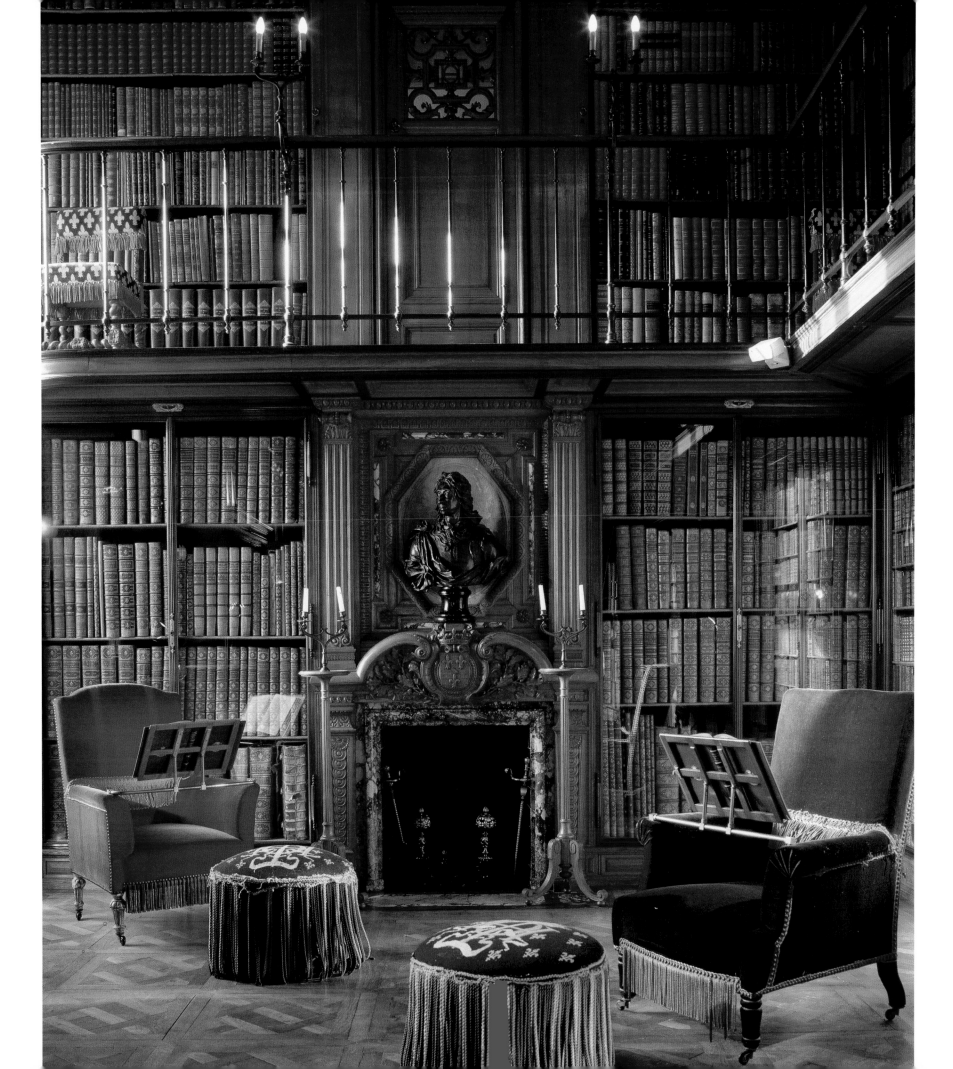

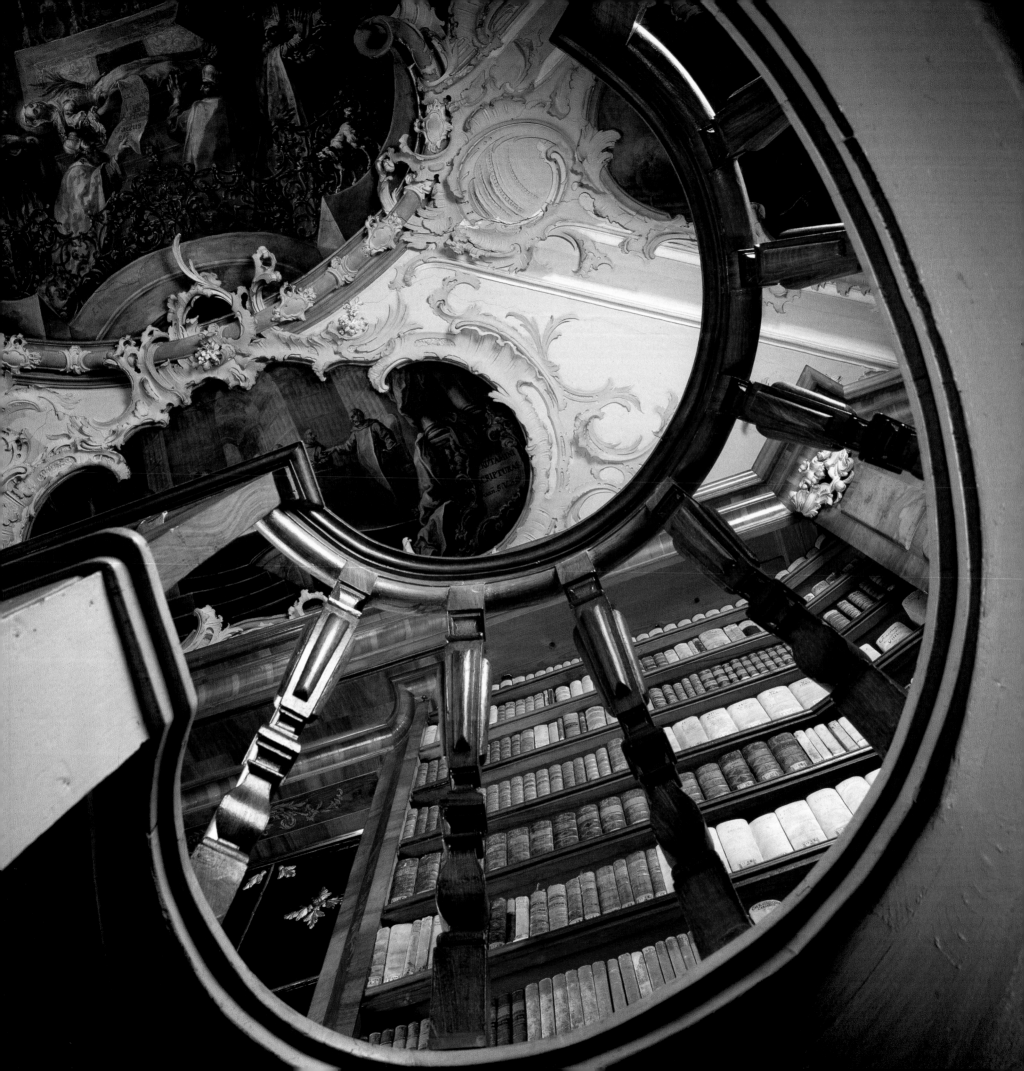

THE ABBEY LIBRARY OF SAINT GALL

THE HISTORY OF THE GREAT MONASTIC LIBRARIES is also the history of European culture. What is known of the foundation of the Benedictine abbey of Saint Gall near Lake Constance and the first centuries of its existence sheds light, in particular, on the rather obscure period that separates the slow collapse of the Roman Empire and the formation of the Carolingian Empire.

Gall—also called Gallus, Gallon, Gallonus, Gallunus, Callo, Chelleh, and Gillianus (complicating the task of the historian)— was part of the work of Columbanus, a noble Irishman who left his island in order to evangelize throughout the pagan continent. After founding the Abbey of Luxeuil, the future Saint Columbanus pursued his missionary work, continuing on to southern Germany, Switzerland, and Italy. Arriving with him in the Bregenz region in 612, Gall decided to stay and withdrew into a deserted area near the source of the Steinach River. When he died in 646 he was recognized as a saint and the residents of the area built a church on the site of his retreat. Charles Martel assigned a priest, Othmar, to look after the holy relics and, with the help and protection of Pépin le Bref, Othmar soon founded a monastery, replacing the rule of Saint Columbanus with that of Saint Benedict. From the start, or very soon thereafter, Othmar installed a scriptorium and began to collect books and opened a school. The Irish and Anglo-Saxon monks, who were then traveling throughout Europe to disseminate their Celtic style of script and illumination came to Saint Gall to copy manuscripts. Under Charlemagne, the monastery also received two cantors sent from Rome to teach Gregorian chants, who created a very reputable local chant school. The scriptorium would produce numerous antiphonaries, many of which are still in the library. A place of exchanges overflowing with activity in the ninth century, Saint Gall was a powerful abbey that, thanks to the emperor, enjoyed many privileges. Its international stature was strengthened in 820 when the famous *Plan de Saint-Gall* was issued in which the abbey was described as a sort of ideal religious enclave in which each building addressed a particular function. Though the plan was never completely applied, it exerted a great influence over Benedictine construction of the Middle Ages. Around 850, the first catalogue of the library was made, whose content indicates that the monks' interests already went beyond theology. More than 400 manuscripts cited in this catalogue still exist today.

Beginning around 930 with attacks by the Huns, Saint Gall underwent a dark period and was forced to move its library to the Abbey of Reichenau on an island in Lake Constance. In 937, Saint Gall was ravaged by a fire that thankfully spared the books and their building. Following the twelfth century, the abbey was enmeshed in numerous secular quarrels and went into decline, despite the fact that some of its abbots had become princes of the Empire. At the beginning of the sixteenth century, Calvinists pillaged the abbey, but a new period of prosperity finally began in 1530. Books continued to play an important role in its influence and by the middle of the seventeenth century, Abbot Pius acquired a press that would transform the former scriptorium into the first printing center in Switzerland. In 1712, the principality succumbed to invaders from Zurich and Bern who pillaged its treasures and, this time, its most beautiful works. The monastery was rebuilt between 1755 and 1765 in a Baroque style, but the period of rebirth was quickly interrupted. In 1798, Switzerland suppressed all ecclesiastic principalities and in 1805, confiscated the abbey's revenues. Saint Gall became a bishopric in 1846 and its buildings were divided up among the bishop, the various offices of the canton, and what remained of the library. Founded in the seventh century and a participant in the evangelization of Rhenish Gaul, the abbey would first fall victim to the Reformation, only to have its revival disappear within the great secularization movement.

In 1750 Abbot Coelestin Gugger von Staudach launched the reconstruction of the abbey that we know today. He entrusted the work to Peter Thumb (1681–1766) and Michael Peter (1725–1769), an Austrian architect and his son who favored a simple, powerful Baroque style that was devoid of all affectations. Their plans set the library in a choice spot. Above its heavy door with gilded moldings reads a Greek inscription that translates as "Sanatorium of the Soul"—the term used by Diodorus of Sicily in the first century AD to describe Ramses II's "House of Books." The door opens onto a sublime space aglow with thousands of warm colors emanating from many types of precious wood. The vast hall is punctuated by overhangs above the bookcases, as well as by pillars that support the wide gallery whose projections are mimicked in the grandeur of the marquetry design of the floor. The elegant wooden columns are topped with Corinthian capitals covered in gold leaf, and the woodwork is also adorned throughout with a light-gold accent. Set in the niches above the windows are stunning, painted *putti* made of wood that symbolize the arts and sciences. Each strikes a different pose and bears in earnest its specific attributes. The ceiling, formed by four flattened domes, is adorned with robust rococo stucco decorations that frame the medallions and frescoes by Joseph Wannenmacher whose paintings are on the theme of the Councils of Nicaea, Constantinople, Ephesus, and Chalcedon. The iconography on display here is infi-

nitely more sober than that found in other German and Austrian monastic libraries. The usual allegories, often conventional and complicated, have been supplanted by simple illustrations of important moments in the life of the Church. Undoubtedly, the Benedictines of Saint Gall believed that the "care of the soul" was better served by thousands of patiently gathered works than by vain, decorative apologetics.

Although they have not always been greatly appreciated, the treasures of this library remain essential to the understanding of the religious history of this part of the world. Saint Gall was not merely a major scriptorium, it was also a cultural center where the monks both copied works and wrote commentaries on them. Some ancient volumes reveal the open spirit that reigned there—quite a rarity for that time. For example, the collection includes a *Life of Charlemagne* written shortly after the emperor's death by Nokter Balbulus, the *Evangelium Longum*, a Gospel book with an ivory cover created by a monk in the abbey, a tenth-century edition of Cicero's *De Inventione*, the *Edicts* of the Lombardy King Rotharis (seventh century), the *Mirabilia Romana*, the first tourist guide to Rome written on parchment, and even a solemn document recounting the cruel acts of Count Dracula. Today the Saint Gall Library, a research center and historical collection, has 150,000 works including more than 2,000 manuscripts and 1,500 incunabula.

Panorama: The great hall. The decision to build it was made on November 28, 1757, construction began in 1760, and it would take more than ten years to complete.

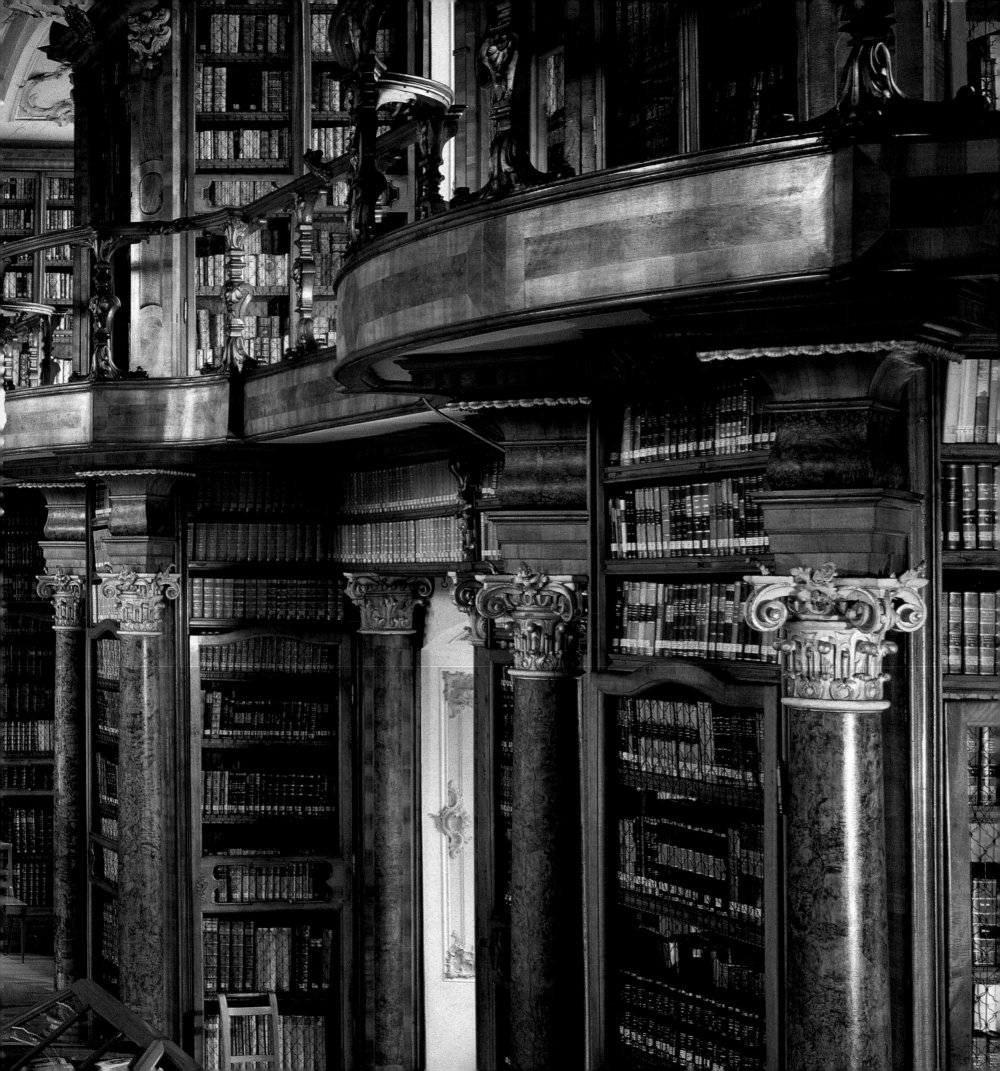

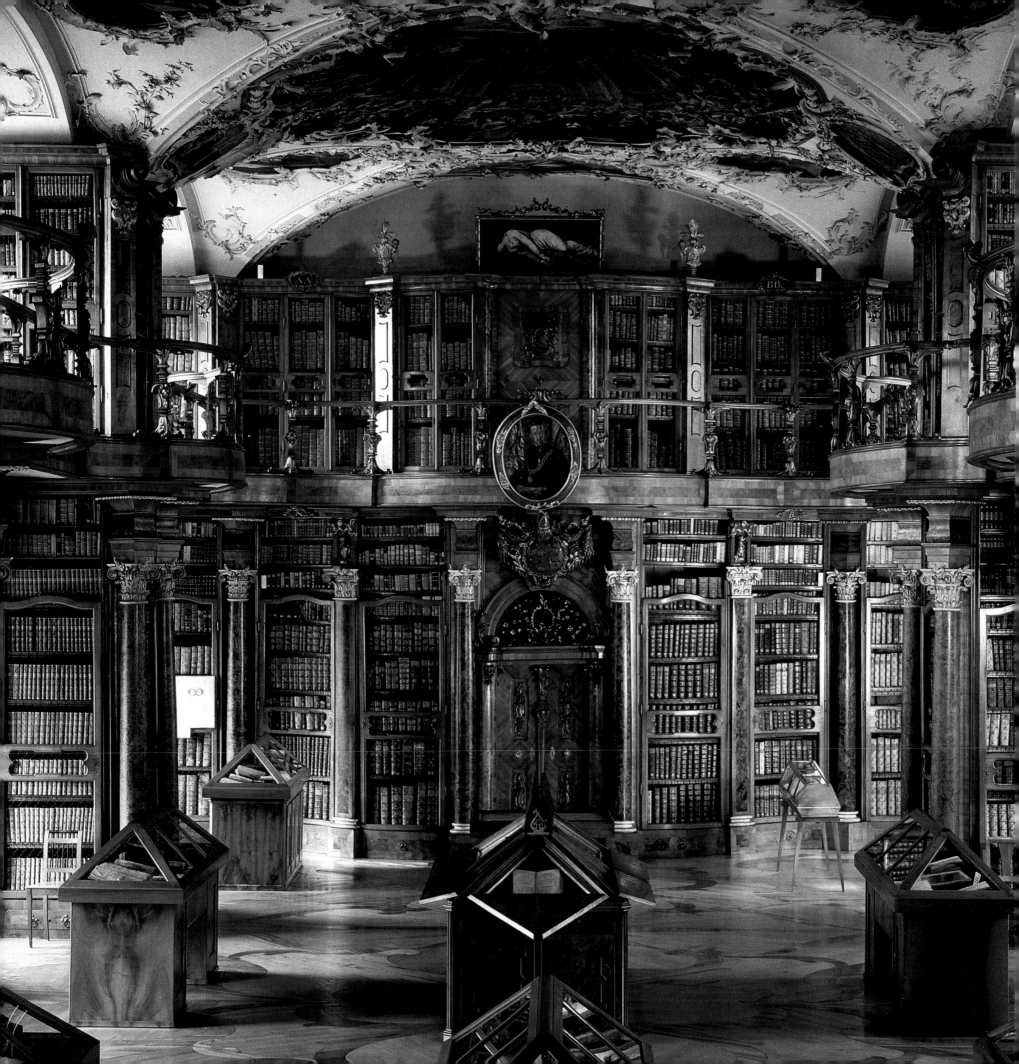

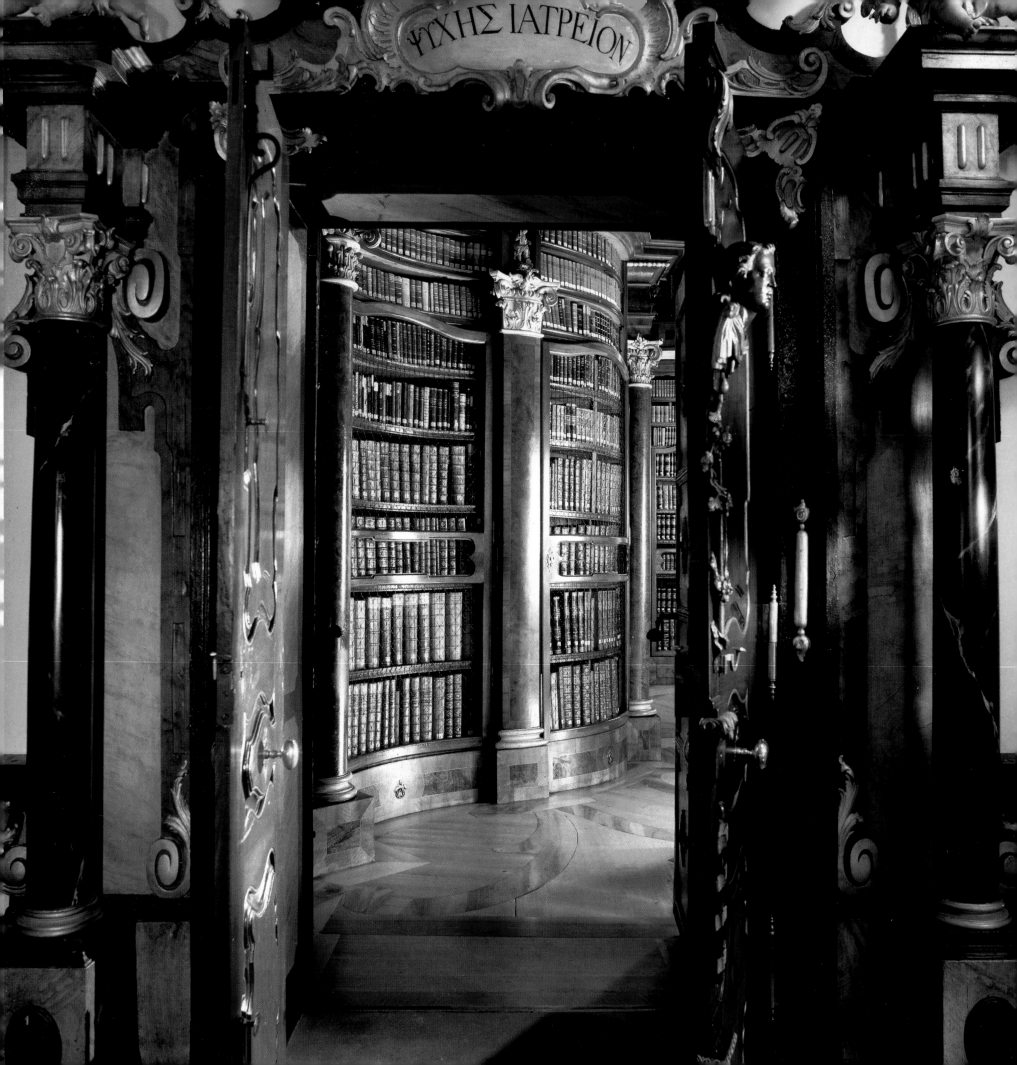

Above: Ivory cover of the Evangelium Longum *copied at the abbey around 900. To the left, a bear helps Saint Gall build his retreat.*

Left: The main entrance of the library. In the medallion, the inscription (in Greek) "Sanatorium of the Soul"

was used by Diodorus of Sicily to describe the "House of Books" of Ramses II.

The niches above the capitals are populated with putti, *sculpted from wood, which represent the arts and sciences.*

Each putto *bears allegorical symbols: books, orbs, a telescope, a lute, etc.*

Above: In a window-frame stands the interior and exterior sarcophagi of the mummy of Schepenese, a young Egyptian woman from the seventh century AD. The set was placed in the library in 1820 during a time when the scholarly world had a passion for Egyptology.

Right: In tribute to Coelestin Gugger von Staudach (1701-1767), his portrait was incorporated into the panelling above the south door. As an energetic abbott he was part of the initiative to construct the new library room and the conventual church.

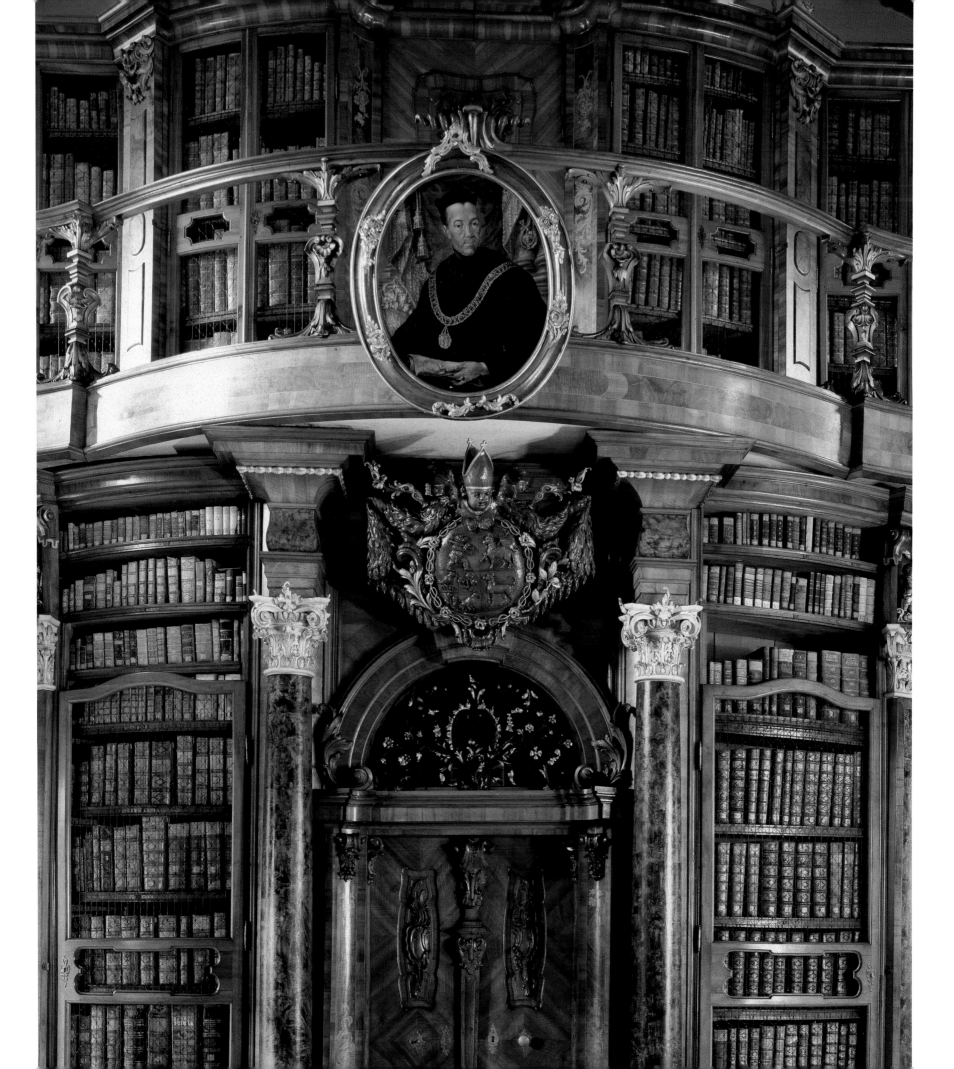

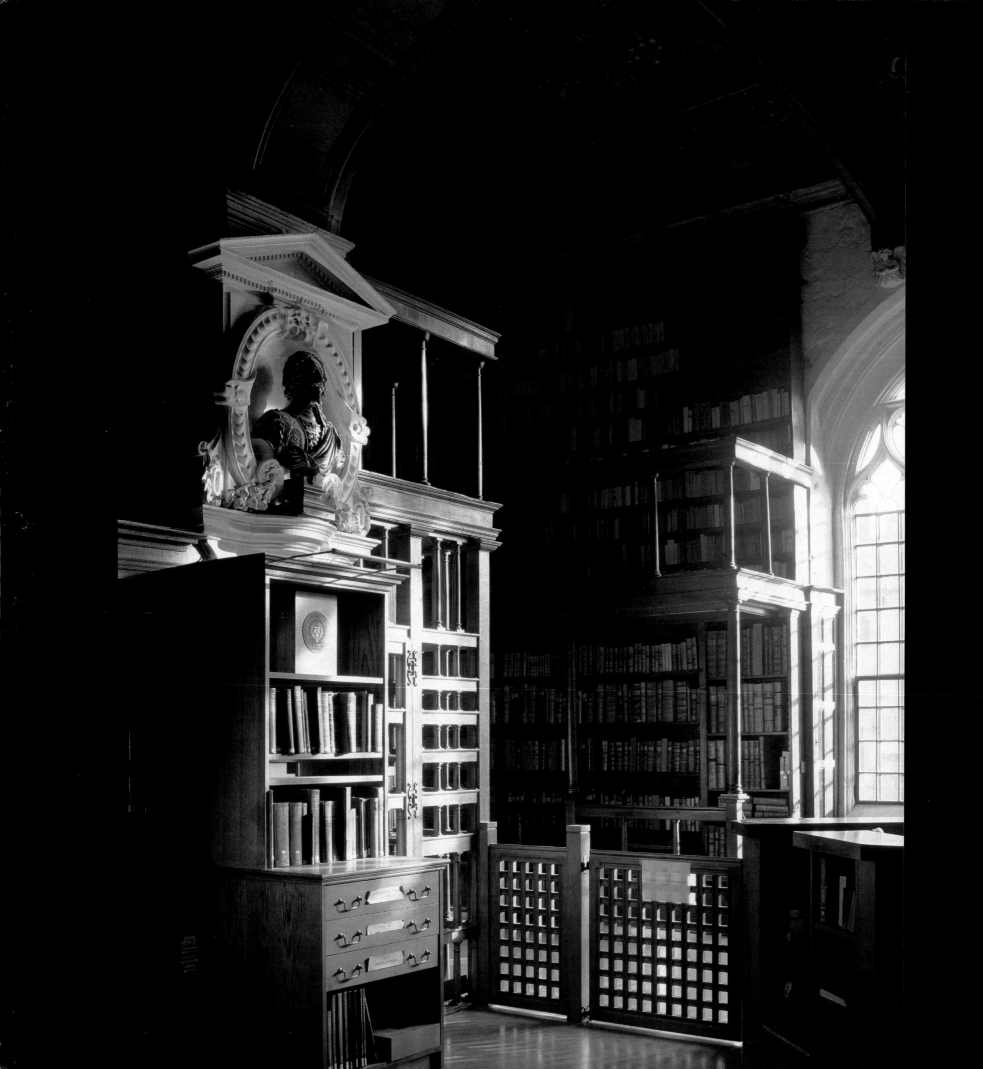

BODLEIAN LIBRARY

IT IS ODD, INDEED PARADOXICAL, TO NOTE THAT though great libraries make up the glory of a culture, their births have not always been easy. One could naively believe that the necessity of these institutions was self-evident, but a man of action with unwavering determination—whether prince, abbot, or scholar—was always required to mobilize the needed energies and especially to provide the financing. Such was the case in Oxford.

At the beginning of the fourteenth century, Oxford University—apart from its numerous colleges—owned an array of manuscripts that were placed at the students' disposal in a gallery of St. Mary's Church. In 1320, the bishop of Worcester magnanimously decided to build a hall for this precious collection; a noble project that slowed down upon his death in 1327. Construction of the building was not completed until 1367 and its installation only in 1444. Following the gift of 281 manuscripts by Duke Humfrey, a brother of King Henry V, the decision was made to construct a new library above the Divinity School, a large, late-Gothic meeting hall. Its doors were opened forty-four years later, proving that time is not of the essence at Oxford colleges. University authorities, however, were utterly indifferent to the library and even hastened its loss by selling books to pay the librarian—a self-negating endeavor. In 1555 came the nadir—all works with any reference to Roman Catholicism had to be purged from the stacks. These magnificent manuscripts were sold to local bookbinders for the cost of the vellum. The furniture was sold in a *coup de grace* to Christ's Church College in 1556 and the empty hall was transformed into the School of Medicine. Oxford University found itself without a library!

Then Thomas Bodley (1545–1613) appeared on the scene. A Protestant born in Exeter, he had immigrated to Geneva with his family to escape persecution and there studied with the finest teachers, including Calvin. Returning to Oxford, specifically, Magdalen College, he first became an instructor and, when he was only twenty-five years old, a deputy headmaster. In 1576, he once again left for the Continent where he traveled extensively before entering into the services of Queen Elizabeth I who sent him to plead the Protestant cause in France, Denmark, and the Netherlands, where he spent several years as her ambassador. After marrying a rich widow, he left his employ with the queen in 1596 and in 1598 chose to spend his time and fortune creating a library at his beloved Oxford. His money and books were accepted in March 1598 and by 1600, the old library above the Divinity School had been restored. At the time of its dedication in 1602, it already held 299 manuscripts and 1,700 printed works. By 1605, its stacks brimmed with 6,000 volumes and in 1610, the knighted Bodley systematically received, free of charge, a bound copy of every work published by London printers. This marked the beginning of copyright registration in England, which the Bodleian oversaw for a long time.

Upon his death in 1613, Sir Thomas left his fortune to the library and construction immediately began on Arts End and the Quadrangle halls, this austere courtyard surrounded by buildings of classrooms that leads to the entry of the library. In 1634, at the other end of the Divinity School, a third hall was built, which was called Selden End in honor of the generous lawyer who financed its construction. The library continued to prosper, receiving numerous gifts of manuscripts and books. As it was not necessary to be a student of Oxford to use the facilities, it attracted researchers from all over Europe. In fact, Oxford undergraduates were not welcomed until 1856. This critical acclaim, however, is tempered by statistics of usage. In 1831, for example, the library received only two or three readers per day. The building was not heated until 1845 and it was only in 1929 that electric lighting was installed—two factors that undoubtedly discouraged researchers from spending long hours there.

Following an interruption during the eighteenth century, the Bodleian Library once again expanded its collection. In 1849, it possessed some 220,000 books and 21,000 manuscripts, making it one of the largest libraries in the world. In 1960, it took the Radcliffe Library under its wing and this stunning, circular Baroque building dominated by a slender dome was renamed Radcliffe Camera and became the primary lecture hall for both institutions. Thanks to the 1939–1940 addition of a building designed by Sir Giles Gilbert Scott, the Bodleian, with its 6.5 million volumes, is today the second-largest university library in the world, second only to the one in Moscow.

Bodley was a humanist in terms of books, but conservative regarding construction. His library is a testament to an imaginative and uncomplicated eclecticism that continues to be the charm of English architecture to the present day. Although in continental Europe the year 1600 signaled the dawn of classicism, English builders continued to look to the past, thus explaining the Gothic panels on the walls of the Quadrangle, the late-Gothic bay windows, and the crenellated pinnacles and parapets that were truly archaic. The historic hall, restored by Bodley, conceals none of its sixteenth-century origins. Its ceiling was repainted in a rather repetitive Renaissance mode—a problem that is often encountered when trying to re-create a style for which the original inspiration has disap-

peared. On either side of the long hall, angled bookshelves have replaced the old lecterns to which the manuscripts had once been chained. Today this room is reserved for the most valuable works in the Bodleian collection, such as the Ormelsby Psalter (England, end of the thirteenth century), a Venetian *Historia Naturalis* by Pliny the Elder, Greek manuscripts from Constantinople, the first edition of *Don Quixote*, and writings in Chinese, one of which is a work by Confucius that was purchased by Bodley at a time when no one at Oxford was capable of reading it. The ceiling of the second hall, Arts End, is once again decorated with the university coat of arms, to which was added that of Bodley. The books are shelved on stacks that run parallel to the walls, over which there is a small gallery, thus making use of the room's full height. The third hall, Selden End, with its two large Gothic picture windows, is decorated in the same manner as the one preceding it.

Thousands of researchers, both famous and anonymous, have worked under these emblazoned ceilings. The halls of Bodleian Library may be small in size, but their prestige is vast. This library is a symbol, *par excellence*, of Oxford's lofty academic reputation. A legend carefully nurtured, it holds its place in the majesty of British civilization, on a par with country houses, the Royal Navy, Parliament, and the Monarchy. ∽

Above left: The old classification system is still evident, painted in fine gold leaf on the risers of the bookcases.

Above right: Detail of a staircase banister leading to the stalls of the Convocation Room (1634–1637), above which Selden End was built.

It was in this hall that Charles I called a meeting of Parliament during the civil war, and also where the election of the chancellor of the university took place.

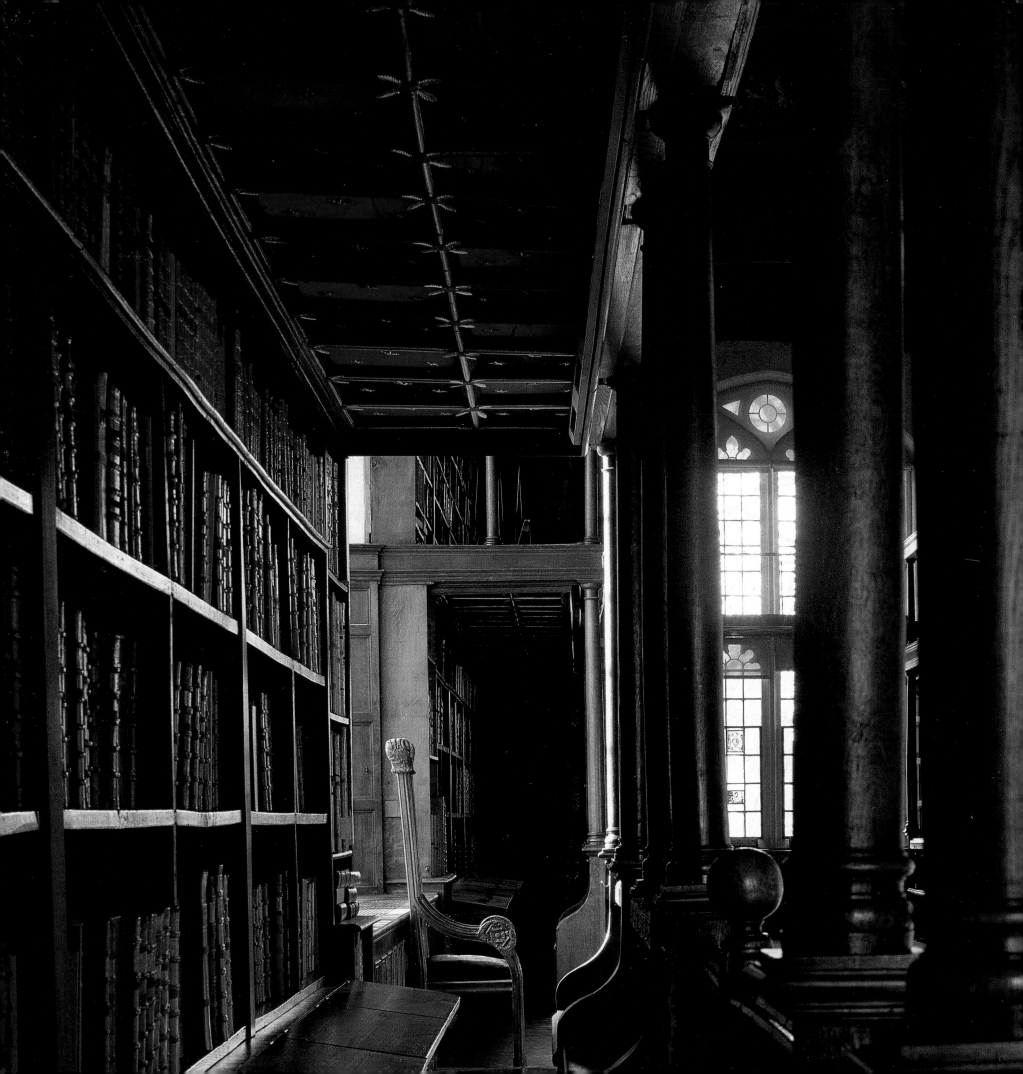

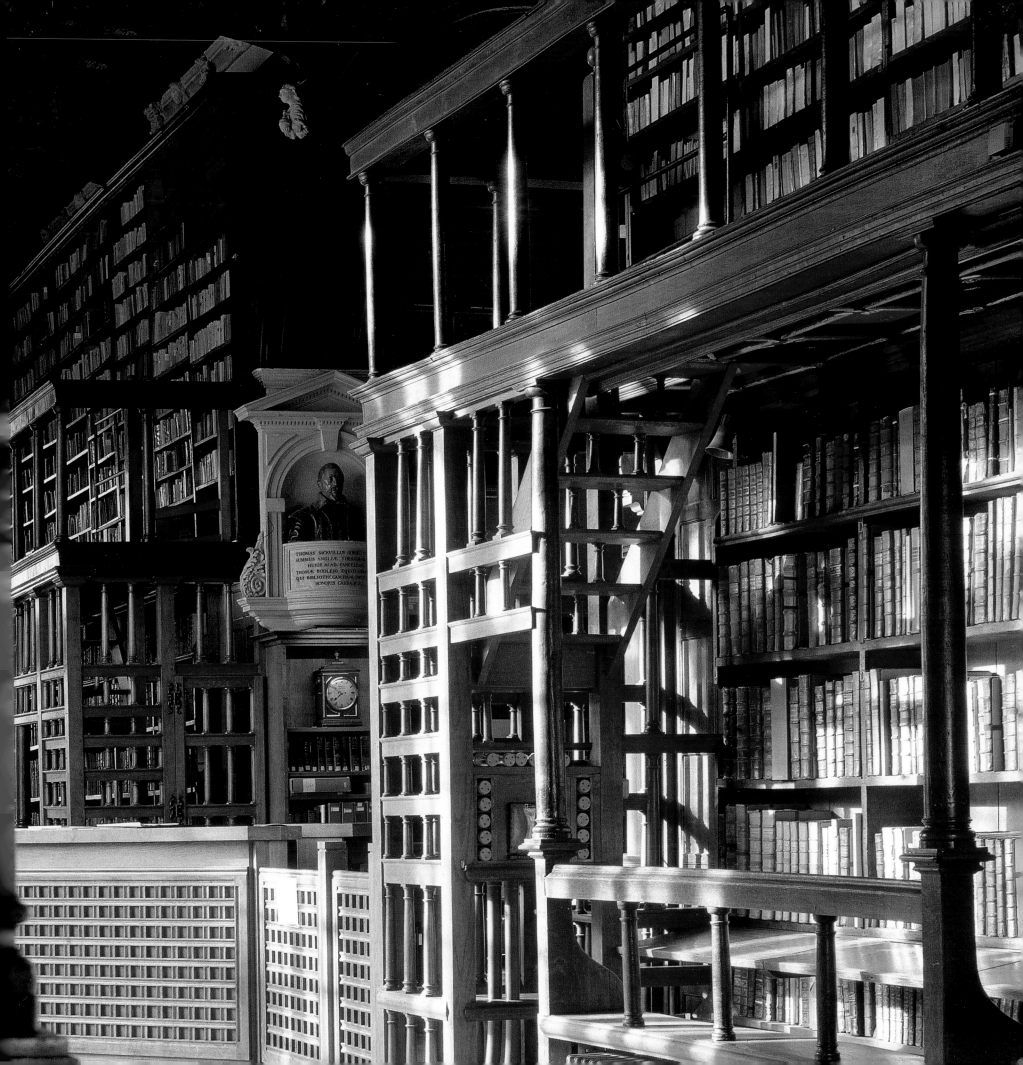

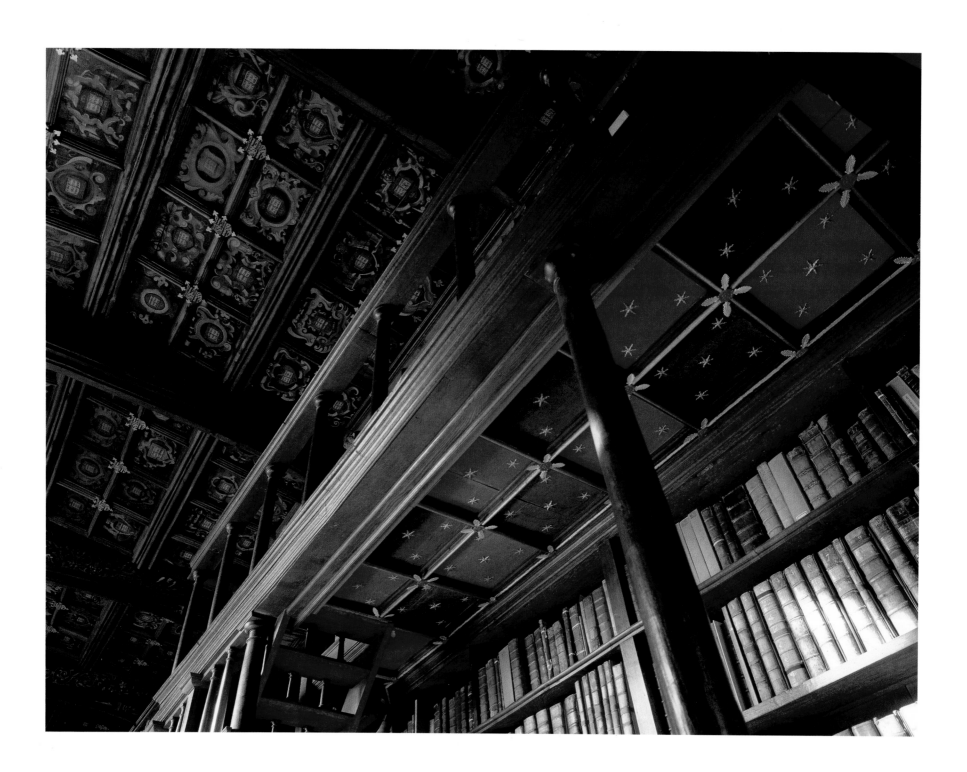

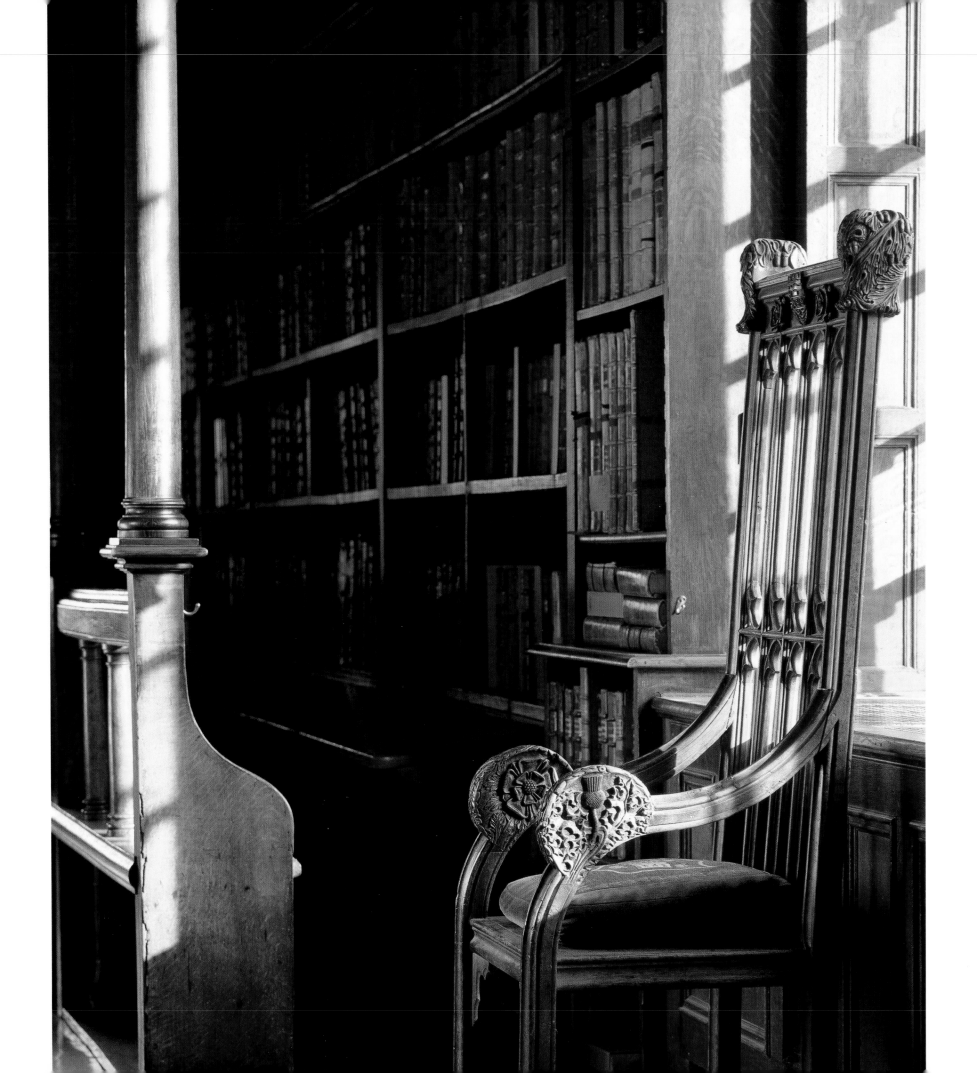

WREN LIBRARY, TRINITY COLLEGE

IN THE WORDS OF ONE OF THE GREATEST HISTORIANS of English architecture, Nicolaus Pevsner (1902–1983) writing about the Trinity College Library, "The library must have come as a revelation to Cambridge, still used to fundamentally unclassical buildings. . . . Here was sonorous grandeur, without bragging, simplicity and ease combined with a mastery of the Romance idiom (more French in detail than Italian, although the shadow of Sansovino's library at Venice looms in the background). It made everything else look fussy and finicky."

To understand the emotion and admiration that this library inspired among the people of the time, one must picture Trinity College, founded by King Henry VIII after the merging of two older colleges—King's Hall and Michaelhouse—at the end of the sixteenth century. At that time Trinity, like all of Cambridge, was made up of discordant buildings of contrasting heights, of styles more or less authentic, with lines not necessarily straight and building junctures that were adventurous. If a certain charm emanated from these already old stones, the interiors were undisputedly uncomfortable as the strong complaints of the college's Masters and Fellows attested. The lighting was poor throughout the college, and most of the rooms were poorly ventilated and humid, a perpetual problem in the Cam River valley. The existing library, built in 1600, was a prime example of these inadequacies. Had it not been relegated to a distant third floor and so badly constructed that in 1670 its walls threatened to cave in under the weight of the books? In 1673, an enterprising Master, Dr. Isaac Barrow, theologian, mathematician, and follower of experimental philosophy was finally appointed. The library was, for him, a major concern. The old one was at risk of collapsing and its roof had recently caught on fire. The scholastic prestige of Trinity was being contested by other colleges that already had renowned libraries.

One such college was St. John, which had constructed a magnificent building in 1620. After long debates, Barrow wanted to rattle the members of the council, which he deemed timid and, out of bravado, decided to build the largest and most beautiful library in Cambridge. Unfortunately, Trinity was undergoing a difficult financial period. Its revenues were mostly founded upon the resources of the agricultural holdings given it by the king after they had been confiscated from Catholic convents, and these farms had been experiencing mediocre harvests for several years. A public appeal was launched, primarily directed at alumni of the college who were solicited through a letter containing a print of the proposed project; somewhat like a direct-mail campaign today. In order to finance the construction, a project that would take twenty years, the mailing had to be repeated several times, along with the promise to display the coat of arms of major donors, or even to place a bust or statue of them in the reading room.

Barrow asked Christopher Wren (1632–1723) to draw up plans for the new library. He had made friends with this architect of the king who was then very busy with the reconstruction of London after the devastating fire of 1666. Wren had been appointed to draw up the plans for the city and to construct fifty-two churches and Saint Paul's Cathedral. As surprising as this may appear—though Le Corbusier or Tadao Ando found themselves in similar circumstances—Wren was not an architect by training. A mathematician and holder of a titled chair in astronomy at London and Oxford, he had been called upon, somewhat by chance, to resolve the roofing problem of a vast theater in Oxford. The subtle solution that he successfully proposed pushed him in the direction of architecture. Different from many architects of the period, he had not been to Italy and thus was familiar with the works of antiquity only through engravings and reliefs done by students. His sole trip abroad was a stay in Paris from 1665–1666, where he was quite intrigued by the

Palais Mazarin and Le Vau's plans for the Collège des Quatre-Nations, which would be the future home of the Mazarine Library. Barrow, on the other hand, had recently returned from Italy where he had visited the library built by Sansovino a century before Saint Mark's Square had been constructed in Venice, as well palaces and public buildings by Palladio in Vicenza and the Laurentian library by Michelangelo in Florence. The engravings that Barrow brought back undoubtedly influenced Wren, who was faced with a project utterly new to him. The proposed plot occupied the fourth side of Nevile's Court. This courtyard was bordered by buildings that mainly had been constructed at the end of the sixteenth century and the beginning of the seventeenth and opened onto the countryside and the River Cam. Wren first proposed a circular library beneath a vast cupola in the center of the courtyard, but then decided upon a long construction that would completely close off Nevile's Court, transforming it into a "quadrangle," a form highly regarded at British colleges. Work began in 1676 and was finished in 1686, but it would not be until 1695 that the books were installed, as the interior fittings took longer to complete and were costlier than projected.

The building is in the form of a long rectangle, and although its east and west facades are quite different (with the west facing toward the countryside), they are both in a noble and classical style. The large reading room runs the length of the building, supported by a level of open arches on the ground floor. This arrangement almost completely conceals the ingenious double solution conceived of by Wren, which defines the building's architectonic originality. To start with, as the land borders the river and is not very stable, the arches are inverted, which is to say that the true arch is under the floor, the pillars rise to the top, and upon each sits an arch. In this way, the architect assured the solidity of his build-

ing and limited the effects of humidity on the books by raising the room several yards or meters above ground level. Second, the tympana of the facade's arches are filled in, as the floor of the reading room does not rest on them as one would expect. Instead, the floor has been lowered into a depression just at the base of the tympana. So, in fact, the arches support both the walls and the roof, while a line of stone pillars, concealed between two rows of exterior arches, supports the floor of the room. This feat of discretion enables the twenty-four enormous bay windows that are above the interior bookcases to open (eleven overlook the courtyard and thirteen the gardens). Even on the grayest and rainiest days in Cambridgeshire, these windows guarantee readers excellent lighting. The classical outline of the cornices on the lower portion of the arch pillars echoes the Doric order, while the bay window pillars the Ionic order.

The interior confirms the "functionalist" vision of the architect, which was a far cry from his German, Austrian, and Italian contemporaries and successors who abandoned themselves to the complicated delights of Baroque spatial manipulations. The vast, uninterrupted hall measures 190 ft. long, 39 ft. 3 in. wide, and 37 ft. 5 in. high (58 m long, 12 m wide, and 11.4 m high), and is modulated by enormous bookcases set perpendicular to the wall, creating eleven alcoves on each side. Each alcove is covered on three sides with bookshelves and closed cabinets, and in the middle Wren placed a heavy table with a central lectern that rotated, enabling the reader to consult more than one work at a time. He designed the table and sturdy stools after having been struck, as he put it, by the "masculine furniture" in the library of Cardinal Mazarin. The floor is a checkerboard of black and white marble to temper the noise of footsteps, while the alcoves have wooden floors for greater comfort. The caisson ceiling found today was in the original plans, but was not installed until the middle of the nineteenth

century. For the décor, Wren suggested placing a statue atop each bookcase. "This will be an ornament of great nobility; they will be plaster, made by Flemish artists for a small cost." Still deemed too expensive, they were never commissioned but were replaced throughout the eighteenth century by marble busts of donors, Fellows, thinkers, and scholars. In 1774, a highly criticized addition was made. While Wren had wanted a space evenly lit by daylight, it was decided to place in the large bay window facing south an enormous picture window of plain and stained glass, designed by Gian Battista Cipriani. In an odd, anachronistic montage, it depicts a rather strong woman, supposedly the muse of the college, pulling Isaac Newton in order to present him to King George III while Francis Bacon looks on. This is the only touch of color in an otherwise black, white, and dark-oak universe. A sole, veritable breach of the design of one of the greatest English architects. In 1845, an imposing statue of Lord Byron by Thorvaldsen, commissioned for his tomb, was installed at the far end of the hall.

Today, Trinity is the largest college at Cambridge, and its library the most important. Conceived by Wren to hold 30,000 volumes—an enormous number for the seventeenth century—the library now has more than 300,000. It history and the generosity of its alumni and Fellows, both famous and not, explains the wealth of its collection. Its possessions include 1,250 medieval manuscripts, including the Eadwine Psalter dating from the

twelfth century and the Apocalypse of the Trinity from the thirteenth century, 750 incunabula from before 1500, the Capell collection of documents on Shakespeare, many books from Isaac Newton's library, 70,000 pieces of printed matter published before 1800, a collection of modern manuscripts including texts by Bertrand Russell, the personal archives of Ludwig Wittgenstein, and, of course, the fascinating college archives in which the religious and intellectual history of the kingdom since the beginning of the twelfth century is described.

The library of Sir Christopher Wren is one of the pinnacles of classical English architecture. Following centuries of "national" styles—Anglo-Saxon, Norman, Early Gothic, Perpendicular Gothic, Tudor, and Jacobean—English architects for a time turned toward Italy and France, but without abandoning their natural tendency for historicist eclecticism that had reached its height in the nineteenth century. It is surprising to note, for example, that while building the Trinity Library between 1681 and 1682, Wren also constructed a Gothic door at Oxford. The classicism of Wren, Webb (Lamphort Hall), Talman (Chatsworth), and Vanbrugh (Castle Howard and Blenheim) would soon be eclipsed by a new style inspired by Palladio, Vitruve, and the work of the architectural genius Inigo Jones (1573–1652). Nevertheless, Wren's library, a masterpiece of masculine elegance, rigor, and functionalism, is one of the first great libraries of modern Europe. ❧

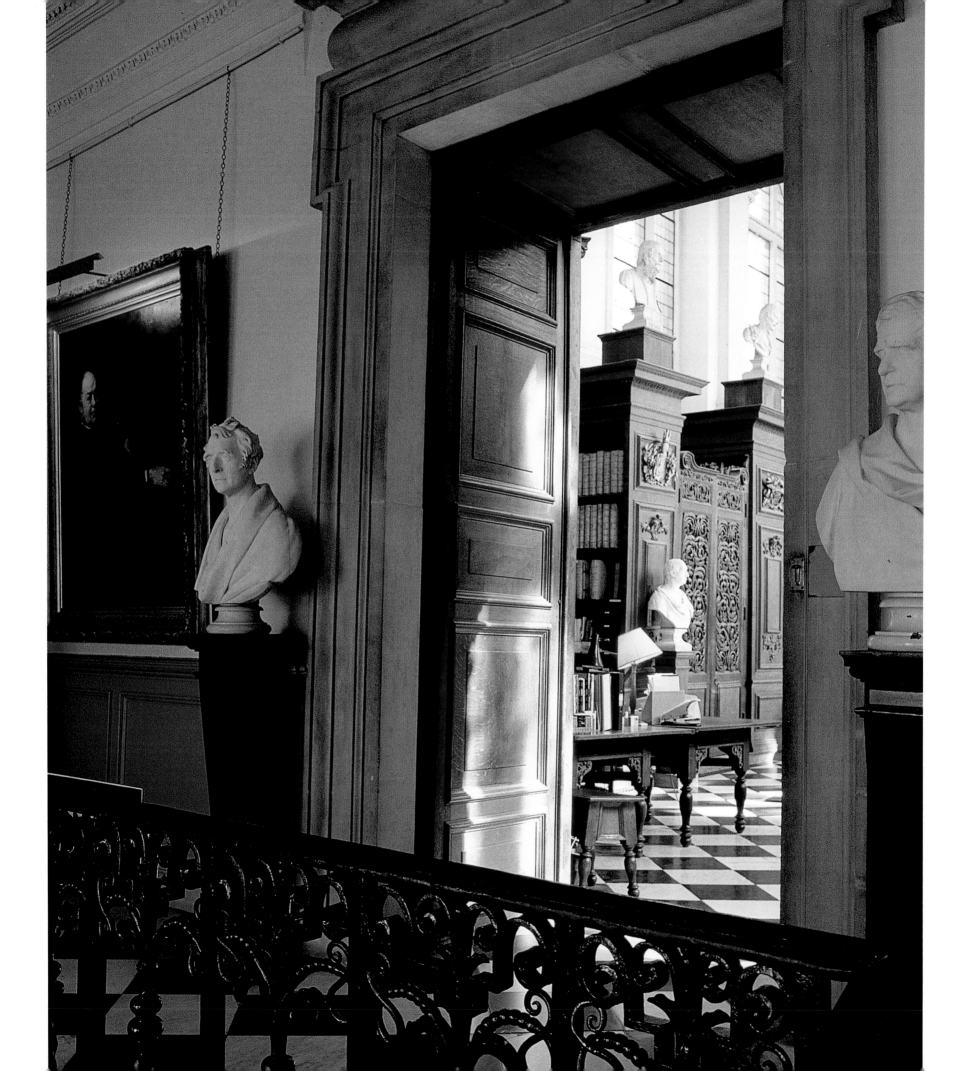

Between 1749 and 1766, many marble busts of famous students and those particularly generous to the college were either bought or donated. Most were the work of the French sculptor Louis François Roubilliac (b. 1700, Lyon–d. 1762, London). While only four marble busts were originally planned, the present collection was amassed during the 1830s, replacing the plaster busts Wren had wanted but which were never commissioned due to lack of funds.

Lord Byron was a student at Trinity, although he did not care for it much. After his death, a group of friends commissioned this statue from the Danish sculptor Thorvaldsen (1770–1844), intending it for Poet's Corner at Westminster Abbey, where it was refused. Also refused by the chapel at Trinity College, the bust wandered about until 1845, when it was installed in the library.

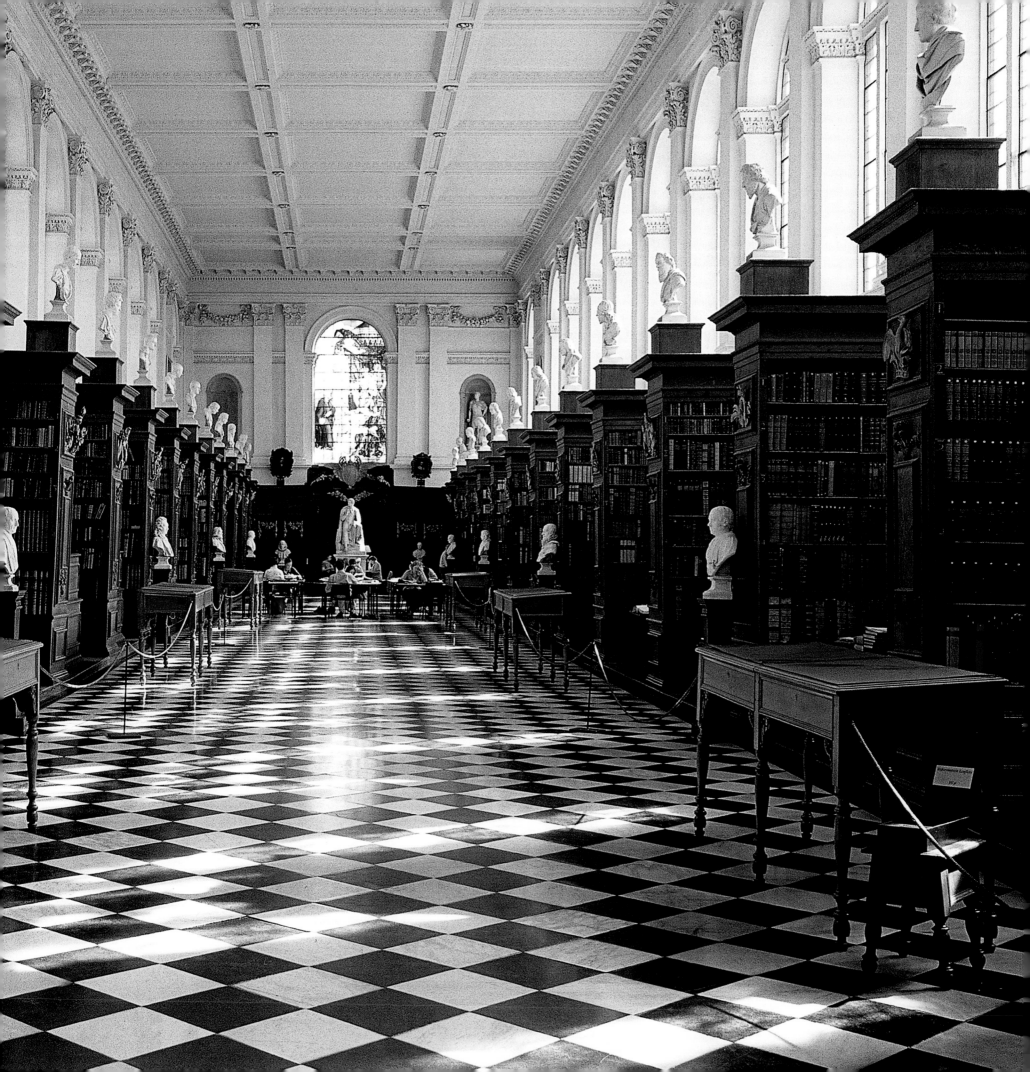

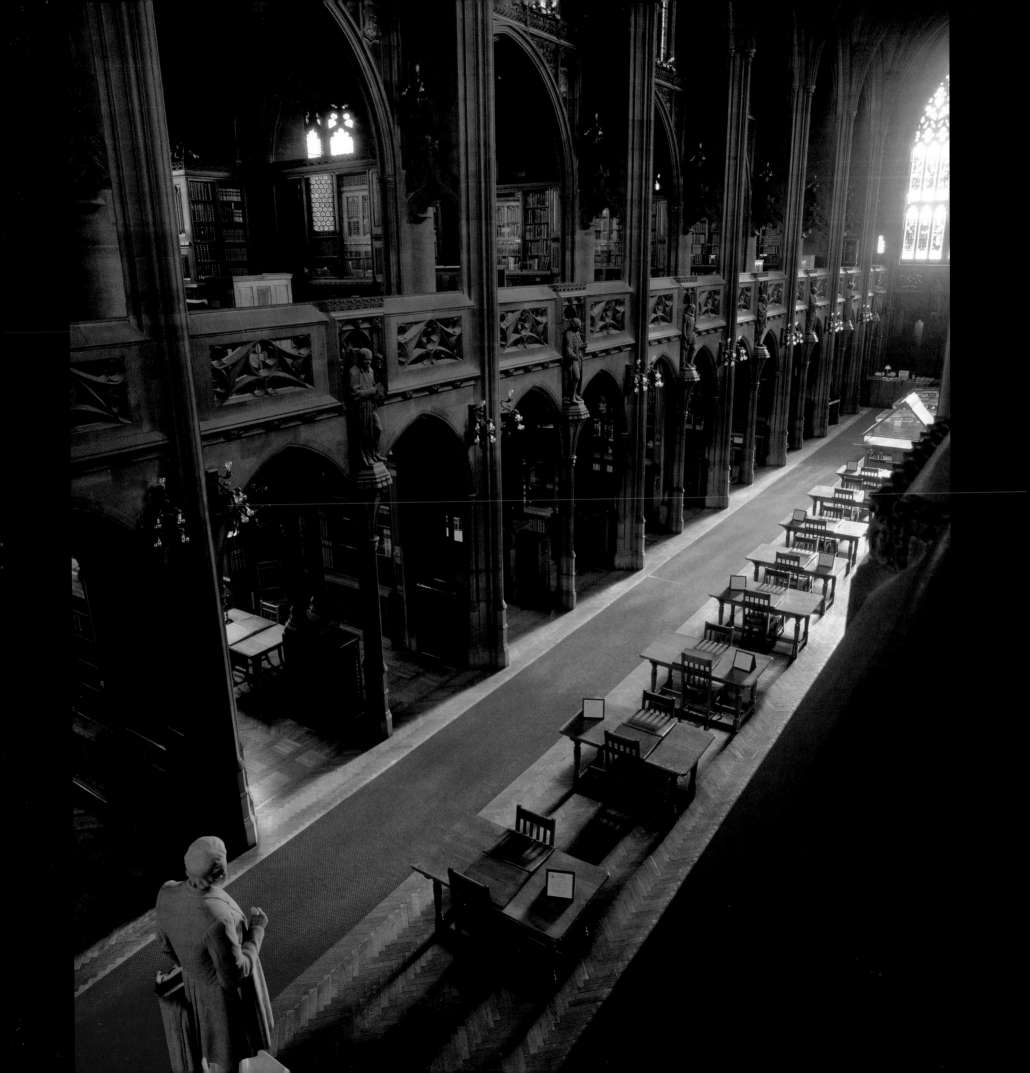

THE JOHN RYLANDS LIBRARY

IF THE HISTORY OF MONASTIC AND UNIVERSITY libraries seems somewhat redundant, the John Rylands Library in Manchester decisively breaks the mold. The paths to salvation are mysterious and filled with surprises even for treasured books.

Enriqueta Augustina Tennant, born in Havana in 1843 of very modest origins, was hired by John Rylands as his secretary around 1865. Two times a widower and childless, he was undoubtedly seduced by his assistant's high moral principles. In 1875, at the age of seventy-four, this cotton magnate married his secretary. Head of a company with 12,000 employees, he was one of Britain's wealthiest businessmen. Nevertheless, the couple led an almost Spartan existence in Longford Hall, located not far from Manchester, which was then a rather unhealthy and polluted industrial city. The two were extremely religious Methodists and John Rylands financed, at a loss, the publishing and distribution of a Bible in which each paragraph was numbered to facilitate reference. At his death in 1888, he left his wife almost 2,600,000 pounds, a considerable sum at the time. Having no particular taste for luxury or social life, his widow decided to build a useful and original monument to her husband—a library that would hold their collection of nonconformist theological works. Enriqueta Rylands was without question a remarkable woman. Solitary, rich, intelligent, and without higher education, she managed in a few years to build one of the most beautiful private libraries in the United Kingdom and amassed the most remarkable book collection of the early twentieth century.

She quickly chose the land (right in the center of the city) and the architect. For a very practical woman of this era, and for a library of theology, the aesthetics of Victorian conformism could only envision a Gothic-style, or rather a neo-Gothic style. The John Rylands Library is actually one of the last incarnations of this style, whose possibilities Victorian architects seemed to have nearly exhausted. The chosen architect, Basil Champneys (1842–1935), soon to be Sir Basil, moreover came from the last generation of those adept, refined, yet eclectic British practitioners who had created England's architectural image. Appreciated by the establishment, the charming Queen Anne-style he used at Newnham College at Cambridge and his modernized Gothic monastic style used for Mansfield College at Oxford convinced Mrs. Rylands to contact him.

If the facade of the building evokes a small cathedral whose towers have been sawed off, the comparison with religious architecture does not end there. The grand reading room, for example, was conceived as an immense church nave with both ends closed off by monumental stained-glass panels. One enters by a majestic, albeit somewhat steep, staircase that mounts beneath a complex ensemble of ribbed vaults, ogive arches, arcatures, fanned out conical vaults, and skylights that are a striking illustration of the enduring talent of Victorian masons at a time when metal structures had already been in use for quite a while.

And here Champneys upheld his reputation for refinement. The attention paid to the most minute detail make the library one of the most perfect examples of the perfection attained by prestigious official and private English architecture at the end of the nineteenth century. Encouraged by Mrs. Rylands, he set out to find the finest materials and—contrary to what this already passé architectural expression would lead one to expect—the most modern techniques to assure the longevity of the building and its collections. The building complex was constructed in gray and pink "shawk," a particularly hard sandstone from Cumbria chosen for its resistance to pollution. All the woodwork is in Polish oak, the best wood then available. In a move considered revolutionary for

the time, all the rooms were lit with electricity produced by a generator. This modern choice provided the readers with high-quality lighting, while eliminating the disadvantages of gas lighting, such as various types of pollution, odors, and the risk of fire. The electric cables were fed through copper tubes to reduce the risk of short-circuiting. And still better, the library benefited from a type of air conditioning; the windows did not open and fresh air was directed to the different rooms though ventilation ducts after first passing through charcoal filters and being humidified and heated. This was all to reduce the effects of the horrific urban pollution on the books.

The decorations are more eclectic than the architecture. The copper and brass light fixtures and lamps are Art Nouveau, while the paneling is in a Gothic, almost Arts-and-Crafts, style. Beneath the C. E. Kempe stained-glass windows at either end of the grand reading room stands a "modern" marble statue of John and Enriqueta Rylands sculpted by Cassidy. Displayed throughout the upper gallery that circles the hall are sandstone statues of great figures from history, religion, literature, science, and publishing. Readers can use comfortable alcoves that are illuminated by the light streaming in the large, plain-glass bay windows.

Luxurious but austere, neo-Gothic but modern, the John Rylands Library opened its doors to readers on January 1, 1900, after ten years of construction and a cost of more than 500,000 pounds. If enthusiasm for its architecture was not universal, such was not the case for its collections, which bibliophiles were anxious to discover.

After 1890, Enriqueta Rylands added considerably to her husband's collection, which had concentrated essentially on nonconformist theology, i.e., non-Anglican, and certainly non-Catholic works. She put Dr. Green, secretary of the Religious Tract Society, in charge of new acquisitions. During a trip to London in 1892, Dr. Green

learned that the library in Althorp, the residence of Count Spencer, was for sale. A few days later, Mrs. Rylands offered 210,000 pounds, and was awarded the acquisition. This library was one of the most prestigious collections of bibliophilia in the kingdom. George John, second Earl of Spencer (ancestor to Lady Diana, Princess of Wales), former first lord of the admiralty and Secretary of the Interior, had amassed a marvelous collection. He had bought entire libraries from Hungary, had taken advantage of the dispersal of prestigious collections during the French Revolution, and was a specialist in the works published by William Caxton (1422–1491), the first English printer. He owned numerous rare works, including a Gutenberg Bible, a 1467 work by Virgil, one by Horace dating from 1474, seventy-eight incunabula of Cicero, and some fifty volumes from Caxton. At the earl's death in 1836, his library contained no less than 40,000 volumes and was deemed by Renouard, the great Parisian merchant-bibliophile, to be "the finest private library in Europe."

Great Britain is home to another famous private library—that of Alexander William Crawford Lindsay, twenty-fifth Earl of Crawford and sixth Earl of Balcarres. Very early on, he became impassioned with books and his goal for his library was "not mere bibliomaniacal congeries of undigested acquisitions, but a library of intrinsic excellence, to contain the most useful and interesting books old and new, in all walks of literature." Once at the head of the family fortune, he set off on great acquisitions throughout Europe and even China and Japan. He collected precious historical documents on the French and American revolutions, and bought the Borghese collection of papal bulls, as well as series of el-Faiyûm papyri. These treasures continued to accumulate in the residence at Haigh Hall until the crisis in farm revenues forced him first to part with some valuable works, and then, in 1901, the major part of his collection. Quickly and without discussion, Mrs. Rylands took them off his hands for 155,000 pounds, having made her decision based upon a

cursive description (663 Western manuscripts, 2,425 Eastern, 464 Chinese, 231 Japanese, etc.), as the Crawfords had never produced a definitive catalogue. In 1924, the twenty-fifth Earl deposited—on loan—the bulk of his historical documents concerning the French Revolution, the papal bulls, and a single-page manuscript of the Gospels According to Saint John (the oldest extant manuscript of the New Testament) at the John Rylands Library.

At the time of Enriqueta's death in 1908, the library held more than 50,000 volumes of exceptional quality. In the following years, thanks to bequests, the library acquired 80,000 works and 3,000 manuscripts, which required the construction of an annex behind the main building. But very soon thereafter, the Great Depression followed by World War II and inflation considerably reduced the revenues of the Rylands Foundation. In 1972, the board of directors accepted the merger of the John Rylands Library with the Manchester University Library.

However, the story does not end there. When, in 1986, financing was needed to create and set up the John Rylands Research Institute, the university decided to sell at auction a hundred or so incunabula. The ensuing controversy was fierce—much like that which flares up from time to time when American museums sell works from their collections. Could an institution of this stature allow itself to sell off its treasures? For the Crawford heir, the answer was clear. In 1988, he took back from Manchester all the documents and works that his ancestors had left on loan and deposited them in the Scottish National Library. ⚮

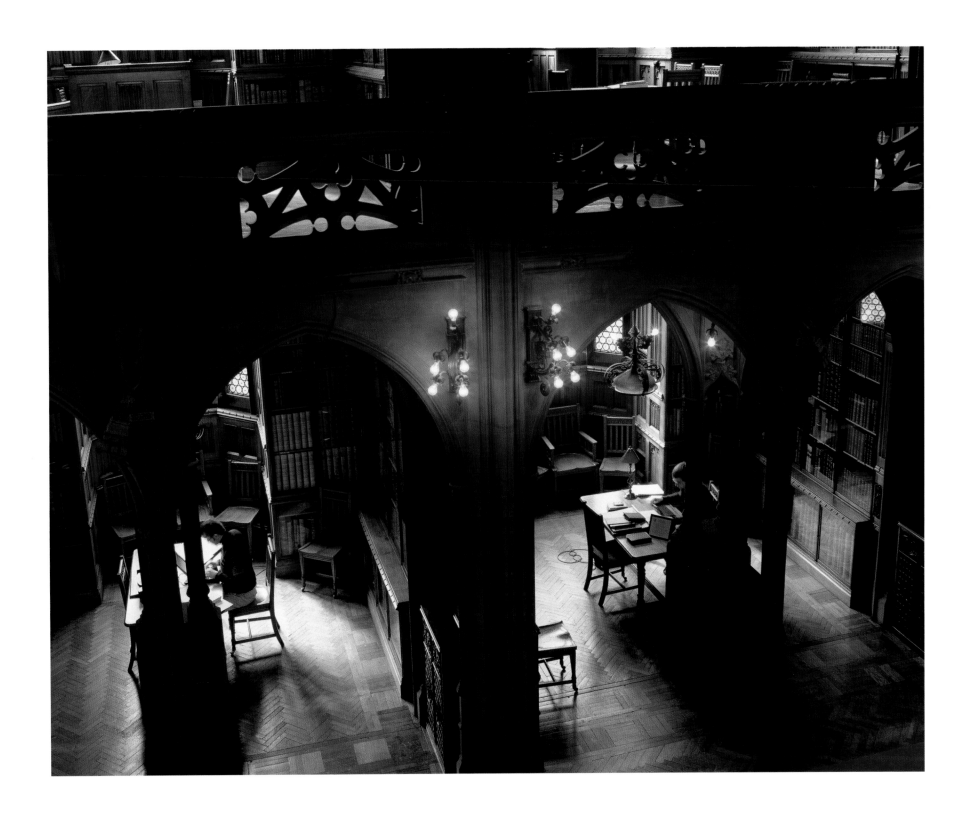

Reserved for researchers or the consultation of catalogues and open-shelf books, the alcoves beneath the gallery are pleasantly illuminated by daylight.
The John Rylands Library, however, was one of the first buildings in Manchester to be equipped with electric lighting.

The library is one of the last great testaments to the craftsmanship and virtuosity of the carpenters and wood sculptors of the Victorian age. The woodwork is of Polish oak.

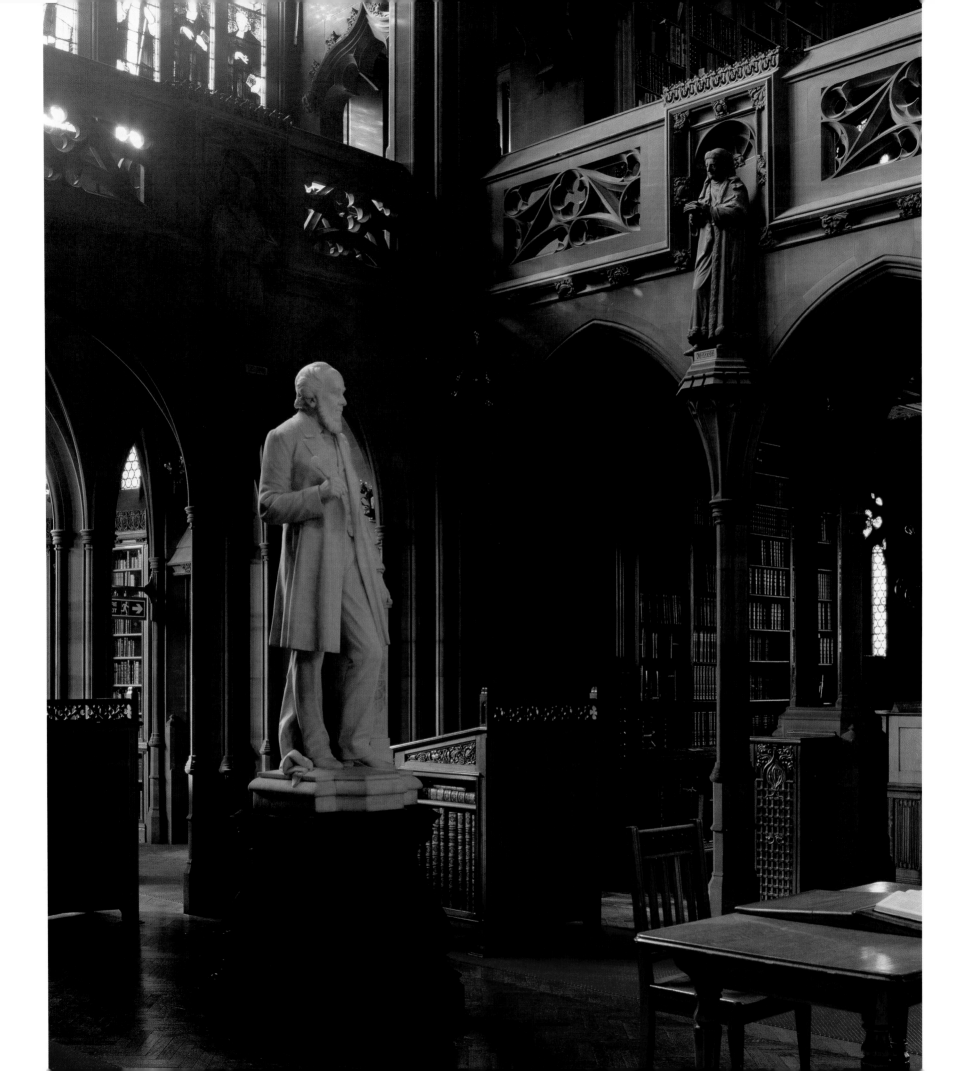

Above: The Charles Eames Kempe (1837–1907) window. He was one of the most famous glaziers of the period. Unable to enter the order, he chose to manifest his faith through the creation of magnificent stained glass windows inspired by medieval art.
Left: A marble statue of John Rylands by the Irish sculptor John Cassidy (1860–1939).

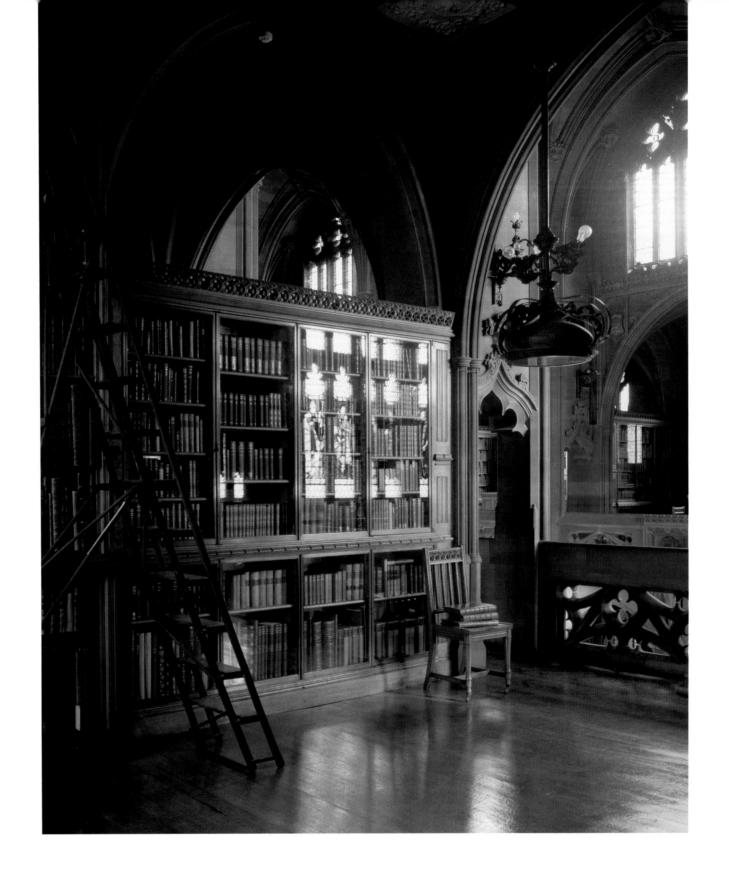

Above: One of the alcoves in the gallery.

Right: View of the great reading room, with its cathedral-like proportions. A statue of John and Enriqueta Rylands, by John Cassidy, look upon one another from either end of the room.

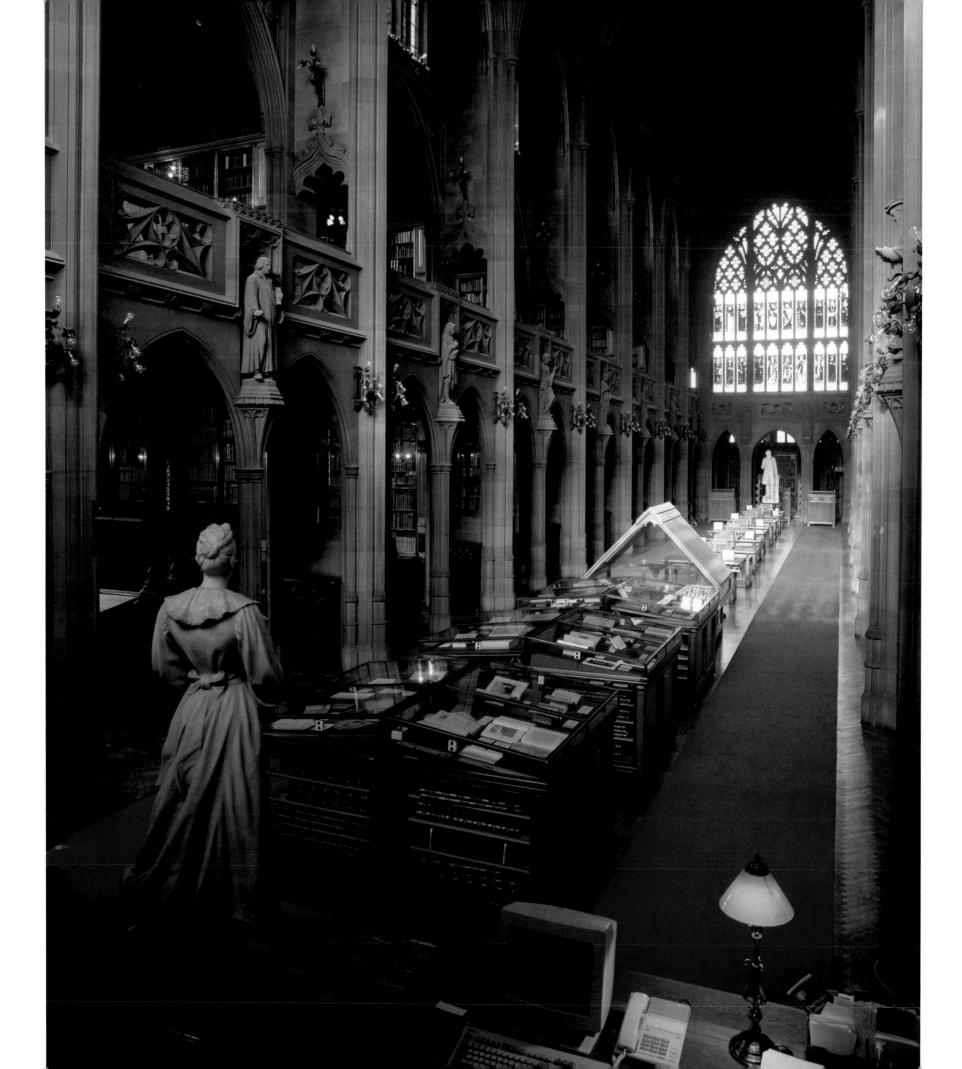

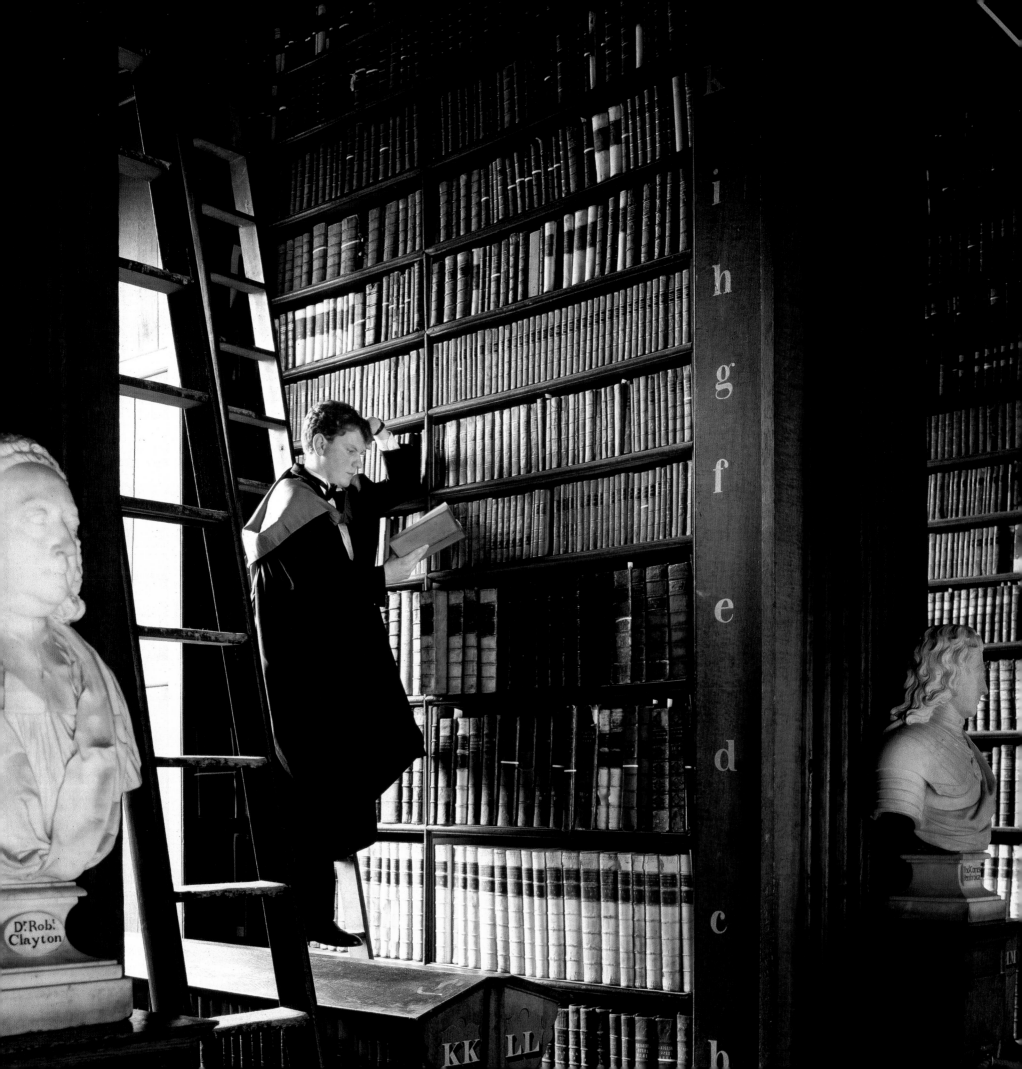

TRINITY COLLEGE LIBRARY

MOST OF THE TWO HUNDRED THOUSAND tourists who visit the Trinity College Library in Dublin each year come to admire the famous Gospels, the *Book of Kells*. Considered to be "the most splendid book that has reached us from the European High Middle Ages" (Peter Brown), it had already fascinated the erudite Welshman Giraldus Cambrensis who, at the end of the twelfth century, wrote, "One could believe that this is the work of an angel rather than that of a man." In fact, visitors are only able to view a superb replica, made in Switzerland and donated to the library in 1990 by Irish Canadians, as the original is far too fragile and is available only to the rare researcher. The climate-controlled strongbox is, without a doubt, the final resting place for humanity's great works of art.

Trinity College was founded in 1592 by Queen Elizabeth I with the clearly stated purpose of propagating the "good" religion, i.e., Anglican Christianity, in a primarily Catholic country. Although the intentions might not be considered the best, Trinity has nevertheless become one of the most prestigious Anglo-Saxon colleges. The library was created soon thereafter in 1601, beginning with a small nucleus of thirty printed works and ten manuscripts, but was quickly expanded through several purchases. The Trinity Library, however, had to wait for the acquisition of James Ussher's personal library, following his death, before it attained some renown. Moreover, it was this same Ussher, primate of Ireland, scholar and bibliophile, who "discovered" the *Book of Kells*. But a century later, the collection was piled up in such a state of disorder, and the rooms were so terribly uncomfortable (they had not been intended for such use), that use of the library fell off considerably. In 1709, the university authorities decided to construct a new building, but it was not until 1733 that a payment of 70 pounds to a person named Hudson "to arrange the books" on new shelves, was recorded.

The long history of this project was typical for the period. An in-depth comparative study of the various libraries at Oxford and Cambridge (in particular, the Wren) was launched and questions, such as financial requirements, were carefully analyzed. With little hesitation, Thomas Burgh, the only architect of any distinction living in Ireland, was appointed. Trinity Library is his sole masterpiece.

As Wren had done at Cambridge for the same reasons (the books had to be protected from the effects of humidity during an era when public buildings were not heated), Burgh constructed a long, rectangular building, one without any particular grace, built atop a double and powerful arcade serving as stilts.

The large reading and preservation room known as the Long Room measures $209\frac{1}{4}$ ft. long (63.8 m), approximately $7\frac{1}{2}$ ft. wide (2.3 m), and a little over 49 ft. high (15 m), a rather grand space for an institution that was still fairly modest. To accommodate a large amount of books without blocking the light from the windows, Burgh designed the bookshelves to be set perpendicular to the long walls framing the bay windows, thus creating a series of twenty alcoves, or carrels, on either side. Each alcove was furnished with benches and a tilted desk for consulting the works. Old engravings depict a library bathed in light. In fact, administrators of the institution did not deem it necessary to install electric lighting until 1960. The alcoves were designated "A" through "W" on the north side and "AA" through "WW" on the south side, and the second level, "a" through "o" (or more) on one side and "aa" through "oo" on the other side. Each book was lettered accordingly. This system remained in use until 1830.

In 1801, the life of the library changed drastically. At that point, the British parliament in London instituted a copyright system for all books published in the British Isles, and Trinity received the

right to retain one copy of each publication for Ireland. At the beginning of the 1840s, the Long Room possessed some 90,000 volumes and had passed the saturation point, with 1,000 to 2,000 works continuing to arrive annually. Some expedient measures were taken, involving some unusual stacking solutions for the books, but in 1856 an alarming report on the strength of the building's roof forced the administrators to take drastic action. After some brainstorming, the architects Deane and Woodward suggested eliminating the original flat ceiling with its moldings and, in order to regain the space between it and the roof, creating a wooden barrel vault that would open up a considerable height over the gallery. This solution was rapidly implemented and greatly criticized at the time by the directors. Today, the vaulting is highly admired and most people are not aware that it dates from the nineteenth century. These important reparations (the central pillars concealed behind the ground floor arcade needed reinforcement and were quickly filled in) enabled the collection to expand by 86,000 volumes. Trinity clearly illustrates the endless struggle that national libraries battle to cope with the growing tide of incoming printed matter as a consequence of the institution of copyright laws. The books, in ever-growing numbers, were sent to other university buildings prior to the construction of a significant extension built between 1963 and 1967. Today, the Long Room contains only old books, those that are consulted rarely, if ever. All the same, it keeps an important place in the history of libraries as its purpose—uncommon at the time—was to create a library for students to pursue knowledge, and not for the prestige or the greater glory of God.

Although perhaps the most famous, the *Book of Kells* is not the Trinity's only treasured possession. Aside from its collection of Egyptian papyri, documents on the history of Ireland, manuscripts by Synge, Yeats, and Samuel Beckett, as well as countless ancient works, the library also has seven manuscripts dating from the sixth to ninth centuries: the *Book of Durrow*, a stunning work of calligraphy; the *Book of Dimma*, used to bring the Good Word to the infirm; the *Book of Molling*, a gospel whose pages have recently been reorganized; the *Book of Armagh*, the oldest book of the New Testament found in Ireland; the *Usserianus Primus*, which was undoubtedly executed by monks who had traveled in Europe; and *Usserianus Secundus*, written and illuminated on vellum as hard as horn. The story of the *Book of Kells* is the best known, but at the expense of accuracy. For a long time, it had been attributed to Saint Columba (521–597), prince of Ulster, who had spent his life copying and illuminating the gospels. He defied his king in order to copy a gospel without permission and then took refuge on the Scottish island of Iona, which, under his influence, became one of the most important sites of Celtic Christianity.

Later, following repeated attacks by the Vikings, the clergy left Iona for Kells, northwest of Dublin, where the manuscript remained until its acquisition by the Archbishop Ussher. We now know, however, that the book could only have been produced around 800, long after the death of Saint Columba. And so go legends. But when the magnificence of its execution, the supreme refinement of its illuminated graphics, the elegance of its script is considered, it nevertheless remains one of the most ambitious examples of copying and illustration of its period, and worthy of true admiration. ✎

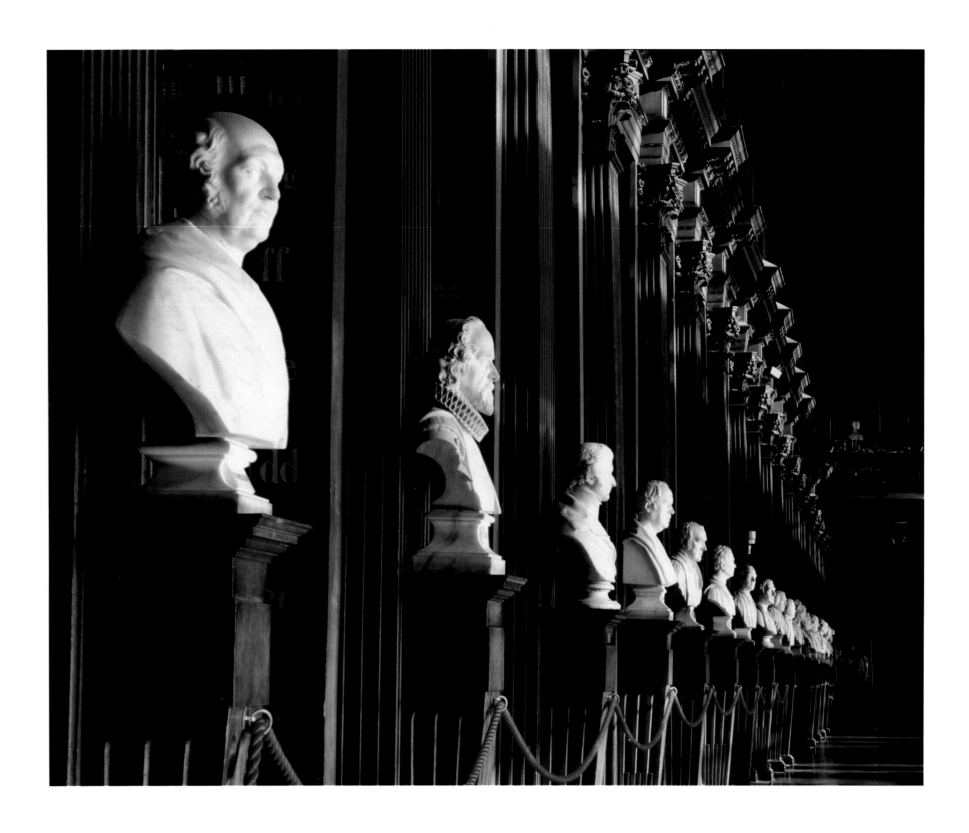

Beginning in 1726, marble busts were placed at the entry of each alcove on both the ground floor and the gallery. Executed by sculptors such as Roubilliac, Van Nost,

and Scheemakers, all famous during their lifetime, the busts are of philosophers, poets, historians, and, ever increasingly, benefactors and professors of the university.

Following spread: The Long Room and its two levels of alcoves are illuminated by the sunlight coming through each of the bay windows. In 1861 a barrel vault replaced the original flat ceiling.

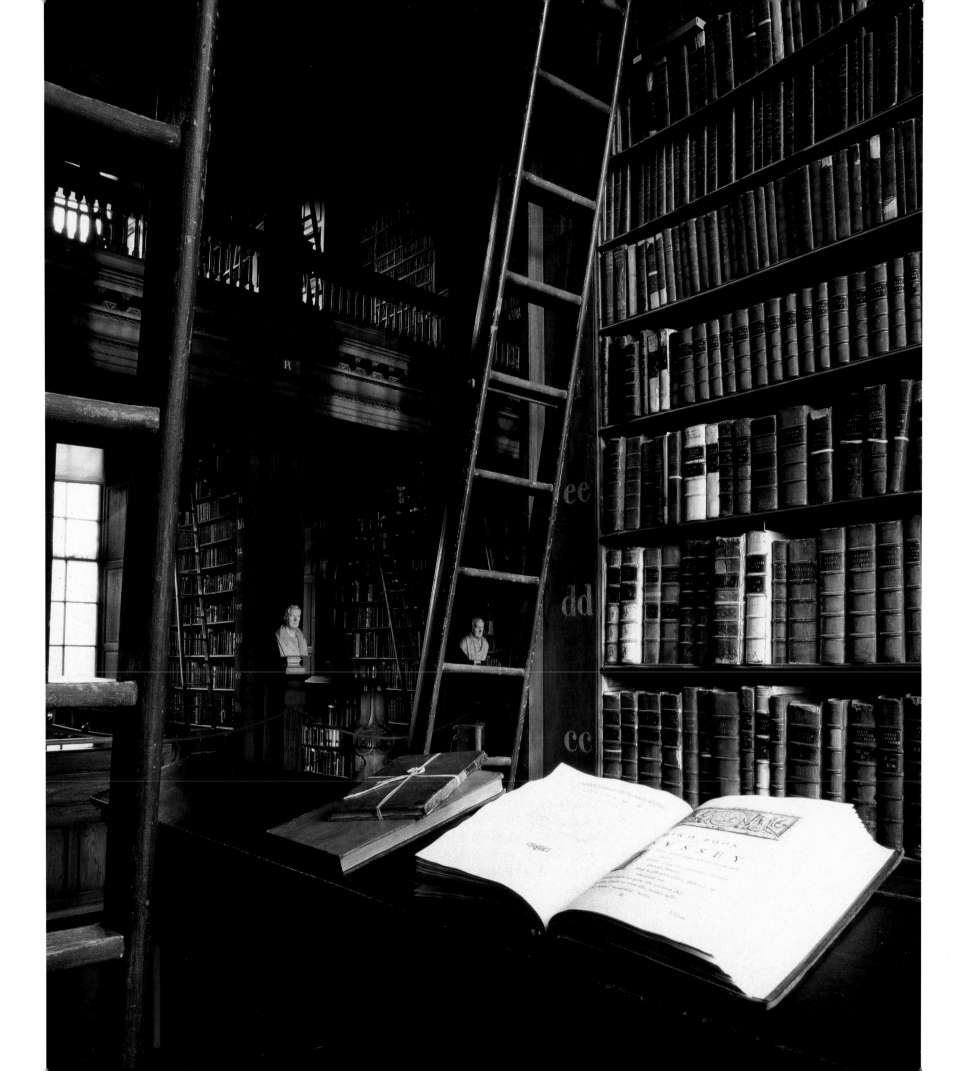

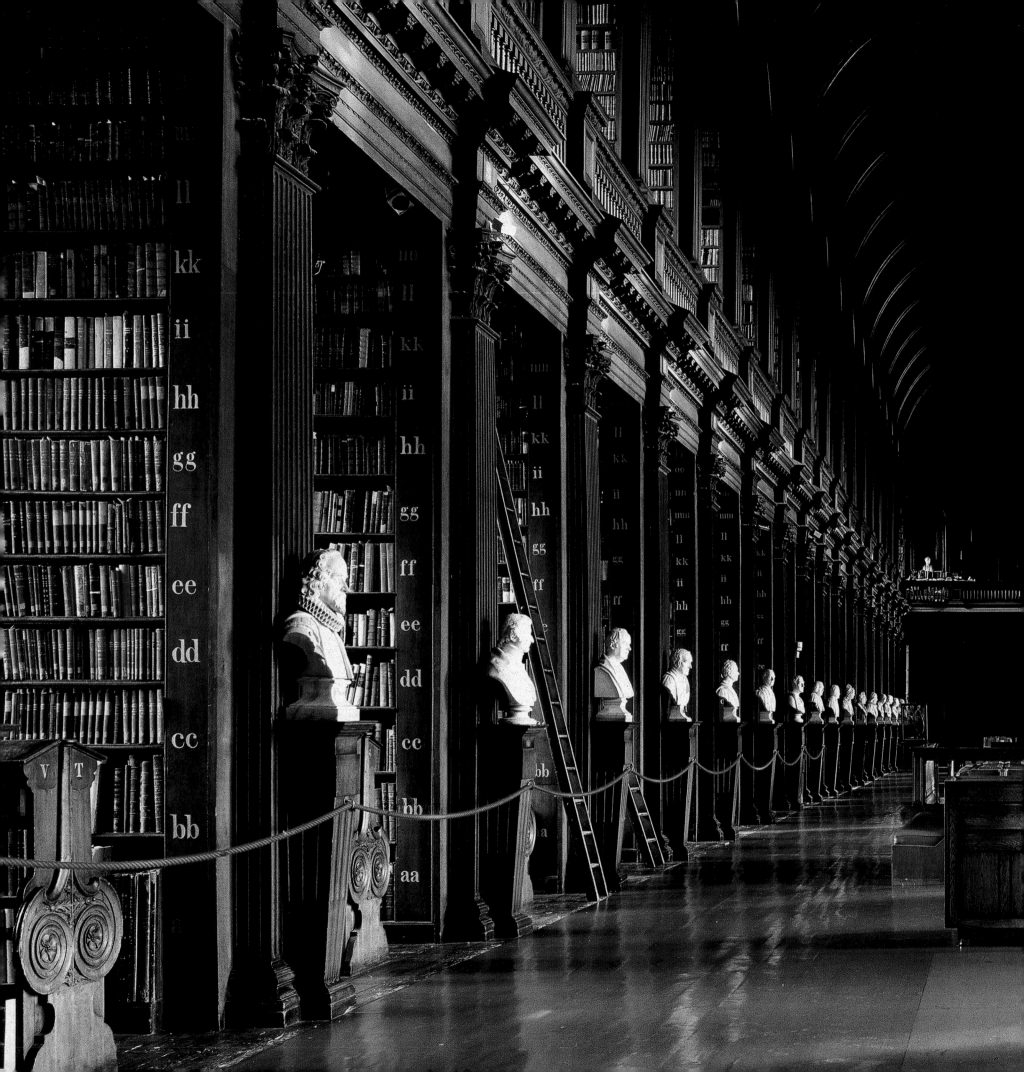

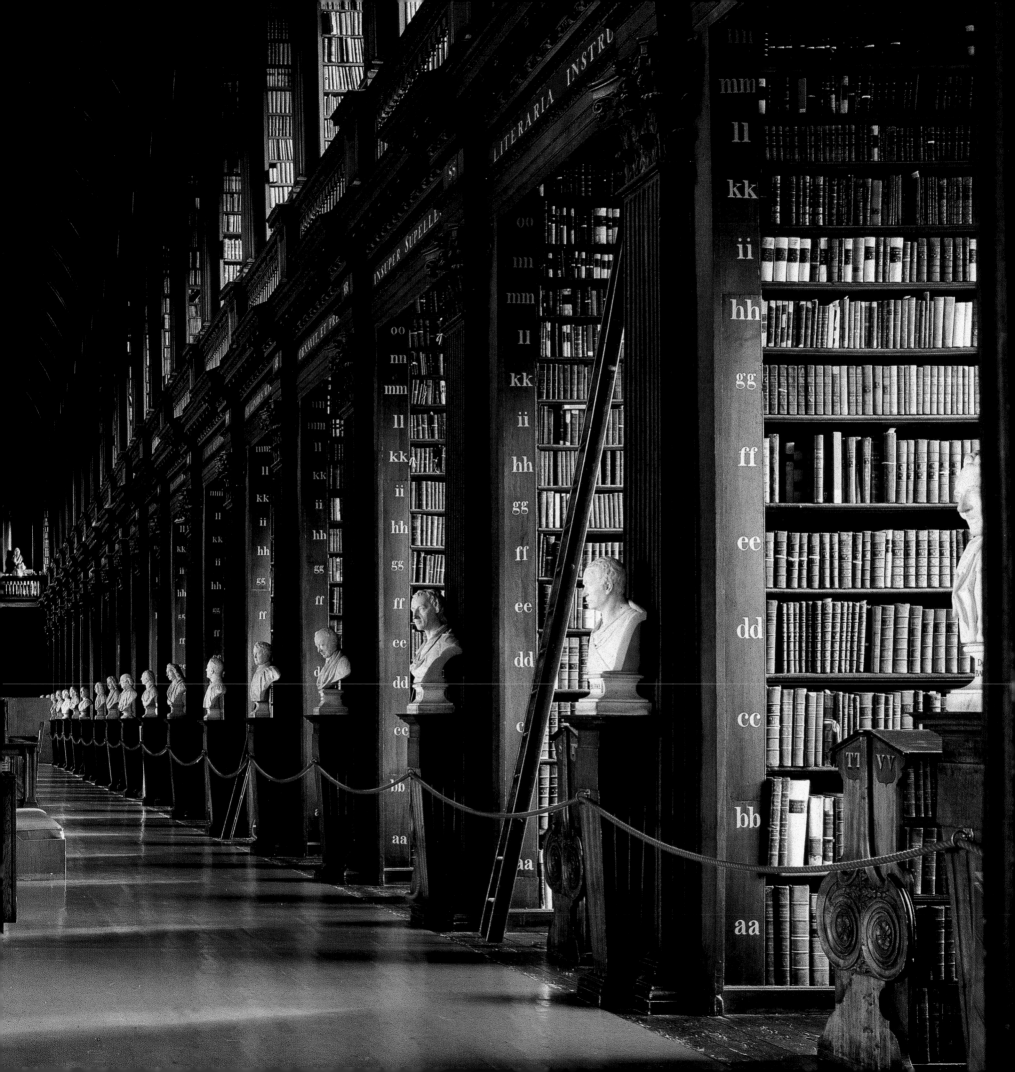

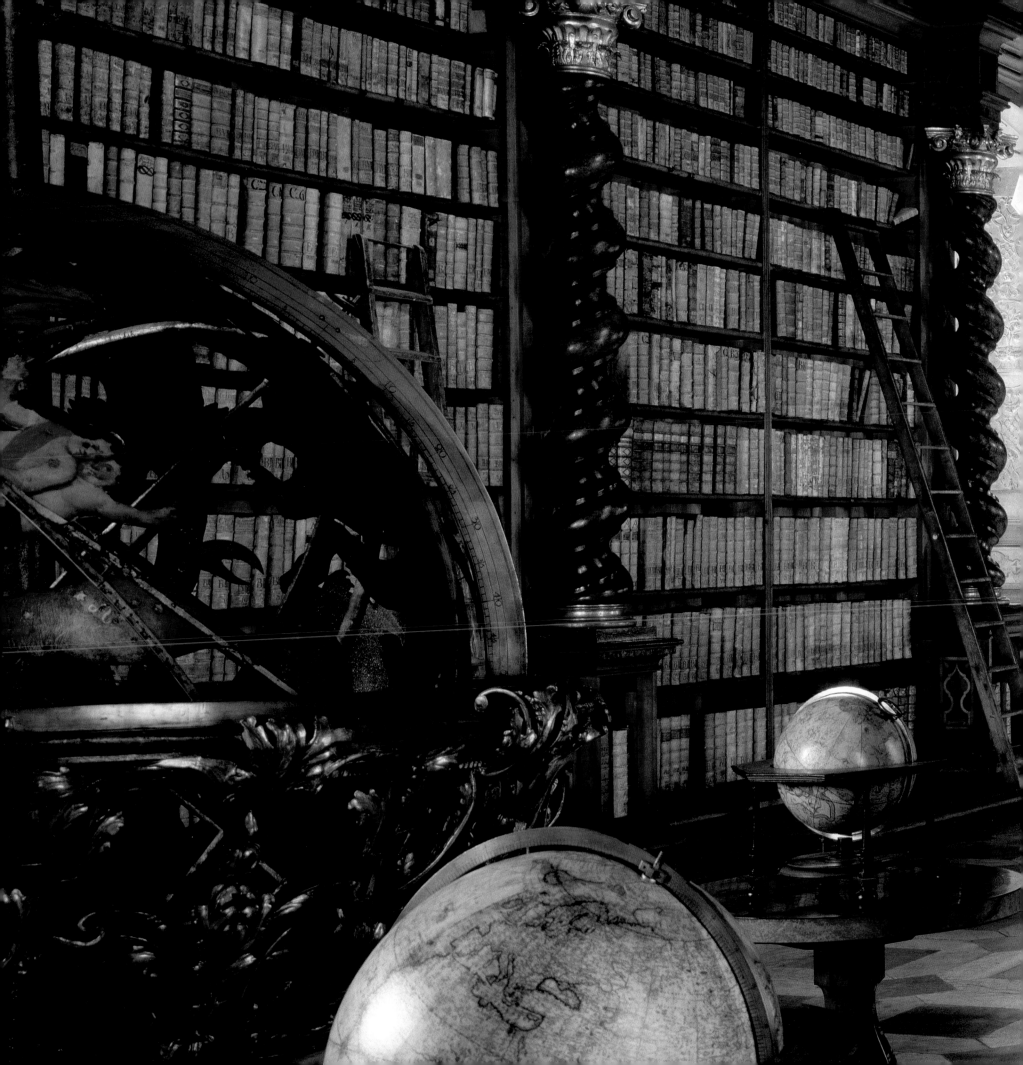

The library was run by the Jesuits for only about fifty years. In 1773, with the pope's suppression of the Society of Jesus, the Jesuits left the Klementinum to the university, and the library, placed under the protection of Empress Maria Theresa, became the Imperial-Royal Public and University Library. Despite numerous name changes—finally becoming the National Library in 1990—it has maintained the same function to this day.

Today, the Baroque hall presents only a fraction of its collection of some six million volumes—a figure that grows by more than 80,000 works a year, in part due to copyright deposits. With a touch of pretentiousness, the library claims that it dates back to 1366, the year the university library was founded, making it the oldest state library in Europe. While its historical collection largely focuses on the history of Bohemia, the library also has numerous Eastern and Greek manuscripts (on papyrus), as well as the codices presented to the university by Charles IV upon its founding in 1366. These include the 1085 Vysehrad Codex, copied on the occasion of the coronation of the first king of Bohemia, Vratislav I, and the Passional of Abbess Kunhuta, rewritten and illuminated at the scriptorium of the Saint George Monastery, housed in the same Prague château. Also to be found here is a part of Tycho Brahe's personal library and such great seventeenth- and eighteenth-century libraries as those of Kinsky and Lobkowitz. The music section brings back to life the extraordinary radiance of Prague's musical families. In particular, there is a Mozart collection of incomparable richness. Frequented by many celebrated readers—in the twentieth century Tomás Masaryk, Edvard Benes, and Václav Havel—the library has played, and continues to play, an essential role in the understanding of Central European cultural and religious history, and remains a brilliant testimony to a Baroque style at its apogee. ✎

RELIGIOUS CONGREGATIONS WERE OFTEN DIVERTED from their spiritual objectives by worldly power, whose concerns temporarily supplanted those of the Catholic Church. This happened in 1556, when Ferdinand I, the emperor and king of Bohemia, bestowed upon the Jesuits the ruins of the Saint Clemens Dominican monastery in Prague, on the Vltava River. The truth was, he needed the religious fighting spirit to circumscribe the influence of the University of Prague, which was too open to Protestant thought and the power of the local aristocracy. The heresy of the Hussites was still quite fresh, and the Hapsburgs entered into an intense Germanization and Catholization of the Kingdom of Bohemia, their personal domain. The Jesuits received all the necessary support and attained such a degree of power that by 1622 they took over the administration of the university and, in 1653, started construction of the Klementinum, which had originally been conceived simply as a college adjoining the Church of Our Savior built in 1601. Three churches and more than thirty houses were razed to make room for the new construction. The Italian architect Carlo Lugaro (1618–1684) started the project and then passed it on to his colleague, Francesco Caratti (died in 1679), who was particularly talented in the Baroque style epitomized by the enormous Czernin Palace, where the motif of repetition continued to infinity. In the course of one century, eight architects, both Czech and Italian, succeeded one another building the largest architectural complex in Prague after Hradcany.

The Klementinum was a university complex that could be described as functional for the period. It was built in the immediate vicinity of the Charles Bridge and occupied five acres (two hectares) plotted on a strict orthogonal plan. The grounds were divided into four rectangular courtyards bordered by long wings that were punctuated by clock towers, immense entryways, and an observation tower where Tycho Brahe's astronomy instruments have been collected. The library, which is housed in the former Jesuit College, was installed by Frantisek Kanka between 1721 and 1727 and is one of the most splendid examples of Prague Baroque. Despite the vicissitudes of first Bohemian, and then Czech history, the library has retained all of its original eighteenth-century splendor. The books collected by the Jesuits were rebound in white, their titles embossed in red, and constitute an impressive collection of theological works written in all languages except Czech. The twisted wooden columns, the gallery defined by the alternation of recesses and juts, the gilded wrought-iron balustrade, the gold of the capitals, and the mount of the globe, along with the marble mosaic of the floor all coalesce in a decorative polyphony to create an elegant harmony. The gaze is drawn to the ceiling and the trompe l'oeil masterpiece of Johann Hiebel, the artist who painted the stunning frescoes at the monastery-château in Doksany. The iconographic composition encompasses three levels. In the window embrasures are reproductions of the emblems of the *Iconologia* that Cesare Ripa (1560–v.1623) composed in Rome, and that use 326 emblematic figures on various themes such as the four elements, the virtues, and wisdom. On the middle, or gallery level, are portraits of famous Jesuits. But without question, it is the ceiling that attracts the eye. Here is the impression of a third level, replete with false balconies on which stand various characters representing the life of the Church. The central section, under an illusory cupola, is dedicated to meditations on the sacred texts, while on either side two huge compositions are depicted: to the north, the seven muses and to the south, the Transfiguration of Christ set between Moses and Eli. The point is to demonstrate how wisdom from antiquity led the biblical prophets to knowledge and the teachings of the Catholic Church. Displayed on the floor, globes of the earth and the heavens, fabricated and decorated at the Klementinum, make the sky and the earth tangible.

THE CZECH REPUBLIC

PRAGUE

THE NATIONAL LIBRARY

Panorama: Sculpture, painting, carpentry, stucco, wrought iron, and gilded wood—all of the fine and applied arts coalesce to create a rich décor. Every space is filled or covered.

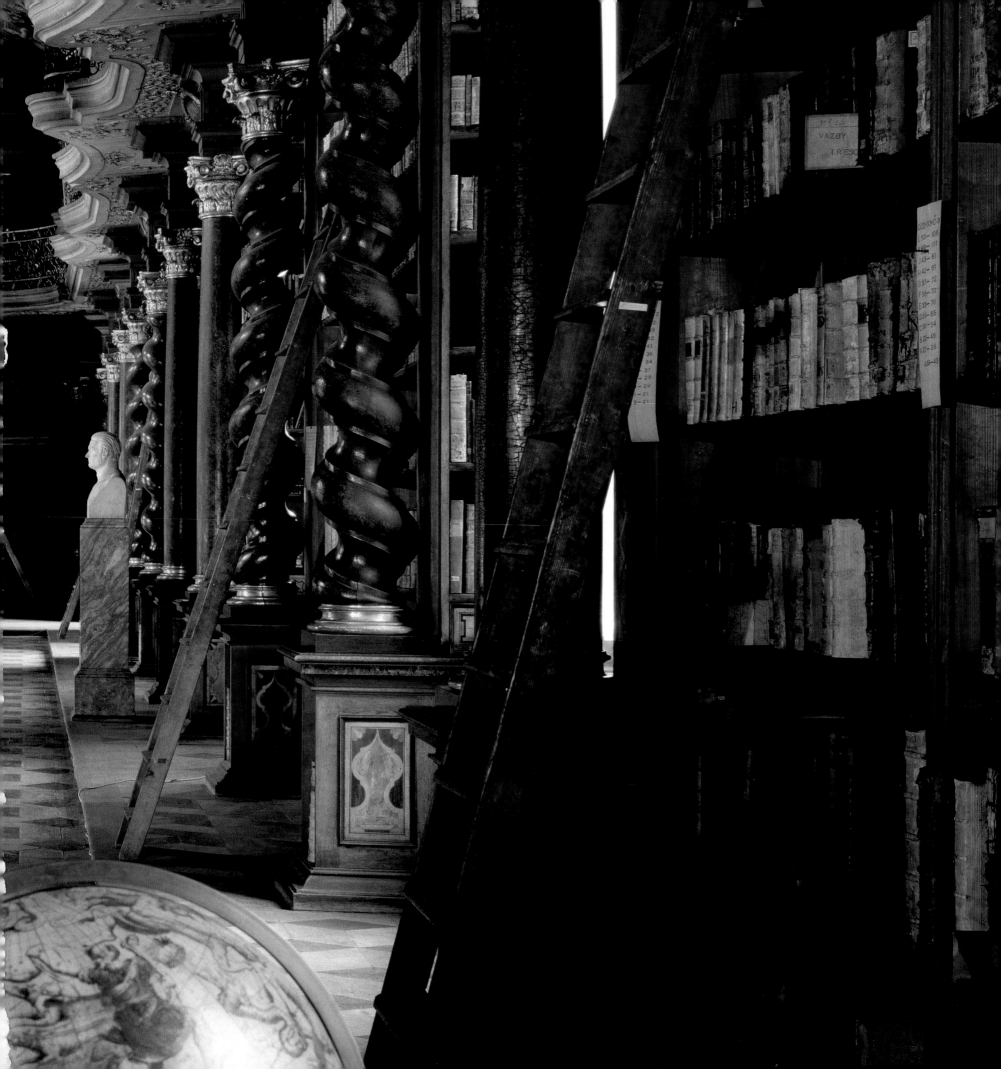

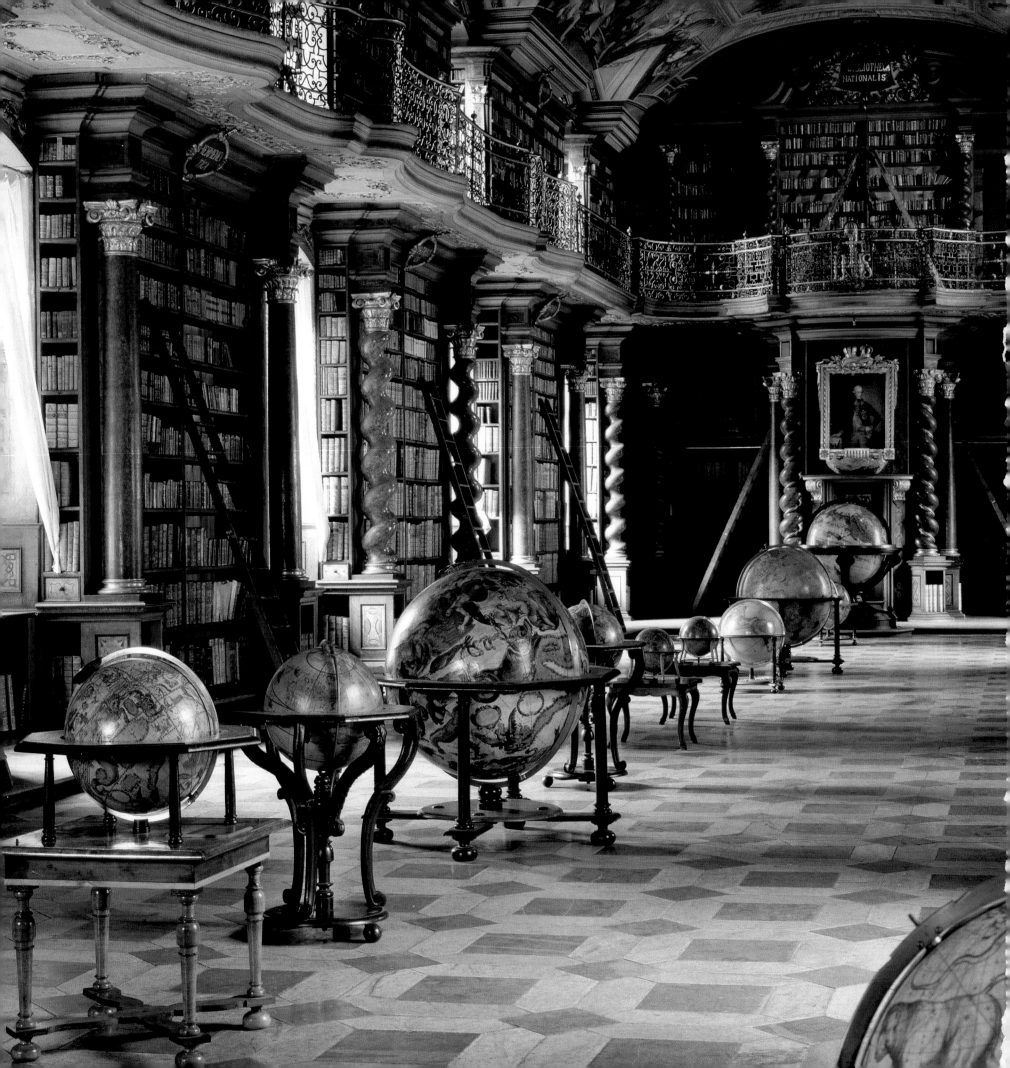

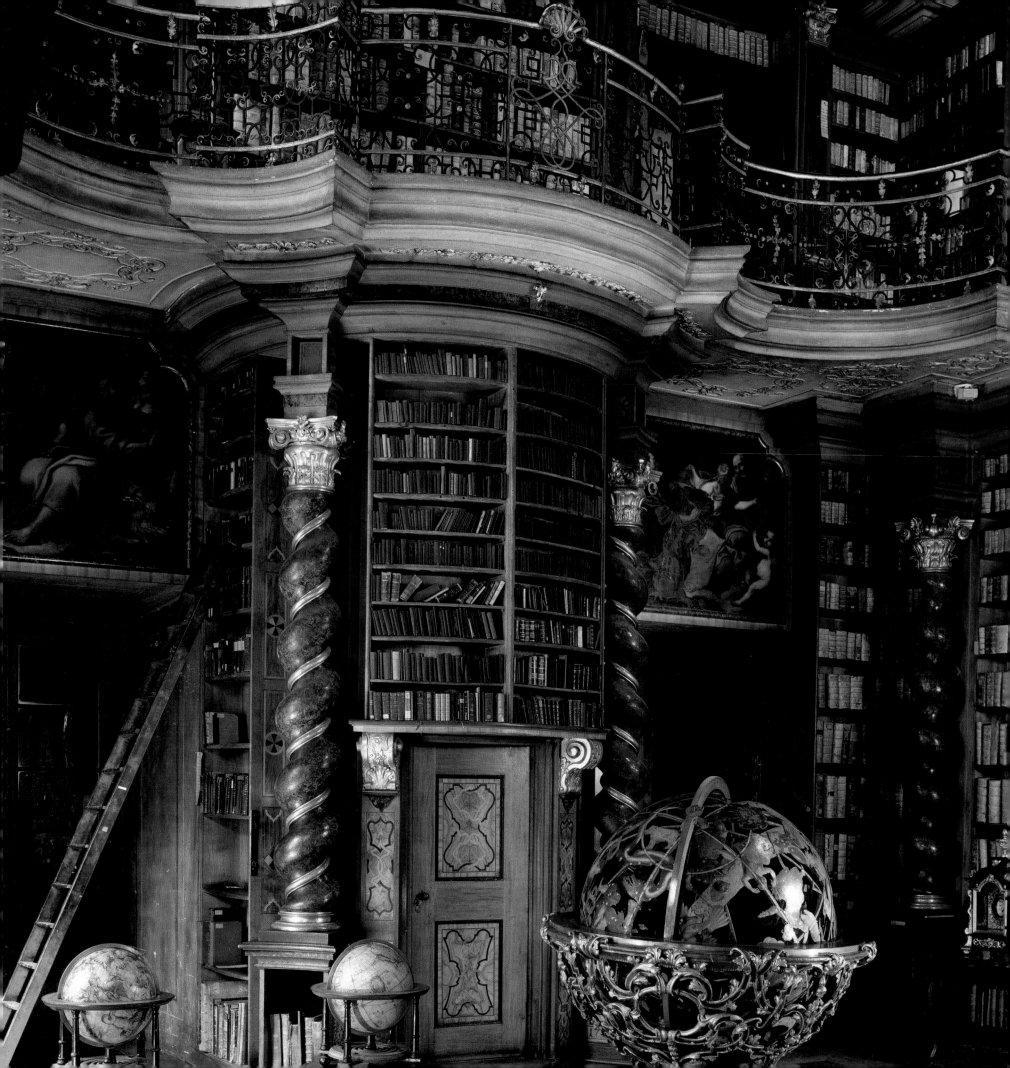

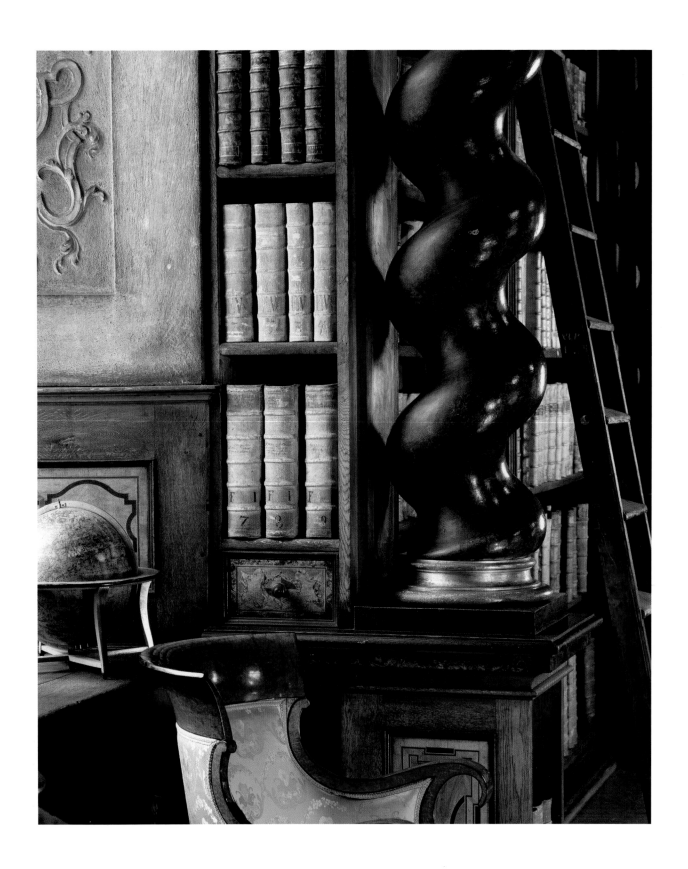

Above and left: Now used as a museum, the main hall holds the rarest works, as well as a collection of globes that date from the sixteenth and seventeenth centuries.

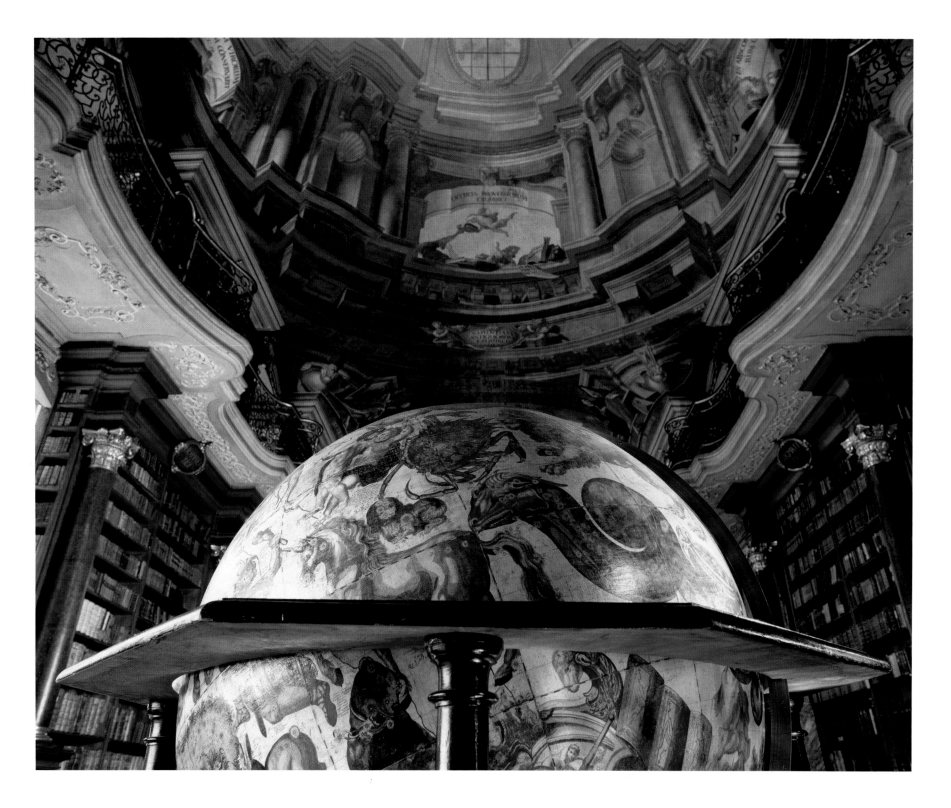

Above: The stunning trompe l'oeil frescoes by Johann Hiebel draw the eye upward and confound the true
(already impressive) scale of the hall. In the foreground, a globe of the world commissioned in 1724.
Right: A globe of the world in sheet iron; the work of Kaspar Pflieger, a Jesuit and professor of mathematics at the Klementinum.
Presented to the library in 1727, this self-turning globe of the constellations is operated by a mechanism concealed in the stand.

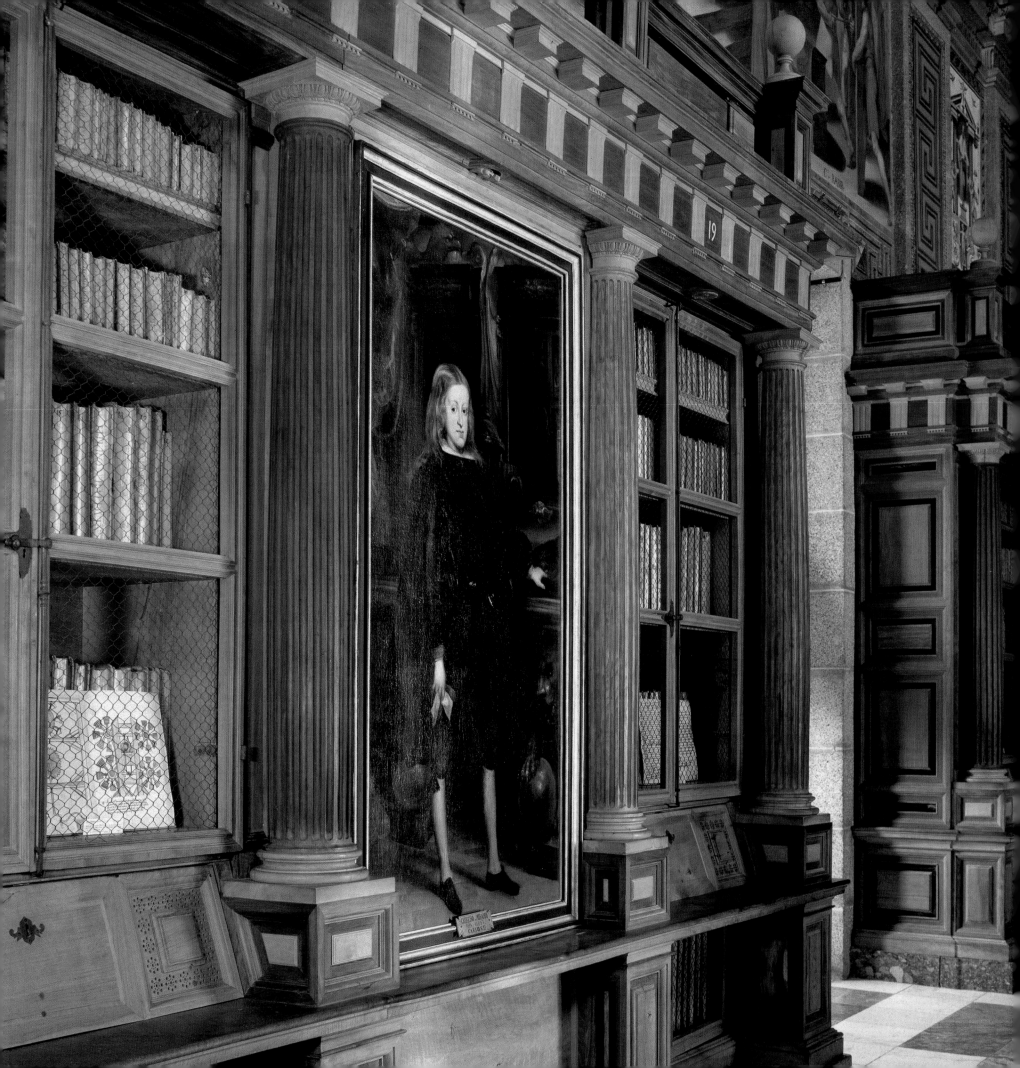

THE LIBRARY OF THE ROYAL MONASTERY OF EL ESCORIAL

TWO FRENCH KINGS, FRANÇOIS I AND HENRI II, perpetrated seven successive wars beginning in 1519 in an attempt to counter the "extravagant expansion of the house of Austria" (P. de Vaissière), exhausting both their energies and their kingdoms. The bloody defeat of France at the Battle of Saint Quentin in 1557 put an end to the Treaty of Cateau-Cambrésis and sounded the death knell for France's designs over Italy. Begun as an act against Emperor Charles V, the conflict proved a victory for his son Philip II, who inherited all his father's possessions, save Austria. To commemorate the victory, the pious Philip chose to erect a monastery dedicated to Saint Laurence, the patron saint of that victorious day.

And thus was born El Real Monasterio de San Lorenzo del Escorial. A few years later, the king looked kindly upon a project to create a "public" library of the sort that then existed in Florence and Venice. The already celebrated University of Valladolid, where until only recently the capital of Castile had been located, seemed the ideal site for such an institution. The king, however, was partial to the medieval model of the monastery library and decided to house his bibliophilic treasures in the future Saint Laurence Monastery. Contrary to all expectations, he chose an out-of-the-way site, the hamlet of El Escorial to the north of Madrid at the foot of the Sierra Guadarramas, and entrusted the project to the Hieronymite monastery, an order that accepted only "blue blood" novices (i.e., without any trace of Jewish or Moorish blood), and was well known for the technique of its choral chants. The books would be at the disposal of the monks and "available to all men of letters who cared to come read them." Because it was so far from everything, at a distance that seemed much greater then than it does now, such wishes were not very realistic and led the poet Luis de León to comment, "These books will be buried treasures." Long

considered by Spaniards to be the eighth wonder of the world, El Escorial was designed by Juan Bautista de Toledo, a former assistant to Michelangelo at Saint Peter's in Rome. The plan is said to represent the grid upon which Saint Laurence was martyred. Upon the death of the architect in 1567, his assistant Juan de Herrera became Arquitecto de Su Magestad (Architect of His Majesty). He gave the project his refined style, which drew upon Doric influences pushed to the point of abstraction, marking the first great appearance in Spain of a national architecture. Of a rare austerity, a true nobility, and imposing size, the royal monastery constructed in light-colored stone covers more than eleven acres (45,000 square meters), and has no less than fifteen cloisters, 300 cells, eighty-six staircases, nine towers, fourteen entry halls, and 1,200 doors. The church was dedicated in 1586, but the entirety of the work was not completed until 1654.

The king's project sprung from a humanist spirit. For him, knowledge did not only dwell in books, but in maps, globes, paintings, scientific instruments, and the thousands of marvels and curiosities brought back on his ships from far-away places. The royal library consists of five rooms distributed over two floors.

The main hall, also called the Print Room, is decorated in a style that is in sharp contrast with the austere architecture. Despite its large size (177 x 30 x 33 ft. [54 x 9 x 10 m]) surprisingly few works are on display. The bookcases, designed by Juan de Herrera, reach only halfway to the ceiling and the lower portion (some 31 in. or 80 cm from the floor) has a tilted desk for consulting books. The marble floor is three shades of gray and the frescoes, primarily the work of Pellegrino Tibaldi (1527–1596), are based upon a theme defined by Father José de Sigüenza. The barrel-vaulted ceilings are divided into seven sections, each illustrating the liberal arts: gram-

mar, rhetoric, dialectics, arithmetic, music, geometry, and astronomy. On the two long sides of the hall, above the bookcases, are impressive friezes depicting anecdotes that correspond to the particular liberal art dramatized on the ceiling above it. For example, grammar is represented by the Tower of Babel, symbolizing the usefulness of knowledge of languages in an empire as large as that of Charles V. At either end of the hall is a semicircular tympanum—in the northern end, philosophy (acquired knowledge) is depicted, while a representation of theology (revealed knowledge) decorates the southern end. This is the only direct suggestion that this place is part of a religious institution.

The High Room, on the floor just above, is identical in size to the main hall. In the past, it contained banned books that were confiscated during the Inquisition. Today, however, it is empty for the most part and in a rather deteriorated state.

The Summer Room, perpendicular to the main hall, is divided into two parts; the larger has manuscripts in Greek and Latin, and the smaller is reserved for manuscripts of other languages, primarily Arabic. While in the past it also held plans, maps, and instruments for calculations, now there is only a single globe of the heavens adorned with a portrait of Tycho Brahe and a globe of the earth made in 1660 that illustrates the geographical discoveries of the era. During different periods throughout Spain's history, many of the treasures originally in El Escorial were moved to museums and palaces in Madrid.

The Manuscript Room, a former monks' cloakroom converted in 1862 into a library for old manuscripts, is decorated with fourteen allegorical paintings from the eighteenth century on the theme of the liberal arts, as well as portraits of important people.

Father Alaejos's Room was destroyed by a fire in 1671 and no longer has its original décor.

An addition of a study room was made in 1875 for the consultation of catalogues and for reading.

Although the library contains only 45,000 printed works, its rich collection of manuscripts numbers 5,000. Their extraordinary quality reflects the ambitions of King Philip II, who was passionate about books and writing in general. He was anxious to leave written evidence of his administration and demanded so many reports that his reign was referred to as "government by paper." On a single day at El Escorial, he signed more than 400 documents. He inherited many precious manuscripts, including the gilded *Book of the Gospels* written for Emperor Henry III, a treatise on the baptism of children that was long believed to be in the hand of Saint Augustine, but which dates to a later period, and another *Book of the Gospels* that belonged to Saint John Chrysostome. A true bibliophile, it appears that the king had researched exceptional works, rendering the names of their previous owners even more famous. From the Inquisition tribunal in Toledo he obtained the celebrated *Libro de la Vida*, the handwritten autobiography of Saint Theresa of Ávila. He also managed to get an Apocalypse by Saint John, which had belonged to his aunt, Maria of Hungary. He researched and bought rare books from all his territories—Aragon, Castile, Catalonia, the Netherlands, and Flanders, arguing bitterly with abbots and priors who knew his tastes as a collector and demanded extravagant prices. He was able to acquire a good portion of the libraries of the Spanish kings of Naples, which contained numerous Greek codes and Visigoth manuscripts. The Inquisition, which he instituted, hunted down prohibited books, and the king provided some of them an eternal asylum. At the end of his life, his collection contained 2,820 manuscripts (of which 1,870 were in Arabic) and 1,700 printed works.

The Order of the Hieronymites did not have a tradition for study. The first librarian, Arias Montano, organized the books according to a method of his own making, separated them according to language and medium (printed matter or manuscript), and put them into sixty-four categories. The label glued to the spine of each work was so large that it more or less concealed the neighboring books. Users found this arrangement confusing and "horrible." Moreover, the king had taken to reshelving the books with their spines to the wall to protect them from light, writing the title on the gilded edge according to a custom initiated by Christopher Columbus's son Hernando at the famous Biblioteca Columbina in Seville.

After the death of Philip II, the library fell into a kind of oblivion. The Hieronymites were no longer able to recruit a librarian from their ranks who could read Greek. During the fire of 1671, the monks attempted to save the precious volumes by throwing them out the windows. Those that managed to survive were unfortunately consumed by the flames from an Ottoman banner brought back from Lepante, which, already on fire, was also thrown out the window. Philip V, the first Bourbon of Spain, decided to create a national library in Madrid, and the one at El Escorial completely ceased its acquisitions. The French under Joseph Bonaparte pillaged the monestary; the books were moved to Madrid. The collection was reorganized and seriously catalogued in 1885, when the library came under the control of the Augustinians.

Despite these vicissitudes, the monastery-palace at El Escorial and its library remain one of the last great examples of the preoccupations of Renaissance men, one of the last testaments of the culture of the Germanic Holy Roman Empire at its height, and one of the most brilliant expressions of Spain's Golden Age. ✐

Opening page: Portrait of the future King Charles II at age fourteen by Juan Carreño de Miranda (1614–1685). It replaces a portrait of King Philip IV by Velázquez that was seized by Napoleon's armies and now hangs in the National Gallery in London. Right: Homer by the Bolognese painter Pellegrino Tibaldi (1527–1596).

OMERO

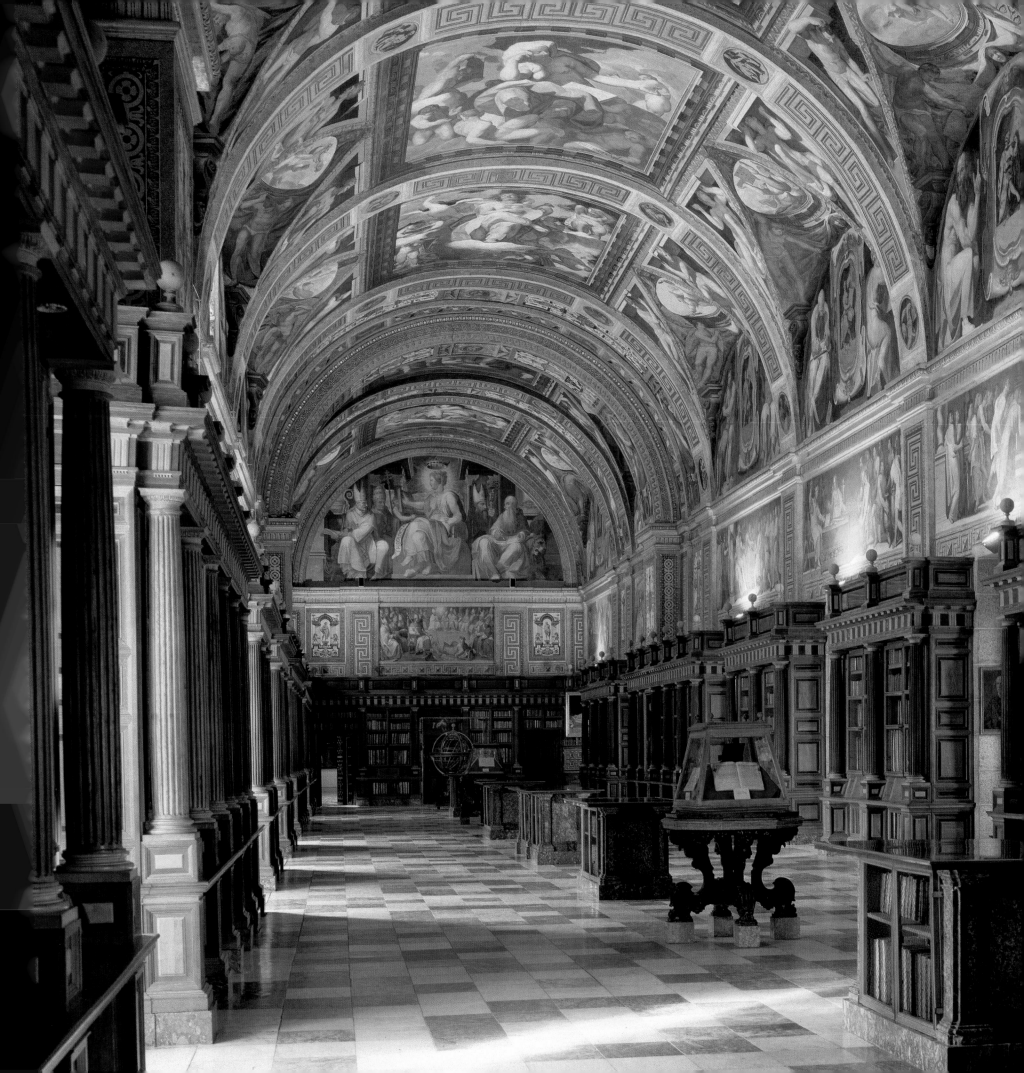

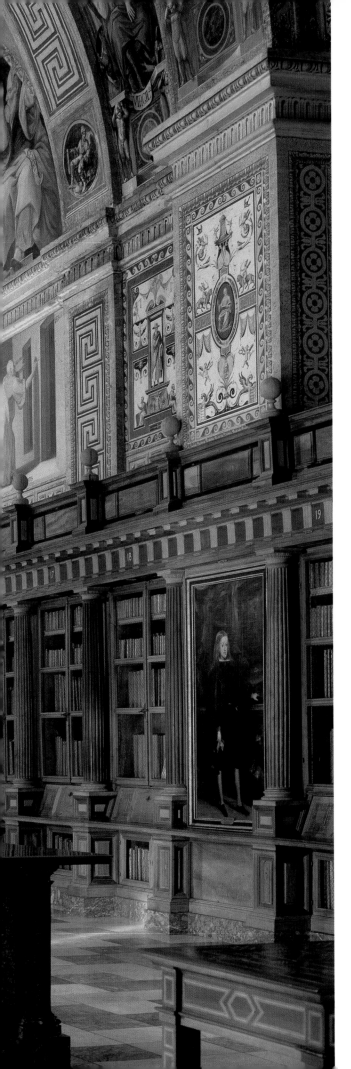

Above: Lateral frescoes by Tibaldi depicting historical stories linked to allegories of the liberal arts. Here, for example, is the assassination of Archimedes during the seizure of Syracuse in 212 BC. Left: The grand hall. Its furniture was designed by Juan de Herrera (1530–1597), one of the originators of a national Spanish architectural style that endured through the middle of the twentieth century.

Above: In the embrasure of a window in the Manuscript Room, a portrait of Brother José de Sigüenza, librarian to Philip II,
who was responsible for the iconographic schema of the grand hall; attributed to Bartolomeo Carducho and dated 1602.
Right: By the order of Philip II, the precious works were—and remain—shelved facing
the wall so as to protect the binding from light. The titles are written on the edges.

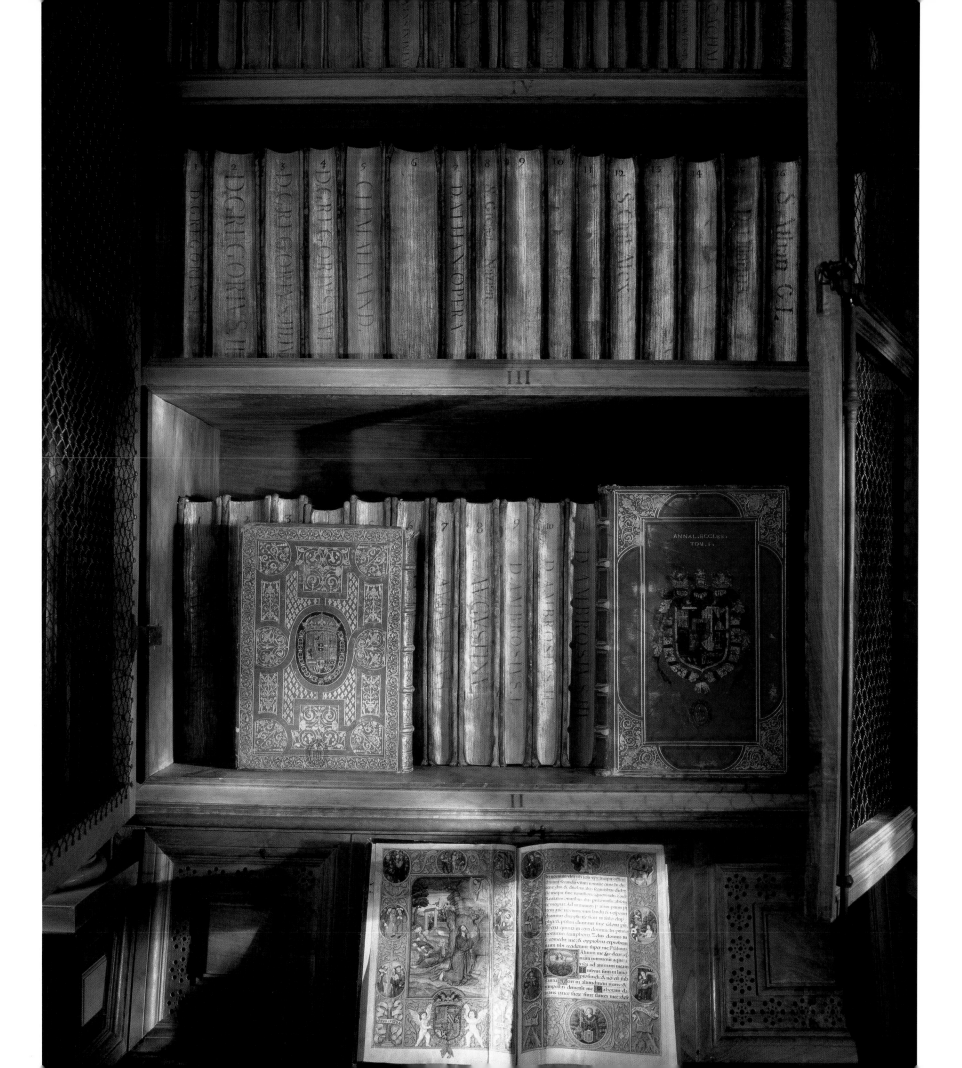

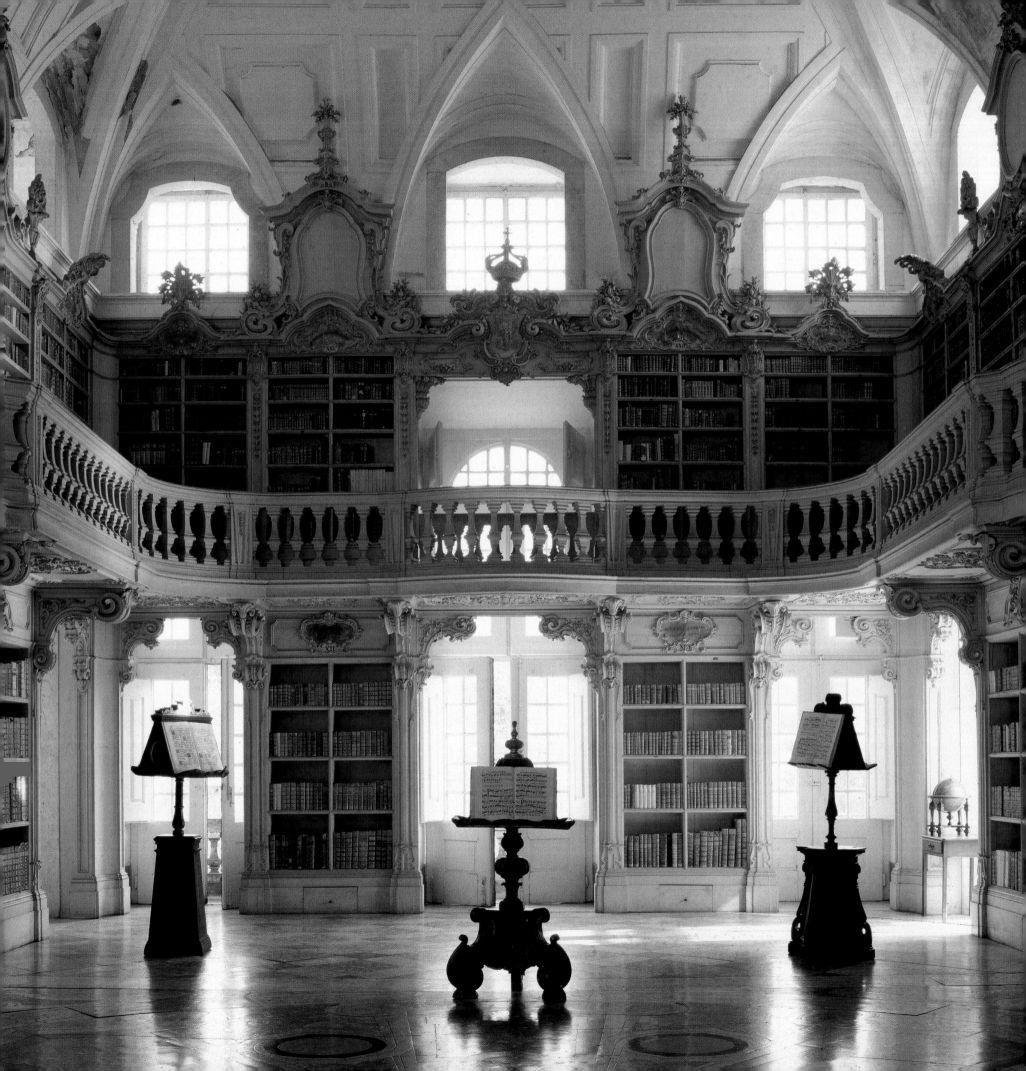

THE NATIONAL PALACE LIBRARY IN MAFRA

THE FATE OF THE ROYAL LIBRARY IN MAFRA, BUILT in the eighteenth century, is closely linked to that of the odd monastery-palace that housed it throughout the vicissitudes of Portuguese history. In fact, the country had largely started its decline just as the library was being built, even if the reigning dynasty in Bragança did not want to recognize this. It was a strange decision on the part of King João V to build, at great expense, a kind of monastic Versailles when he was about to relinquish his enterprises and trade to England in accordance with the Treaty of Methuen, when the Dutch were chasing him out of Asia, and when he took the side of Austria against neighboring Spain, risking a war at his borders. It would be interesting to examine more deeply the psychological motivations of these kings, princes, and archbishops who, between the seventeenth and eighteenth centuries, built countless oversize palaces, summer residences, and palatial hunting pavilions throughout Europe. Certainly Portugal—and above all, the royal family—was still rich, and while the new gold mines discovered in Brazil would finance the construction of Mafra, the importation of gold had slowed down and the colossal undertaking would experience lengthy delays. In fact, the palace was never truly completed. At the time of its completion in 1730, this construction site in the middle of the mountains thirty-one miles (fifty kilometers) north of Lisbon employed 52,000 men, making it a veritable temporary city. When work was done, the celebrations went on for a week. With no less than 65,000 guests attending, the royal finances were threatened. At the same time that he decided to erect Mafra, João V also embarked upon the reconstruction of the university at Coimbra, placing emphasis on its library, which he wanted to be the largest in Europe. Perhaps an optimist, perhaps a megalomaniac, this king chose to build two enormous libraries, each similar in size to the Hofburg in Vienna, some 18½ miles (30 kilometers) apart when his collection of books

could in no way justify such an expenditure, and when the kingdom's future was especially gloomy.

Another explanation has it that the king's decision to build Mafra was the fulfillment of a vow. He had pledged to construct a monastery if his wife produced an heir to the throne. As she held up her end of the bargain, so did he. The heavens thanked him profusely—five more children followed (not counting the many illegitimate ones he denied). The Franciscan Order of the Arrabidos Brothers was suspected of having promulgated this edifying story, perhaps to excuse the grandeur of the sovereign's architectural ambitions.

João V had already reigned for ten years when he decided, in 1716, to build a monastery and church for thirteen monks in the midst of the wild terrain where he loved to hunt. As the years passed, the project swelled, first to accommodate eighty monks, then three hundred monks, and finally, the entire royal family and court. "The Royal Works of Mafra" was assigned to the German architect Johann Frederick Ludwig (Ludovici, in official documents), but it seems that the king, less than confident, had the plans checked in Italy by Juvarra and Carrevari. The first style, an austere, angular classicism, with a tendency for giganticisms, is apparent in the excesses of Mafra. After all the successive modifications, the monastery-palace ended up 406,015 square ft. (37,720 square m), with 880 rooms and bedrooms, 300 cells for monks, 4,500 doors and windows, 154 staircases, and 29 interior courtyards.

The library in the center of the north wing is larger than the church. Its gigantic hall beneath a central cupola (in the spirit of the Hofbibliothek in Vienna) measures almost 287 ft. long (87.4 m), 31 ft. wide (9.5 m), and 42½ ft. high (13 m). Light streams through the large south-facing bay windows, while those opposite are covered with mirrors. The depletion of the Brazilian gold

mines and the 1755 earthquake that devastated Lisbon put an end to the interior decorations, and the Franciscans had to content themselves with temporary bookshelves for the rather few books they had, bequeathed to them by João V upon his death in 1750. The Franciscans were soon expelled and were replaced by Augustinians, who decided to complete the furnishing of the library, handing the work over to the architect Manuel Caetano de Sousa. De Sousa designed an ambitious décor in a kind of Rocaille style that was already outdated when compared to the styles then in fashion in Spain, France, and England, where the "Greek taste" and a desire for antiquity had begun to take hold in royal residences.

In 1771, the two levels were ready to receive books; the second level is accessed by a heavy gallery with balustrades. William Beckford, the extremely wealthy English aesthete who moved near to Sintra in 1781, deemed it all "awkwardly conceived, crudely realized, and darkened by a gallery that projects into the hall in a very clumsy way." All the molding was supposed to be covered in gold leaf and the false dormers were intended to hold portraits of philosophers and famous writers, but these projects were never completed.

In fact, in 1792, the Franciscans returned and took over from the Augustinians. In keeping with their vow of poverty, they refused to gild the woodwork and instead whitewashed it, which with age took on an elegant, parchmentlike coloring. It would not be until 1797 that the books were installed. In 1809, the first great librarian of Mafra, Brother João do Santa Anna, created the catalogue, a manuscript that has not been published to this day. The books remain precisely where they were shelved at the end of the eighteenth century. Portugal entered a difficult period that saw, in 1834, the suppression of those religious orders that had become the greatest landholders in the country. Mafra was emptied and declared a national property, and there were hopes of transforming it into a barracks.

The dream of João V had become nothing more than an empty monastery, a palace that had almost never been inhabited, and a library where almost no one read anymore. The collection contained twenty-two foreign incunabula and 40,000 volumes primarily from the sixteenth, seventeenth, and eighteenth centuries concerning theology, canon law, ecclesiastic history, literature, geography, philosophy, and law.

The Franciscans' vow of poverty, however, has produced an unexpected decoration. Shelved on woodwork that has become the color of parchment, the titles and the gilded coats of arms branded into the leather bindings stand out, as do the glistening page edges of those books that are considered so valuable they have been shelved with their spines turned to the wall for their protection. The light is stunning, unreal, poetic, in keeping with this odd country where the aristocratic elite thrived on faraway dreams for such a long time. At sunset, bats appear that seem to have lived here forever in some hidden nook in the gallery. They have become the protectors of Mafra. Silently, they take wing, exploring their Baroque domain and hunting the insects that dare to attack these forgotten treasures. ❧

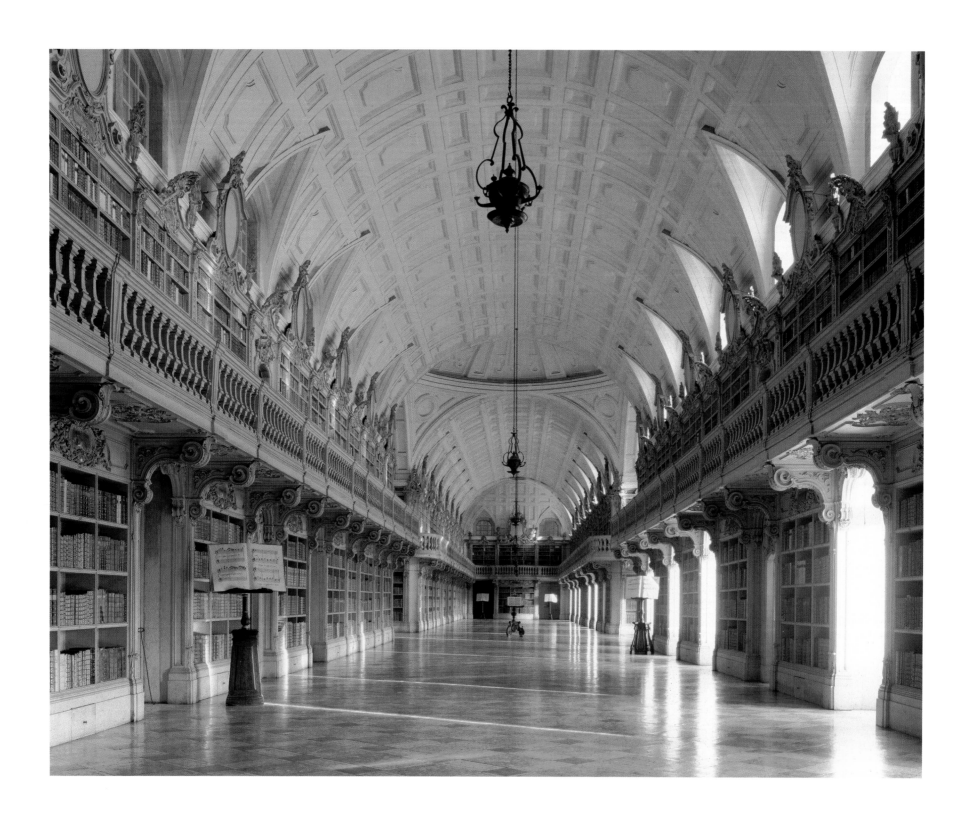

Above: The plan for the monastery-palace library in Mafra was inspired by the imperial library in Vienna. The great hall, measuring 279 ft. long (85 m), is composed of two wings that meet in the center under a cupola.

Right: Beneath the cupola, the 5,000-piece marble floor gives a glimpse of the luxury of the décor as it was originally conceived.

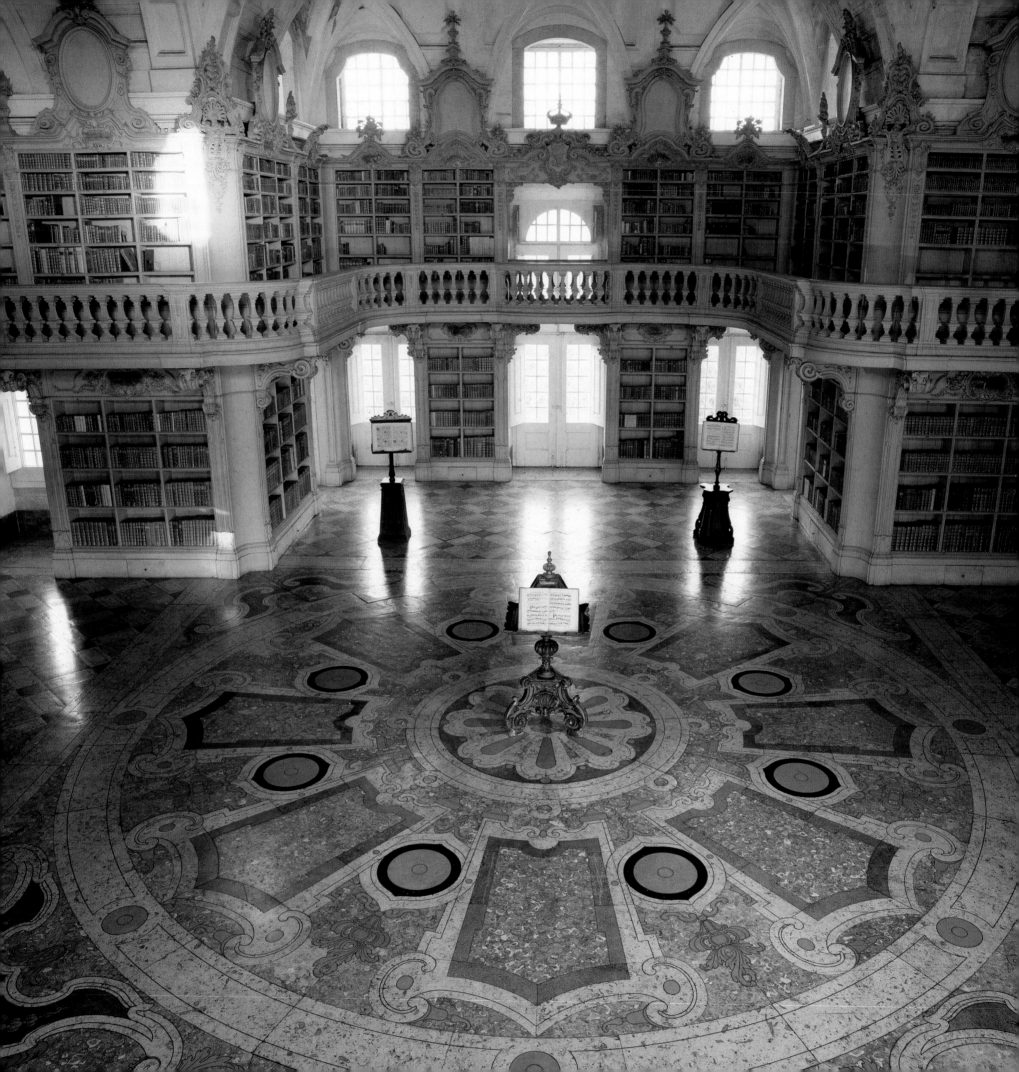

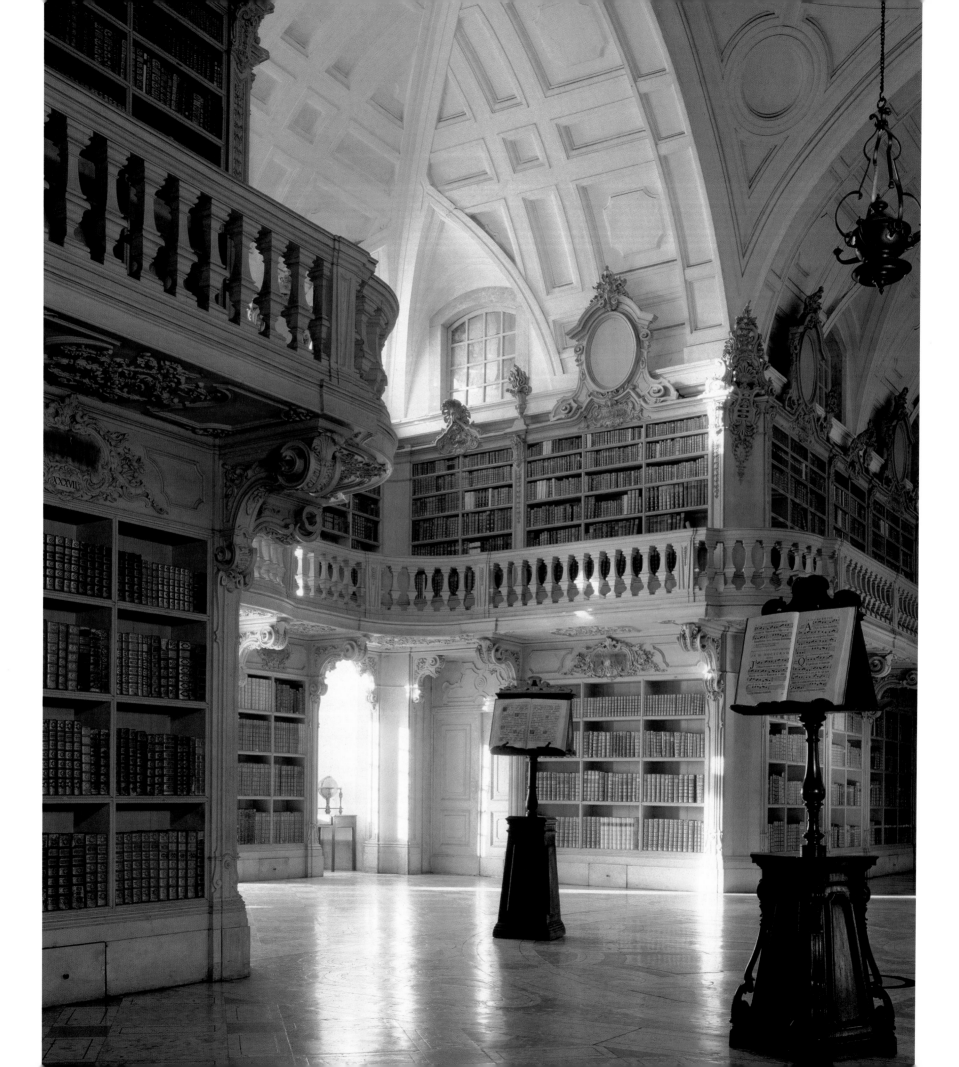

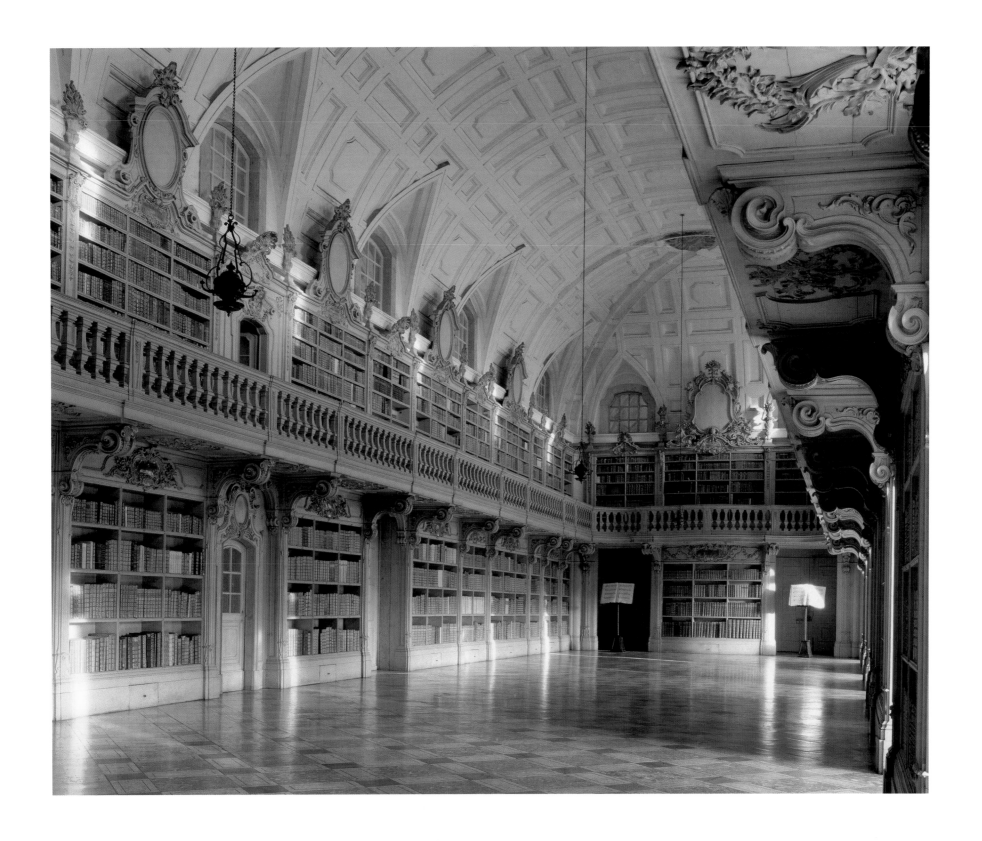

The library was never decorated to the luxurious extent that the architects had foreseen. The construction, which took twenty years longer than planned, fell prey to history. Faithful to their vow of poverty, the Franciscans, who were followed by the Augustinians and later returned to Mafra in 1792, simply whitewashed the woodwork. The gallery on the second level is almost 985 ft. long (300 m).

UNITED STATES OF AMERICA

BOSTON

BOSTON ATHENÆUM

IT WAS THE BEGINNING OF THE NINETEENTH century and Boston was a "European" city *par excellence*, the cultural capital of North America. Established in the 1630s by a group of English Puritans under the leadership of John Winthrop, the colony belonged to the Massachusetts Bay Company founded by an act signed by King James II. Slowly, a society took shape in which the state, commerce, and religion were intrinsically intertwined. Education was one of the primary concerns of these pioneers, who saw themselves far from the mother country, its schools, and its universities. In 1637, one of their first endeavors was to create a seminary in Cambridge on the other side of the river, which would become Harvard University. The wealthy bourgeoisie that earned its living not only through trade but also through property worked by black slaves and sharecroppers, very soon took on aristocratic attributes. A few important families, descended from the first colonists who arrived on the *Arabella*, made up a veritable caste known as the "Brahmins" in the nineteenth century. In 1805, several of the families created the Anthology Society, which published two journals. In 1807, they founded the Boston Athenæum, whose name was derived from Athena, the Greek goddess of wisdom. Their goal was to make "an establishment similar to that of the Athenæum and Lyceum of Liverpool in Great Britain; combining the advantages of a public library [and] containing the great works of learning and science in all languages." The project was ambitious and the first of its kind in America.

The only imaginable location for this institution was Beacon Hill, the "sacred" hill in the center of historic Boston, which has been home to the Athenæum since 1807. The exact site changed very quickly—four different sites in the same area—until in 1847, its administration decided to construct a building specifically for it. The plans were awarded to Edward Clarke Cabot, who was a member of one of the most important families in Boston and the preferred architect of New England high society. He designed a grand neo-Classical building, in which the ground floor contained a sculpture gallery, the second floor a library, and the third floor a painting gallery. The decoration of the grand reading room (recently renovated) was in a style then in vogue in the United States. Classical, sober, and repetitive, its construction made use of a semiindustrial manufacturing process and is slightly boring, though overall very elegant. The hall is composed of a long, central nave off which are numerous alcoves, each illuminated by a large bay window that reaches almost to the floor. The gallery on the upper level is accessed in quite an original manner through the protruding alcove bookcases. The green-painted lattice balustrades, along with the precious carpets, fireplaces, and beautiful mahogany furniture create a décor with a light touch in the style of *House & Garden* that one would be hard-pressed to find in a European library. The conditions for reading are ideal and, except during tours, banquets, and receptions, a sense of calm reigns. The Athenæum calls to mind a London club. Essentially, use is reserved for members who have owned its 1,049 shares since its beginnings, as well as "young" associate members and authorized university students and researchers.

The library's collection—more than 500,000 works—focuses on the history of Boston and New England, biographies, English and American literature, and the fine arts. It possesses one of the largest collections of American documents on the Confederate states, gathered on expeditions to the South at the start of the Civil War. It is also the proud owner of George Washington's library, which it bought through a fund-raising campaign following the death of Henry Stevens, who had acquired it for the British Museum. Its other treasures include the King's Chapel Collection, a set of seventeenth-century religious books presented to the colony in 1698 by the king and queen of England; a remarkable

collection of engravings and photographs on the history of New England and on the Civil War, which contains more than 300 daguerreotypes and 3,000 old photographs; and a rare set of works on Native American themes that was amassed in the nineteenth century by the explorer and ethnologist Henry Rowe Schoolcraft. The collection of paintings and sculptures, quite extensive in the nineteenth century, formed the nucleus of the Boston Museum of Fine Arts, which was initially housed at the Athenæum before being moved to Copley Square in 1876. Some very beautiful portraits by Mather Brown, John Singer Sargent, and Chester Harding remain, as well as busts of Washington, Franklin, and Lafayette sculpted by Houdon.

Like all libraries throughout the world, the Athenæum is periodically overwhelmed by a space problem. From 1913 to 1914, the building was completely renovated and two floors were added. In 1966, it was declared a National Historic Landmark, and from 2001 to 2002, the building underwent a second major renovation carried out this time by the firm of Schwartz/Silver Architects. The objectives were to provide the utmost space for books, create new reading rooms, offer greater comfort to members, and modernize the security systems. The ground floor, in particular, had to be entirely remodeled to accommodate a visitor reception area and to display temporary exhibitions without disturbing the serenity of the reading rooms.

This refined club, one of the showcases of the East Coast American aristocracy, quite wisely opened its doors to researchers—and to the public during exhibitions—and thus continues to play an important role in the intellectual life of the area, as well as in the preservation of American history. The Boston Athenæum is one of the oldest and most impressive examples of American cultural philanthropy. ⌒

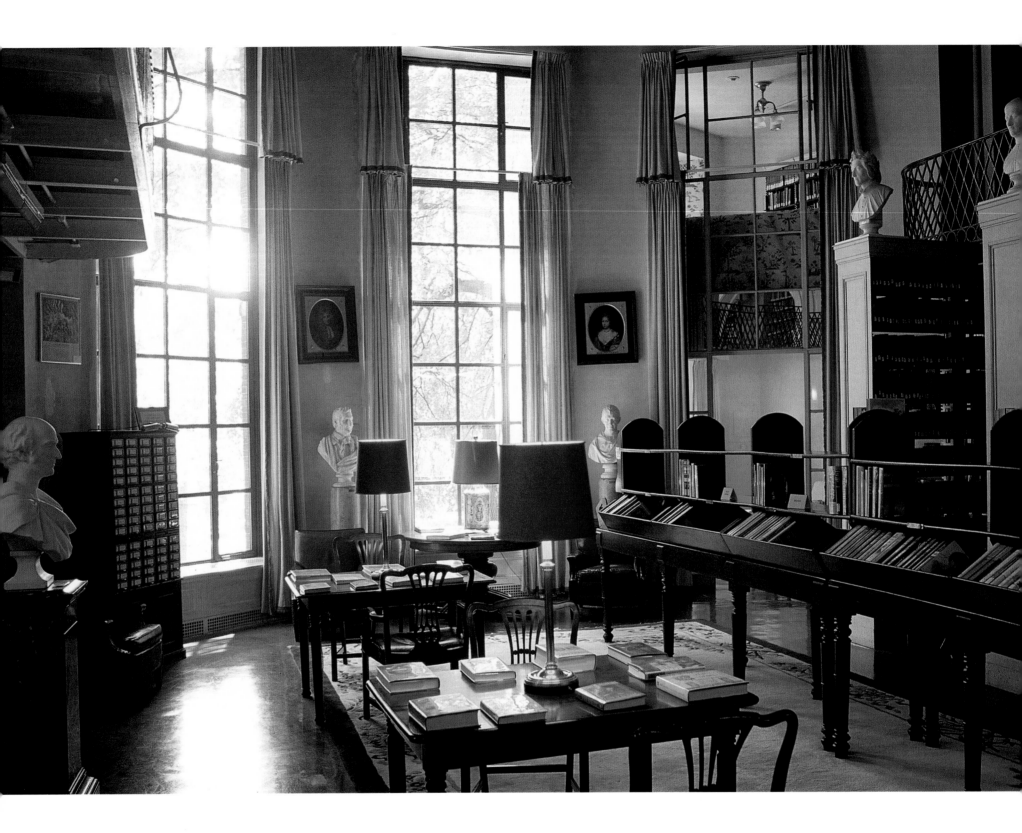

Above: The old card catalogue room with reference books.

Right: The Athenæum offers its members a place for meetings, dinner-debates, official and private receptions, signings, and conferences. The Wednesday tea is a weekly event on Boston's social calendar.

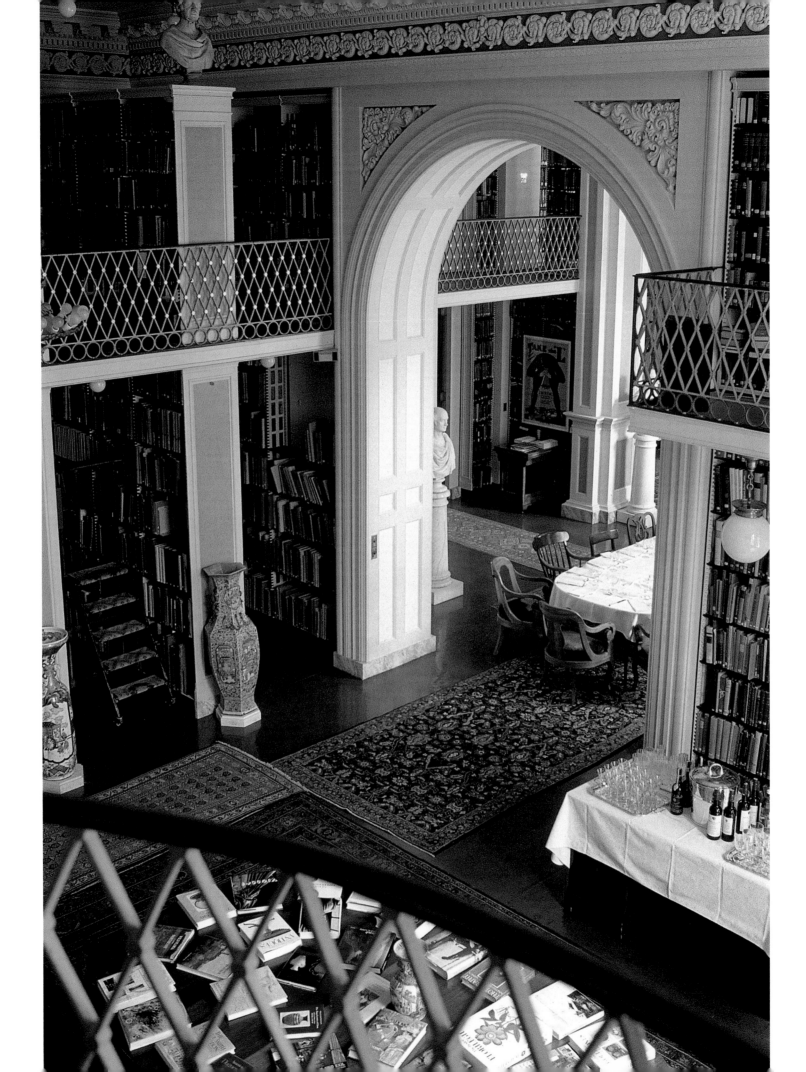

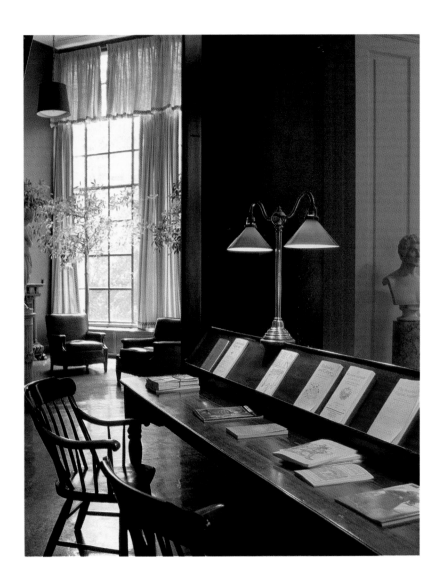

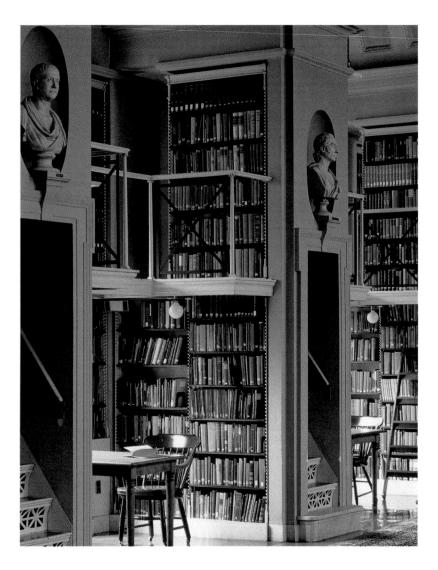

A private library, the Athenæum is a cooperative reserved for its members (at a relatively high annual fee). With authorization, university students and researchers may consult the collections.

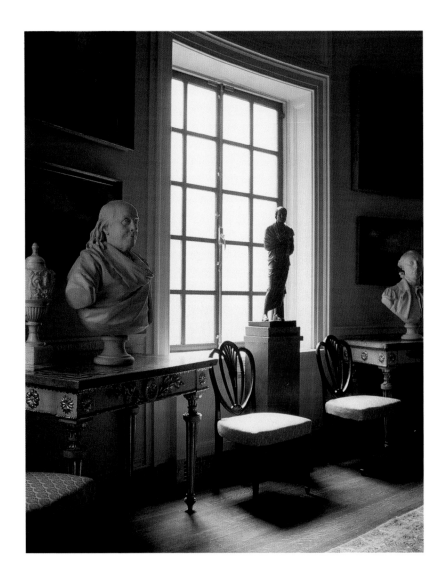

Birthplace of the Museum of Fine Arts, Boston, the Athenæum retains much evidence of the aesthetics of its founders. The strong presence of decorative objects reinforces the impression that one is visiting a private home.
Following double-page spread: The design of the large reading room, with its protruding bookcases, was copied from the great libraries of Europe, such as Trinity College.

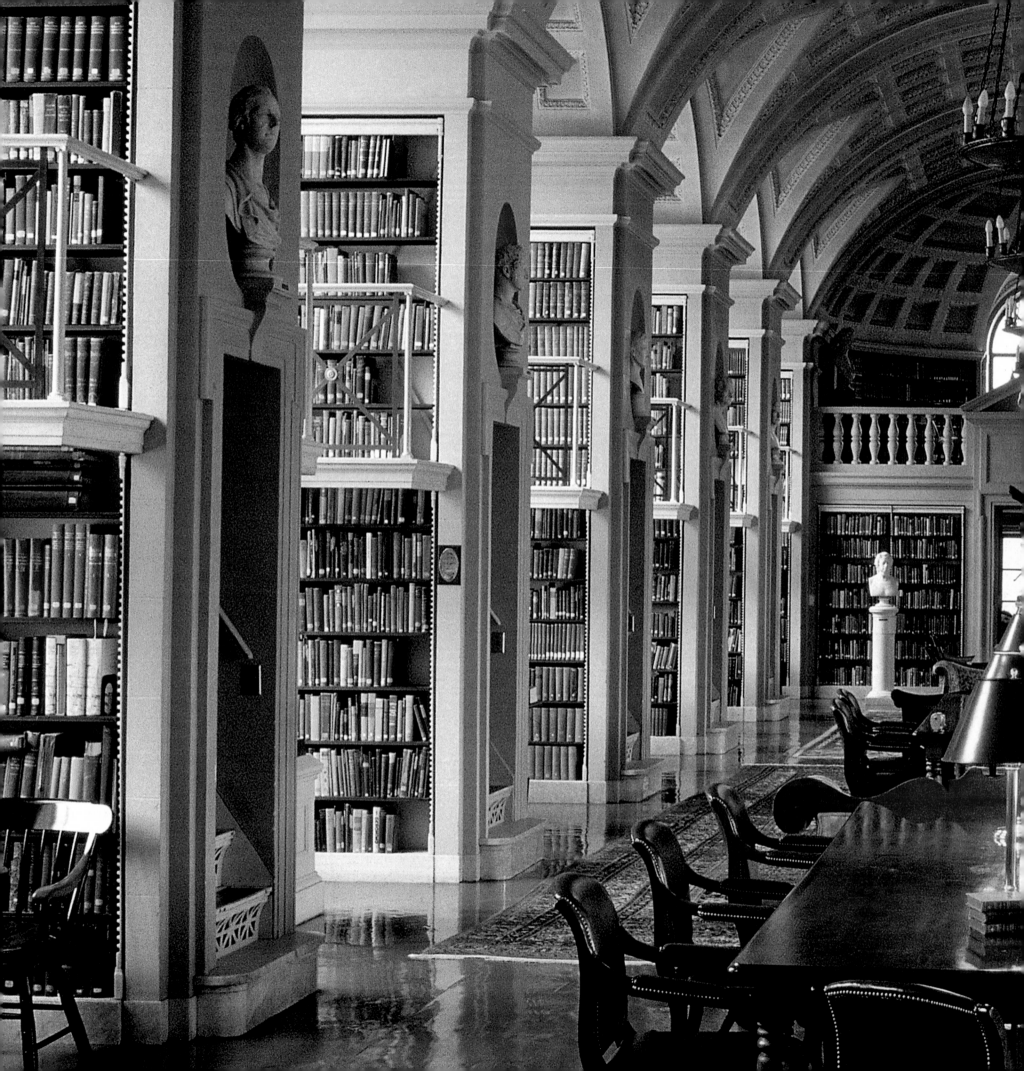

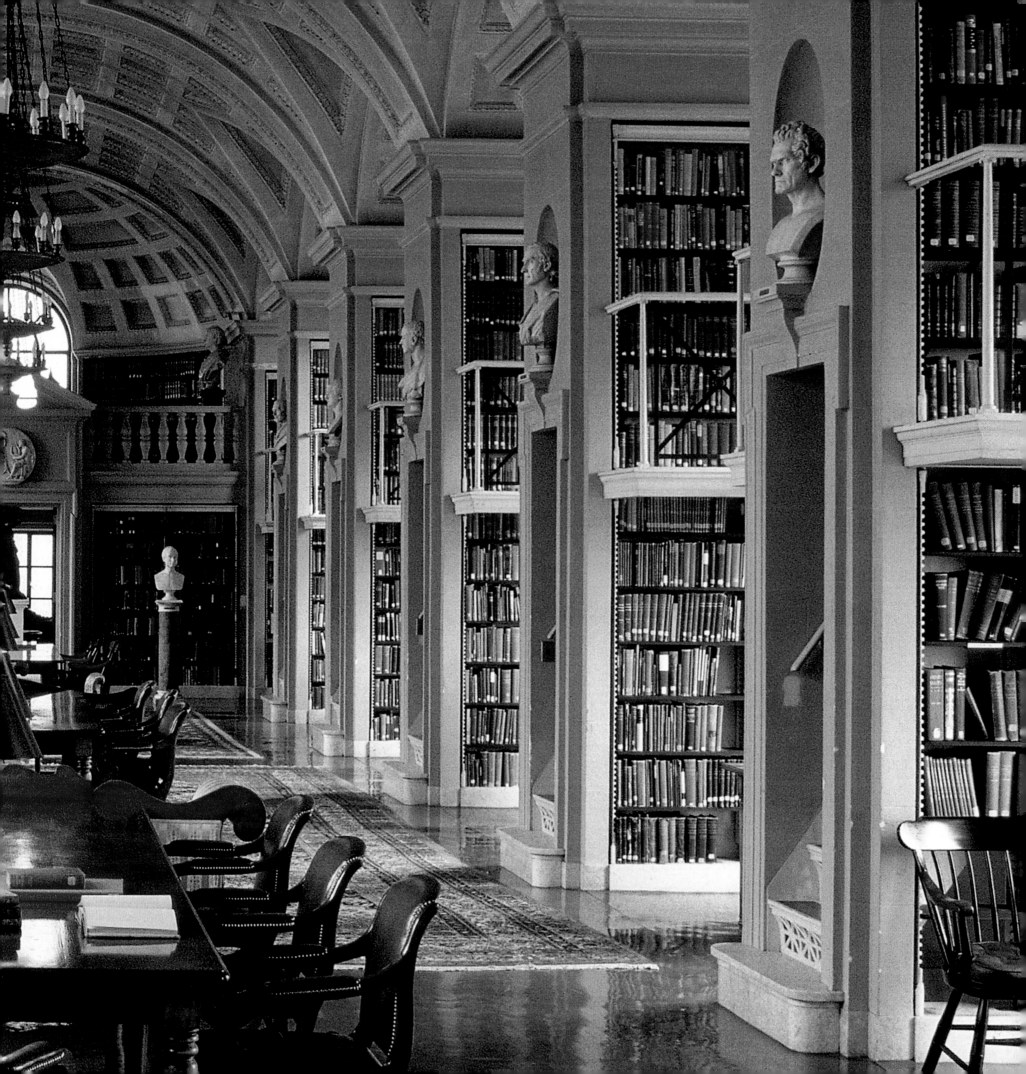

THE LIBRARY OF CONGRESS

"THE LARGEST, MOST EXPENSIVE, AND MOST RELIABLE library in the world" and "The most beautiful public building in all of America" were some of the words of praise that accompanied the opening of the Library of Congress on November 1, 1897. Overflowing with optimism and self-confidence, the United States went to great expense to present itself with this extraordinary symbol of its burgeoning powers. The foundation of the largest library in the world remains, however, the intellectual creation of Thomas Jefferson (1743–1826), third president of the United States. A highly cultured man and one of the fathers of the American Constitution, he was heir to the philosophy of the Enlightenment, which he was quite familiar with, having spent time in Paris after succeeding Benjamin Franklin as ambassador to France. A man of an encyclopedic intellect, he believed that there is "no subject to which a member of Congress may not have occasion to refer" and, therefore, Washington, DC, needed a library that covered all fields of knowledge. He believed in the direct link between democracy and knowledge, and saw in the Library of Congress an essential tool for the political progress of his country.

This institution on Capitol Hill is a unique example in the world of "parliamentary" libraries, which later became national libraries, even if it is not referred to as such and is still strictly dependent on Congress. It fulfills several functions, serving as a library for the members of the House of Representatives and the Senate; a copyright deposit for all works that are published in the United States in all media; a research center; a governmental library that is used extensively by members of the government and its agencies; the largest library in the world of maps and atlases, printed and copyrighted musical works, films and television programs; and finally, a public library open to everyone. Its growth has kept pace with the rhythm of American expansion and it is, without question, one of the most venerated and most visited monuments. In 1800,

shortly following its creation by John Adams, the library had 740 volumes and three maps that had been bought in London. Once president, Jefferson enlarged the collection through numerous purchases, almost all of which disappeared in 1814. On the sad day of August 24, 1814, English troops led by Rear Admiral Sir George Cockburn set the Capitol Building ablaze. The former colonizer encountered little resistance, and the books, which were housed there at the time, helped stoke the flames. Congress quickly rebuilt the collection of important books and in 1815 even bought from an indebted Jefferson the books of his personal library—the largest in the country—for $23,940.

This original collection is a reflection of that which would become the Library of Congress over the course of the century—i.e., a compilation of all works useful to an American legislator. It contained books on law, economy, geography, history, literature, and works on the arts, not only in English, but also in French, Latin, Greek, Spanish, German, and even Russian.

In 1897, the library owned 840,000 volumes, not counting its collection of maps, musical scores, engravings, and miscellaneous historical objects. The collections piled up for a long time in the west wing of the Capitol, and once the copyright function was delegated to the Library of Congress in 1870, the disorder worsened by the day. In 1873 an architectural competition for a new building was organized. In 1886, following numerous proposals, all of which ignited the feverish controversy that ordinarily accompanies projects of this magnitude, the plans by the Washington architects John L. Smithmeyer and Paul J. Pelz were accepted. In a style dubbed "Italian Renaissance," but in truth, far more reminiscent of the noble integrity of the Beaux-Arts style, the building was constructed by the army engineer General Thomas Lincoln Casey, assisted by Bernard Green, who oversaw the work to its completion in 1914. The initial architects were

pushed aside rather quickly in favor of Edward Pearce Casey, son of the general, who was primarily in charge of the fittings and interior decorations.

A grand and rich décor is hidden behind the building's austere and impressive facade. It is superbly enhanced by the refined lighting system installed during the 1997 restoration. The style of the décor and the complicated perspectives, in particular those found in the Great Hall, were undoubtedly inspired by the Charles Garnier Opera House in Paris and the staircase of the Vienna Kunsthistorisches Museum. However, all the work was awarded solely to American companies, artists, and artisans. More than fifty marble workers, sculptors, tilers, fresco painters, general painters, and specialists in stucco and bronze worked on the opulent décor. In a country that usually destroys its architectural past too quickly, the library remains a remarkable testament to the technical expertise that America had achieved by the end of the nineteenth century. Based upon universality and the history of knowledge dating back to ancient Egypt, the iconography depicts or symbolizes the great names of literature throughout history, along with the virtues, the sciences, and the continents, all in the eclectic array of styles then in vogue. The reputations of these artists, who had often studied in Europe or were influenced by its artists (among them Olin L. Warner, Herbert Adams, Charles Sprague Pearce, John White Alexander, Elihu Vedder, Edwin Blashfield, and Charles H. Niehaus) are still limited to the American continent, but the day will unquestionably arrive when their originality is better recognized.

Three elements are distinctly represented in this *America Triumphans* style, including the Great Hall, with its extraordinary marble staircase; the Members Room, a vast and luxurious reading room reserved for members of Congress; and the circular main reading room, with its extremely high ceiling beneath a lantern cupola decorated with a fresco depicting the great periods of civilization.

Today the Library of Congress is housed in three separate, nearby buildings: the Thomas Jefferson Building, which is the historical seat and dates to 1897; the Adams Building, in a style inspired by Art Deco, which opened its doors in 1938; and the James Madison Memorial Building, inaugurated by President Reagan in 1981. Numerous annexes complement these three enormous structures, and collections are spread throughout Washington, DC, and the surrounding area. Like all similar institutions the world over, the Library of Congress has been faced with the ongoing problem of space. To date, it has more than seventeen million books and almost ninety-five million maps, manuscripts, photographs, films, audio and video tapes, prints, drawings, and other collections in 460 languages. Every day, 20,000 documents, new copyright registrations, are deposited, along with the hundreds of works that pour in thanks to the 15,000 exchange agreements with foreign institutions.

The wide scope of the works making up the Library of Congress is unique. Since it didn't inherit any royal or historical collections, it possesses relatively few ancient books and manuscripts (when compared to the total number of its treasures). Nevertheless, some illuminated manuscripts, like the *De Consolatione Philosophæ*, three superb Gutenberg Bibles, some Coronelli globes, its collections of tenth-century Chinese scrolls, and Japanese prints, as well as one of the world's oldest printed documents—a passage from the Buddhist *sutra* dating from 770—are all of the finest museum quality. On the other hand, everything that has been written, thought, exchanged, or discovered in the universe during the course of the nineteenth and twentieth centuries is here, scientifically preserved and easily accessible. Researchers throughout the world

use the library's catalogues or visit and consult its collections. One example among hundreds: a recent investigation revealed that the Library of Congress has more works on the great, if poorly known, French architect Tony Garnier than does the National Library of France. Its wealth in the realm of music (and other domains) is unequaled. Not only are Gershwin's archives found there, but also countless recordings of his works from the time of their creation to the present day.

From the start, the Library of Congress has not blinked, keeping an eye open on the ever-changing world around it. Ever since its inception, it has adapted, without hesitation, to new technologies, beginning with photography and the phonograph, and continuing on to computers. A tool for universal knowledge, it has remained faithful not only in word but in deed to its goals, acquisition policies, organization, and concerns for the public. In the words of Thomas Jefferson, "Enlighten the people and tyranny and oppressions of body and mind will vanish like evil spirits at the dawn of day." ✖

Opening page: The two sets of double bronze doors at the entrances to the Jefferson Building on Second and Third Streets, sculpted by Lee Lawrie, present the history of the written word.
Right: In its splendor, the staircase of the Great Hall calls to mind both those of the Paris Opéra and the Kunsthistorisches Museum in Vienna. The profusion
of symbols, allegories, quotations, and architectural details presents a glorification of the American contribution to universal knowledge.

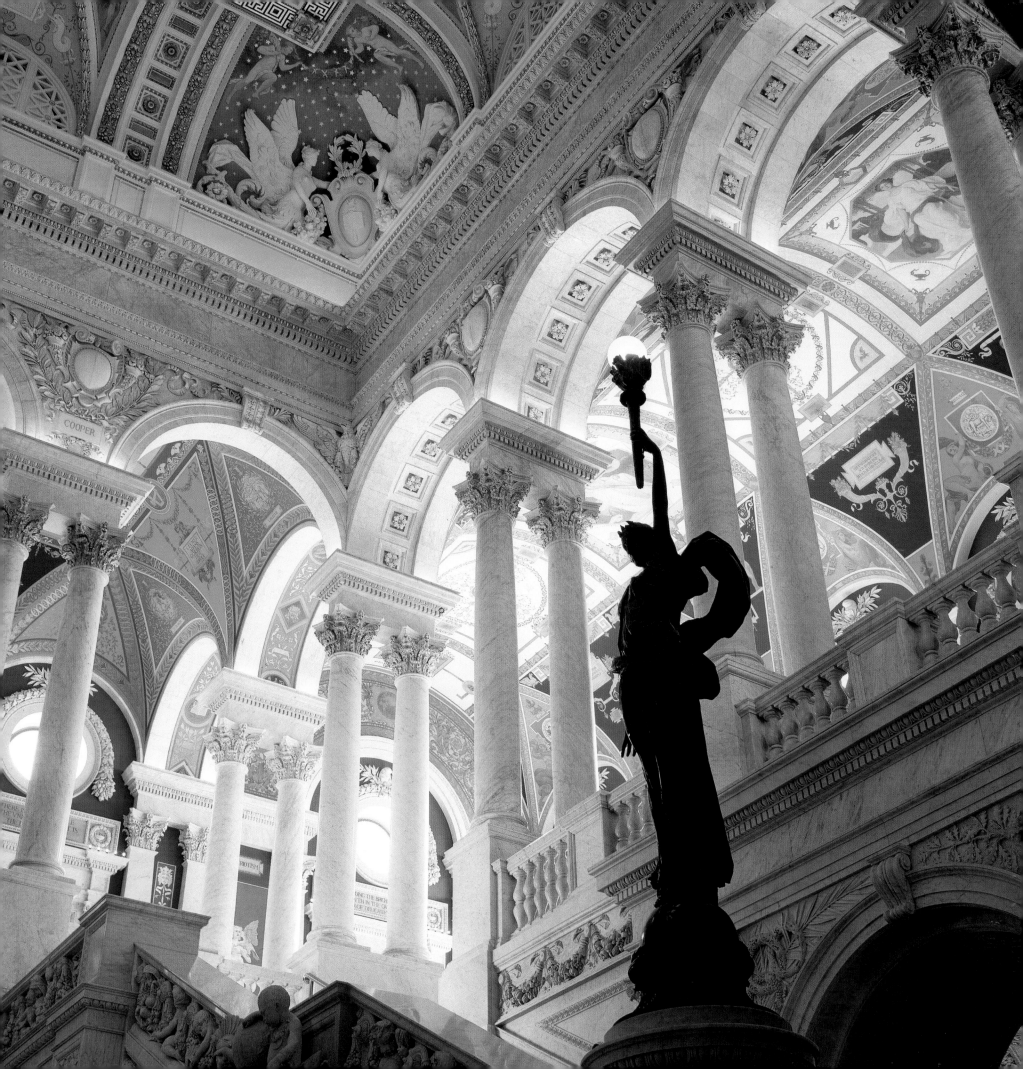

On the occasion of its centenary in 1997, the building was entirely restored, its interior decorations conserved or retrieved, creating the atmosphere of an elegant club library as originally conceived by Congress.

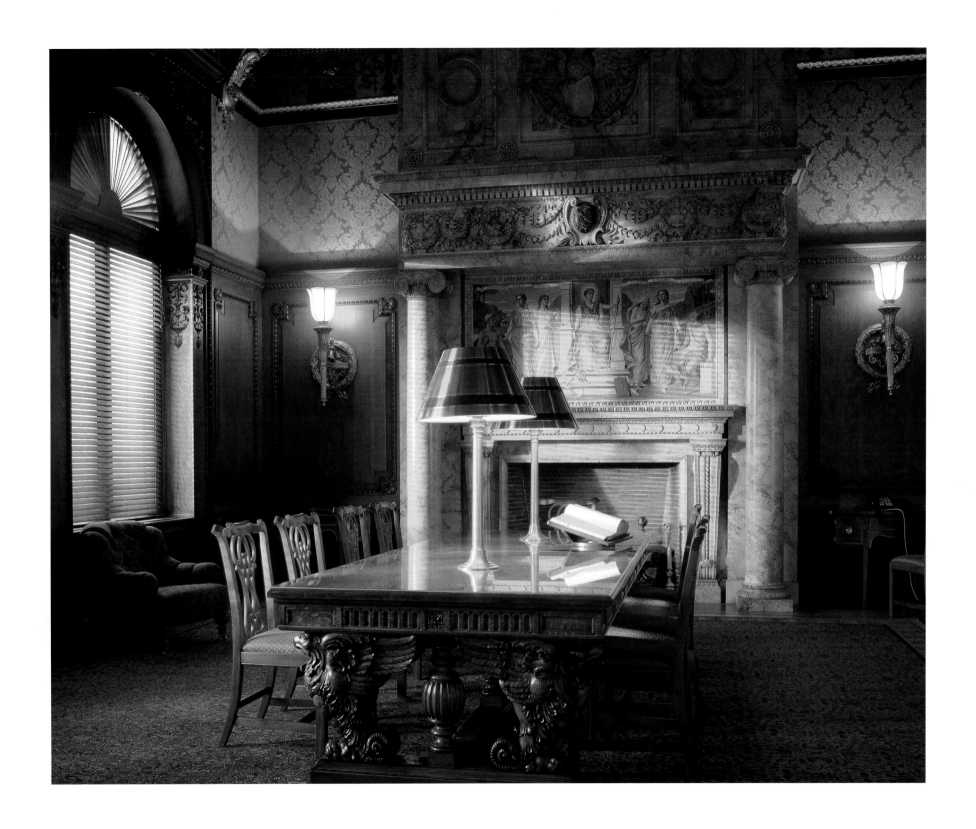

The Members Room is reserved for members of Congress and is accessed through a private entrance. Over the fireplace made of Sienna marble is a Venetian mosaic depicting The Law.

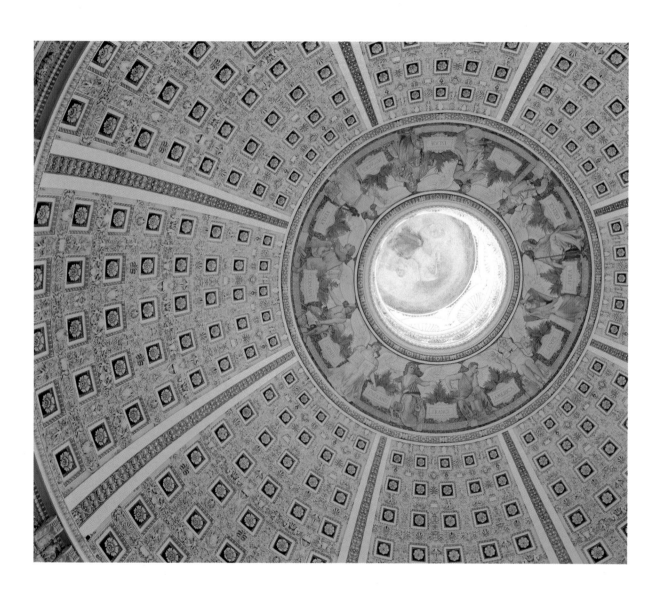

Above: The dome is decorated with Human Understanding, *a fresco by Edwin Holland Bashfield. It depicts twelve personifications of the countries and themes that influenced the development of Western and American civilization, including Egypt and Science, Islam and Physics, Rome and Government, Germany and Printing, France and Emancipation.*
Right: Beneath the gilded cupola, the main reading room has kept its comfortable original furnishings and its well-designed lighting.

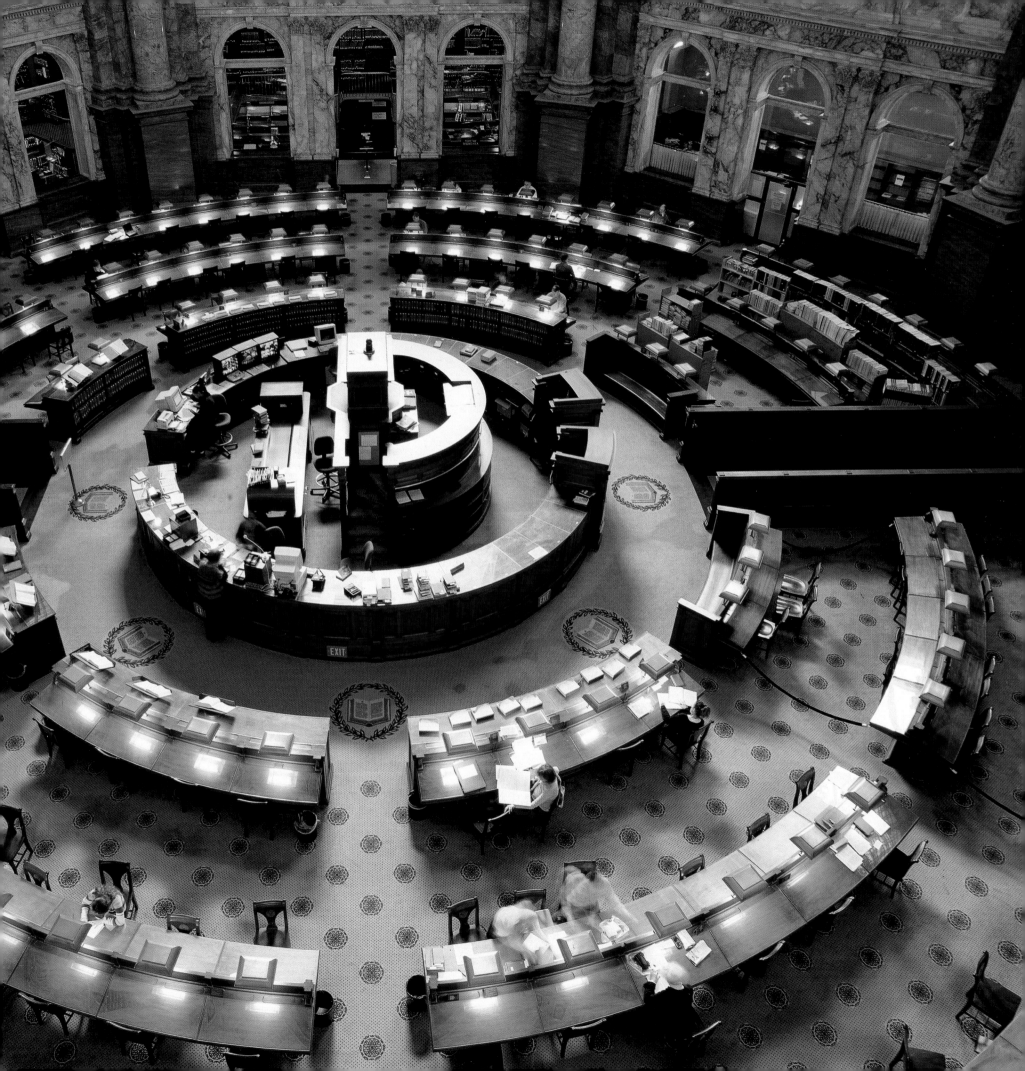

UNITED STATES OF AMERICA

NEW YORK

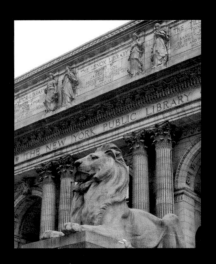

THE NEW YORK PUBLIC LIBRARY

PATIENCE AND FORTITUDE ARE THE NAMES OF THE two pink Tennessee marble lions sculpted by Edward Clark Potter that welcome the visitor to the New York Public Library. Deemed a bit too placid when they were first installed, these two superb felines are today two of New Yorkers' preferred beasts. On the occasion of the library's centennial celebrations, the cover of the *New Yorker* depicting the two lions dressed in tuxedos, strutting down the red carpet and waving to the admiring throngs represented more than the simple whimsy of a cartoonist. The history and substance of this remarkable library were wonderfully conveyed by this genial image to some of the library's haughty and prestigious sister institutions in Europe.

The New York Public Library is, in fact, an authentically democratic tool of knowledge reflecting the American conviction that education is one of the surest ways to climb the social ladder.

Its complicated history began in 1848 with the considerable gift of $400,000 by John Jacob Astor (1763–1848), the wealthiest American at that time, who wanted to create a reference library open to the public. The development of New York's cultural institutions had not kept pace with its economic growth, and the largest city in the United States did not even have a proper library. The Astor Library, which was soon built on Lafayette Place, was in fact reserved for people from high society. In 1870, a wealthy merchant and housing developer, James Lenox, decided to found a library from his own large collection of rare works, manuscripts, and documents on the history of the United States. Toward the end of the century, however, the two institutions experienced the same fate—they suffered from their reputation for elitism and, more important, from insufficient funding. During the same period many public lending libraries were being created, while the universities were forming their own prestigious research centers. New York, unquestionably already the most powerful city in the

world, had yet to learn that it needed to finance cultural ventures and was still deprived of a library equal to its own status. Salvation came from a former New York State governor and past presidential candidate, Samuel J. Tilden (1814–1886), who left his considerable fortune to a foundation charged with the creation of a great public library. After lengthy discussions and complicated legal negotiations, the Tilden Trust and the Astor and Lenox libraries were finally merged under the name of The New York Public Library, a private, nonprofit association, directed by a board that gradually came to include city representatives in exchange for operating subsidies.

The board found an outstanding director in the person of Dr. John Shaw Billings, who immediately dedicated himself with boundless energy to merging the collections, recruiting a specialized staff, creating a catalogue, and launching the construction of a new building worthy of the challenge.

In 1897, the city offered a plot of land occupied by a used reservoir, but that was well located in a flourishing neighborhood, just a few steps from the site of the future Pennsylvania Station. A determined and direct man, Billings wanted a functional tool, destined for public use, that did not forgo a certain luxury ardently desired by the board of directors, which was concerned with the city's prestige. A competition for architects was won by the still little known firm of Carrère and Hastings, specialists in the construction of private mansions. Both architects had graduated from the École des Beaux-Arts in Paris and had worked at McKim, Mead & White, the most prestigious firm of its time.

For the cost of nine million dollars, two million more than the Library of Congress in Washington, DC, one of the most superb New York monuments was erected. The construction lasted nine years, the first stone was laid in 1902, and the inauguration day was on May 23, 1911. The roof was installed in 1906 and the following five years were devoted to completing the interior furnishings.

The style is what has come to be called Beaux-Arts, replete with classical references, nostalgic harkening to Rome and the Renaissance, but with a functional severity and a concern for comfort so thoroughly idiomatic of the New World. Erected on a base that removed it from the traffic of Fifth Avenue, the back of the building opens onto a small park that is bordered by Sixth Avenue. Beneath the gaze of Patience and Fortitude, the visitor climbs the many flights of stairs and crosses into the grand marble entry hall from where staircases lead to several reading rooms, most notably, the vast Rose Reading Room that has recently been restored to its original grandeur. From the congested avenue below to a comfortable oak chair waiting beneath gilded ceilings adorned with frescoes, the reader forges an almost ritualistic distance between the bustling street and the simple, pure, and auspicious act of opening a book. During the construction of the main library, the institution continued to expand, in particular with the establishment of lending libraries throughout different neighborhoods. In 1901, it was placed in charge of operating thirty-nine branch libraries that were established thanks to a 5.2 million-dollar gift from the magnate and patron Andrew Carnegie. This overture to a very broad public was far more than symbolic; it was the demonstration of the will to make culture readily available to everyone, particularly the hundreds of thousands of immigrants flooding into the United States, most of whom disembarked in New York.

Today, the New York Public Library is visited each year by more than ten million readers. Its collection contains almost twelve million items and it has eighty-five lending and research branches in neighborhoods spread throughout the city. Aside from the main library on Fifth Avenue, which has been listed as a landmark monument, there are three other venues: The New York Public Library for the Performing Arts at Lincoln Center; Schomburg Center for Research in Black Culture on Malcolm X Boulevard in Harlem; and the Science, Industry, and Business Library located on Madison Avenue in the former B. Altman Department Store, which was renovated by the architects Gwathmey Siegel & Associates.

The collections are extremely varied, as much in terms of their contents as their sources of origin and their media and formats. It owns the first Gutenberg Bible brought to America, as well as a collection of science-fiction magazines from the 1920s, great works of literature in twenty-six languages, and an album of plates on the *Wiener Sezession*, George Washington's farewell address, a German illuminated Book of the Gospels dating from 970, Vladimir Nabokov's notes on the morphology of the genus *Lycaeides* butterfly, and the scenery from *West Side Story*. Since the beginning of the twentieth century, the collections have grown at a startling pace, and even today more than 10,000 new documents are catalogued each year. The librarians had—and continue to have—a particularly open and unfettered approach to the contents of this great democratic library. Their vision, free from all academic ties and constraints, is universalist. The library is there both to preserve and disseminate the countless documents that are testaments to a humane society. As Edward G. Freehafer, its director in 1957, stated, "We are at the service of that odd reader who may be the genius of tomorrow and of a genius whose works remain beyond our comprehension."

The New York Public Library is decidedly unique, like the city that saw its birth. ✑

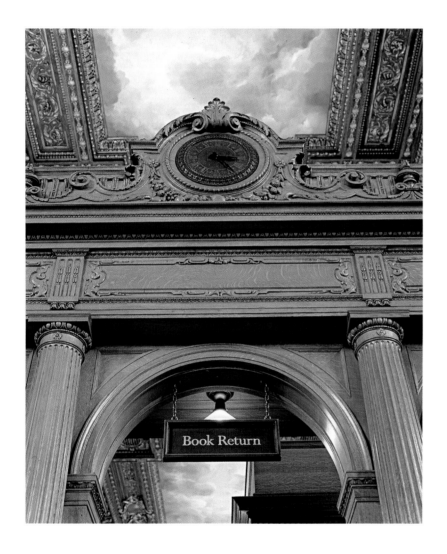

Above: The "Book Return" in the Rose Reading Room. A glimpse of the ceiling painted with a cloud motif is visible, an escape into the heavens for the distracted reader.
The eclectic décor makes reference to an array of styles, from neoclassical to Baroque, and even to the Renaissance, as in this door panel with its "grotesque" motif.
Right: One of the entrances to the Deborah, Jonathan F. P., Samuel Priest, and Adam Raphael Rose Main Reading Room.

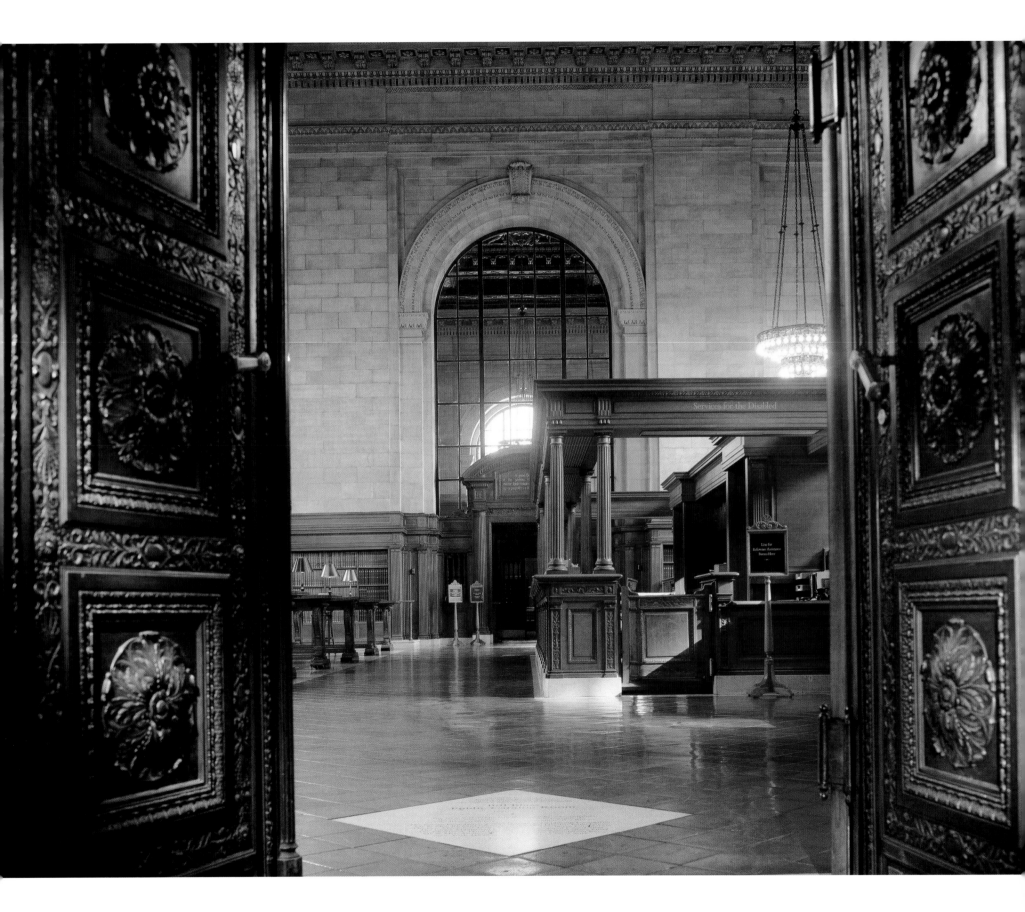

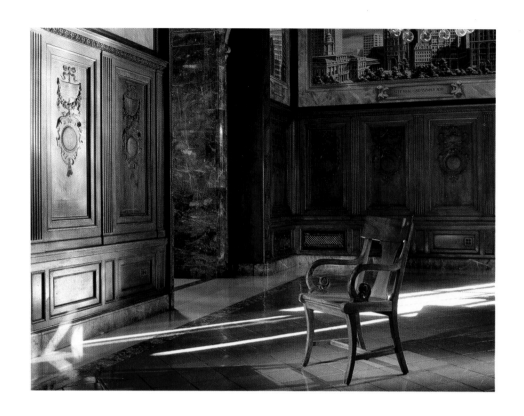

*Above: The luxurious décor is found even in the ancillary rooms. An archetype of the American library,
both luxurious and functional, the New York Public Library "is to New York what cathedrals
were to the cities of the Middle Ages," as a journalist wrote at the time.
Right: A masterpiece by the architects Carrère and Hastings, the Rose Reading Room, measuring 14,000 square feet
(1,300 square meters) and with 52½-feet- (16 m-) ceilings, can accommodate up to seven hundred readers.*

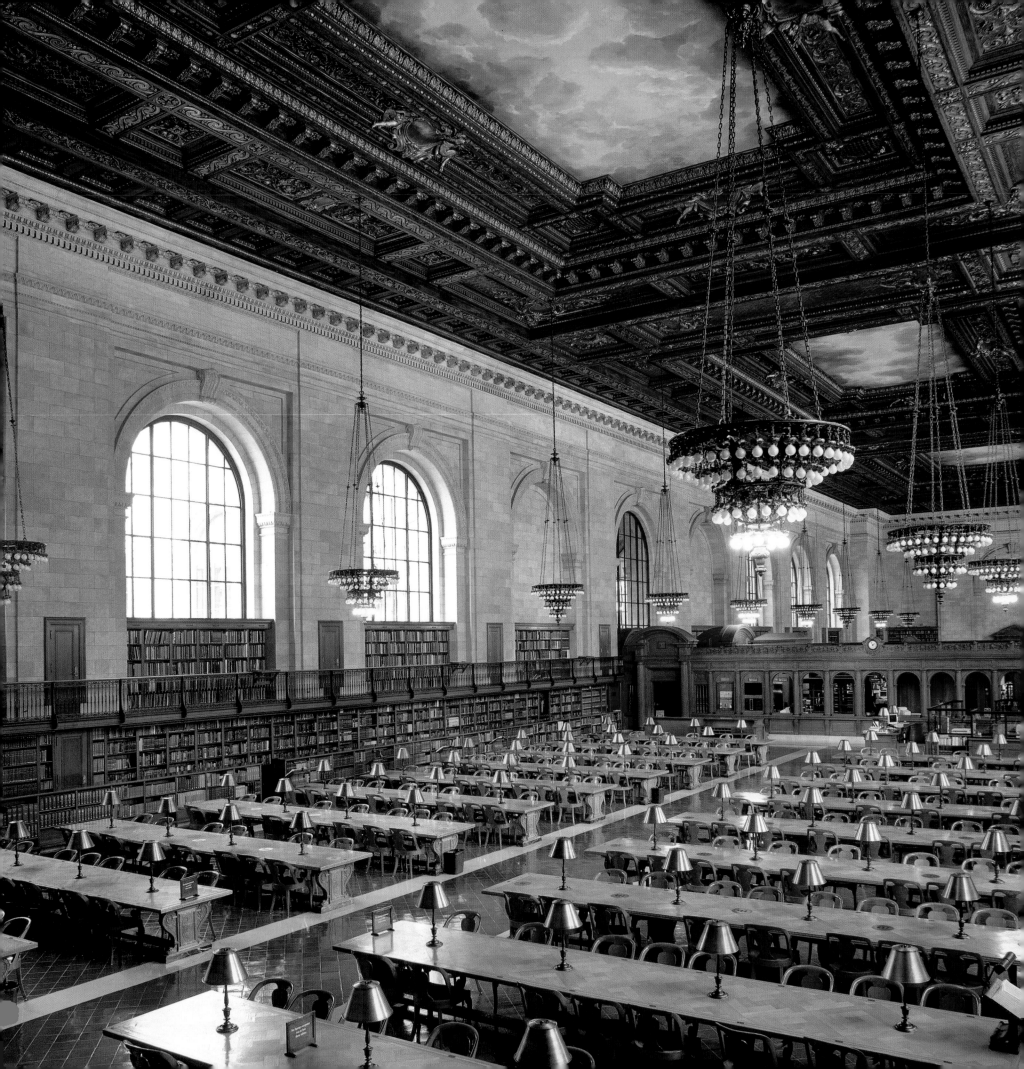

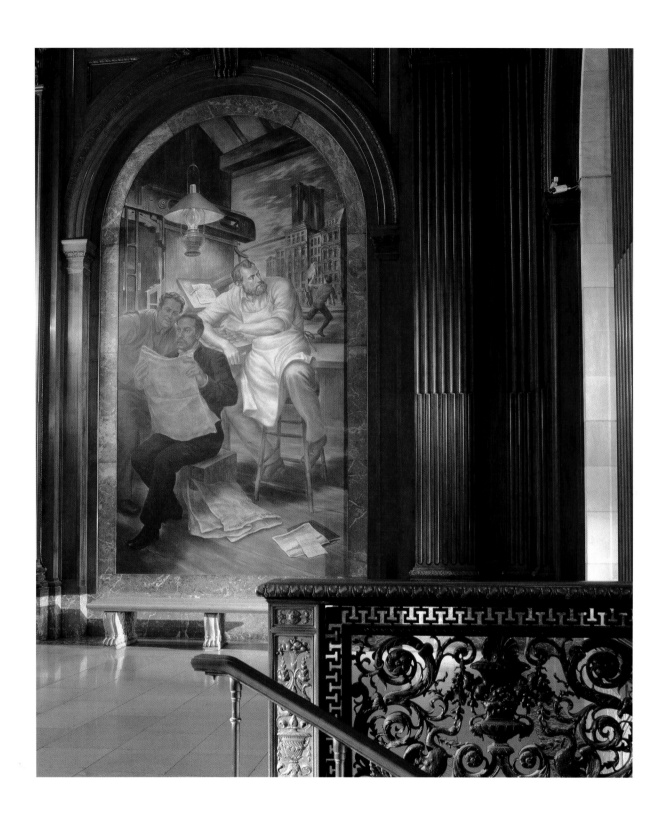

Above: Beneath the McGraw Rotunda, four frescoes by Edward Lanning, painted from 1938 to 1940, depict the history of the recorded word:
Moses and the Tablets, a medieval scriptorium, Gutenberg's invention of the printing press and, shown here, Mergenthaler and his invention of the linotype.
Right: The periodical room overseen by a painting of the Flatiron Building, New York's oldest skyscraper.

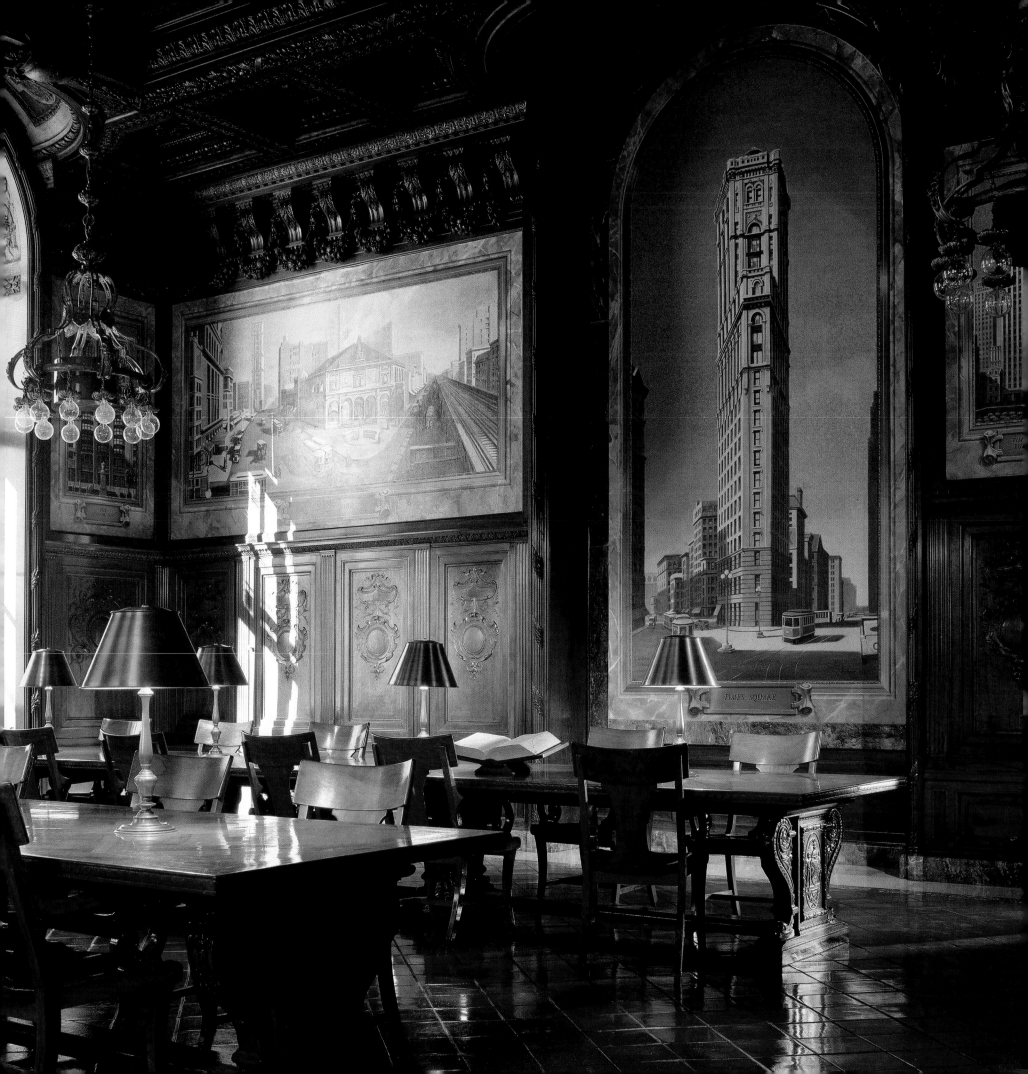

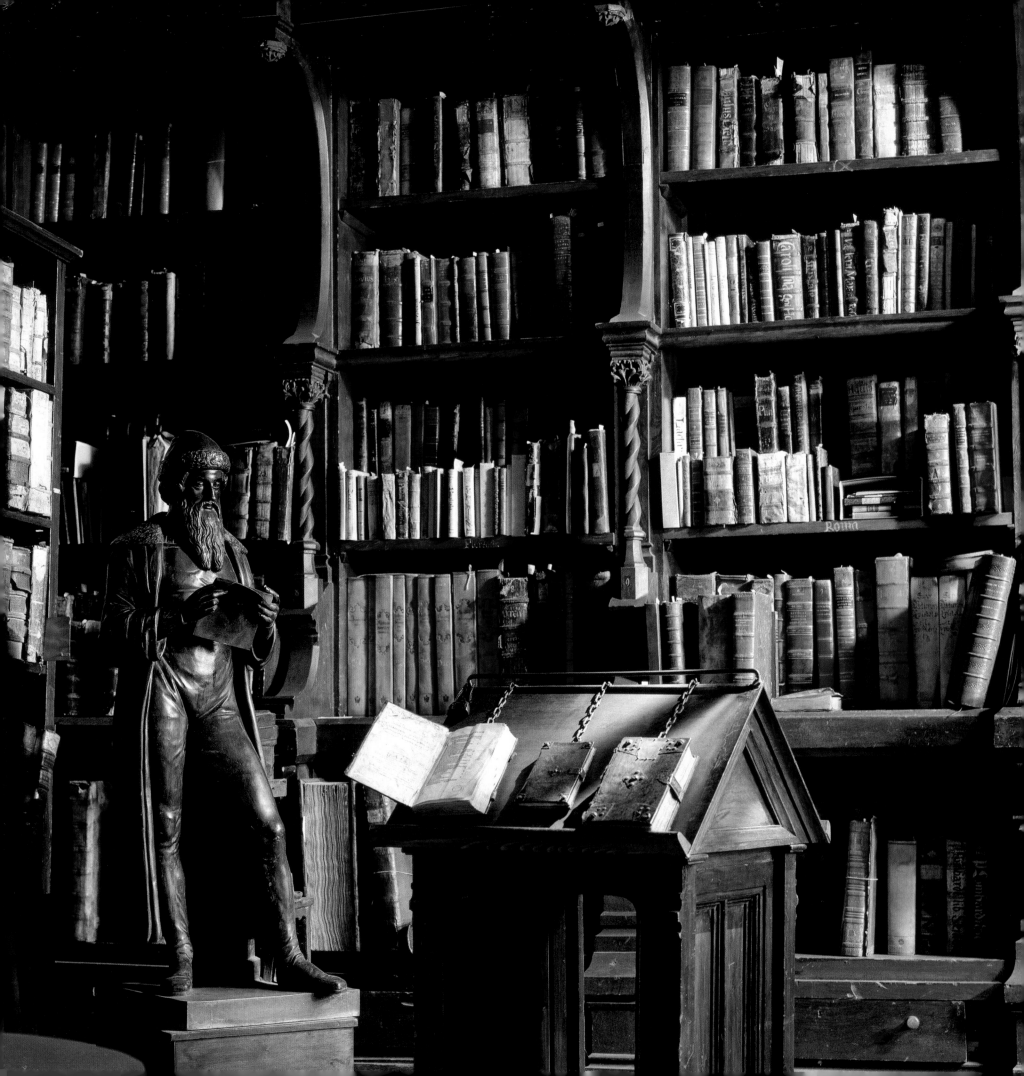

RUSSIA

SAINT PETERSBURG

THE NATIONAL LIBRARY OF RUSSIA

"THE ROYAL EMPRESS CATHERINE II, HAVING DECIDED to make of this library a deposit of books, open to the public, in this same year of 1795, ordered the construction in the capital of a building of the utmost splendor according to the plans of the former architect of the firm Yegor Sokolov, the construction of which has begun immediately." Thus reads the official declaration of the decision to build a great imperial library that would be inaugurated twenty years later. The empress was sentient to the thoughts on education coming from France and wanted to form an intelligentsia of "enlightened aristocracy." For a long time she had nurtured the idea of opening a library, the kind of institution that was virtually nonexistent in Russia at the time. She wanted one that would be widely accessible, unlike most of the royal institutions in Europe, so as "to bring the enlightenment of education to her Russian subjects." However, things did not progress as quickly as she would have liked. Paul I, who succeeded her in 1796, did not hold the same interest in education, and the project was not revived until 1800, when Count Alexander Stroganoff was designated director of the imperial libraries. The count, who had lived for a long time in France, was an extremely rich patron and lover of fine books. He had a very clear vision of what a great imperial library "for public use" ought to be. After the assassination of Paul I, his successor Alexander I was more open to modern ideas and imparted to Stroganoff some important collections, in particular that of Piotr Dubrovsky, a former Russian diplomat to Paris who had bought many books that had been either confiscated or stolen from Parisian monasteries during the French Revolution. But the building was still not ready. In 1808, Stroganoff appointed Alexei Olenin, a mythic figure among Russian bibliophiles for having created a department of Russian books, an odd innovation in a library whose acquisitions until then centered on western European culture. Moreover, with the institution of copyrights he obtained of all

works printed in the empire, a great influx of works was created that expanded the project. Meanwhile, with the French troops bearing down on Saint Petersburg, all the valuable books were sent far away and would not be brought back until the official inauguration of the library on January 14, 1814.

The building, erected at the junction of Nevsky Prospekt and Sadovaya Street, is a beautiful neoclassical palace with a quarter-circle peristyle supported by six columns surmounted with statues. Designed by the architect Sokolov, it is in line with Peter the Great's plans for Saint Petersburg and illustrates the taste of Catherine II and her successors for the elegant and cold style that distinguishes their capital. Here it is expressed through the horizontal and repetitive distension of the facades, decorative elements with inspirations from antiquity, an expression full of grandeur and a timorous respect for power. The interior furnishings are of the same rather austere neoclassical style, without any great luxury. Only three spaces (designed at various periods) were treated differently: a vast rotunda that is terribly and eclectically overfurnished and poorly lit today; the Manuscript Department with a décor in birch wood and a Slavic influence; and the "Faust Cabinet," a charming neo-Gothic setting where the collection's 6,000 or so incunabula are kept.

The history of the library itself is rather complex, a reflection of the growing tensions that were simmering in nineteenth-century Russian society and its intelligentsia. Following a triumphant inauguration, the library soon rested on its modest laurels. However, it was considerably enlarged through several constructions including a palace built by Carlo Rossi in 1828–1834, an enormous building constructed by Sobolschikov in 1861 that connected to the original one, and, finally, through an addition built by Vorotilov at the turn of the twentieth century. Around 1840 many readers began to complain about the chaotic disorganization. The German writer J. G.

Kohl wrote in 1842, "Getting access to a book [. . .] is practically impossible here, even if you can see where it is shelved." The opening hours were extremely limited, the days it was closed were numerous, and the rules governing access to the books, punctilious. During certain periods poorly dressed readers were turned away, the works being reserved for a privileged elite. It would not be until 1849 and the appointment of Modeste Korff as director of the institution that the library would truly open its doors to students and young readers, and become a real public library.

The Russian Revolution of 1917 obviously caused changes in the statutes and procedures overseeing appointments. The librarians, most of whom emigrated, were replaced by unqualified workers and although acquisitions slackened off, the collections expanded through books confiscated from ministries, monasteries, churches, and seminaries along with an ever-more-encroaching influx of Marxist and communist works. In the middle of the 1920s, a special department was created for banned works (49,000 between 1935 and 1938), while, at the same time, the library was restructured into general rooms and research rooms. The thirty-nine reading rooms were then (and remain) organized according to specialty: socioeconomics, literature and the arts, natural sciences and medicine, physics and mathematics, and chemistry and technology.

The prodigious collection of the National Library of Russia in Saint Petersburg—there is another in Moscow—contains more than thirty-two million volumes. Quite rich in works from the eighteenth century (the Tsarina had bought Voltaire's personal library), it also possesses two-thirds of all known books printed in the Cyrillic alphabet during the sixteenth century, 40,000 manuscripts including the famous Ostromir Gospels (1056), and countless documents on both the birth of Russia and the Orthodox Church. Its "Rossica" Collection consists of the majority of works on Russia published before 1917. Its collection of the Revolution and communism—the largest in the country—not only contains books, but also posters, tracts, films, and photographs.

The disruption of educational institutions following the fall of communism affected the network of 15,000 Russian libraries, and though a great number of them were restructured, some were even privatized. The Library at Saint Petersburg, which until 1992 was called the "Saltykov-Shchedrin State Public Library Under the Order of the Workers' Red Flag," was renamed the National Library of Russia and in 1998 inaugurated a new building on Moskovsky Avenue. But the considerable reduction of administrative appropriations explains the mediocre, and indeed obsolete, state of its holdings. Nevertheless, it continues to grow—not entirely due to copyright deposits—and today the library possesses more than thirty-two million classified items. The number of readers is continuously increasingly, and Catherine the Great and her successors, whether tsars or general secretaries of the Party, have undoubtedly achieved their objective to disseminate knowledge to the masses. Their library has become one of the five largest libraries in the world. ✍

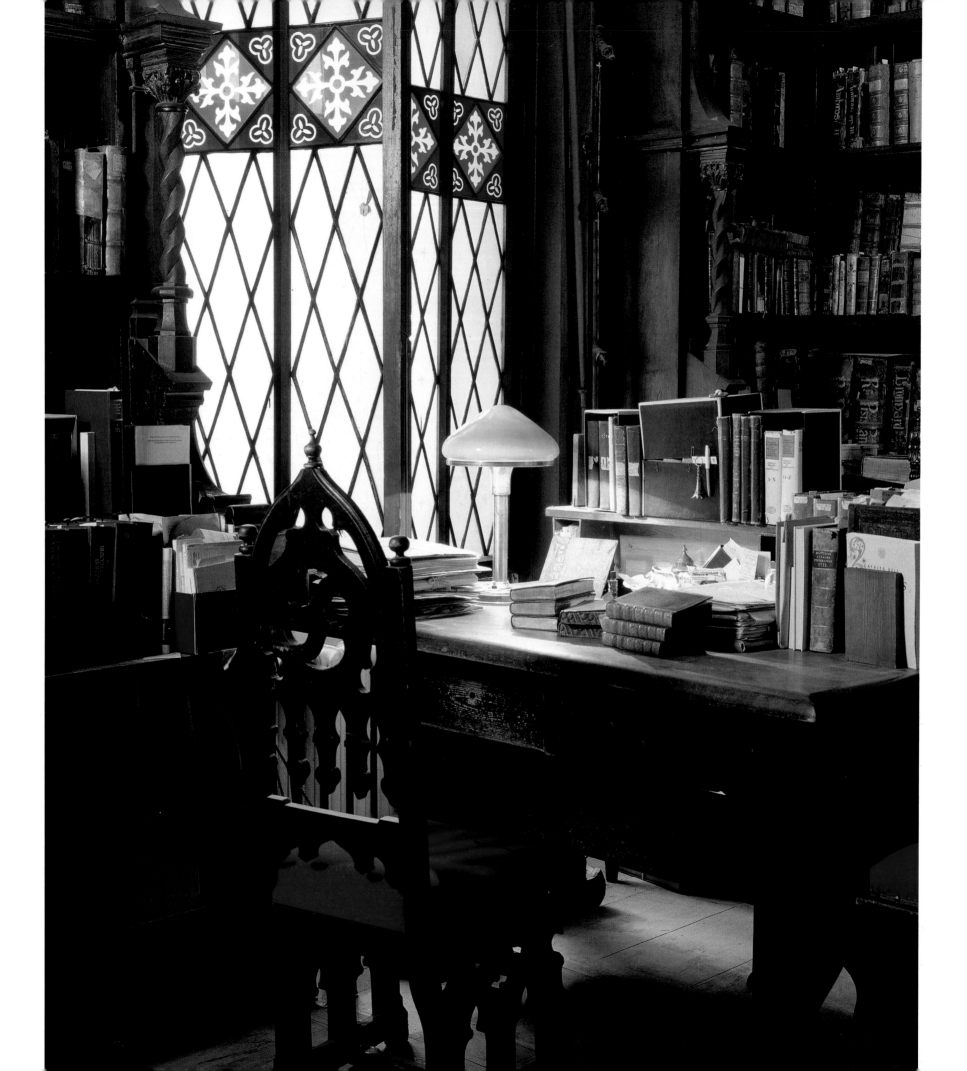

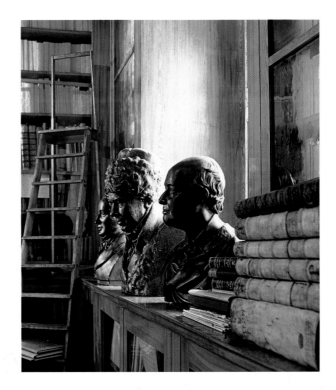

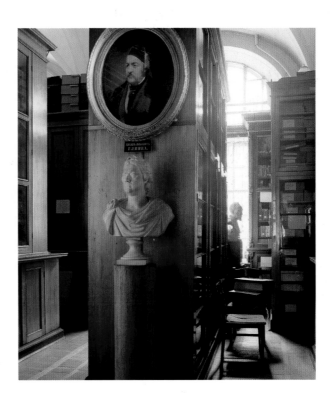

Above: The furnishings, sometimes cluttered, bear witness to the turbulent history of this library founded by Catherine II.
Left: The librarian's desk in the neo-Gothic Faust Cabinet.

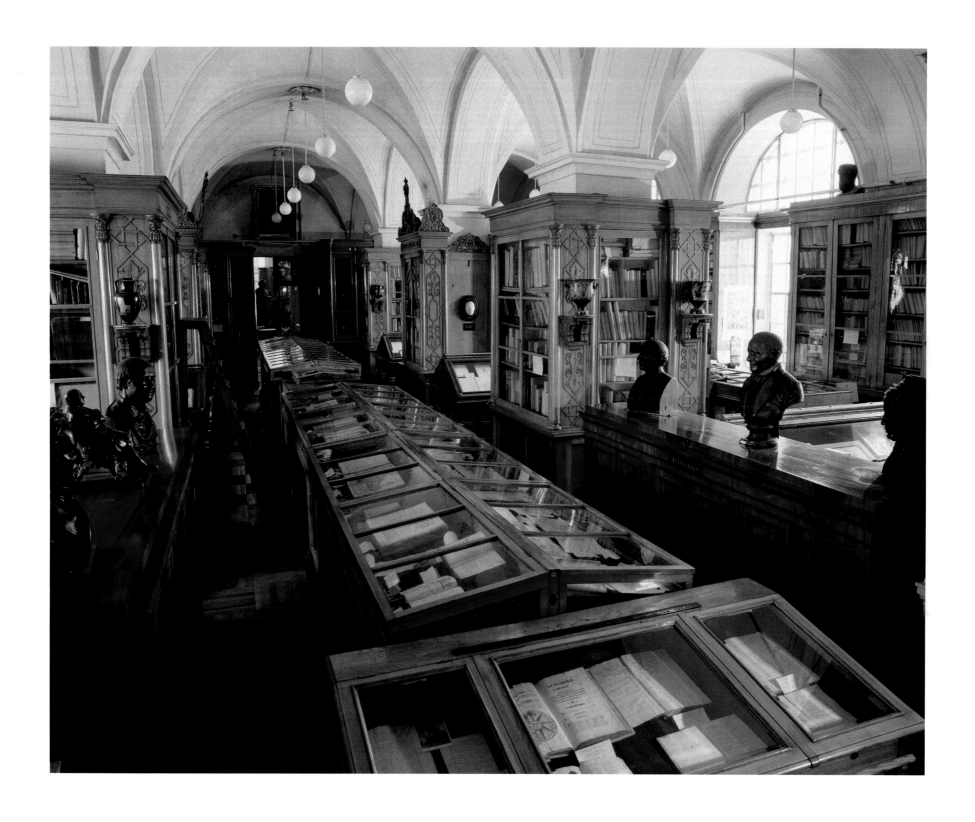

Above: The exhibition hall in the Manuscript Department; its woodwork is in a "Slavic" historicist style.

Right: The National Library of Russia owns Voltaire's personal library (6,814 works), which was bought by Catherine II upon the philosopher's death.

Above: The Music Department has more than 300,000 scores and 32,000 recordings. Shown here, a score and portrait of Rimsky-Korsakov
that is part of a particularly rich collection of documents on the late nineteenth century, the "golden age" of Russian music.
Right: A montage of a page from Dostoyevsky's journal (1880).

BIBLIOGRAPHY

Basbanes, Nicholas A. *Patience and Fortitude*. New York: HarperCollins, 2001.

Beck, James H. *Italian Renaissance Painting*. Cologne: Könemann, 1999.

Béthouart, Antoine. *Le Prince Eugène de Savoie, Soldat, Diplomate et Mécène*. Paris: Perrin, 1975.

Cole, John Y. *Jefferson's Legacy*. Washington, DC: Library of Congress, 2003.

Dain, Phyllis. *The New York Public Library, a Universe of Knowledge*. New York: The New York Public Library, 2000.

Drexler, Arthur, ed. *The Architecture of the École des beaux-arts*. New York: The Museum of Modern Art, 1977.

Dupront, Alphonse. *Genèses des Temps Modernes: Rome, Les Réformes et Le Nouveau Monde*. "Hautes Études" series. Paris: Gallimard-Le Seuil, 2002.

Ein Weltgebaüde der Gedanken (Collective work on the National Library of Austria). Graz: Akademische Druck- u. Verlaganstalt, 1987.

Fox, Peter, ed. *Treasures of the Library: Trinity College Dublin*. Dublin: Royal Irish Academy, 1986.

Gama, Luis Filipe marques da. *Palácio Nacional de Mafra*. Lisbon-Mafra: Éditions ELO, 1992.

Hobson, Anthony. *Great Libraries*. New York: Putnam Pub Group, 1970.

Kinane, Vincent, and Anne Walsh, eds. *Essays on the History of Trinity College Library*. Dublin: Four Court Press, 2000.

Marès, Antoine. *L'Institut de France, Le Parlement des Savants*. Découvertes series. Paris: Gallimard, 1995.

Masson, André. *Le Décor des Bibliothèques du Moyen Âge à la Révolution*. Geneva and Paris: Librairie Droz, 1972.

McKitterick, David. *The Making of the Wren Library*. Cambridge, England: Cambridge University Press, 1995.

Müntz, Eugène, and Paul Fabre. *La Bibliothèque du Vatican au XVe Siècle*. Paris: E. Thouin, 1887.

The National Library of Russia 1795–1995. Collective work. Saint Petersburg, Russia: Liki Rossii, 1995.

Pallier, Denis. *Les Bibliothèques*. 10th edition. "Que sais-je?" series, Paris: PUF, 2002.

Patrimoine des Bibliothèques de France/Île-de-France. Collective work. Paris: Payot, 1995.

Staikos, Konstantinos Sp. *The Great Libraries, from Antiquity to the Renaissance*. London: Oak Knoll Press and The British Library, 2000.

Stummenvoll, Josef. *Geschichte der Österreichischen National Bibliothek*. Vienna: Georg Prachner Verlag, 1968.

Tyack, Geoffrey. *The Bodleian Library*. Oxford: University of Oxford, 2000.

Vergne, Frédéric. *La Bibliothèque du Prince*. Paris: Éditions Editerra, 1995.

Watkin, David. *English Architecture*. London: Thames and Hudson, 1979.

ACKNOWLEDGMENTS

To each of the libraries and their librarians. They simply and confidently accepted the constraints sometimes unexpectedly tied to the arrival of a photographer in the secret and protected world of knowledge.

To all who accompanied me on these literary voyages, especially Marc Kunstlé, Marie-Claire and Amélie Blanckaert, Francine Vormese, Laurence Chavane, and Magdalena Banach. As well as to the magazines, which were still able to be enthusiastic while faced with the unexpected: *Figaro Magazine*, *Elle Décoration*, and *Point de vue*.

To the spirit and kind help of assistants over the years: Éric d'Hérouville, Pierre-Laurent Hahn, Jan Turnbull, and Guillaume Czerw.

To Hervé de La Martinière's attentive team.

And to the professional constancy of Central Color lab.

Project Manager, English-language edition: Susan Richmond
Editor, English-language edition: Lenora Ammon
Cover design, English-language edition: Robert McKee
Design Coordinator, English-language edition: Tina Thompson

Library of Congress Cataloging-in-Publication Data

Laubier, Guillaume de.
 [Bibliotheques du monde. English]
 The most beautiful libraries in the world / photographs by Guillaume
de Laubier ; text by Jacques Bosser ; foreword by James H. Billington ;
translated from the French by Laurel Hirsch.
 p. cm.
Includes bibliographical references and index.
 ISBN 0-8109-4634-3
 1. Library buildings. 2. Library architecture. 3. Libraries. 4.
Library buildings—Pictorial works. 5. Library architecture—Pictorial
works. 6. Libraries—Pictorial works. I. Bosser, Jacques. II. Title.

Z679.L37 2003
022'.3—dc21
 2003011073

Printed and bound in France
10 9 8 7 6 5 4 3 2 1

Harry N. Abrams, Inc.
100 Fifth Avenue
New York, N.Y. 10011
www.abramsbooks.com

Abrams is a subsidiary of
LA MARTINIÈRE
G R O U P E

Laubier, Guillaume de.

The most beautiful libraries in the world.

$50.00

DATE			